MARKS OF CIVILIZATION

MARKS OF CIVILIZATION

Artistic Transformations of the Human Body

Arnold Rubin, Editor

Museum of Cultural History
University of California, Los Angeles

COVER: Back and arm tattoos (Micronesian, Indone-
sian designs) by Ed Hardy, right arm, 1978; left arm, 1981;
back piece (based on Central Carolines [Micronesia] designs),
1982–83. Photograph by Richard Todd, 1987.

DEDICATION PAGE: Back tattoo based on Picasso's
Minotauromachy by Cliff Raven, 1984–87. Photograph by
Richard Todd, 1988.

Permission to reprint Paul Bohannan's article ''Beauty and
Scarification Amongst the Tiv'' from Man 129:117–121,
September 1956 was granted courtesy of the Royal Anthro-
pological Institute of Great Britain and Ireland.

This publication was supported by funds from The Ahmanson
Foundation, The Ethnic Arts Council of Los Angeles, and
Manus, the support group of the Museum of Cultural History.

Museum of Cultural History
University of California, Los Angeles
405 Hilgard Avenue
Los Angeles, California 90024

ISBN 0–930741–12–9 (softcover)
ISBN 0–930741–13–7 (hardcover)
Library of Congress Catalog Card Number: 88–19536

Table of Contents

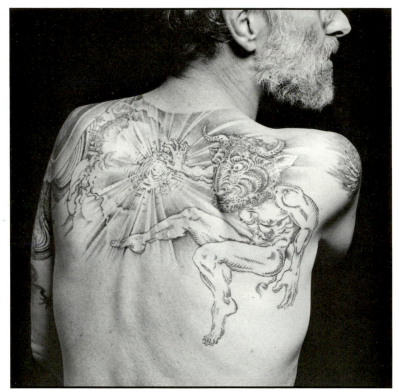

Arnold Gary Rubin, 1937–1988

The search for a permanent talisman representative of
inner work pertains to those who have chosen the path.
29 January 1983

In Memorium: Jamie Summers
1948–1983

Preface

During the relatively short twenty-five year history of the Museum of Cultural History its publication program has continually evolved and expanded. While the initial focus was on the Museum's own collections, and catalogues for traveling exhibitions, over the past several years it has attempted to publish volumes that significantly advance the literature of a given field quite apart from any connection the topic might have with the Museum's holdings. At the same time the varied and non-collectible body arts of non-western peoples have been crucial components of many Museum exhibitions and publications. This area of study is brought into clearer focus in the present volume while simultaneously reflecting the broad geographical and cultural interests of the Museum. We would like to thank the contributors for their vigorous and concerted efforts. It has long been recognized that the advancement of scholarship is a collaborative and mutually reinforcing achievement. It has been an honor to work with colleagues who share such a high sense of collegiality.

This is the most recent of many significant contributions Dr. Arnold Rubin has made to Museum of Cultural History programs. Tragically, he died of cancer as this book went to press. Arnold Rubin's legacy at UCLA is a strong one. His graduate students have consistently brought a high level of scholarship and a strong commitment to professional achievement in museum research projects, exhibitions and publications. Rubin's carefully documented field collections, now housed in the Museum, filled a once lamentable void in the Mu-

seum's otherwise extensive Nigerian holdings. His work on this volume and the forthcoming *Sculpture of the Benue Valley* exhibition and publication promise to stand as lasting models in their respective fields. As teacher, scholar and counsellor, Dr. Rubin has contributed enormously to the growth of the Museum. He will be missed.

The Museum of Cultural History's ability to publish volumes such as this is the direct result of the Ahmanson Foundation's generous funding of the Museum's Endowment and of the annual contributions provided by Manus, the support group of the Museum. The Ethnic Arts Council of Los Angeles has also offered sustained support for publications, including this one. To all three institutions the Museum owes a major debt of gratitude.

Within UCLA itself it is clear that the growth of the Museum in recent years is directly attributable to the foresight of Vice Chancellor Elwin Svenson and Chancellor Charles Young. Their commitment to the Museum and its programs has ensured a vital future.

Christopher B. Donnan, Director
Doran H. Ross, Associate Director

Acknowledgements

This book is based on a symposium entitled "Art of the Body," held at UCLA between 28 and 30 January 1983. For me as convenor and moderator, the symposium culminated an expanding research involvement which began in 1976 with a field-methods seminar project on contemporary tattoo carried out by Louis Quirarte, a UCLA graduate student in Design. The 1983 symposium was intended to be a global survey of irreversible modifications of the surface and structure of the human body, primarily (if not exclusively) for aesthetic purposes. Contributions encompassed the fields of anthropology, sociology, art history, folklore, and medicine. One of the twelve papers presented to the symposium—that by Harvey Zarem, M.D. on plastic surgery—is not included here. The papers by Berns, Bohannan, Gritton, Teilhet-Fisk, Roberts, and mine on Gujarat, not presented to the symposium, were added later.

The symposium audience numbered approximately one hundred for each of three sessions organized within a tripartite geographical and historical framework: Europe and Euro-America, Sub-Saharan Africa, and "The Pacific Basin" (comprising Asia, Oceania, and Native America). Formal commentaries were provided by Herbert Cole on the African papers, by Jehanne Teilhet-Fisk on those dealing with the Pacific Basin and by David Kunzle on Europe and Euro-America. A concluding session featured comments by a number of outstanding tattoo artists, notably Jamie Summers, Ed Hardy, Bob Roberts, Jack Rudy, Leo Zulueta, and P. J. English. These contributions, and discussion generally, were consistently trenchant and lively. The insights they provided are developed in the introductory sections of this book and helped to enrich and refine the versions of those papers presented to the symposium which are published here.

The symposium was originally intended to complement a comprehensive exhibition of "body-art" at the Frederick Wight Gallery, UCLA. Planning for this exhibition began in 1979, but applications for funding were unsuccessful and the exhibition was abandoned in 1981. However, work on the symposium as an independent project shifted into high gear following expressions of support from Dean Robert Gray of UCLA's College of Fine Arts. Announcement of the symposium in journals of learned societies, approaches to scholars known to be active in these fields, and consultations with colleagues regarding their own research or that of others generated a pool of abstracts from which I, as convenor, selected the papers to be presented.[1]

The authors of most of the papers presented to the symposium, and those solicited subsequently, registered, in one form or another, some variation on the following rationale for their willingness to participate:

> My people—the people I study—invest these forms of body art with profound cultural and social meaning. So I documented them thoroughly. My other people—my colleagues in scholarship—do not esteem these forms very highly, however; allowing more than two or three sentences about them to enter my work would persuade them that I am kinky and weird. So I resigned myself

9

to leaving most of these data to moulder in my files. Then along comes a proposal for a serious symposium on body art, and since there's strength in numbers, why not?[2]

I thus owe a major debt of gratitude to the symposium discussants—Cole, Teilhet-Fisk, and Kunzle—and to the contributors to this volume for their courage, for the depth of their knowledge, for the richness of their insights, for their hard work and, perhaps most of all, for their patience with the fits and starts and long, anxious indeterminacies which have marked this project from its inception. I also thank Frances Farrell for photographically documenting the symposium and for otherwise making available her considerable photographic skills for the advancement of this project.

Funding for the symposium was provided by UCLA's College of Fine Arts, with additional support from the Art History Area of the Department of Art, Design & Art History, and the African Studies Center. UCLA's Department of Anthropology and Center for the Comparative Study of Folklore and Mythology joined in sponsorship. Robert Gray, Dean of the College of Fine Arts, was unfailing in his support of the symposium. I believe the results of this project, as set forth in this volume, have shown him to be farsighted, even brave, in providing the necessary resources to make possible what has become an increasingly lonely, anomalous, even anachronistic conception of what a college—and a University—should be: a framework for adventures at the edges of our intellectual and artistic universe. Ruth Schwartz, Molly MacGuire, Barbara Bevis, Glyn Davies, and Tony Sherwood of his office were also consistently helpful with arrangements.

No less significant in finally realizing the scholarly potential of what began as something of a personal crusade on my part has been the generous support of UCLA's Museum of Cultural History. Betsy Quick, Curator of Education installed a very effective exhibit of body art-related materials from the Museum's collections as a highlight of the symposium. Doran Ross, Associate Director, came forward with an offer to publish the proceedings of the symposium, representing a dramatic departure from the succession of brilliantly produced object-oriented catalogues and monographs which have established the Museum of Cultural History's pre-eminence in the field. Irina Averkieff, the Museum's editor, worked closely with the contributors on the development of their papers. Richard Todd produced a number of excellent photographs for the book. Robert Woolard's design maintains the extremely high standards which both scholars and general readers have come to expect of the Museum of Cultural History's publications. Paulette Parker handled the organization of the book in an exemplary manner, and her sensitivity and cheerful efficiency smoothed out the inevitable complications. I also must thank the Ethnic Arts Council of Los Angeles for their contribution to the cost of publishing this book.

Finally, I offer my deep appreciation to Cliff Raven, Ed Hardy, Jamie Summers, Jack Rudy, Bob Shaw, P. J. English, Lyle Tuttle, Dave Yurkew, Bob Roberts, and many other tattoo artists, and many of the clients who are privileged to wear their works. Individually and collectively, they helped me to see, and perhaps even to understand, something of their roles in the fascinating drama of art and culture being played out in our time under the banner of tattoo. The contributions of two special collaborators in this work must also be acknowledged: Francoise Fried pioneered a new approach to the photographic documentation of tattoo; I profoundly regret that she did not live to see our explorations come to fruition. Jan Stussy, my partner in the original body-art exhibition project, sharpened—and continues to sharpen—my thinking about tattoo as an art form.

It is obviously not for me, as convenor and moderator of the symposium and editor of this volume of papers, to assess the significance of the project. Nevertheless, it does seem appropriate to acknowledge that this compendium appears to represent the first systematic, cross-cultural and interdisciplinary attempt to compass these extraordinary modes of artistic expression. The papers which follow reveal, I believe, something of the variety of forms and the astonishing range of meanings embodied in aesthetic acts which are awe-ful in the demands they make on the persons who submit to them, and in the challenges they pose to those who seek to understand them

In the last analysis, this volume represents a tribute to the human beings whose bodies bore these marks of civilization.

Arnold Rubin

Notes

1. Neither the symposium nor this publication was intended, *a priori*, to focus on modifications of the skin, i.e. tattoo and cicatrization. This emphasis reflected the interests of the participants and in a broader sense probably parallels the recent expansion of popular interest in tattoo in the West (see Rubin, "Renaissance"; citations in this form refer to papers which make up the body of this volume.)

2. See also Roberts on the neglect of extreme forms of body-art by anthropologists. A particularly interesting aspect of the discussion which followed the symposium centered on the question of "participant observation" in body-art research—whether it is necessary, for example, to be tattooed in order to discuss tattooing. For anthropologists, the question of whether one needs to be a member of a group in order to understand and interpret its beliefs and practices seems to have been long since settled; the clear consensus is that both "insider" and "outsider" perspectives are productive. In the discussion period following the symposium, Peter Gathercole cogently focused this question on the differences in context and meaning between modern and traditional (e.g. tribal) tattoo in cases where some sort of historical or ethnographical reconstruction is the objective.

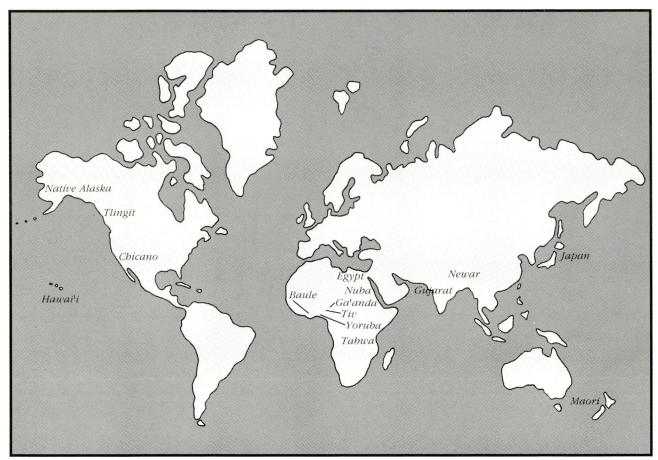

Map of cultures discussed in text

General Introduction
Arnold Rubin

Any truly systematic study of artistic transformations of the human body must be broadly synthetic. Whether oriented toward the beliefs and practices of a particular society or utilizing a comparative approach, irreversible forms of body art must ultimately be seen as belonging to a much larger complex which includes coiffure, cosmetics, dress and adornment.[1] An attempt to survey this larger complex in a single volume, however, encompassing all forms in all times and places, would have to be based on the few detailed studies and the large number of usually offhand and essentially random observations scattered throughout travel accounts and the archaeological and anthropological literature. Such a study would necessarily risk superficiality, arbitrariness and an impressionistic and overgeneralized result.[2] For this reason, and out of a sense that irreversible modifications of the human body represent a coherent domain within the larger complex of body art, we decided to limit the universe of discourse to these forms.[3] In sum, our objective was to develop a series of case-studies, embodying description in depth and systematic exploration of the meaning and function of particular forms, approached within the widest possible range of disciplinary frameworks. This expansion, and amalgamation, of the pool of available data by scholars with first-hand research experience of the subjects of which they treat, would avoid the sensationalism and facile generalizations which prevail in more popular, less focused treatments. These studies would serve as a foundation for further systematic expansion of the data-base, for comparative analysis, and for the development and elaboration of theories across a wide spectrum of fields and approaches.

Practically every human society and a number of disciplines and approaches to body art beyond those represented here could have been included. Similarly, a much wider range of forms is evident in the literature than was represented in the program of the symposium or the contents of this volume. Only two papers deal in depth with piercing, dental alteration is only briefly mentioned in two papers, and nothing is included on skull modelling or the proliferating modes of present-day plastic/cosmetic surgery. An interesting sub-category of body art involves long-term but not irreversible modes, such as "body-building," tight-lacing, or staining (or marking) the skin with henna or other substances (e.g. *shase* among the Tiv; see Bohannan).[4] These modes point up the fact that most "irreversible" body art is not "permanent", in that, over time, tattoos tend to fade, cicatrizations flatten, and (smaller) piercings close.

A particularly remarkable aspect of this publication is the variety of "styles" of scholarship exhibited by contributors, extending from detailed description to explorations of meaning to political critique. If nothing else, this project has put to rest the idea that tattoo, cicatrization, piercing, and other irreversible forms of body art are in some sense peripheral or inconsequential aberrations; or that, in and of themselves, they would for any reasonable person objectively embody deviation or perversion.[5] Despite some measure of continu-

ing currency elsewhere, we have scrupulously avoided terms with negative associations (e.g. deformation, disfigurement, mutilation) and frankly hope that they will eventually disappear from serious discussions of these phenomena.[6] Rather, by acknowledging these modes of artistic expression as something very interesting and mysterious and profound that human beings do to themselves and to each other, we prefer the positive bias embodied in terms such as ''perfection'' —and ultimately civilization—as closer to peoples' own conceptions of the activities involved.[7] As Vogel stipulates in her paper, a civilized person is not simply a human being in contradistinction to an animal. Cole's comments at the symposium amplified this point by recognizing that for most African peoples, a child is by definition not yet civilized, by which is meant encultured and socialized. According to Gathercole, a Maori without *moko* is not a complete person. More broadly, changes in role and status are often reflected in distinctive regimes of body art; in their irreversible forms, the traces of such alterations of the body amount to a kind of biographical accumulation—a dynamic, cumulative instrumentality representing the palimpsest of intense experiences which define the evolving person.

Europeans became aware of the relatively extreme forms of body art practiced by the peoples of Africa, Asia, and the Americas early in the ''Age of Exploration,'' from the late fifteenth century onward.[8] Expanded interest and, in the case of tattoo, actual involvement in body art on a significant scale among Europeans (and Euro-Americans) dates to the late eighteenth and early nineteenth centuries. This interest was one result of the intensified penetration of eastern and southeastern Asia and Oceania by European and American commercial and political interests which took place around that time. In fact, the most likely derivation of the modern term ''tattoo'' is from one of several Oceanic languages. Sailors and other travellers returned to Europe from Indochina, Indonesia, Japan, Micronesia, and Polynesia with strange and exotic tattoos pricked into their skins, ranging from stark black geometric designs to delicate renderings of fish, flowers and dragons. The stories of their exploits and adventures were usually more lurid than their tattoos, and many subsequently made a comfortable living by recounting their experiences and exhibiting their marks for paying audiences. Early nineteenth-century explorers added their accounts of the strange forms of body art which they had encountered.

Consciousness of these manifestations of the diversity of human culture was further expanded during the second half of the nineteenth century as the major European powers assumed imperial dominion over vast areas of Asia, Africa, Oceania, and Native America. Anthropology emerged as a field of study, by and large, when colonial administrations realized their need to know something of the beliefs and practices of the diverse peoples whom they were charged with governing. Simultaneously, awareness of other cultures on the part of Europeans and Euro-Americans was dramatically expanding through more comfortable, less expensive, and faster travel; the invention of photography; the emergence of mass media through industrialization of the printing industry; expansion of literacy through public education; recreation of the habitats of colonial peoples as features of the great (''World's Fair'') expositions; development of national ethnographical collections (usually in conjunction with ''natural history'' museums); expanding ethnographical and archaeological research and the publication thereof; and a host of other factors.

However, rather than precipitating a sense of the functional equivalence of particular social and cultural systems, of the shared principles ultimately to be found in the nominal diversity of cultural forms, of appreciation for the many and varied ways of being human, the net effect of all this new information was largely to widen rather than narrow the cultural gulf, and to reinforce the European/Euro-American sense of cultural superiority. During the early twentieth century, despite abundant evidence for its invalidity, the stereotype of the naked savage persisted: dark and ominous, with bones in his nose and pierced earlobes, and strange figures incised into his skin. This conceptualization began to be rooted out following World War II, however, as more and more of the peoples so stigmatized gained political independence, increased control of their collective resources, and acknowledgement of their right to seek for themselves the benefits of participation in the modern world.

During the 1960's, two additional developments—in interesting ways complementary— appear to have had a major impact on the evolution of body-art consciousness in the United States and Europe. The Peace Corps and comparable European programs made possible experience of other cultures—particularly of the ''Third World'' —outside the usual sanitized touristic framework, introducing participants to new attitudes toward the body (including dress and adornment). At about the same time, the ''Hippie Movement'' ac-

complished a similar expansion of consciousness, reflected in exposure to (and, in some cases adoption of) a non-European (predominantly Asian or Native American) attitude toward the body. Tattoo was rejuvenated; men began to pierce their ears, women to pierce their ears multiply, and occasionally their nostrils. During the 1970's, Women's Liberation and Gay Liberation asserted —even celebrated—peoples' control over their own bodies, sometimes expressed in previously anathemized forms of body art. Subsequent developments, originating among the Punks, further challenged entrenched conventions about the presentation of the self (see Rubin, ''Renaissance'').

These gains in information and understanding, this opening up of new possibilities, were accompanied, however, by a kind of cultural homogenization. Although there are a few exceptions, ''modernity'' has been realized largely at the expense of cultural diversity, particularly as regards the more extreme forms of body art. Beyond more or less subtle educational, religious and ''life-style'' pressures to conform to more generalized, essentially anonymous ''national''—and international—systems of dress and adornment, a number of governments have gone so far as to apply legal sanctions to more traditional modes of body art (See Berns; Rubin, ''Renaissance''). There is, in short, a certain irony in the fact that at a time when advanced artists, scholars and theoreticians in Europe and Euro-America are discovering the formal, conceptual, sociological and psychological richness of tattoo and other forms of body art, the forms themselves are disappearing from the cultures which have nurtured and refined them over thousands of years.

Such a statement, of course, begs a very large question: despite their wide distribution, the historical record of irreversible forms of body art is incomplete. Skeletal materials preserve evidence of skull modelling and altered dentition, and may eventually reveal whether or not a person was tattooed; since skin does not ordinarily survive in archaeological contexts, only through such a breakthrough can the antiquity of the medium be revealed, except for the times and places (such as ancient Egypt, Pre-Columbian Peru, and parts of the Arctic, Central Asia, and Indonesia) where intentional or accidental mummification of human remains took place. The earliest firm evidence for tattooing yet recovered comprises patterns of dots and lines on the body of a priestess of Hathor from the XIth Dynasty of ancient Egypt, around 2200 B.C. (see Bianchi).[9] The earliest appearances of ear, nose, and lip piercing or of skull modelling or al-

tered dentition have not, to my knowledge, been noted in the archaeological literature.

At another level, determining the ultimate age of body art in human history is essentially of academic interest; given the probability that the few comparatively simple techniques involved were independently discovered more than once, a single origin for any of them is unlikely. Nevertheless, in view of their wide distributions, the major modes and techniques of body art would seem to be very old, and the historical dimensions of body art, particularly in the technical realm, can and should be pursued. Studies of the distribution of particular techniques *may* yield insights into their origins and diffusion. For example, tattooing in parts of the Arctic employs a very distinctive technique: a needle is used to draw a carbon-impregnated thread under the skin to produce linear patterns (see Gritton). Throughout most of Oceania, on the other hand, a small adze-shaped implement with multiple points attached to (or cut into) the blade is tapped with a rod to drive pigment into the skin. In Japan, south, southeast, and western Asia, and North Africa, points set into the end of a rod are pushed directly into the skin. (One may reasonably suspect that the nature and distribution of tattooing changed when, in European and Asian antiquity, metal needles became generally available; this has certainly been the case as electric machines began to replace hand-techniques early in the twentieth century.) Tattooing was not practiced among the dark-skinned peoples of sub-Saharan Africa, south Asia, Melanesia and Australia, since the pigment would not show up; cicatrization or scarification were typical of these areas.

Despite the comparatively simple technology involved, the forms of tattoo range (as noted earlier) from simple patterns made up of dots and lines—typical (for example) of early Egypt and Peru, the Islamic world, and northwestern India— to the highly stylized, stark black geometric shapes of Indonesia, Micronesia and Plynesia, to the large-scale, richly pictorial tradition of Japan. Yet, as is evident in several papers included here (particularly Kaeppler's and Gathercole's), the same technique and conceptual framework can produce strikingly different results, with correspondingly divergent meanings and functions, even among people who share a common heritage. Moreover, the functional contexts within which body art is produced are extremely diverse, and meanings are usually multiple, overlapping and interpenetrating (see Jonaitis; Roberts). Tattoos with explicit religious associations (see Roberts), as in Coptic Chris-

tianity (see Govenar), are frequent, occurring in some branches of Buddhism and among Hindus and tribal peoples in some parts of India (see Teilhet-Fisk; Rubin, "Gujarat"). These religious associations may be coupled with the idea that one's tattoos, inalienable in this life, can be bartered to accomplish the transition to the afterlife (see Rubin, "Gujarat"; Teilhet-Fisk). A related tradition encompasses designs intended to protect against illness or other misfortune; (see Drewal; Vogel) tattooed charms to ward off the evil eye are widely distributed in the Islamic world, and Hawaiian warriors wore tattoos to protect them in battle (see Kaeppler).[10]

Tattoos and piercings also occur as emblems of accomplishment—among Inuit whaling captains (see Gritton) and head-takers in Indonesia and Irian Jaya, for example. They may be the hallmarks of a traditional way of life, as with Tiv, Ga'anda, or Nuba women's scars (see Bohannan; Berns; Faris), or Tlingit women's labrets (see Jonaitis). Or they may reflect modernity, as with Tiv and Baule adoption of letters and numbers—or wristwatches—as scarficiation motifs (see Drewal; Vogel; Bohannan), or tattoos of Hindu deities by Gujarati men (see Rubin, "Gujarat"). From an iconographical point of view, the importance of the lizard motif to Polynesian peoples (see Kaeppler, Gathercole), but also to Africans (see Drewal; Bohannan) is clear. It seems plausible that the jewel-like reticulation of the skins of certain lizards and other reptiles may have represented a paradigm for ornamenting the human skin.

Marking of the skin, or some piercings, may indicate group-membership, such as tattooed "caste-marks" among the tribal peoples of Dangs in western India (see Rubin, "Gujarat"), or tribal scarifications among the Yoruba (see Drewal) and other African peoples. Marks may record significant events in the life of an individual, such as initiation into the Butwa Society among the Tabwa (see Roberts), nubility among the Ga'anda and their neighbors of northeastern Nigeria (see Berns), the Nuba (see Faris), the Tlingit of the northwest coast of North America (see Jonaitis), or marriage among Ainu women of northern Japan (see McCallum). Distinctive tattoos were put on to memorialize a deceased relative in traditional Hawaii (see Kaeppler) and among the Yoruba (see Drewal). Tattoos may refer to vocation, as among Japanese firemen or palanquin-bearers (see McCallum), or female musicians, dancers, and courtesans in ancient Egypt (see Bianchi).

Yoruba women's tattoos, Tabwa, Ga'anda, and Nuba scarification, various Tiv forms, and some early Edo (Japanese) tattoos show a willingness to endure pain in order to please a lover (see Drewal; Bohannan; McCallum; Faris; Berns; and Roberts); a related idea seems embodied in Newar conceptions that the wounding process—the record of suffering—accrues religious merit (see Teilhet-Fisk). Intriguingly, practically all the African papers indicate the importance of the abdomen—and particularly the navel—in initiating women's programs of body scarification.[11] More or less explicit reference to the woman's childbearing function, to the succession of the generations, seems to be involved in most cases. Whatever else they may embody, the explicitly erogenous content of African women's body scarification—largely, it seems, in tactile terms—is clear (see Bianchi; Drewal). Roberts establishes the relevance of Victor Turner's sensory and ideological dimensions of symbolism to an understanding of such a wide range of simultaneous meanings.

Body art which signals status—high or low—ranges from the Maori *moko* (see Gathercole), the tattoos of the Scythian chief interred Pazyryk (see Asia, "Introduction"), an Inuit whaling captain's labrets (see Gritton), or a Marquesan chief's full-body tattoo, to the pictorial tattoos of a Japanese gangster (*yakuza*) or the markings of a slave or habitual criminal in various cultures (see McCallum; Bianchi). A fundamental aspect of these questions of context relates to the question of visibility. Modern plastic surgery seeks to camouflage its procedures, realizing a "natural" look, whereas traditional forms tend toward ostentation. Depending on prevailing attitudes, visibility may be manipulated in order to accomplish a particular social objective (see Drewal; Rubin, "Renaissance"; Gathercole; Teilhet-Fisk). Conceptualization of the serial development of body art over time as a "work in progress," is opposed in Drewal's and Berns' papers to the negative associations of being "incomplete".[12]

As implied by the foregoing, irreversible modes of body art amount to a quintessential imposition of a conceptual—cultural—order upon nature. Given their heavy loading of cultural values, the media of irreversible body art are typically taken for granted by insiders and arouse strong (predominantly negative) feelings among outsiders—usually fascination blended with distaste or even repugnance. Institutionalized repression is one frequent reaction. For present-day Europeans and Euro-Americans such reactions may be seen as a response to the sense of potency associated with body art which has been largely neutralized (by familiarity and facility) in other

areas of art-making. Instances of such potency, when the inscription of a line was believed to affect the flow of energy in the universe, survive in the anthropological and art historical record, such as the print by Kuniyoshi showing Nichiren quelling the storm by writing the Buddhist invocation, "Hail to the jewel in the lotus" on a wave.[13] In Nepal, there are traditions of magic writing which could cause or stop earthquakes, tornados, or other natural phenomena; additional examples include Navajo powder-drawings used in healing disease and rock- or ground-paintings by Australian aborigines intended to reactivate the creative centers of the universe.

The diversity, apparent antiquity, wide geographical distribution, and artistic potency of irreversible modes of body art as a vehicle of human expression would seem to merit more attention than has previously been paid by students of art and culture.

Notes

1. Among the most detailed, focused, and synthetic of such studies, to date, are James Faris, *Nuba Personal Art*, Duckworth, London, 1972, and Andrew and Marilyn Strathern, *Self Decoration in Mount Hagen*, Duckworth London, 1971; see also Herbert Cole *African Arts of Transformation* (exhibition catalogue), Art Gallery, University of California, Santa Barbara (1970), and Paul Bohannan, "Beauty and Scarification amongst the Tiv," *Man*, vol. 56 no. 129 (1956), pp. 117–21, reprinted here.

2. A number of writers have not been daunted by these risks, beginning with Hilaire Hiler, *From Nudity to Raiment: An Introduction to the Study of Costume*, The Educational Press, New York, 1930; see also Bernard Rudofsky, *The Unfashionable Human Body*, Doubleday & Co., Garden City, New York 1971; Victoria Ebin, *The Body Decorated*, Thames & Hudson, London, 1979; Robert Brain, *The Decorated Body*, Harper & Row, New York, 1984. Norman Goldstein, M.D. is currently completing work on a compendium, (entitled *Micropigmentation*) including (but not limited to) medical and legal aspects of tattoo; see his earlier articles in *The Journal of Dermatologica Surgery and Oncology*, vol. 5 no. 11, (November 1979), pp. 848–916.

3. This process of exclusion also extended to irreversible modifications of the human body whose intent was less aesthetic than the enhancement of function, as with most orthodonture and some rhinoplasty, or cultural in other terms, such as circumcision, clitoridectomy, and marks resulting from incisions made for medical or medicinal purposes; see e.g. Vogel, Drewal, note 4.

4. See also David Kunzle, *Fashion and Fetishism: A Social History of the Corset, Tight-Lacing and Other Forms of Body-Sculpture in the West*, Rowman and Littlefield, Totowa, New Jersey, 1982; Charlotte Wruck, *Jewels for Their Ears*, Vantage, New York, 1980; also *Piercing Fans International Quarterly*, published by Gauntlet, Inc., P.O. Box 69811, Los Angeles, California 90069-0811.

5. As is evident from its title, the earliest (1653) attempt to bring together all available information on body art was essentially a negative polemic: John Bulwer, *Anthropometamorphosis: Man transform'd, or THE ARTIFICIAL CHANGLING Historically Presented, In the Mad and Cruell Gallantry, Foolish Bravery, Ridiculous Beauty, Filthy Finesse, and Loathsome Loveliness of most Nations, Fashioning and Altering their Bodies from the Mould intended by Nature, Figures of those Transfigurations, to which Artificiall and Affected Deformations are added all the Native and Nationall Monstrosities that have appeared to disfigure the Humane Fabrick, with a Vindication of the Regular Beauty and Honesty of Nature* I thank John Lemes, M.D., for bringing this book to my attention.

6. Cicatrix, as opposed to keloid, is used throughout; the former term refers to an intentional, controlled raised scar, the latter to excessive and uncontrolled formation of scar tissue.

7. Several of the papers (notably Vogel's and Robert's) and commentaries made this correlation more or less explicitly. Cole, in discussing Vogel's paper, identified this theme as the hallmark of the symposium.

8. It is possible that North African or other Islamic and Western Asian traditions were known earlier. This is also to leave aside little-known European body-art traditions during antiquity, and survivals of them into the Middle Ages (see Govenar).

9. Hiler 1930:25,45,56–7 (see note 2, Introduction) suggests that evidence for tattoo in the European archaeological record may go back 25,000 years.

10. Teilhet-Fisk, in her comments on the Pacific Basin papers, suggested that the widespread practice of extensively tattooing women's hands may be associated with their role in food-preparation and handling of unclean materials such as preparation of corpses for burial or cremation. See also Kaeppler, and cf. Berns (re: the importance of Ga'landa women as cooks).

11. Also see Kaeppler; a design over the navel completes Samoan men's tattoo.

12. Cf. Gathercole; also Rubin, "Renaissance" regarding the recent elitist stigmatization of "International Folk Style" of modern European and Euro-American tattoo.

13. From the series "Abridged Illustrated Biography of Koso (Nichiren)," dated 1835–6. My thanks to Ed Hardy for sending me a copy of this print.

OVERLEAF: Jawara male with facial scarification, Northern Nigeria. From Hugo Adolf Bernatzik Der Dunkle Erdteil: Afrika*, Berlin, 1930.*

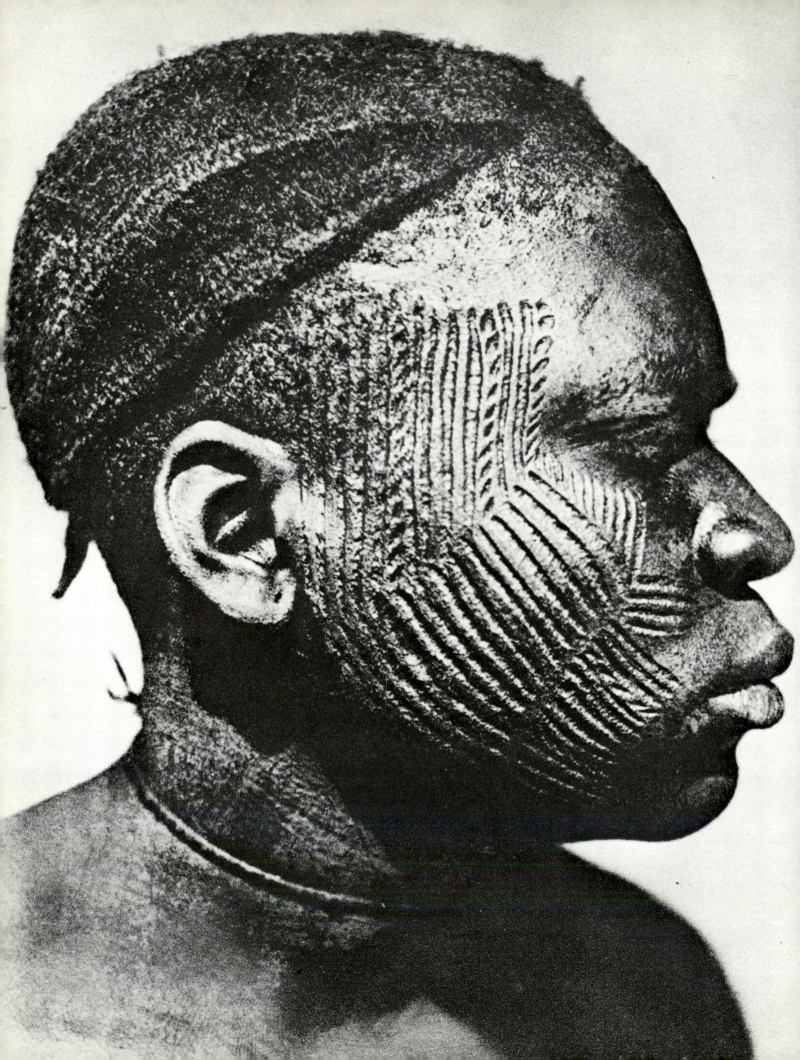

Introduction: Africa
Arnold Rubin

The dark pigmentation of the peoples of sub-Saharan Africa has determined, by and large, that the sculptural quality of cicatrization, rather than the more graphic medium of tattoo, is the predominant mode of irreversibly altering the surface of the human body. Yet, the first of the seven papers presented here dealing with body art in Africa—Bianchi's on ancient Egypt—documents both the earliest known firm evidence for tattoo in human history and its clear Black African (i.e. Nubian) roots. Extended forward in time through Coptic, Islamic, and modern forms, the Egyptian record of 4500 years of tattooing is presently the longest in human history.[1] Indeed, the richness of tattoo among North African peoples and—south of the Sahara—among lighter-skinned peoples such as the Fulani serve to qualify categorical statements about the distribution of tattoo and cicatrization in Africa.

The more or less prominent relief typical of cicatrization clearly contrasts with paint or tattoo; thus the nature of skin-treatments shown on most African sculptures representing humans—archaeological and more recent—is not generally open to question.[2] While the seven essays presented here reveal the wide range of meanings and functions invested in such irreversible markings, their importance for understanding the traditional conceptualization of women, in particular, is remarkably consistent. The tactile, erogenous quality of cicatrization is widely appreciated and appears to be fundamental; the role of such marks in making broader statements about personal qualities, about the historical situation and cultural status of the woman, is no less clear.

Following Bianchi's assessment of ancient Egyptian tattoo, Faris' critique of the profound differences between men's and women's body art among the Nuba of southern Sudan expands his earlier descriptive study of these forms.[3] Next, Roberts analyzes the social, conceptual, and cosmological implications of scarification among the Tabwa of Zaire. Moving westward, Berns documents the importance of scarification motifs across the spectrum of material culture among the Ga'anda of Nigeria; triangular designs emerge as charged with symbolic meaning in both the Tabwa and Ga'anda traditions of cicatrization. Bohannan's classic study of body art among the Tiv of Nigeria, reprinted here, is illustrated with a previously unpublished photograph of Tiv men taken by Frobenius during his 1910–12 expedition to the Benue Valley.[4] Drewal's account of the aesthetic and philosophical associations of body art among the Yoruba, also of Nigeria, richly complements those of Berns and Roberts. Concluding the African section, Vogel draws upon her data from the Baule of the Ivory Coast to explicate the conceptual framework within which body art is realized as a key element in the "civilization" of an individual.

Excepting Bohannan's brief mention of dental alteration among Tiv and Vogel's for Baule, a number of other widely distributed African body-art traditions, including skull-modelling and a variety of piercings, are not discussed here.

Notes

1. Continuity between the phases remains to be established; see McCallum regarding a similar problem for Japan. For Islamic and pre-Islamic tattoo from Afghanistan to Morocco, see Henry Field, *Body-Marking in Southwestern Asia*, Papers of the Peabody Museum of Archaeology and Ethnology, Harvard University, vol. XLV, no. 1 (1958); regarding Islamic Egypt, see Dalu Jones, "Notes on a tattooed musician: a drawing of the Fatimid Period." *AARP*, no. 7 (June 1975), pp. 1–14. For references to Coptic tattooing, see Govenar; for modern Egypt, Charles S. Myers, "Contributions to Egyptian anthropology: tatuing," *Journal of the Royal Anthropological Institute*, vol. 33 (1903), pp. 82–9. As a project for my 1984 graduate seminar on body art, Emiko Terasaki produced an (unpublished) annotated bibliography which lists 21 sources on North African tattoo.

2. Vogel suggests that the relief effects shown on African sculpture are frequently exaggerated, but cf. Roberts. Regarding what may be either paint or tattoo on early Egyptian and Japanese ceramic figurines, see Bianchi and McCallum; for translation of cicatrization motifs and effects to sculpture and other categories of material culture, see Berns; Drewal; Roberts.

3. James Faris, *Nuba Personal Art*, University of Toronto Press, 1972.

4. Taken at Salatu. Photograph courtesy of the Frobenius Institut, Frankfurt.

Tattoo in Ancient Egypt
Robert S. Bianchi

The ancient Egyptians were reticent about tattoo and there is almost no mention of it in their preserved written records.[1] That tattoo did exist in ancient Egypt is certain. This certainty derives from a small but exceedingly important group of tattooed mummies. These mummies are, however, far too few in number and too separated from each other in time to provide an adequate framework for generalization. Written records, physical remains, and works of art relevant to Egyptian tattoo have virtually been ignored by earlier Egyptologists influenced by then-prevailing social attitudes toward the medium. What follows is a discussion of the little that can be reasonably reconstructed from the evidence about tattoo in ancient Egypt.[2] Whatever secondary information can be gleaned from the artistic legacy concerning tattoo must, of course, acknowledge conventions governing Egyptian aesthetics in general.

During the fourth millennium B.C., an urban civilization evolved in Egypt out of which the great empires would emerge. The arts of this Predynastic Period include male and female figurines in a variety of media (Ucko 1968). The decoration of some female figurines in clay is thought by some to represent tattoo (Keimer 1948:fig. 3). One such figure, which can be taken as typical of the series, is now in the Metropolitan Museum of Art in New York (Fig. 1; Kantor 1974:pl. 191; Hays 1953:fig. 11; Ucko 1968:155). Its anatomy is abstracted, and in that regard it has affinities with steatopygous statuettes from other pre-historic cultures (see McCallum re: Jomon Japan). The unbaked clay is coated with a white, unglazed slip onto which are painted a series of geometric patterns in various colors. Traditionally, such decoration, which is not found on male figurines of the period, was interpreted as representing tattoos, clothing, or a combination of both (Keimer 1948:181; Hornblower 1929:28; Thévoz 1984: 62–63). Such an interpretation concurs well with data from later historical epochs in which tattoo appears to be reserved exclusively for women. Human remains from the Predynastic Period are of no value in deciding the question because the craft of embalming did not fully develop until Dynasty IV, about 2600 B.C. (Bianchi 1982). Extant female mummies from Dynasty IV do not exhibit tattoos, however. Recent investigation has shown that many of the motifs that adorn the figurines in question are identical to those that decorate some types of pottery from this same period (Kantor 1974).[3] At present, however, these pottery motifs should not be regarded as somehow derived from or related to tattoos.

Firm evidence of tattooing appears rather late in Egypt's cultural development. From the Predynastic Period through the Pyramid Age and into the period of political upheaval following the collapse of the Old Kingdom, there are no human remains and virtually no works of art that can be convincingly put forward as demonstrating the existence of tattooing in ancient Egypt. During the course of the Middle Kingdom, however, the first incontrovertible evidence of tattoo enters the record. That evidence takes the form of actual tattoo preserved on the mummy of a woman named Amunet, who served as a priestess of the goddess

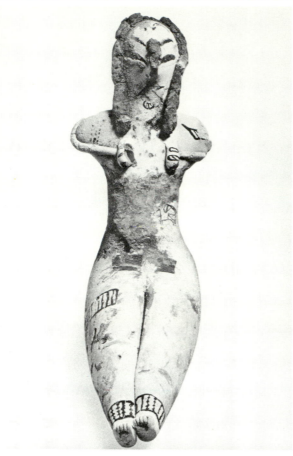

1. *Female figure from the Predynastic Period. Metropolitan Museum of Art 07.228.71, New York.*

2. *Configuration of the body decoration of the second mummy from the Middle Kingdom. From Keimer 1948:fig. 9, where the caption incorrectly identifies the mummy as that of Amunet.*

Hathor at Thebes during Dynasty XI, about 2160–1994 (Winlock 1947:43). Her mummy was in an excellent state of preservation. Her tattoos comprise a series of abstract patterns of individual dots or dashes randomly placed upon the body with apparent disregard for formal zoning (Keimer 1948:8; Bruno 1974:68–70). An elliptical pattern of dots and dashes is tattooed on the lower abdomen beneath the navel. Parallel lines of the same pattern are found on the thighs and arms. A second mummy, identified as that of a female dancer who lived at approximately the same time, is decorated with dots composed into diamond-shaped patterns on the upper arms and chest (Keimer 1948:8; Winlock 1947:43). In addition, this second mummy exhibits a remarkable cicatrix across her lower abdomen just above the pubic region (Fig. 2; Keimer 1948:fig. 9). This incision, whether made by knife or cautery, does not invade the muscles of the abdominal wall and thus cannot be explained as surgery or a wound.[4] A third female mummy, contemporaneous with the previous two, displays similar tattoos (Keimer 1948:8–9; Winlock 1947:43).

The elements and configurations of such tattoos are seen in a group of faience figurines also assigned to the Middle Kingdom (about 2000 B.C.) and generally labeled "Brides of the Dead." One in The Brooklyn Museum is naked and is depicted wearing a wig, the curls of which overlap the tops of her breasts (Fig. 3; Bianchi 1983:no. 25; 1985). This particular wig is associated with the goddess Hathor (Daumas 1977; Sourouzian 1981). Her body is decorated with a series of black dots, many in diamond-shaped patterns, that resemble the actual tattoo on the female mummies of the Middle Kingdom mentioned above (Bruyere 1939:128). Particularly intriguing is the horizontal line of dots just over the pubic triangle that recalls the cicatrix of the second of the female mummies mentioned above.

All these figures are highly abstract: arms and hands merge into the thighs, and the legs terminate at the knees. Small in scale, easily fondled, and intentionally rendered physically helpless, such statuettes were interred with the deceased to arouse his primitive sexual instincts and, by means of an elaborate religious conceit associated with Osiris, the God of Resurrection, to insure magically his rebirth (Bianchi 1983:no. 25; 1985). The priestess Amunet and the figurines in question are all associated with Hathor, the most lascivious of all Egyptian goddesses (Daumas 1977). Consequently the tattoos of this group of figurines and of the mummy of Amunet have an undeniably car-

nal overtone. Apparently for reasons of prudery, earlier commentators held ancient Egyptian tattoo in low esteem and had little regard for those who were so decorated (Bruyere 1939:109; Omlin 1973:22; Keimer 1948:98; cf. Desroches-Noblecourt 1953:43). Nevertheless, the eroticism which is undoubtedly associated with Egyptian tattoo of the Middle Kingdom correlates, at least as far as the faience figurines are concerned, with a prevailing religious attitude that linked physical procreative drives with the loftier aspirations of a resurrection in the Hereafter (Desroches-Noblecourt 1953:15). Therefore, unqualified moral judgments linking Egyptian tattoo exclusively with debased, carnal lust are inappropriate.

Since tattoo does not appear to have been part of native Egyptian cultural tradition until the time of the Middle Kingdom, many (but not all) scholars attribute its introduction to the Nubians, particularly since it has been demonstrated that Amunet and the other two female mummies from the Middle Kingdom are associated with Nubia (Winlock 1947:43–44). From the fourth millenium B.C. the region extending from Aswan, in the present Arab Republic of Egypt, to as far south as Khartoum, the present capital of The Republic of the Sudan, was home to several distinct cultural phases that were, for the most part, quite independent of Egypt proper (Wenig 1978:21). One such cultural phase is designated by the rubric "The C-Group"; its peoples flourished during and after the time of the Egyptian Middle Kingdom (O'Connor 1978). Excavations in C-Group horizons at the Nubian village of Kubban conducted by Firth in 1910 brought to light fragments of a tattooed female mummy datable to about 2000 B.C. and therefore roughly contemporary with that of Amunet (Firth 1927). Her tattoos correspond closely to those found on Amunet and the other two mummies mentioned earlier (Keimer 1948:16–17; Vila 1967). Such tattoos, created by grouping dots and/or dashes into abstract geometric patterns demonstrate the long duration of tattoo in ancient Nubia, as recent excavations at the Nubian site of Aksha demonstrate. Excavators at Aksha uncovered a number of mummies of both adolescent and adult women with blue (or blue-black) tattoos in precisely the same configurations as those found on the three Egyptian mummies from the Middle Kingdom and those from the C-Group (Fig. 4; Vila 1967:368, pl. XV; Seguenny 1984:151). The archaeological context in which these mummies were found places them in the fourth century B.C. That such dot-and-dash tattoos persisted in Nubia in an unbroken tradition for almost two

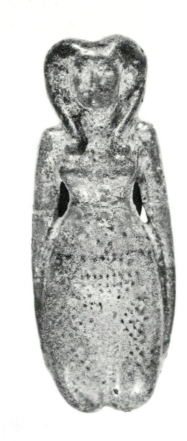

3. Bride of the Dead. The Brooklyn Museum 44.226.

4. One of the mummies from Meroitic Aksha. From Vila 1967:373.

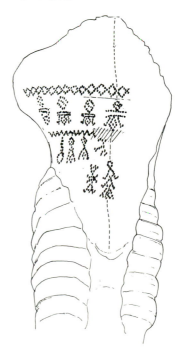

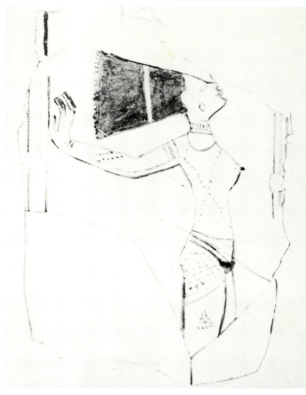

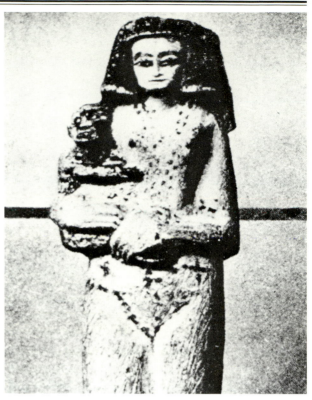

5. *Figural ostrakon from Deir el Medineh with a depiction of a Nubian tumbler. From Vandier d'Abbadie 1959:pl. CXXIII (2868).*

6. *A Bride of the Dead in limestone. From Desroches-Noblecourt 1953:fig. 14 (Berlin 14517).*

thousand years may be inferred from at least one representation of tattoo from the Egyptian New Kingdom, about 1000 B.C.: a dotted triangle on the thigh of a Nubian tumbler on a figural *ostrakon* from Deir el-Medineh in Western Thebes (Fig. 5; Vandier d'Abbadie 1959).[5] The Nubian tattoo represented on this *ostrakon* is the chronological link in the unbroken chain of Nubian tattoo that began with the mummy from Kubban and continued through the New Kingdom into the Meoritic Period of the fourth century B.C. with the mummies from Aksha. Whether or not tattoo had the same erotic overtones for the Nubian peoples as it apparently did for the Egyptians is open to discussion; a great deal more investigation is required before the issue is settled (Seguenny 1984:153; Wenig 1978:88–89).

Available evidence, therefore, suggests that Egyptian tattoo was imported from Nubia and developed during the course of the Middle Kingdom. In addition to abstract patterns composed of dots and dashes, which reflect their Nubian origins, other motifs appear as painted decoration on some other classes of the Brides of the Dead in both limestone and faience (Fig. 6). Some of those designs have been interpreted as representations of

tattoos although no such corresponding motifs have been found as tattoos on any preserved mummies. Of these decorations, the cross, or letter "t," is the most common (Desroches-Noblecourt 1953:13). This interpretation is analogous to the suggestion that the series of parallel lines incised on bodies of terracotta female figurines recently excavated at Gebel Zeit near Hurgadah on the Red Sea represents tattooing (Mey 1980; Posener-Krieger 1984; Castel 1985). The earliest figurines from Gebel Zeit are datable to the Second Intermediate Period, around 1700 B.C., an era of decentralization following the end of the Middle Kingdom. If the interpretation of these two types of designs on the body as tattoos can be maintained, one could posit that the Egyptians went considerably beyond the dot-dash patterns in which the medium was introduced.

In fact, tattoo is firmly established within the cultural traditions of the New Kingdom from 1550 B.C. on. During this time tattoo continues to be reserved exclusively for women but is dramatically transformed. Abstract geometric patterns of dots and dashes now give way to representations of the genius Bes, a curious deity thought to derive from a leonine god of the Predynastic Period

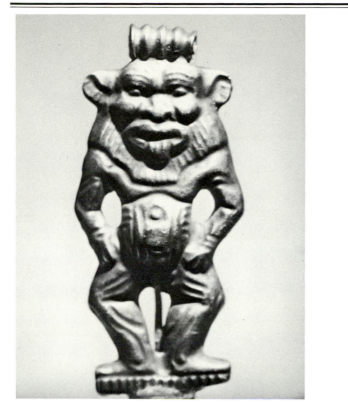

7. *A figure of the god Bes in gold. The Brooklyn Museum 37.710E.*

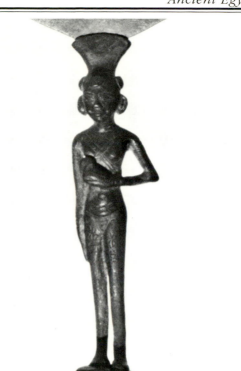

9. *Detail of a bronze mirror with a representation of a tattooed female figurine used as the handle. The Brooklyn Museum 60.27.1.*

8. *A faience bowl from the New Kingdom with a representation of a female musician. Leiden, Rijksmuseum van Oudheden, AD 14.*

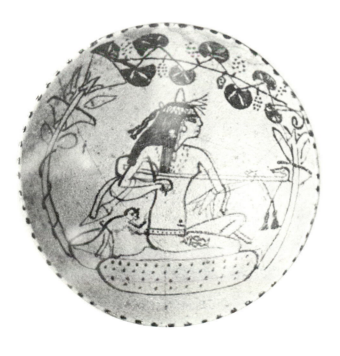

(Romano 1980).[6] Bes was associated with the household and was employed as a protective talisman on such objects as beds and chairs that came into direct contact with one's person. He was also the tutelary deity of revelry and unbridled cavorting and, axiomatically, was thought to preside at childbirth (Fig. 7; Romano 1982:223–224). An abstract image of Bes tattooed in the time-honored dot-and-dash method was found on a Nubian mummy at Aksha, datable to the fourth century B.C. (Fig. 4; Vila 1967). As a result, one can interpret the image of Bes shown on the thighs of representations of dancers or musicians in the art of the New Kingdom as tattoos, so placed to remind one of his lascivious nature. Such a motif appears on the thigh of a female lute player on a faience bowl in Leiden (Fig. 8; Milward 1982:144–145). Two additional images of Bes appear as incised decoration on both thighs of a naked female figure in bronze that serves as a handle for a mirror now in Brooklyn (Fig. 9; Eaton-Krauss 1976:no. 47). The most eloquent Bes tattoo, however, is found in a wall painting from a private house in the craftsmen's village at Deir el-Medineh in Western Thebes (Fig. 10; Vandier d'Abbadie 1938). Here a lithe dancer, clothed in gossamer fabrics, grace-

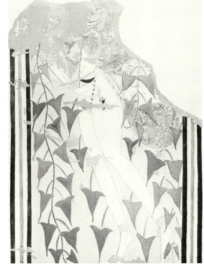

10. *The fresco from Deir el Medineh. From Vandier d'Abbadie 1938:pl. III.*

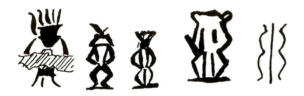

11. *A selection of images of Bes employed as tattoos during the New Kingdom. From Keimer 1948:fig. 39.*

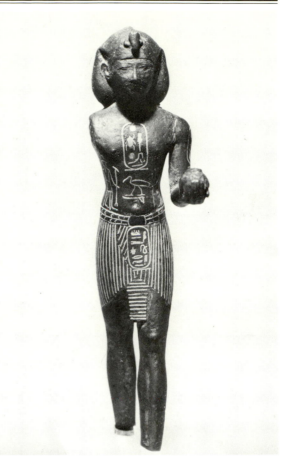

12. *A bronze statuette of King Osorkon I. The Brooklyn Museum 57.92.*

fully pirouettes. Upon her thigh is an image of Bes, painted in dark blue-black colors that correspond, again, to the coloration of the tattoo of Bes on the mummy from Aksha. The significance of this particular dancer and her tattoo is not fully understood. The initial publication of this fresco stressed the secular nature of the image and its erotic overtones (Vandier d'Abbadie 1938). On the other hand, this fresco does decorate a wall to which is attached a benchlike structure that might have been used for actual birthing (Bierbrier 1982). Until additional evidence is forthcoming, the resolution of this queston will remain moot, particularly since the image of Bes can connote either carnal love or childbirth (Romano 1980; 1982:223–224).

With the exception, perhaps, of the fresco from Deir el-Medineh, the appearance of Bes (Keimer 1948:41; Thévoz 1984:64) in association with the naked female figure typifies the *carpe diem* theme of much of the art of the New Kingdom and inextricably links these representations to the small but significant corpus of Egyptian erotica that has recently begun to emerge (Bian-

chi 1983:no. 70). Despite the self-censored nature of most modern public exhibitions of Egyptian art, the ancient Egyptians were sensually oriented and have discreetly indicated their penchant in that direction with representations such as those of the tattooed image of Bes (Fig. 11; Keimer 1948:fig. 39). Some scholars, motivated by "liberated" modern sensibilities, might label the ancient Egyptians "sexists" or "chauvinists" since Egyptian tattoo is associated with a male-oriented view of women and eroticism. Such a stand is inappropriate because it ignores the wider cultural context of which tattoo is a part. The *personae* of the so-called "Love Sonnets" of the New Kingdom are most often women musing abut the mutual satisfaction of sexual encounters (Foster 1974:11,13, passim). The images of tattoos and their erotic associations with women must be understood in terms of this wider cultural context (Derchain 1982:168).

In this context a reference in the Papyrus Bremner-Rhind is significant. There one reads, ". . . their name is inscribed into their arms as Isis

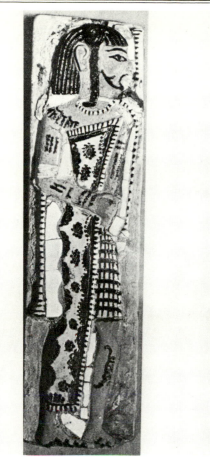

13. Representation of a Libyan on a faience plaque. Cairo, The Egyptian Museum JE 36457 d.

and Nephthys . . .'' (Desroches-Noblecourt 1953: 27; Sauneron 1960; Faulkner 1936; cf. Dolger 1929). The meaning of this passage is elusive at best. The key word is the verb *mentenu*, connoting ''to inscribe; to provide with an inscription; to etch; to engrave'' (Meeks 1979; contra Keimer 1948:52). This determinative, like most Egyptian determinatives, is a single ideogram conveying, in a generic sense, the meaning of the signs so determined. Such a passage might imply that a design was cut into the skin with a sharp instrument. Interpreting this passage as evidence for a pigmented scar, for which there is no corroborating evidence, places unwarranted emphasis on the determinative and fails to accept the established denotative and connotative meanings of the verb *mentenu* itself. The form of those putative tattoos remains problematic since there is no supporting evidence from any other medium to suggest that images of the goddesses Isis and Nephthys were ever used for such decoration. Nevertheless, some scholars cite an interesting artistic convention found on some stone sculptures, but more often

on bronze, as a gloss for the passage in Papyrus Bremner-Rhind (Keimer 1948:64–70). Such statuettes, which become exceedingly frequent from the end of the New Kingdom, have either hieroglyphs or images of various deities, alone or in vignettes, depicted on their arms or chests (Fig. 12; Keimer 1948:64–70). These scholars contend that such representations embody the citation from the Papyrus Bremner-Rhind.

More recent opinion, however, tends to regard such decoration as an artistic convention that utilizes any available surface on a sculpture or figurine at random, rather than as a true depiction of tattoo (Yoyotte 1958). The question of branding may also be relevant here. There is abundant evidence of the branding of cattle (Doll 1982:44–49) and human beings (Schneider 1977:16) by the ancient Egyptians. Slaves and prisoners of war are said to have been branded. According to ancient texts, the verb employed, *ab*, ''to brand,'' is determined by a fire (Bakir 1952:110; Kurchten 1981: 81–84). Some scenes from the mortuary temple of Rameses III at Medinet Habu in Western Thebes have been proposed as examples of this practice, but there the implement appears to be merely a scribe's reed pen, indicating that only fugitive marks were being made (Osten 1927:33–35). Papyrus Anastasi does contain a passage in which acolytes of the god Thoth are said to have been branded as an emblem of their indenture to that deity (Caminos 1954), but there seems to be no additional evidence to support this literary testimony. The immutable alteration of human skin by branding needs to be considered in relation to, but ought not be confused with, tattooing in ancient Egypt.

Tattoo in ancient Egypt is neither indigenous nor early. It makes its first appearance during the course of the Middle Kingdom at which time the Egyptians seem to have borrowed the form of the tattoo—a series of abstract patterns composed of dots and dashes in a bluish-black color—from the Nubians. Whereas the function of that type of tattoo in Nubian civilization is open to question, the Egyptians appear to have regarded the tattoo as one of several vehicles by which the procreative powers of the deceased could be revived in the Hereafter in order to assure resurrection based on a complex Osirian model. The available evidence suggests that only women were so decorated and that these women were associated with ritual music and, on occasion, with the goddess Hathor. Once adopted, the tattoo survives into the New Kingdom,[7] at which time its Osirian overtones, if the interpretation of the ''t-shaped'' designs on the officiants in the Tomb of Amennakht as tattoos

can be maintained, appear to continue.[8] At the same time, the tattoo is transformed both in form and function. The dot-and-dash technique exists side-by-side with the introduction of a silhouette, invariably an image of the genius Bes. This motif imbues the subjects it adorns with a secular eroticism divorced from religious connotations, as can be judged from the subject matter in Brooklyn. Despite the equivocal nature of the evidence provided by the wall painting from Deir el-Medineh, the subject of both the Leiden bowl and Brooklyn mirror suggests the secular use of the tattoo to enhance the latent eroticism of the objects it decorates. The mirror in Brooklyn is an example of how contemporary in outlook the ancient Egyptians were in this regard. The "message" is obvious; the woman who made herself up by using this mirror in her toilette might hope to become as seductive as the figure of the woman that serves as the handle of that mirror.[9] That approach corresponds with modern advertising techniques, as even a passing familiarity with ads for cosmetics in contemporary society reveals. One can conclude, therefore, that during the course of the New Kingdom the ancient Egyptian tattoo enjoyed the height of its popularity and diversity. Reserved exclusively for women,[10] the tattoo of the Egyptian New Kingdom could be at once imbued with either religious or secular overtones. This duality of function, which characterizes the Egyptian tattoo, may serve as a reminder that even today, in such a pluralistic society as ours, the tattoo continues to serve diverse needs and interests. The ancient Egyptian tattoo is to be regarded, therefore, as part of the larger cultural continuum of this particular medium.

Notes

1. I would like to thank the organizers and especially Arnold Rubin for the kind invitation to participate in this symposium. I should also like to thank Kyria Marcella Bianchi and Lillian Flowerman for assisting in the preparation of the manuscript and John Di Clementi for kindly providing some of the visuals used in the illustrations.

2. The role and status of the individual(s) who executed the tattoo lie beyond the scope of the present essay.

3. Both A. Kaeppler and S. Vogel informed me during the course of the body-art symposium that in Hawaiian and Baule cultures, respectively, motifs decorating the body are also found as decoration on inanimate objects (also see Berns). An investigation of these and similar ethnographic analogies may eventually help to decide this issue for Egypt. Alternatively, the apparent body decoration on these female figures might be regarded as a conscious attempt to replicate the environment in which they were intended to exist magically. This hypothesis gains support

when one adduces statuettes of hippopotami in turquoise-colored faience from the Middle Kingdom. These are often decorated with representations of Nilotic flora and fauna as if to replicate the Nile marshes of their natural habitat (Müller 1975). Until additional evidence is forthcoming, any interpretation of the painted surfaces on these Egyptian female figurines from the Predynastic Period is necessarily speculative.

4. This observation is based on D. E. Derry's notes on the physical examination of the mummy in question, dated 31 December 1938, and published in full by Keimer 1948: 14–15.

5. The body jewelry depicted on this Nubian tumbler is reminiscent of that represented on the faience figurines of the Brides of the Dead from the Middle Kingdom (Figs. 4,6).

6. As Romano demonstrates, this bandy-legged dwarf ought to be called a Bes-image because it is just one representation of the several distinctive Bes identities. For convenience, nevertheless, the designation "Bes" has been employed throughout this essay. The earlier arguments of Keimer (1943:159–161,508) linking certain images of Bes to the Shilluk and Nuer of the Nilotic Sudan on the basis of an alleged correspondence between the dots on some Egyptian images of Bes and the cicatrices of these Nilotic peoples can now be dismissed in light of Romano's more recent investigations.

7. There is some speculation that some members of the Macedonian aristocracy, who ruled Egypt as pharaohs from 305–330 B.C., might have been tattooed. The evidence is particularly strong in the case of Ptolemy IV Philopator, who may have been tattooed with representations of leaves of ivy as an emblem of his association with Dionysus, the God of Vine and the Revel (Le Corsu 1978; Tondriau 1950a,b). For the possible Thracian origin of this use of the tattoo, see Zimmerman 1980.

8. Although the decoration of this skin of the female officiants in the Tomb of Amennakht have been called tattoos (Desroches-Noblecourt 1953:25–33), those "t-shaped" patterns cannot be convincingly associated with similarly-shaped designs on some Brides of the Dead (Fig. 6) nor with the passage under discussion.

9. Although both men and women used mirrors in ancient Egypt, available evidence indicates that mirrors with handles in the form of female figures are to be associated with women, rather than with men (Husson 1977). Although tattooed Black females are often represented as sex symbols on Egyptian toilette objects, one cannot assume that the tattoo had similar erotic connotations in Nubian society. No such objects have heretofore been discovered in any Nubian context. Here one should also recall that the Nubians practiced scarification. The evidence for this phenomenon, which is not to be confused with tattoo, derives from the Meroitic Period (Wenig 1978:227).

10. On a group of faience tiles used to decorate some of the royal palaces of the late New Kingdom are depictions of the nine traditional foes of the Egyptians. Each foe, customarily a male figure, is represented as a stereotype in native costume and coiffure. Among the nine is the Libyan who is depicted with markings on his flesh. These have been interpreted as representations of tattoo (Keimer 1948:105–107; Hayes 1937) and are the only evidence for Pharaonic Egyptian tattoo on males who are intentionally not native Egyptians (Fig. 13). It remains to be seen whether this practice was the prototype for tattoo among the Berber peoples of North Africa.

Significance of Differences in the Male and Female Personal Art of the Southeast Nuba[1]

James Faris

I

Art traditions can be theorized as having possible significance as cultural ideologies. They may be treated as discursive practices which can be read without epistemological appeal, and in terms only of their logic—their consistency, their uniformity, and their internal structure. Thus, no scientific privilege need be claimed—there need be no necessary search for an ultimate meaning, essence, or structure, and such discursive practices need not thus necessarily be regarded as situated to reproduce, reveal, conceal, or reflect. They are practices which constitute and condition, but they neither require nor create. Without subjective judgements, moral objections, or political critique, they can be read only in terms of their own logic —that is, the link between content and form given by the cultural ideology.

Political critique of such discursive practices is possible, premised on a view of alternative social relations and the appropriateness of the discursive practice under consideration to such alternative social relations. This paper is such an explicit political critique. It suggests the significance an indigenous ideology—the personal art traditions of young males and females—might be argued to have for the constitution of specific social relations, divisions of labor, forms of appropriation.

But as I argue that the aesthetic ideology is constitutive and situating of specific social relations, I am talking about power, a power that is all the more effective because it is never manifested

as force, but maintained as belief. This belief, moreover, is about the presentation of the body— about a personal art tradition, physical beauty, aesthetic pleasure, and personal attraction—concerns that are probably as powerful as any in human interaction. There is certainly little in this that is abstruse or deeply profound. Indeed, the only problem is in focusing on it *as* a discursive practice, *as* an ideology, and thus (as is possible for all human beliefs) subjecting it to deconstruction.

It is important to stress that this deconstruction is not in any way questioning the effectivity of southeast Nuba beliefs—it is not suggesting they are untrue, irrational, wrong, and that as an analyst I have found what the ideology "really" does. On the contrary, I present below exactly what local people say it does. This is not in debate as it usually is in anthropology, as investigators ferret out, reveal, and uncover fundamental or universal structures, latent functions, or the "real" rationality or meaning.

Since the rise of rationalism as the dominant philosophical tradition, anthropology—now epistemologically centered—has confronted the beliefs of Others in essentially one of two ways: either through the bogus notion of relativism—a patronizing position at best since practitioners do not believe the representations of Others;[2] or by way of a romantic partisanship—though this is a difficult position to consistently uphold, particularly if it involves social forms and practices and representations that are dramatically different or considered immoral by the anthropologist's own social form.[3] But these positions do provide the

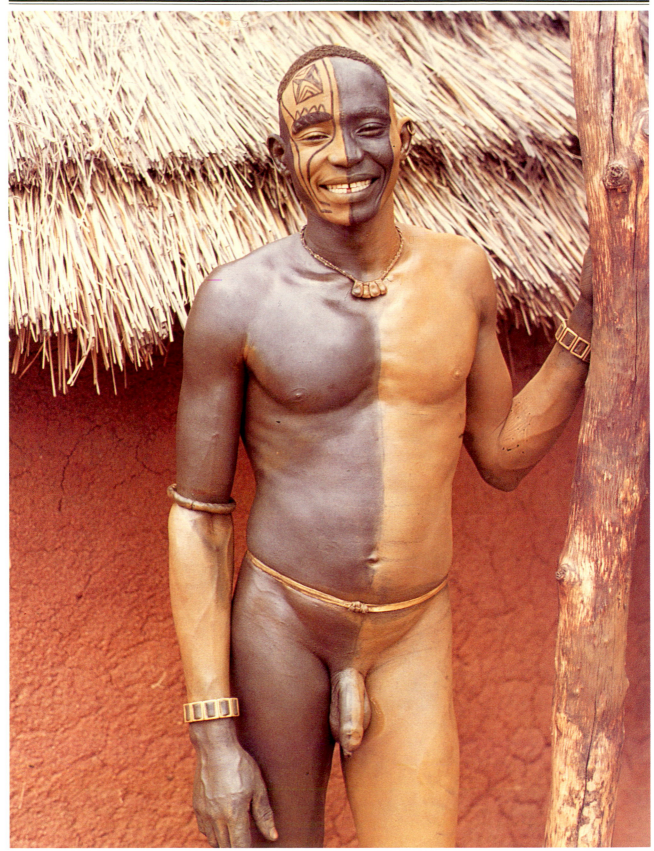

1. *Older age grade decorating; non-representational design. Note attention to color weight and balance. J. Faris photo, 1969.*

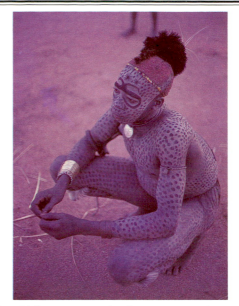

2. *Older age grade decorating; design represents a species of leopard. The size of spot and the color of background distinguishes this from the giraffe design of Figure 3. J. Faris photo, 1969.*

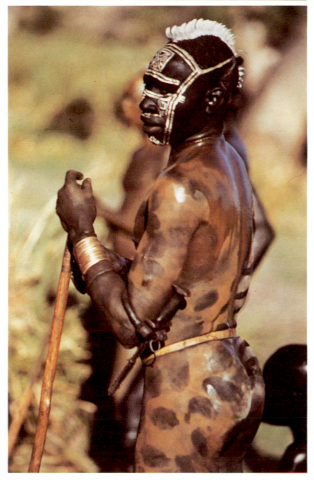

3. *Older age grade decorating; design on left side of body represents a giraffe species, and design (striped) on right side of body represents a wasp species. J. Faris photo, 1969.*

means for an anthropology whose rationalist foundation allows it to situate, if not appropriate, the Other as object—equally "acceptable," of course, but necessary to be understood with developed techniques and confidence of purpose that were the intellectual and geographical heritage of imperialism.

The following study is a departure. It assumes only a political critique of a social form (and a social form—here labelled the southeast Nuba—that has so very much to promote acceptance of its own truths, in a context of change that has so little to recommend), and thus assigns significance to certain practices by which such social form is constituted. There is no need to query *belief* in those practices or to introduce anthropological rationality. My task is to *convince* and *persuade* readers of my political position, not to demonstrate a truth, reveal a fundamental structure, or prove a theory. It is, then, an exercise in political rhetoric, in the most instrumental sense.

II

The social organization of the small-scale agriculturalists known as the southeast Nuba has been treated elsewhere (Faris 1969a; 1969b; 1972b; 1987), as has their personal art tradition (Faris 1972a; 1978). What follows is an initial attempt to specify the link between content and form, and to object to that link—to argue a signification for the personal art tradition in the constitution of certain specific social relations and specific divisions of labor which are regarded as inegalitarian, as politically objectionable.

The age-based art tradition of the southeast Nuba is principally confined in its most spectacular form to the bodies of young males and young females. Males paint themselves from about twelve years of age until approximately twenty-seven years of age, often daily during the season after harvest and before the next year's planting. It is also at this time that they are least involved in productive activities and spend much time in sport and dance. Rules prescribe the colors used for various age categories during this period—for example, only the older age groups are eligible to use the greatest elaboration in color, including the deep black and yellow prohibited to younger grades (Figs. 1–3).[4]

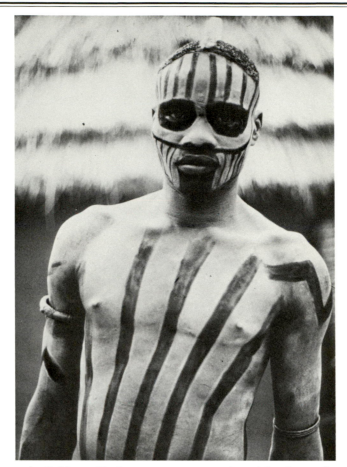

4. *Self-applied non-representational body and facial design. J. Faris photo, 1969.*

Significantly (it will be argued), the elaboration in design and color for males, is executed in paint only, and not accompanied by physiological changes (such as might be suggested by the fact that it is age-based). Rather, this elaboration signals changes in productive status and sport. The younger decorating age grade (with the most stringent color regulation and least elaboration) principally comprises herders for the elders of their matri- and patri-clan sections. This lower grade is also involved in extensive brideservice labor for elders of their betrothed's matri- and patri-clan sections. And they wrestle one another.

The next or upper decorating age grade, now farmers in their own right, their marriages consummated, become active in ritual congregations and may use the entire repertoire of colors and designs. And they engage one another in bracelet and stick combats, and participate in dances at which their praises are sung. The elders, no longer decorating, lead and inaugurate rituals which demand the sacrifice of labor and product of juniors; they also pass judgement on the adequacy of de-

sign and enforce the rules of color use for those still decorating. And they decide who may and who may not meet in the sporting events.

One universe of southeast Nuba representational designs on the young male body has been formally analyzed (Faris 1972a:93). A series of algorithmic operations was specified, which, operating on phanetic primitives, generated all possible productions in this universe. Such algorithmic operations were based along axes of semantic significance and no other—thus indicating something of the logical permutation and formal elegance of this elaborated form. The degree to which all possible productions of every possible operation were "saturated" (that is, actually produced meaningful representations) is another measure of elaboration in the historical evolution and the compositional elegance of the finite form morphology (Faris 1972a:110–111).

In *Nuba Personal Art* (1972a) I viewed this tradition as a celebration of the productive male body—essentially the reading given the personal art tradition by southeast Nuba males themselves.

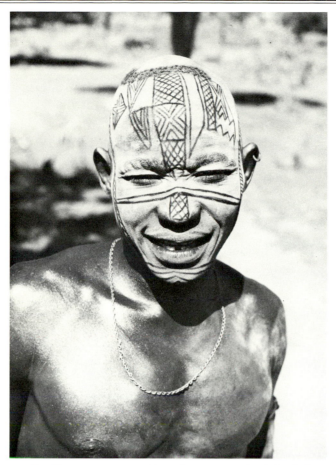

5. *Non-representational assymetrical facial design. See Faris, 1972a:24 for discussion. J. Faris photo, 1969.*

Now I am attempting to ask what signification such a tradition might have were that tradition to stem from an alternative view—to treat the cultural reading *as* an ideology and to posit an alternative discourse, premised in specific political critique of those social relations argued to be constituted by the personal art tradition.[5] It is my view that such an alternative reading helps to comprehend more recent events of change in the personal art tradition. Thus, I am attempting to specify certain effects that the art tradition might potentially have by adopting another view of the potentiality for the social relations of production and division of labor to be something but what they are—to critique those than exist—to adopt in other words another political position. As will be seen below, changes in the current situation do, in fact, lend support to these theorized effects.

The most technically elaborate male designs can require some time to execute properly, though representational designs do not necessarily require more time than nonrepresentational designs. (Moreover, as will be argued, actual labor time be-

comes significant only in recent circumstances.[6]) Traditionally, time expended expresses only one aspect of the elaboration in the art of males, and a minor one. More important here is the expression or capture of the structure of the formal system of representations themselves, and the expression or exhibition of the command of style rules of body display (the former actually executed only in terms of the latter—cf. Faris 1972a: 82; Figs. 4–5)—even if the design is morphologically, semantically, and stylistically achieved with minimal effort and maximum elegance (see Faris 1983b:fig. 7.10). This expression of elaboration in style and form of the complex evolution of the decorative tradition is argued here to have distinct signification. It is not necessarily the degree of formal elaboration that is a reflection of the quality of the signification, but the fact that it can do so is indicative. Men's socialization (especially surrounding production), then, is marked—marked and progressively elaborated. This can best be seen in contrast to the body decoration of young females.

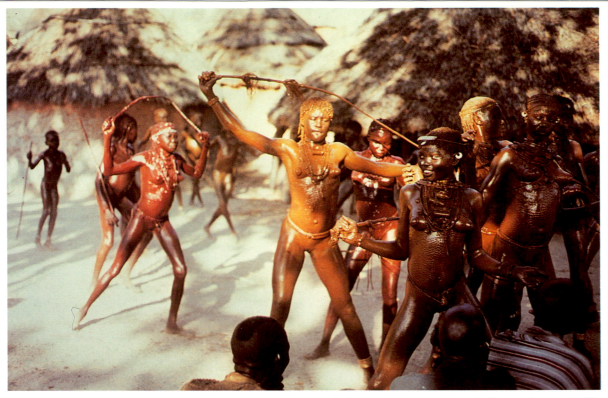

6. *Betrothed girls dancing—colors appropriate to their patrician section. J. Faris photo, 1969.*

7. *Betrothed girl, post-menses abdomenal scarification. J. Faris photo, 1969.*

Females, from the age of about six years (when they are first betrothed) until consummation of marriage, oil and ochre daily if possible, in colors appropriate to their patri-clan section (see Faris 1972a:32, for patri-clan section specific colors; Fig. 6). And, on childbirth and while nursing, again may wear some oil and ochre on their shoulders—this time the color appropriate to the infant's patri-clan section. What is signalled, then, is their father's and their husband's patri-clan section membership—no visual diacritica marks their matri-clan section membership (which females, of course, pass on to their offspring).[7]

But, a young girl also receives an initial set of body scars on the first sign of approaching maturity when her breasts first start to appear (scars from the navel to the breasts—see Faris 1972a:34). Other more extensive scars are cut (now covering the entire torso) on initial menses (Fig. 7), and a final set covering the back, the back of the legs, arms and neck, are cut after a woman weans her first child. This last set of scars signals sexual availability again after a long postpartum sexual restriction while the infant is nursed. The final set is regarded as a beauty necessity, and if a husband refuses to pay for the scarring specialist, a woman may seek a lover who will do so, and her first mar-

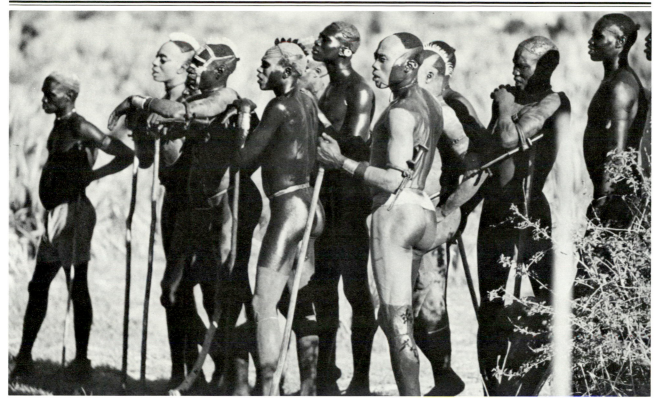

8. Decorated young men—note varieties of body and hair decoration. J. Faris photo, 1969.

riage will end. The scars on a woman's back are regarded as sexually pleasurable to her lovers (see Faris 1972a:Pl. 28). And finally, at menopause, she takes on a distinctly different skirt color and a belt that no longer allows the cowries on it to rattle as she walks (see Faris 1972a:Pl. 3)—a sound said to be sexually attractive.[8]

The personal art of young women, then, is rigidly structured about physiological changes and reproductive capacities, and rigidly fixed on the body with scarification. Note just what is signalled in the female art tradition: physiologically-specific diacritica, sexual and reproductive capacities, and patri-clan section diacritica of father and of husband. The significance of the patrilineal-male association has been indicated (Faris 1969b), and the conceptual associations which assign females, through coloring, a patrilineal address, are clear. The cicatrization dramatically marks physiological changes—even to sexual availability important to further reproduction. Production, except for new human beings, is not signified in personal diacritica for females.[9]

For males, on the other hand, physiological changes can be coded lexically (see Faris 1972a: 38), but all visual diacritica emphasize change in productive status. The most elaborated form is peculiar to the most productively elaborate di-

vision —males between about seventeen years of age to twenty-seven to thirty years of age (Fig. 8). Here the form is the most visible—the content "formed" in the most dramatic and most redundant manner. This can be represented in Figure 10.

III

Certain social relations of production and divisions of labor are argued to be constituted and situated *in part* (see footnote 9) as a concomitant of the personal art tradition. Let me present data on some of these social relations. Although both men and women can and do perform all tasks in cultivation, a division of labor is maintained in most circumstances—not only task-specific, but also for each task. That is, not only technically, but also organizationally.

Men and women rarely work together, although both can and do cultivate on plots to which they have access by virtue of their membership, from birth and irrevocably, in matri- and patri-kin based groups organized as clan sections which hold land and other property communally. The work of women in threshing, for example, is usually individually or in twos, without ritual, sacrifice, sociality or ado. It is accomplished with a heavy wooden paddle, much like a cricket bat,

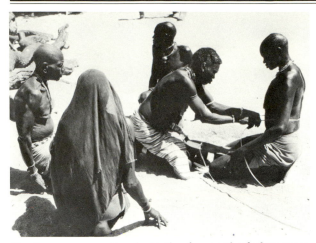

9. *Pregnancy ritual. At the funeral of clanspeople, women of the clan section of the deceased, whether or not still fertile, undergo this increase ritual. J. Faris photo, 1969.*

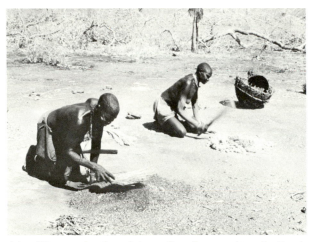

11. *Women's threshing, far farm site. J. Faris photo, 1969.*

12. *Men's threshing, far farm site. J. Faris photo, 1969.*

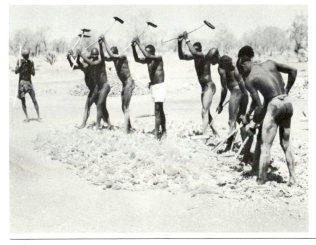

used while kneeling to hammer the harvested grain (Fig. 11). This is in marked contrast to the threshing activity of men. Men thresh only in groups of up to ten—usually in reciprocal brideservice parties, accompanied by appropriate sacrifices, beer, and food. The threshing is done standing, using a light paddle with a springy handle, to the chorus of an elder singer who rakes grain from a prepared stack into the paths of the rhythmically pounding threshers (Fig. 12). The stack is carefully arranged in attractive and labor-consuming ways designed to show off the productive effort of the grains' male owner (see Faris 1972a:39), while the stacks of women's grain are simply piled randomly (Fig. 13).

The ritual surrounding male threshing activity is significant. A village section priest (or male elder surrogate) will perform a sacrifice, and, tossing some of the blood of the sacrificial animal over the beautifully prepared stack of unthreshed grain, will utter an incantation to insure that the threshed grain be large in amount, the threshing easy, and the general welfare and an ample food supply be insured (Fig. 13). Not to do so would be a serious risk, as it is such rituals that prevent grain shortage *for all producers*. Note, however, the absence of such ritual (or any ritual) in the threshing activities of women. There is no specific reference in any of the ritual activities to the sexual division of labor in such activity.

Similarly, in winnowing, women work alone, without ritual, by pouring grain back and forth between two bowls (Fig. 14) or into a hollow depression in a rock, small amounts at a time. Men, on the other hand, winnow with special tossing spades, in groups, with sacrifice and prayers for abundant wind to blow away the chaff and to insure successful results and a large grain supply for the entire community (Fig. 15).

The grain of women goes into their own granaries and is used to prepare food for the family first. A man's granary will provide grain for beer and sacrifices, and will not be used for food until a woman's grain is exhausted. Women, of course, grind the grain, cook and ferment, and do all the other preparations for the all-important beer (including carrying the water).

This division of labor based on gender is repeated in most productive tasks. Men thus never grind grain, women never herd nor hunt with guns. Women primarily carry water and firewood, men primarily thatch roofs and build walls. Elder men spend somewhat more time in ritual activity than elder women. Senior women, however, may appropriate the labor of junior men in brideser-

	Quality	*Duration*	*Signification*
Females	*simple*	*accumulative and fixed (re: marks), standardized (re: ochre)*	*physiology and reproduction, sexual availability, sexual pleasure for males, patrikin group membership (i.e., father's), patrikin group membership of offspring (i.e., husband's).*
Males	*elaborate, representational or conceptually/syntactically dense*	*changing, individualized*	*production, sport participation, personal choice*

10. Visual Diacritica, Southeast Nuba Personal Art.

vice, and there is, in fact, no direct control or appropriation by a category of men, as such, over a woman or over women. Individual men can and do appropriate the labor and product of their wives, mothers, and daughters. They do so, however, only in part as men, but more importantly as husbands, sons, or fathers. Appropriation, then, requires some specification *in addition* to gender for its mandate. Indeed, this is one reason I argue *both* sex and kinship are so vividly marked in female personal art.

Similar social relations of production characterize the relations between juniors and elders. Elders principally appropriate as individuals through brideservice for their daughters, through parenthood, and through relative age authority within the clan section. Young men work for their betrothed's parents in weeding (Fig. 16), threshing (Fig. 12), winnowing (Fig. 15), hut building (Faris 1983b:fig. 7.14), and fence construction. Moreover, they must provide gifts, in grain, tobacco, oil, and ochre.

Thus, through control over marriage and inheritance, individual elders (both male and female) appropriate from some juniors, who structurally, as a result of betrothal and kinship, find themselves in a position of subservience *vis-a-vis* a given elder. The fundamental enabling mechanism of appropriation, then, of juniors by elders, is kinship. But elders are importantly the priests and leaders who direct the age organization activities that form the basis (in addition to gender) for differentiation in the personal art tradition. Thus, the intersection of the age organization and kinship (with its terminological emphasis on generation and sex; see Faris 1969a; 1969b), are the social mechanisms situating the foundations of the personal art tradition. Despite the fact that both men

13. Animal sacrifice prior to men's threshing. Note randomly piled women's grain in background. J. Faris photo, 1969.

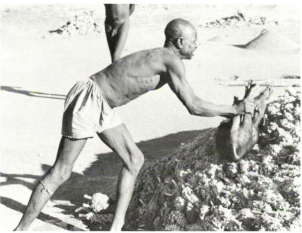

14. Women's winnowing, far farm site. J. Faris photo, 1969.

15. *Men's winnowing, far farm site. J. Faris photo, 1969.*

16. *Brideservice weeding party. J. Faris photo, 1969.*

and women actually produce similarly, the cultural ideology marks gender in organization of such production, then systematically denigrates the contribution of women and celebrates the contribution of men.

I have outlined "the significatory functions of the cultural ideology" (Foucault 1972). Local ideology was treated as a discursive practice and examined in its specific form and content. The extraordinary elaboration in the young men's personal art is appropriate to their productive status and sport participation. Male personal art is marked, and the form permutation, its change potential, the complex evolution, and the compositional elegance all testify to its incredible elaboration. This is in striking contrast to female personal art—unelaborate, permanent (with cicatrization), and appropriate to their physiology and reproductive status. My reading of the significance of the art tradition to the constitution of the social relations and gender division of labor is made

complete by reference to recent events and contemporary change in the personal art tradition documented during a visit in the spring of 1980 (see BBC-TV 1982).

Since the publication of *The People of Kau* (Riefenstahl 1976), European tourists have repeatedly visited the southeast Nuba, principally to duplicate Riefenstahl's photographs and emulate her experience. "Africa had never presented me with a finer visual experience (p. 10) . . . the Kau Nuba wild and passionate (p. 6) . . . among the southeast Nuba, love and sex play a major role which is manifest in their singular cult of the body, their erotic dance and knife fights."[10]

As a consequence of this attention, the social relations of production are undergoing rapid change—young men are refusing to do brideservice and insisting instead on payment of bridewealth. Kingroup elders, thereby, no longer have the grip on the young men they once had, and consequently have less control over the decorating tradition and use of color and design. This is evident in the emergence of a group of young men, principally in the village of Nyaro, who now decorate principally for European tourists in return for payment (BBC-TV 1982; Faris 1988). Tourists photograph the decorating, the dances, the scarring, and the sport with still and ciné cameras, and design forms have come to be principally those which require more time for their execution, or those whose elaboration is potentially unlimited (thereby enabling the young male artists to command greater amounts of money for time spent in decorating and posing). In the indigenous design system, only one design form type, however, is capable of infinite expansion and thus potentially can consume unlimited time in its execution (see Faris 1972a:74ff). This design form type is now the most common primary form type in use. But the invasion of Europeans has also expanded the materials used, so that now European lip glosses for women are found in the southeast Nuba male design color vocabulary (Riefenstahl 1976:*passim*). The personal art tradition of young men is now premised in part on the sale of decorating based on the time expended in its execution, as in the economic relations of capitalism where labor is sold in terms of its duration. It includes a coterie of young Nuba men who effectively make their living this way, as exotic male models.

It is also significant that the design form type now in vogue has no representations coded iconographically. It is the form type in which elaboration devoid of representation constraint is most possible. Representation is simply no longer relevant. The representational designs of other design form types are found on the body only in bits and pieces, simply because their proper execution as whole body designs is limited in the time necessary to their execution. As a consequence, the iconographic feature codes for many representations are being forgotten (see BBC-TV 1982) today.

For women, however, where elaboration was not possible, we find tourists photographing southeast Nuba females in their traditional design fashion (indeed, scarring was encouraged, and Riefenstahl paid to have it done—see BBC-TV 1982). In the accounts of these later visitors, we see only the young, the bleeding, the decorated. We see no elders, no production, no clothed.

A final word: it must be understood that this analysis in no way suggests that there is anything inherently wrong with body scarification in general—nor is it intended to be critical of these forms, except as responses to the grotesque voyeurism of European photographers. On the contrary, were men to have body scarifications like those of the women, at points of physiological change and reproductive significance in their lives, my critique would vanish. The social relations and divisions of labor I find objectionable might then be constituted in some other manner, but I could not assign significance to the personal art in constituting such social relations. The political critique is of *social relations*, not aesthetic practices as such (see Faris 1987, for details). It is the assigned significance of differences in male and female personal art that is thereby subjected to critique, not the personal art tradition itself. The understanding of this distinction is vital, for it indeed enables us to examine art traditions free of the paralyzing grip of cultural authority that has so long dominated functionalist anthropological analyses.

Notes

1. Research, beginning in 1966 and most recently in 1979–1980, was facilitated by the University of Connecticut Research Foundation, the University of Khartoum, the British Broadcasting Corporation, and the Fulbright-Hayes Program, upon the generous permission of the Government of The Democratic Republic of Sudan. This paper, in a slightly different form, is elsewhere part of a much longer article—see Faris 1983b.

2. See Hirst 1979; Faris 1983a for an argument that indeed relativism is a position only possible within epistemology.

3. Indeed, this conference, with the participation of body artists, celebrating practices which are considered if not suspect, at least questionable by the moral guardians of our social form, is an example of such partisanship. The otherwise dreary exchange between nontattooed anthropologists and art historians (who were nevertheless heavily signalled in other sexual, class, and sociopolitical ways) was eclipsed (salvaged?) by the dramatic shift on the second day with the presentations of these reflective practitioners and their gentle and profound contribution.

4. As certain representations require specific colors (and not others), elaboration is also possible in the greater number of species represented with increasing age—until "retirement" to nondecorating elderhood. See Faris 1972b.

5. Though earlier accounts were adequate descriptions of the logic of form permutation and elaboration and adequate statements of the cultural reading, such treatments remained politically impotent in that the signification of such traditions were not theorized beyond the local ideology (Faris 1972a;1978).

6. Young men of the eldest decorating grade may use any representational (or nonrepresentational) design they choose. No restrictions apply to them save those imposed by lack of talent, knowledge, or the rules of correct body display (see Faris 1972a;1972b; BBC-TV 1982).

7. The southeast Nuba have a fully functional duolineal or bilineal descent system (Faris 1969b)—that is, every individual has both a matrikingroup and a patrikingroup, of their mother and their father, respectively.

8. I have no data on actual sexual activity of postmenopausal women.

9. Many other ideologies and practices situate divisions of labor, of course, apart from personal art. See, for example, Figure 9, and Faris 1987.

10. See Riefenstahl 1976:220. There are, of course, no "knife" fights. Riefenstahl's grotesque treatment of the southeast Nuba (for critique, see Faris 1980; 1988; Iten 1977; BBC-TV 1982), celebrated in the popular press and elsewhere, has had very unfortunate consequences in a wide area of Southern Kordofan, and indeed, for serious research elsewhere in Sudan. In my view, this circumstance is not simply another case of cultural change—that despite the change, somehow this form of African art is yet alive, well, dynamic. It is instead a pathetic case of devastation by a more benign form of European exploitation. This, too, however, is a political judgement—in this case, my own *versus* Riefenstahl's.

Tabwa Tegumentary Inscription[1]
Allen F. Roberts

Tabwa of southeastern Zaire and northeastern Zambia once "covered [themselves] from head to foot" (IAAPB 1896:7) with scarification. According to one early observer, Tabwa scarification was "elevated to a position of an art," covering the body in "the most artistic and symmetrical manner with raised spots and lines of relief" (Thomson 1881/1968 II:113n, fig. 1). In so doing, Tabwa sought to *perfect* the human body through a system of signs. This essay will examine the social context and significance of scarification for late-nineteenth-century Tabwa, the factors that contributed to its abandonment, and the reasons for scholarly neglect of African body arts in general (cf. Vansina 1984:73).

Turn-of-the-century photographs, European explorers' accounts, and ancestral figures collected in the 1880s attest to the incidence and importance of scarification among Tabwa (Figs. 1–6, 10–12,14–17).[2] A clue to the purpose of scarification is found in the verb Tabwa use to denote its practice, *kulemba. Kulemba* means "to scarify," but also "to draw or paint, design"; "to innoculate with herbal medicines" (later extended to include smallpox vaccination); "to put out new leaves"; and "to succeed, reach a goal, catch hunted game." After contact with literate coastal Swahili and European colonizers, the definition of *kulemba* was extended to include "to write" among its meanings in KiTabwa and the two neighboring and closely related languages, CiBemba and KiLuba (Van Acker 1907:43; White Fathers 1954:319; Van Avermaet and Mbuya 1954:349). Nouns derived from the verb root *-lemba* refer not only to scarification, writing, and other inscriptions, but also to successful hunters and perhaps to the Supreme Being.

If a useful English translation of *kulemba* is "to inscribe," which means "to write, mark or delineate [words, a name, characters, etc.] in or on something, especially so as to be conspicuous and durable" (OED 1982:1445), there is an added sense implied and communicated by the term *kulemba*. "Success," one of the meanings of *kulemba* in Tabwa thought, results from the recognition of order, which inspires appropriate actions, often guided and facilitated by divination and magic. The link between such social processes and the Supreme Being (another derivaton from *kulemba*) is reflected in a Tabwa praise for God, "Leza Malango" (Almighty Intelligence). "Leza" is from the verb root *-ez-* and refers to power and ability in conception or knowledge. "Malango" is from *kulanga*, "to show, demonstrate, think" (Debeerst 1894:3; Van Acker 1907:42–43). The praise, then, refers to the divinity of ultimate order as "thought" and "demonstrated by God." Divination, like hunting, helps one to recognize a pattern of events, a particular history from the "noise" of one's life, that explains some misfortune.[3]

Hunting is only successful when one can perceive, even in dense vegetation and unfamiliar terrain, where an animal may be or may have gone. Tabwa hunters use powerful magic to increase their powers of perception, and associate hunting as a mode of thought and action with divination and the "tracking down" of causes of misfortune. One is reminded of the late Victor Turner's discus-

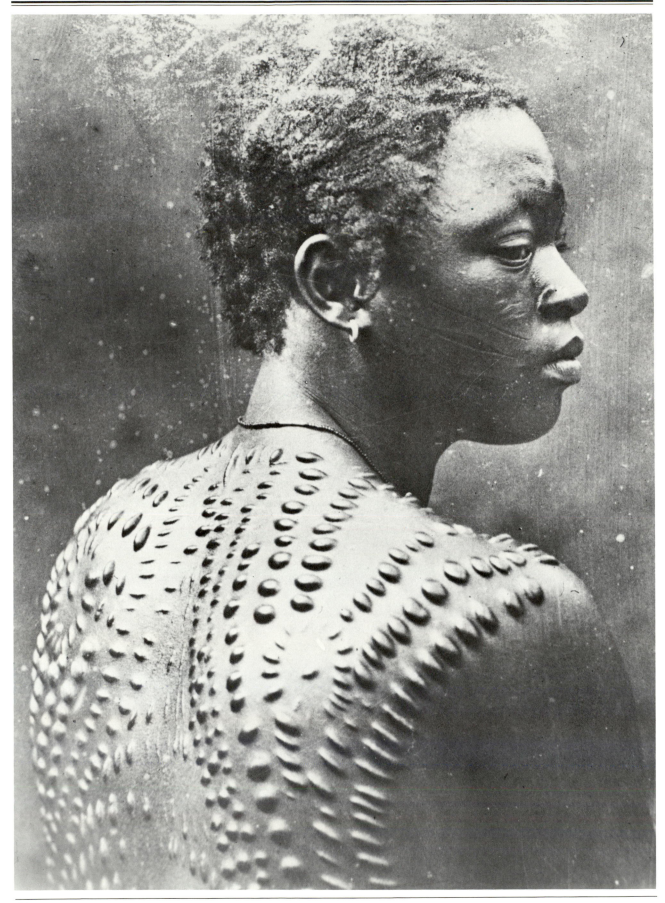

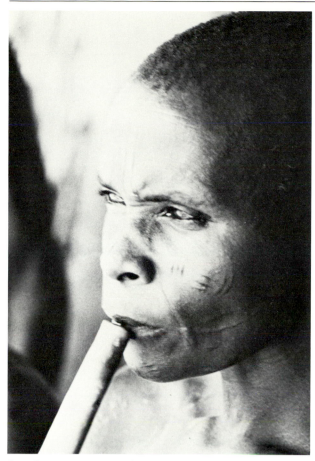

2. Contemporary Tabwa woman at Nanga, Zaire, 1976, photograph from the field research of Christopher Davis-Roberts and Allen F. Roberts. The woman shown here smoking a gourd waterpipe, has a line of scarification down the center of her forehead and the length of her nose, a pattern still common. The groups of three marks, arcs and lines outward from the corner of her mouth are less frequently seen any more.

1. Tabwa woman with tegumentary inscription on face and back, unknown photographer, c. 1900 at Kirungu, Zaire; White Fathers' Central Archives, Rome (see Roberts 1986a:32). The circle of keloids around a central point is a symbol representing fecundity and generation found elsewhere in Tabwa culture, as well as in rupestral paintings of the defunct Butwa society, and on lukasa *mnemonic devices of the Luba (see Fig. 5). A line of* kulemba *scarification across her brow is similar to that of the "face-of-the-cross" pattern found on many Tabwa ancestral figures, while the lines outward from the corners of her mouth are a pattern still practiced by some Tabwa women.*

sion of the nature of symbols among the Ndembu of northwestern Zambia, a Central Bantu group related to the Lunda, Luba, Tabwa, and other peoples of the region. The Ndembu term for symbol is

chinjikijilu, from *ku-jikijila,* 'to blaze a trail,' by cutting marks on a tree with one's ax or by breaking and bending branches to serve as guides back from the unknown bush to known paths. A symbol, then, is a blaze or a landmark, something that connects the unknown with the known (Turner 1970:48).

This trail-blazing makes the forest comprehensible; it introduces order and sense, and in so doing "inscribes" human consciousness and being, so that the hunter (and those to follow him) may perceive, know, and succeed. *Kulemba,* the Tabwa verb, similarly connotes success, in the hunt and other important endeavors (for which hunting is often an allegory) that require prior "trail-blazing" and recognition through human inscription—hence perfection—on the inchoate presentations of Nature (the bush, the human skin).

Kulemba, then, means to inscribe and render meaningful an otherwise blank or incomprehensible surface or situation. Tabwa scarification may be termed "tegumentary inscription." What do Tabwa mean to communicate through *kulemba* inscription? Two points may be raised, with regard to inscription as a form of social process and to inscription as a "visual support for a certain vision of the world" (Kazadi Ntole 1980:9).

Only one known historical document offers a sketchy description of early Tabwa scarification.[4] In the late nineteenth century, Tabwa women received elaborate marks on their faces, chests, abdomens, and backs; men bore simpler patterns. *Kulemba* inscription was begun when a girl was young and "her breasts were still small" (interview 9 July 1977 at Mpala, Kalulu and others), but it might be continued at other points in a woman's life (Anon. n.d.).

The body arts of Hemba, northwestern neighbors of Tabwa, were of a brilliance and complexity equal to those of Tabwa; their practices are useful for a comparative perspective on those of Tabwa. Hemba followed a schedule for the inscription of particular parts of the body determined by the individual's physical development. Between the ages of eight and eleven, a Hemba girl received the *acunga musu* or "guardian of the navel" motif, just below the navel. At puberty, she acquired several other motifs or patterns on her chest and abdomen; the last markings were on the

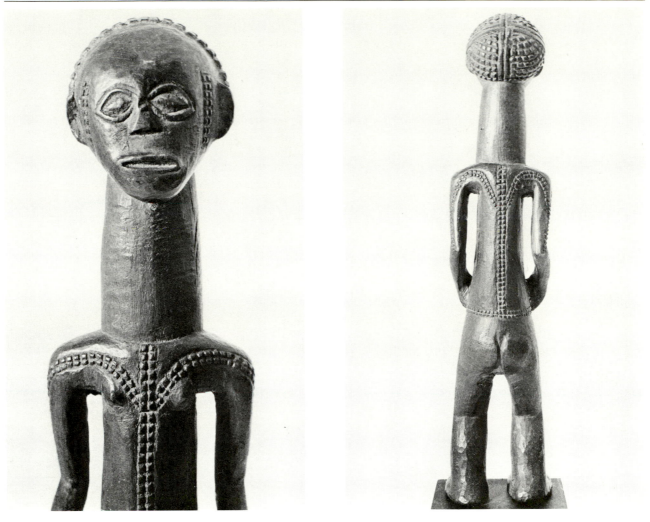

3a–b. *Tabwa ancestral figure, wood, 26cm., The University of Michigan Museum of Art, gift of Helmut Stern. Figures such as this one were objects of statement art, used to extol the ancestors of a chief's lineage (see Roberts 1986a:10–16); the style of this figure is very similar to that of several*

others (Roberts and Maurer 1986:234). The mula-lambo *human body midline is elaborated with tegumentary inscription, and the Butwa V-shaped pattern is carved across the top of the chest and back.*

face (Kazadi Ntole 1980:3–5). It may be that Tabwa women followed a similar sequence.

A skilled woman, other than an in-law or maternal aunt, inscribed the Tabwa girl; arrow points, beads, or the meat of small animals were given in exchange for this service, unless the woman was a close friend who would expect no such payment (Anon. n.d.). Among Hemba, a male sculptor of ancestral figures would trace designs on the skin with *mbese* sap, and then make incisions on the "less intimate parts of the body, leaving the rest to a woman" to complete (Kazadi Ntole 1980:2–3).[5] Tabwa women used razors made by local blacksmiths to slit skin plucked up with an acacia thorn, fishhook, or arrowhead.

These incisions (*tusimbo*) were then rubbed with soot from a pot bottom, an irritant that produced the desired raised cicatrices (Anon. n.d.). (Hemba women sometimes recut the marks to produce even more dramatically raised patterns [Kazadi Ntole 1980:2; cf. Faik-Nzuji 1983].)

Scarification is a painful process. While it appears that most men and women received certain motifs and patterns (collectively called *vindala* in Kitabwa, *bindala* by Hemba), other marks were elective. Some women acquired only minimal patterns, because of the fear of pain and infection (interview 9 July 1977 at Mpala, Kalulu and others). The courage to withstand pain was explicitly communicated by elaborate *vindala* on a woman's

skin.

Young women endured *kulemba* in order to achieve the state of perfection required of those wishing to marry and have children. Hemba girls who had not yet received scarification were teased, their smooth bellies compared to those of men or to the surfaces of gourds. Hemba aphorisms say that beauty is not physically innate, but rather is a function of a girl's *bindala* inscriptions (Kazadi Ntole 1980:10–11). Luba refer to a girl without markings on her skin as a "catfish yet to be split," presumably in reference to her smooth skin and to the incision made in a catfish (*dilembo*), which severs its bones and spine and serves to protect one's fingers when preparing the fish for smoking (Van Avermaet and Mbuya 1954: 349–350). Again, comparable ethnographic data for the Tabwa is unavailable, but one can suppose that nubile girls were similarly enjoined to receive the perfection of *kulemba* inscription as a demonstration of adulthood.

According to informants, the inscription of *kulemba* was not noted outside a young woman's immediate family, but the *event* was highly significant for that individual. Patterns were chosen for reasons of aesthetics and symbolic meaning. Their complexity depended upon the artist's skill and the girl's tolerance of pain. These choices must be seen as episodes in social proceesses and interpersonal politics of the community in which the girl, her family, the woman chosen as artist, and possibly other concerned people were parties.[6] *Kulemba* inscription not only signified change in a young woman's status, it also reiterated commitments and social relationships within the community.

Tabwa scarification as an element of social process can be seen in the utilization of one particular pattern on men and women, as well as on Tabwa ancestral figures (Figs. 3–4; Jacques and Storms 1886:21). This mark, from shoulder to shoulder, across the top of the breast and back, was sometimes straight, but more often dipped in a "V" at the body midline. It was the distinctive sign of the Butwa Society.

Butwa was a pan-ethnic society with both male and female members. The northernmost adherents were Tabwa and the society extended to peoples as far south as the northern part of present-day Malawi. Although data are fragmentary and include no descriptions of the actual performance of rituals, something is known of the purposes and practices of Butwa.[7] Among the Bisa around Lake Bangweulu, "its power [was] felt in every relationship in life" and its aims were "to

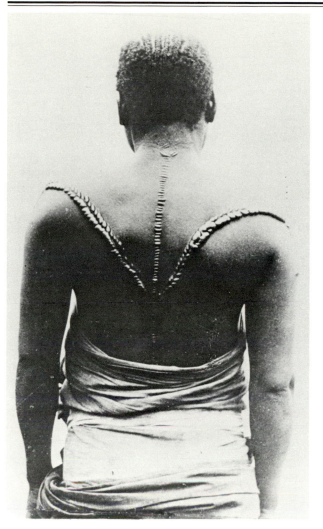

4. *Woman, C. 1900, Archives of the Museum für Völkerkunde, Berlin; originally published in Frederick, Duke of Mechlenburg,* In the Heart of Africa *(London: Cassel, 1910: opposite p. 38), as "cicatrisations on a Mkondjo woman." The Kondjo or Konjo people live between Lakes Mobutu and Amin, along the border of Zaire and Uganda; my thanks to Mrs. Margaret Carey for tracking down this obscure photograph, unidentified in the Berlin archives, and for making this information available to me. Although this woman does not appear to be Tabwa, her scarification is similar to that of Butwa Society members among late-nineteenth century Tabwa, as seen carved in relief on many Tabwa ancestral figures, and as described by early European visitors to Tabwa lands.*

suppress selfishness and promote social life" (Campbell 1914:77–79). Among Tabwa, Butwa members offered each other "help in sickness and need, with the prospects of a respectable funeral and worship after death" (Ferber 1934:62–63).[8]

Initiation into the Butwa Society was divided into two phases. The first sequence took three days. Those being initiated were taken to a prescribed place where an adept dug a shallow hole in the ground and poured an "inebriating drink" into it, containing crimson camwood powder (*nkula*, from *Pterocarpus* bark). Each "initiand" prostrated him or herself, arms extended, and drank some of the fluid from the hole.[9] "Thereupon, they became as though dead drunk," and were brought back to the temple (*lutenge*; a large, rectangular building with small chambers around a central room). There, after an introduction to the lore of the society, "absolute liberty was given to the most shameful debauchery for the rest of the night" (Colle 1912:196–197).[10]

The events of this first phase of the initiation allude to the primordial state of chaos (according to Tabwa cosmology) that precedes initiation into social perfection. Tabwa portray this unrefined, inchoate state of the universe as dominated by a solar anti-hero that assumes the form of an "endless" serpent called Nfwimina, whose rainbow breath "burns [up]" the rain and desiccates the landscape and people on whom the rainbow falls (see Roberts 1980:ch. 8–10,14).[11] The snakelike position that was assumed while drinking the red potion from the hole in the earth was an enactment of Nfwimina's being and role, the fluid representing the terrestrial waters from which Nfwimina (or its breath), as the rainbow, rises or into which it falls. The ensuing "debauchery" was the dramatization of primordial excess, including incest.

The second day of this first phase of Butwa initiation was characterized by the resolution of this chaotic state. Initiands were told to stretch out on the ground once again. Then they had to rise and drink from a newly made pot containing a potion which included a suspension of "pulverized crystal" obtained from certain mountaintops associated with important *ngulu* earth spirits.[12] This was called "drinking Butwa" (Colle 1912:196–197; Campbell 1914:78). Women adepts participating in the ritual were called "mothers of the crystal fetish" (Campbell 1914:79), and quartz crystals were central symbols of the Butwa society and related activities (Roberts 1986a:28). The regularity of the crystals was associated in general terms with the perfection of divinity (Crawford 1924:332–333). More important, however, were

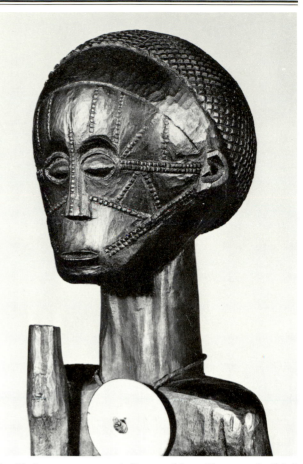

5. *Tabwa ancestral figure (detail), wood, 64.2 cm., No. R.G.31661, Royal Museum for Central Africa, Tervuren. This figure portrays the ancestor of Tabwa chief Manda, who now lives near Moba, Zaire. The elaborate "face-of-the-cross" pattern of facial scarification is completed by lines down the forehead and across the cheeks. The forehead is shaved and the coiffure of a style similar to that described by early European visitors to the area (Roberts 1986c). An ivory disk worn around the neck is a symbol of a set comprising* conus *shell disks, concentric circles of cicatrices and other objects or designs, referring to kinship and the generations of a chief's lineage. (See Roberts and Maurer 1986:124–125.)*

the clearly defined isoceles triangles of the crystal tip. These are similar to the motif of juxtaposed triangles called *balamwezi*, "the rising of the new moon," so frequently found in Tabwa art and material culture, and which represents the key metaphor of Tabwa philosophy (Roberts 1986a:1–3; Roberts and Maurer 1986:*catalogue raisonné*). The two basal points of the triangle refer to opposed cardinal directions (west and east) and the

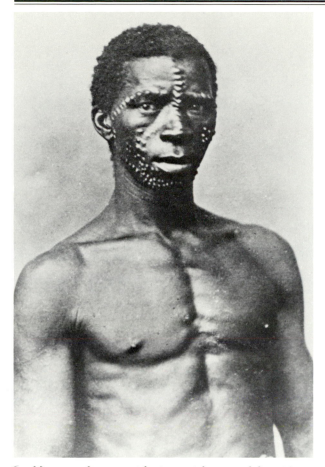

6. *Man, unknown photographer and location, c. 1900, Archives of the Museum für Völkerkunde, Berlin. This pattern of scarification was popular among Tabwa, but also along Mbote "Pygmies" in the area and other peoples such as the Nyamwezi of present-day Tanzania, who hunted for elephant in Tabwa country. The "face-of-the-cross"* (sura ya msalaba) *pattern shown here has elements in common with that of the ancestral figure of the chief Manda, Fig. 5. (See Roberts 1986a:34–35.)*

that is, their imposition of order. The rising of the new moon is a moment of hope and courage, as the evils of darkness are once again conquered by light, which in turn allows perception and the knowledge necessary to take action. When initiands "drank Butwa," then, they drank "moonlight" and its refinement, as they entered a new state of perfected being.

New names were given initiands after Butwa was "drunk" (Campbell 1914:78). All placed their "Butwa fetishes" over an archway of branches at the crossroads of the path leading to the *lutenge* temple and passed underneath. This was the threshold of a new state of being achieved as the initiands were given a V-shaped line of *kulemba* inscription across the breast and/or back (Colle 1912:197).

No data has been found to date concerning particular local performances of these Butwa rituals. It is not possible, then, to construct the kind of extended case of social drama, involving particular actors assuming particular roles and including or omitting particular aspects of the ritual according to local-level political concerns, of the sort that Turner has provided for Ndembu male initiation (1970:151–279). It is unlikely that such data will be discovered, given the fact that most Butwa groups ceased their ritual practices during the first decades of this century. Nonetheless, one must keep in mind that while the V-shaped Butwa inscription may have been common, for each individual the operation signified far more than a badge of Butwa membership. Instead, for that person and those who knew him or her, the V-shaped pattern must have stood for the event of the inscription, the moment in the lives of that individual and others of the immediate community when a new state of being was assumed, at the hands of and in the company of meaningful others. The sign of Butwa, like other scarification, included among its meanings such historical factors as these.

The V-shaped pattern had a more profound, less personal sense as well. Nfwimina, the rainbow-breathing serpent anti-hero of the first day of the Butwa initiation ritual, is one of a set of phenomena, and is the prosopopoeic rendering of the cosmological principles they all represent. This set is given the generic name *mulalambo* in the Tabwa language, and includes lines of demarcation that define the symmetry of the land (i.e. watersheds), Lake Tanganyika (the horizon line or "back" of the north-south oriented lake), the sky (the Milky Way), and human anatomy (the *linea nigra* body midline). Such "endless" lines divide west from

qualities associated with them (e.g., death and birth, respectively) as mediated by the moon at the triangle's apex.

Quartz crystals catching the gleam of moonlight were and still are regarded as the "flash" of "a spirit manifesting itself to them to ask for hospitality" (Guilleme 1887; Guilleme 1897:104; Roberts 1980:397; cf. Thompson 1983:123–124). Such a crystal (*kisimba*) was taken as a "mark of kingship" by Tabwa and some surrounding groups (Crawford 1924:333; Tytgat 1918). The phases of the anthropomorphic moon, as opposed to the unchanging sun, are felt by the Tabwa to confer refinement and bearing through their periodicity,

east, left from right, even as they connect south and north, up and down. It is significant that the human body midline (one instance of *mulalambo*) should be elaborated with a line of *kulemba* tegumentary inscription (Fig. 3a–b) and that the Butwa V-shaped pattern was perpendicular to this (Roberts 1986a:28–29, 33–34; and *idem.*, 1986b).

As Jean Laude commented with respect to Dogon myth, sculpture, and iconography, "symmetry tends to mitigate the effects of intemperate dynamism. . . . It suggests a classification, an order. It tends to repress dynamic power with ordering power" (1973:60). In the Tabwa case, "intemperate dynamism" is represented by Nfwimina, avatar of excess, lord of change. In cosmogonic myths, Nfwimina the solar serpent is defeated by a lunar hero (as is his Luba equivalent, Nkongolo Mwamba, by Mbidi Kiluwe and his son), and a refined, socialized, *perfected* state of being is introduced to the universe. This is an epic struggle, enacted during Butwa initiation and inscribed on the bodies of adepts.

The human body midline defines right and left, which are symmetrical yet opposed. "Left" has negative associations, just as it does in Western traditions ("left" = *sinister* in Latin), connoting deception, malice, underhandedness, corruption, impurity, and portentiousness (OED 1982:2834). "Right" is positive, correct, masculine, strong, and straightforward. These opposed principles are manifested in different ways in all people; for example a person may be outwardly charitable and loving, while inwardly jealous, greedy, and capable of harming others. For Tabwa (as for neighboring Luba), the moon is an apt metaphor for this most basic conundrum of life, with its phases of light (perception and beneficence) and dark (ignorance and evil) representing "two faces of the same reality" that are "as ambiguous as life itself" (Theuws 1968:11).[13] The Butwa V-shaped inscription, then, reinforces this recognition of opposed forces as well as the perfected state of being that leads both the individual and society to positive fulfillment.

These simple motifs inscribed on the human body, may thus be seen to communicate information about the event of inscription (a social process) and the profound principles associated with a perfected state. An argument may be raised at this point. Isadore Okpewho (in Burt 1982), while discussing permanent body arts in Africa, criticizes "those who look for religion or worldview behind everything in traditional art [and who] have often ignored the basic 'play' interest of the artist." Eugene Burt asserts that this leads

to "a distortion of reality" (1982:68). In contrast, Kazadi Ntole states that "one can reproach researchers who have paid attention to scarification in Africa, who have often seen in it only an erotic adornment for 'the provocaton of the male' and 'the stimulation of male passion.'" He calls for the study of body arts from the perspective set forth by Marcel Griaule (1980:1,9), that "'art is one language among others to express a system of thought.'" This last is consistent with Dominique Zahan's (1975:101) description of "a tegumentary language in which the verb is replaced by beard and hair styling, depilation, scarification, tattoos, and body painting," and with the sense of the Tabwa verb *kulemba* as tegumentary inscription, discussed above. Yet Okpewho and Burt are correct to bring attention to the erotic aspects of body arts such as tegumentary inscription. For, *vindala* patterns on a woman's abdomen are first and foremost erotic and are touched during the early stages of lovemaking (Roberts 1986a:32–33).

A reconciliation of these views can be found through a consideration of the nature of Ndembu ritual symbols as proposed by Victor Turner. According to Turner (1970:28–29), symbols are bipolar. At the "sensory pole, the meaning content is closely related to the outward form of the symbol," and "those *significata* that may be expected to arouse desires and feelings" are concentrated there. Opposed is an "ideological pole" where there is "a cluster of *significata* that refer to components of the moral and social orders of Ndembu society, to principles of social organization, to kinds of corporate grouping, and to the norms and values inherent in structural relationships." If *significata* at the sensory pole are "'gross' in a double sense," both as "the lowest common denominator of human feeling" and as "'frankly, even flagrantly, physiological,'" "the same symbols, at their ideological poles of meaning, represent the unity and continuity of social groups, primary and associational, domestic and political." Thus, the sensory pole of a symbol evokes emotion that may then be focused upon the greater truths and values of society. Eroticism leads to conception, birth, parenthood, and the furtherance of lineage and society. Eroticism, however, like other passions, must not be allowed free or excessive expression, but must be refined and channeled by the principles of society. Nature is perfected by culture.

A final word may be added as to how, for Tabwa as for Hemba, tegumentary inscription provided "visual support for a certain vision of the world" (Kazadi Ntole 1980:9). *Kulemba* inscrip-

tion was a *mnemonic device*, similar in this regard to other systems devised by Tabwa or recognized in nature. Rupestral paintings in southeastern Zaire and northeastern Zambia may be a case in point. Concentric circles, line segments radiating from an arc, and other figures are painted or pecked into stone, and are said to be linked to Butwa Society practices (Derricourt 1980:9,14). These motifs may represent the same signs, or at least a similar system of signification, as tegumentary inscription. Another example of a Tabwa mnemonic device is the identification of certain constellations of stars as the stellification of important myths and the cosmological principles their characters personify (see Roberts 1981).[14] The best-known Tabwa constellation, Kabwa "The Little Dog" (the three stars of Orion's Belt), is said to be a hunter following his dog who is tracking a cane rat. This is a reference to Tabwa origin and migration myths and the "seemingly endless" path the hero follows. On earth, this path is identified with the Mwila watershed (one instance of a *mulalambo* line of demarcation) that is stellified as the Milky Way (another). The same constellation is recognized by Luba and called *bwamba ne kilembi ne nyema*, literally, "the dogs and the hunter and the animal" (Van Avermaet and Mbuya 1954:349). Use of the word *kilembi* for "hunter" in this name refers us back to previous discussion of the Tabwa verb *kulemba*, the senses of which include "to inscribe" as well as "to be successful in the hunt." The blazes left by Ndembu hunters ("symbols," as translated by Turner), like the *kulemba* skin inscriptions of the Tabwa, Luba, and Hemba, and the constellations such as Orion's Belt, are sensible patterning in the density of the forest, on the blankness of unperfected skin, and in the infinity of the heavens.

Another mnemonic device worthy of mention here is the *lukasa* of the Luba. This "long hand" is an hourglass-shaped piece of flat wood, incised on its back to represent a tortoise shell and embellished on its front with either nails and small beads or carved or incised symbols. As Thomas Reefe (1977) and, more recently, Francois Neyt (1986:67) have described them, these "memory boards" were used in Mbudye Society ceremonies to recall and extol Luba culture heroes, especially the victory of the lunar heroes Mbidi Kiluwe and his son, Kalala Ilunga, over the solar serpent and "drunken king," Nkongolo Mwamba. The various glyphs and configurations of pins represented significant relationships and events in the Luba epic. As with Ndembu symbols (Turner 1970:19–47), the stories evoked by the *lukasa* mnemonic de-

vice made accessible to a wide audience the basic values of Luba society. It can be hypothesized that this mnemonic form (like the stars differentiated into constellations and the designs pecked or painted in rock shelters by Butwa adepts) functioned in the same way, perhaps using some of the same configurations, as did Tabwa tegumentary inscription. The elaborate *vindala* cicatrices on a mature woman's body, then, might be "read," and messages conveyed about her individual person and ultimate social being.

That Tabwa have abandoned tegumentary inscription today (although see Figs. 2, 7–9, 13) may be attributed to the influence of missionaries and colonial administrators dedicated to suppressing such "pagan" practices. This much one can infer from documents and informants' accounts, although scarification is not specifically mentioned. The Missionaries of Africa (White Fathers) who settled among Tabwa of the Marungu Massif in the 1880s, were especially heavy-handed as they attempted not only to convert the Tabwa to Roman Catholicism, but also to create a "Christian Kingdom" in the heart of Africa, with Tabwa as their loyal subjects (Roberts 1986a:19–21 and forthcoming). The Catholic priests considered Tabwa traditional religious practice to be diabolical, literally, and they decried "the excessively impetuous passion of the Black for the carnal and sensory satisfactions" (Roelens 1938:62). Such "carnal satisfactions" were to be rigidly controlled by the missionaries. A mnemonic system such as tegumentary inscription, depending on the sensory pole of symbols as a vehicle for statements concerning profound ideals, could have no place in a world overseen by the Fathers. Nor could the values of the past, represented mnemonically, be retained in the changed and changing social circumstances of colonized Tabwa.

Such an explanation, while probably correct, is just as probably too simplistic. A further dimension may be explored which, in turn, may suggest a reason for the neglect of the body arts in general by Africanist authors.

Missionaries and other colonizers drew allegorical portraits of the "Exotic Other" to give purpose to their activities for themselves and for those interested in their work. The more debased the "savages," the greater the need for "civilization" and the more justification for personal sacrifice and martyrdom. It is easy, in hindsight, to critique such a portrait and both its motives and results. Recently, however, a few anthropologists and other social theorists have begun the more difficult task of reflecting upon the manner in

7. *Contemporary Mbote elder at Abunamboka, Zaire, 1975, photograph from the field research of Christopher Davis-Roberts and Allen F. Roberts (1973–77). Mbote hunter-gatherers have lived among Tabwa for centuries, and conserve certain traditions once shared with Tabwa, that Tabwa have abandoned in recent years. This man's face shows three converging lines down the center of the forehead with a single one continuing down the length of the nose. At the bridge of the nose, inscribed points lead perpendicularly across each cheek to meet another line of short line segments leading upward from the corners of the mouth. This, then, is a contemporary example of the "face-of-the-cross" pattern once common among Tabwa, and seen on nineteenth-century ancestral figures. Further lines of inscription arch over each eyebrow. The man bears the ax of a medical practitioner over his left shoulder.*

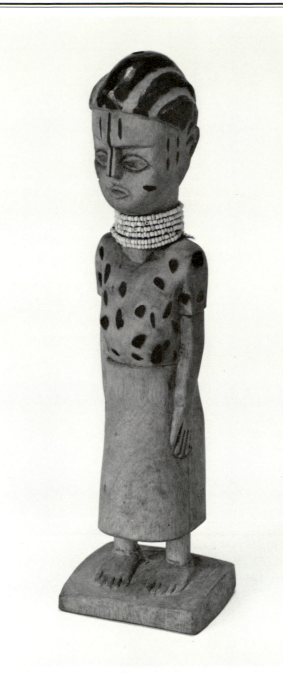

8. *Contemporary female figure; wood, glass beads, cavity in top of head to contain magical medicines; 22.3 cm.; private collection. This figure, field collected at Mpala in the mid-1970s, was owned by a Tabwa diviner-healer who used it as a "witness" to his divination. The carving of its face reflects patterns of scarification popular today, especially in the mountainous regions southwest of Lake Tanganyika. The line from the widow's peak to the tip of the nose, is a vestige of the earlier "face-of-the-cross" pattern. The blouse, embellished by pyrograven spots, and the skirt are similar to those worn by contemporary Tabwa women.*

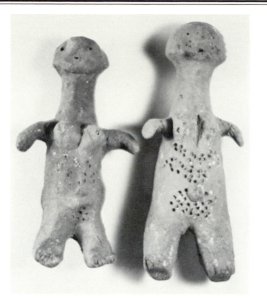

9. *Contemporary child's dolls, fired clay, 9.7 and 11 cm., private collection. Dolls such as these called* watoto wa udongo *or "children of earth or clay," are made by little girls (7–9 years old) and fired by setting them on the edges of their mothers' cooking fires. Tabwa girls play with these in much the same way that American girls play with their dolls. They are dressed in scraps of cloth, which then cover significant anatomical details such as the belly scarification seen on these examples, poked into the clay with a piece of straw. Such aesthetic attention includes other formal elements shared with much older plastic art such as wooden ancestral figures, including elongated necks, tilted faces and proportions. The figure on the right has facial scarification patterns as well.*

which they and their predecessors in the field have indulged—often as ingenuously as most of the missionaries and colonial administrators—in the creation of allegories as they have sought to describe non-Western peoples. As James Clifford (1986:101–103) writes, these have been "'fables of identity,'" or "controlled fictions of difference and similitude," often having as much or more to do with the writer and his or her times, as with the people being written about. Clifford's examples include Margaret Mead's and Derek Freeman's disparate, but equally allegorical, accounts of Samoa. Mead proposes "moral, practical lessons for American society" through the model of an "attractive, sexually liberated, calm Pacific world," while Freeman describes "a sensuous paradise woven through with dread, the threat of violence." Together, the two views "form a kind of diptych,

whose opposing panels signify a recurrent Western ambivalence about the 'primitive.'"

It is the transformation implicit to the writing down of impressions, observations, conversations, and other information, and the choosing from all that is going on those few things that are deemed meaningful, that both introduces and facilitates the fundamentally allegorical nature of ethnography. Scarification *is* erotic and *does* suggest a portrait of the traditional African as naked, polygynous, and driven by lust. Coffee table books about "Vanishing Africa" abound, their color photos often composed to maximize the effects of shock, titilation, revulsion, and pity. Anthropologists react to these popular representations with righteous anger, and the argument may be made that their scholarly neglect of African body arts is a reaction to this exploitation and misrepresentation. As Isadore Okewho asserts, the work of some anthropologists (this paper included) who find "religion and worldview . . . behind everything in traditional art," may be an equal "distortion of reality." It is a compelling exercise to attempt to "prove" that people so despised and misunderstood live complex lives according to a logic of astounding subtlety.

Finally, though, as one becomes more self-reflective in writing and reading ethnographic accounts, "one begins to see the 'writing' activities that have always been pursued by native collaborators" as they have sought to convey information to literate observers (Clifford 1986:117). As Jean Laude (1973:26, 45) suggests for Dogon sculpture, these systems of thought *represented* through tegumentary inscription or other mnemonics, do not symbolize thought as much as they *stimulate* it. For Laude, Dogon "sculpture produces ideas". There can be no ultimate explanation of symbolism, then, to be discovered if research is sufficiently persistent and scientific. Rather, permanent body arts, like plastic representation, afford a multiplicity of meanings through the multireferential nature of their symbols, as well as the social processes and history of which they are a part. The blazes on trees in the Ndembu forest will remain many years after their purpose and meaning are forgotten. So it is with other inscriptions.

Tabwa tegumentary inscription was one aspect of *lived* lives, as opposed to idealized ones. Ultimately, one can only speculate upon its significance to particular individuals and to groups of Tabwa. In essence, it signified sensory experiences linked to ideological references to moral and social orders apposite to those individuals in their own particular spatial and temporal circumstances.

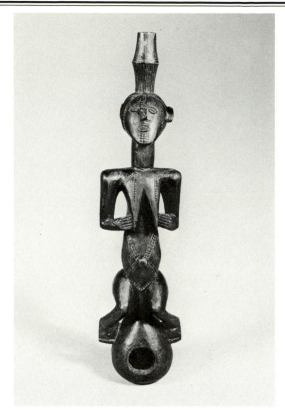

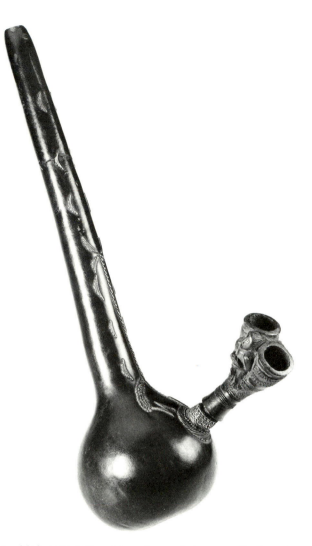

10. *Anthropomorphic tobacco pipe, wood, 37.9 cm., No. 59.37.319, Royal Museum of Central Africa, Tervuren, Belgium. This wooden pipe, of a type also made by neighboring Luba, is of a Tabwa figural substyle found on both sides of Lake Tanganyika (and called ''Jiji'' occasionally, from the slaving entrepot of Ujiji around which many Tabwa settled in the mid-19th century). Scarification patterns are carved into its surface. The pipe is incomplete as shown, as the lower opening would have been closed with mastic of some sort, and a bamboo reed inserted to allow a terracotta bowl to be attached. The anthropomorphism of the pipe includes the visual pun of the lower cavity being analogous to a vagina. Tabwa make these allusions very obvious, as they identify the reed segment as male, inserted at either end into the female body of the pipe or the clay bowl, said to be female as well. The play is more complex than it might seem, then, for the seemingly insignificant male part connects female containers of water (through which the smoke is cooled and filtered) and fire, a dualistic theme represented in other plastic and spoken art forms. The tobacco smoked in such pipes is synonymous for Tabwa with important moments of exchange and intercourse: it is offered at certain points in marriage proceedings, is ''cut'' as a gesture signifying divorce, and is given as a gift of solidarity to mourners.*

11. *Tobacco pipe; gourd, reed, terracotta bowl, glass beads, copper wire; gourd 46 cm., bowl 8.9 cm.; private collection. Most Tabwa waterpipes are not explicitly anthropomorphic as in Fig. 10, yet all are implicitly so: parts of the pipe are given anatomical names (e.g. the bulging base of the gourd are the pipe's ''buttocks,'' matako), and the wirework is effected in reference to female scarification patterns, Tabwa say. In this example, a star shape midway up the stem is the ''navel,'' and a* mulalambo *body midline runs from it to the ''vagina'' of the gourd, into which a ''male'' reed segment is fitted to hold the terracotta bowl—also said to be ''female''—in place. The unusual double bowl of this pipe may be a reference to U-shaped terracotta objects, also open at the ends, made by Tabwa as shrine items for the spirit Mwamba. The placement of a human figure on the bowl, its white-bead eyes staring at the smoker, is reminiscent of pipe bowls made by central Tanzanian peoples.*

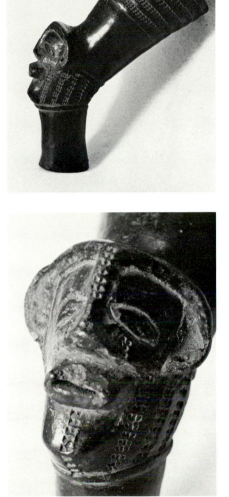

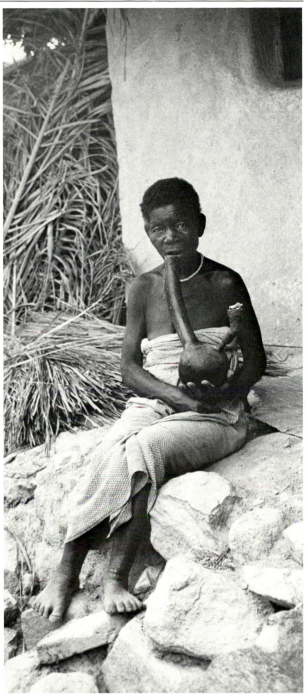

12. *Pipe bowl [two views], terracotta, 8.9 cm., private collection. This Tabwa pipe bowl is decorated with a human face bearing scarification patterns on the face and around the neck. The same stippling, so regular as to make one assume it was made with a tool created for the purpose, encircles the top of the bowl itself. This echoes the wirework on the gourd's "vagina," the point where a reed segment is inserted to link the clay bowl and gourd waterpipe. Both bowl and gourd are symbolically "female," although one contains fire, the other water; connecting the two is a "male" reed. This male mediation provides an important metaphor of duality, artistically embellished in pipes, found in social life when men feel themselves pulled from opposing, "hot" and "cold" aspects and sides of life organized around matrilineal descent.*

13. *Contemporary Tabwa woman smoking a waterpipe [two views], Mpala village, 1975; photograph from the research of Christopher Davis-Roberts and Allen F. Roberts. The face of this elderly Tabwa woman is decorated with a line of scarification down the ridge of the nose, with other lines parallel to the eyebrows. The gourd waterpipe is of the sort commonly smoked by men and women. The bulb of the gourd, where water is contained, is decorated with copper wire in patterns imitating women's abdominal scarification.*

*14. Anthropomorphic comb, wood, 21.6 cm., No. AE 5554, City of Antwerp Ethnographic Museum. Combs or picks of this sort were commonly used by 19th-century Tabwa, both to dress their hair and to decorate it. The hourglass shape is a stylized torso found in the carving of certain Tabwa staffs, plucked idiophones (*kankobele *"thumb pianos") and high-backed stools or thrones. This one is decorated with the *balamwezi *"rising of a new moon" motif of juxtaposed isoceles triangles that earlier Tabwa wove into their pendant coiffures, and used as a body scarification pattern. A further line of scarification follows the *mulalambo *human body midline of the comb torso. Combs such as this, stuck into the elaborate hairdos of Tabwa men and women, were references to the presence of beloved ancestors, watching over their survivors.*

*15. Anthropomorphic comb, wood, 13.1 cm., No. 54.26.7, Royal Museum of Central Africa, Tervuren. The line of scarification extending from the widow's peak to the tip of the nose, continues in the elaborated *mulalambo *human body midline of the "torso" of the comb. Although a more simple creation than the comb in Fig. 14, the scarification pattern conveys the anthropomorphism of the upper part that would protrude from a coiffure into which the teeth of the comb were thrust.*

16. Twin figure, wood, 22.9 cm., No. III E 8626, Museum für Völkerkunde, Staatliche Museen Preussischer Kulturbesitz, Berlin. This mpundu *twin figure, possibly carved by the same artist that made the ancestral figure shown in Fig. 3, served to commemorate the death of a twin, and to celebrate the continued care that the bereaved parents give to the surviving twin. Care must be taken, lest the survivor become depressed and seek to join its fellow in death; honor is paid to the dead twin by commissioning a figure such as this that will be talked to, fed and carried about as the infant would have been, had it not perished. Scarification patterns on the face and torso of this figure add a dimension of realism to an otherwise reduced form. The figure-eight is both a version of the* balamwezi *"rising of a new moon" motif, and a means to define the torso that is divided by further scarification patterns defining the "arms" and the body midline. Such patterns allude to the duality important to Tabwa philosophy generally, but that is made manifest by twins in a most obvious manner, as two are born when one is expected.*

17. Twin figure, wood, 25.4 cm., No. III E 8039, Museum für Völkerkunde, Staatliche Museen Preussischer Kulturbesitz, Berlin; collected by Lt. Glauning at Moliro in 1900. The abstraction seen in the previous twin figure is extended in this one, as three geometrical forms replace head and body. Only a notch for a mouth, bumps for breasts and navel, and, above all, scarification patterns, remain as anthropomorphic references. The scarification on the second form, downward on either side of the notched mouth, is similar to the patterns on the temples of the twin figure of Fig. 16. The diamond shape and elaborated body midline are present as well. Vertical lines parallel to the midline represent scarification on the figure's "arms," while the circlet below the navel is the figure's "belt."

Notes

1. Field research among the lakeside Tabwa of Zaire (1973–1977) was supported by grants-in-aid from the National Institute of Mental Health, the Committee on African Studies and the Edson-Keith Fund of the University of Chicago, and the Society of Sigma Xi. Subsequent archival research was financed by a Mellon Foundation Faculty Development Grant at Albion College and a National Endowment for the Humanities Summer Stipend. My thanks to Dr. Evan M. Maurer for discussion of these and related topics and to Mary Kujawski for ideas and editing.

2. Tabwa body arts are discussed in Roberts 1986a, 1986b, and 1986c. The range of ancestral figures and body arts can be seen in Roberts and Maurer 1986. As is evident from the photographs presented there and with this essay, objects of material culture such as water pipes, bellows, and combs were decorated with inscriptions similar to those on people's bodies and thus the objects gain an anthropomorphic quality.

3. There are several forms of Tabwa divination; the principle common to all of them is that when misfortune strikes, a person needs to know what *particular* events, encounters and other circumstances of the past, have contributed to a present state of distress. There is a sorting out, then, as the diviner assists the afflicted person to decide what is relevant, what is "noise" (as that term is used in linguistics), or irrelevant. This process of "historization" is described in Davis-Roberts Forthcoming; see also Roberts 1986a:7–8.

4. This unpublished document (Anon. n.d.), was probably written by a Tabwa seminarian (perhaps Stefano Kaoze) early in this century. Informants in the 1970s could supply no data more precise than this earlier source.

5. The noun, *mulembi*, among the Tabwa refers to one known for expertise in scarification (Van Acker 1907:43). There is no indication that the Tabwa, like the Hemba, associated skill in scarification with the carving of wooden ancestral figures.

6. The concepts of social process alluded to here are developed in Turner (1969, 1970). His last works on the anthropology of performance (1985:177–204) are also apposite.

7. The Butwa Society is discussed in Roberts 1980:ch. 13, which includes a relevant bibliography; see also Roberts 1986a:35–36 for a brief review of these materials.

8. It is likely that in these and other ways, Butwa bore some similarity to better-known societies among neighboring peoples, such as Bwami among the Bembe, Lega, and other groups to the north (Biebuyck 1973) and Mbudye among the Luba (Reefe 1981).

9. "Initiand" is a term used by Victor Turner to describe those being initiated; he reserves "initiate" for those who have completed the ritual (1970:151–279).

10. Pierre Colle is best known for his two-volume work on Lubaized Tabwa, *Les Baluba* (1913), but his early experience as a missionary was at Mpala Lubanda, among the Tabwa. The references in his short article on Butwa (1912) refer to these latter people. It must be stressed, especially with regard to an association as widespread as Butwa, that variation in ritual probably existed from one ethnic group to another as well as over time for the same group.

11. Nfwimina has analogues in the belief systems of neighboring groups. The best-known is Nkongolo Mwamba, the "drunken king" of the Luba political epic who can also assume the form of a rainbow-breathing serpent; see Heusch 1972.

12. *Ngulu* earth spirits and the "territorial cults" by which Tabwa honor them are discussed in Roberts 1984 and reviewed in Roberts 1986a:4–5.

13. See Roberts 1983 for related lunar symbolism among the Tabwa and Roberts 1986b and 1987 on duality in Tabwa art and philosophy.

14. "Stellification" means "to transform (a person or thing) into a star or constellation" (OED 1982:3039).

Ga'anda Scarification:
A Model for Art and Identity
Marla C. Berns

Introduction

The Ga'anda are a small group of Chadic-speaking people living in northeastern Nigeria, north of the Benue River and east of its confluence with the Gongola (Fig. 1). This part of Gongola State, called the Ga'anda Hills (Aitchison et al. 1972:43, Text Map 2), is characterized by high rocky terrain punctuated with clusters of granite inselbergs, supporting a settlement pattern of dispersed hamlets. Largely due to their geographical remoteness and decentralization, little was known about the Ga'anda until recently.[1] Although their dominant artistic mode is ceramic sculpture, the scarification of women (*Hleeta*, ''scarifying'') is highly elaborate and contributes significantly to an understanding of Ga'anda social and art history.[2]

Ga'anda hamlets consist of numerous independent households, the heads of which are usually related through the male line.[3] Although such hamlets tend to represent patrilineal kindreds, a brother or a cousin can set up a household in another hamlet or in some other locality distant from his relatives (Meek 1931 II:380). With increases and dispersals of population over time, three relatively independent Ga'anda subsections have emerged—Ga'anda, Gabun, and Boka—each with its own dialect. Today, much of the Ga'anda population has moved from relatively inaccessible hill sites to more centralized villages on the plains created since colonial reorganization.[4]

Each Ga'anda locality was traditionally an autonomous political unit. Authority was vested in families whose elders historically served as ritual priests and shrine custodians. Otherwise, social and economic processes were governed almost entirely by the independent decisions of household heads. The main responsibility of ritual chiefs, called Kutira, is still to preside over sacred and ceremonial activities oriented toward spirit-veneration and social integration. Today, village heads assume administrative responsibilities and judges appointed by the government of Gongola State deal with local disputes.

Each household enjoys the rewards of its own labor and enterprise. The Ga'anda are essentially subsistence agriculturalists who farm during a short rainy season (June-October) and supplement their crop yields with game killed during dry season hunts. Farmlands are inherited through the male line and are located in valleys some distance from the rugged hills where people live and where little arable land is available. Men and women grow sorghum or guinea corn, the staple of the Ga'anda diet, and women also plant smaller gardens of cow peas, cassava, and ground nuts.

Polygynous marriage is the basis of household organization and is governed by strict rules of exogamy usually involving kindreds who do not necessarily live in close proximity.[5] Therefore, marriages tend to widen spheres of geographic, as well as social and economic, interaction.

Marriages are arranged in infancy and are completed only after a demanding series of reciprocal obligations are met by the families involved. From the earliest stages on, large iron hoe blades must be given by the family of the prospective groom to that of the bride. Although no longer the

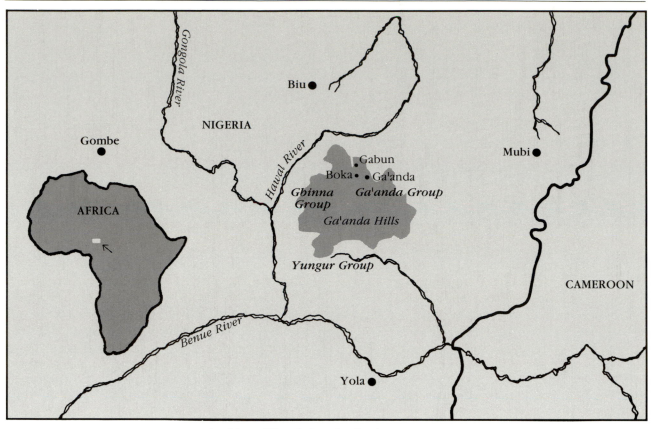

1. Map: The Ga'anda Region.

case, the Ga'anda formerly regarded the blades as valuable currency and as primary markers of wealth and prestige. Large numbers of pots, gourds, and other household items are also given by the groom to his bride-to-be.

The importance of marriage is supported by the rites of personal transition both boys and girls must undergo before they are considered eligible. Girls experience a lengthy program of body and facial scarification, *Hleeta*, completed in a series of biennial stages.[6] At each stage, prescribed areas of the girl's body are cut in increasingly elaborate patterns. *Hleeta* also determines the timing of the suitor's continuing bridewealth payments, which escalate as the scarification becomes progressively more extensive and complex. These arrangements involve long-term familial obligations, which draw on household resources for at least fifteen years.

Sometime between the ages of six and sixteen boys also go through an initiation ordeal, *Sapta*, held every seven years. No youth may marry or engage in independent economic pursuits until this three-month ordeal has been successfully completed.[7] The objective of *Sapta* is to teach boys three fundamental and interrelated skills: how to hunt and defend one's future household, how to make the tools and weapons associated with these tasks, and how to endure the hardships one might suffer in discharging these responsibilities.

Hleeta

Hleeta is accomplished in six stages, beginning when a girl is five or six years old (Fig. 2). Toward the close of the dry season each year, usually in late March or April, *Hleeta* is performed by specialists in each Ga'anda locality. It is always done in a secluded area outside the hamlet, with the girl kneeling on a fixed stone, called a *dakwan fedeta* ("stone of the razor"). The elderly women (*hletenhleeta*) who do the scarification usually learn this skill from their mothers and grandmothers. They are compensated after the final marks are made with iron hoe blades, guinea corn, and tobacco. Annual permission to perform *Hleeta* must be granted by the families who historically exercise ritual control over this practice.

The patterns worked during each stage of *Hleeta* are characterized by rows of closely placed cuts that scar to form slightly raised "dots" somewhat lighter than the surrounding skin (Fig. 3). To

2. Hleeta scarifications. Numbers correspond to stages of marking described in text and in accompanying caption. Contours of figures drawn after Chappel (1977:206).

1. hleexwira *("scarification of the stomach").*
2. hleepa?nda *("scarification of the forehead").*
3. hlee'berixera *("scarification of the 'neck' of the arm [forearm]").*
4. hleefelca *("scarification of the waist and buttocks")* and hleekersiberata *("scarification of the back of the neck").*
5. njoxtimeta *("cutting in places").*
6. hleefedata *("scarification on the thighs")* and hleengup *("scarification all-over"):*

 a. njoxta, *seven parallel lines across the upper chest, over which a row of forked branches are aligned, creating a continuous pattern (Design A); the central branch stands out from the rest, as it is a bisected arc.*

 b. ?inhluuta *("knife handle"), opposed triangles between the breasts repeating the distinctive shape of Ga'anda knife hilts.*

 c. caxi'yata, *opposed curves framing the central column of* njoxtimeta; *they take their name and shape from a round piece of calabash shell (*caxa*) used to scoop out guinea corn porridge (*'yata*).*

 d. kwardata, *the same alternation of chained lozenges and vertical lines repeated at the side of the body; informants considered* kwardata *to be the "finest" part of the design program.*

 e. shembera, *lateral lines adjoining the* hleexwira *chevrons over the navel and* kwardata *at the sides of the body; it creates another frame for a series of Design A.*

 f. kun'kanwannjinda *("curve at the base of the navel"), a semicircle underscoring the navel and then continuing around the body as a set of three parallel lines; this curved motif balances the bisected arc worked at the top of the chest.*

 g. saxti'yera *("ropes of rain"), closely placed vertical lines under the* kun'kan-wannjinda, *which look like continuous drops of falling rain.*

 h. kwerimbete, *parallel lines following the vertical planes of the back, which intersect with the encircling band of* kun'kanwannjinda.

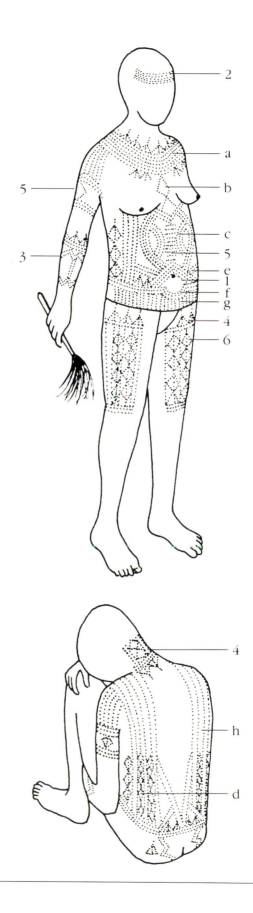

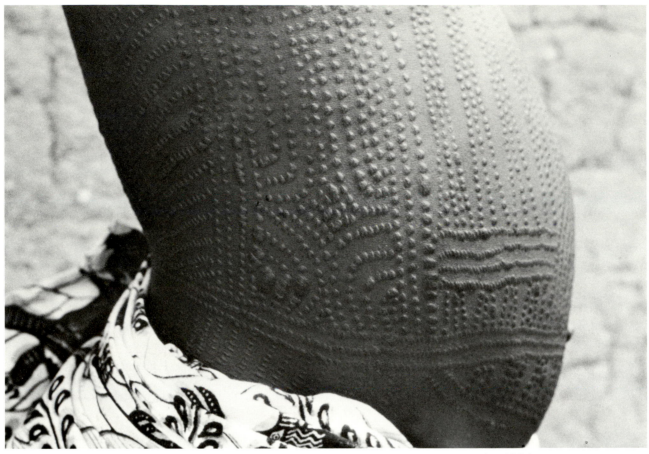

3. *Raised scarification markings on a Gbinna woman. Riji. 1981.*

4. *Ga'anda scarification tools: a.* fedeta *razor. Iron; b.* ngalkem *hook. L. 8 cm. Iron. 1981.*

execute a row of incisions, the skin is pierced with an iron hook (*ngalkem*), its point at a right angle to the shaft, and lifted into a ridge; fine, regular lines are then deftly cut across with a triangular razor (*fedeta*; Fig. 4). The result is a neat, delicate pattern of scars.

The first set of markings, called *hleexwira* ("scarification of the stomach"), consists of two concentric, bisected chevrons above the navel (Fig. 5a). That the first cuts made draw attention to a young girl's womb emphasizes her reproductive potential. This stage also initiates the boy's formal gifting of iron hoe blades to the girl's family.

The second stage of *Hleeta, hleepa?nda* ("scarification of the forehead"), entails the incision of four or five horizontal lines extending from ear to ear, the number of lines determined by the height of the girl's brow (Fig. 5b). Two years later, the third set of markings, *hlee'berixera* ("cuts on the forearm"), is incised and involves more elaborate patterns of compact designs (Fig. 5c). The most distinctive element is a row of forked branches aligned over horizontal lines. This motif, which will be called Design A, is one of the few

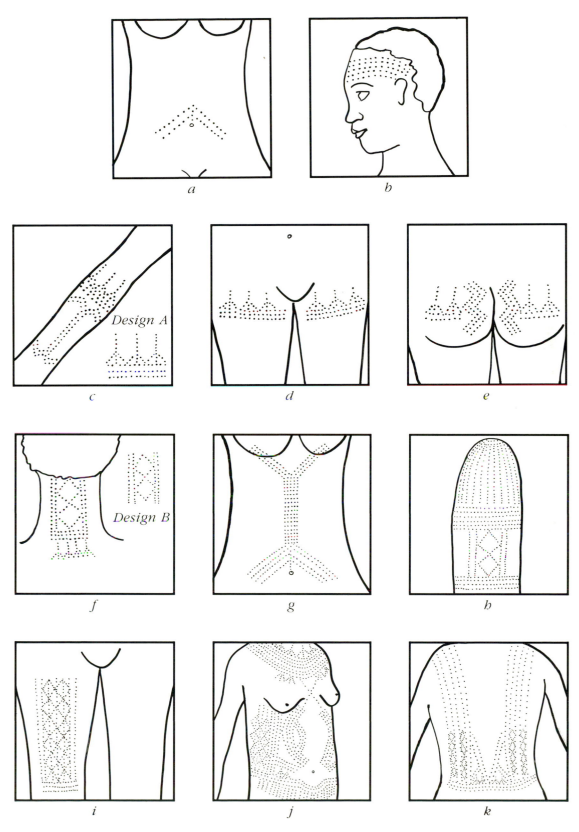

5a–k. Stages of Hleeta *scarification as described in text.*

6. *Ga'anda ceremonial beer pot (*'buutiwanketa*). Ceramic. H. 85 cm. Made by Cexawiwa Gudban, Ga'anda Town. 1981.*

362) explains that after the beer was delivered to the bride's father, instead of distributing it freely, he would sell it to his relatives in exchange for guinea corn. What he received, supplemented by his own surplus stocks of corn, would then be brewed into a second batch of beer. If the second brew exceeded the first in quantity, it was taken as a symbol foretelling the groom's productivity and the bride's fertility.

The fifth stage of *Hleeta* is done when a girl is around thirteen or fourteen, called *njoxtimeta* ("cutting in places"). A column of short horizontal lines is cut down the center of the torso, branching at the top (Fig. 5g); more lines are worked at the shoulder and upper arm, framing another unit of Design B (Fig. 5h). As the penultimate stage of *Hleeta*, the completion of *njoxtimeta* serves notice to both families that the substantial quantities of foodstuffs necessary to finalize the marriage contract must be accumulated before the last scarification can be done. The groom's family also must collect a large number of pots and calabashes to give the girl as bridewealth. In fact, the considerable economic effort such marriage payments demand often mean that the bride's family will postpone the last stage of *Hleeta* for years to extend the suitor's period of agricultural service.

Before the final phase of scarification begins, each girl must have her ears pierced and her upper and lower lips perforated. Traditionally, blades of grass were worn as daily adornment; iron or brass earrings and labrets were substituted on ceremonial occasions. (Today, no jewelry other than imported or manufactured earrings is visible on Ga'anda women.)

In March of the year when a girl's scarification is to be completed, the front of her thighs (*hleefedata*) are first marked with rows of vertically linked lozenges alternating with vertical lines (*kwardata*), a continuous multiplication of Design B (Fig. 5i). *Kwardata* shows that a contract of marriage has been officially "sealed" and prohibits any other young man from approaching the girl. Previously, other suitors may have competed for a girl's hand, and her parents might decide to favor a more promising partner.

Two months later, the girl undergoes *hleengup* ("cicatrization all over"), which involves filling in the areas of the body still left unmarked: the chest, the sides of the torso, the lower abdomen, and the back (Fig. 5j–k). This is a far more extensive phase of scarification than any the girl has previously experienced; it is likely that the prolongation of *Hleeta* over a number of stages prepares a girl physically and emotionally for this final

repeated elsewhere on the body, and whenever it occurs, the syntax of its two component parts is always the same. After *hlee'berixera*, the groom begins helping his in-laws on their farms, an activity he repeats each season until the girl's final marks are made. This means that a youth is effectively indentured to the bride's parents for at least eight to ten years.

The fourth stage of *Hleeta* requires repetitions of Design A to be made across the top of the thighs and buttocks (*hleefelca*; Fig. 5d–e) and at the base of the neck (*hleekersiberata*; Fig. 5f). On the nape, another distinctive, repeated motif is introduced, consisting of a lozenge or chain of lozenges framed by vertical lines, called Design B.

After these marks are made, a substantial payment in guinea corn beer (*mbaala*) is made to the bride's family. The beer is displayed in a number of ovoid gourd bowls and large, decorated pots (Fig. 6). Both the number and size of these containers testify to the considerable economic investment such gifts of beer represent. Boyle (1916b:

ordeal.

After *bleengup* a girl observes a period of seclusion to allow the cuts to heal. She is then eligible to participate in the public festivities that conclude her marriage contract, beginning in July or August. It should be noted that one last unit of Design B can be cut into the backs of a woman's calves (*bleekante?ta*) before she completes *bleengup*. Boyle (1916b:364) indicates that these calf markings were only made if a girl procured an abortion twice while still living in her mother's compound. Although Meek (1931 II:384) does not specify that such markings were made, he does state that it was considered a "gross offence for any girl to conceive a child before this final inscription of her bodily marks." There is an apparent discrepancy between these two views, the former suggesting the marks are a further enhancement of the total *Hleeta* schema and the latter indicating they would be viewed in negative terms. Without question, for the Ga'anda, the consequences of having a child out of wedlock are severe and strong pressures are exerted to discourage premarital relations. While calf markings, done as Boyle suggests only after the second premarital pregnancy, may be permanent reminders of a girl's injudicious behavior, they are still regarded as part of a positive program of aesthetic transformaton. In any case, avoiding sexual contact must have been increasingly difficult since, as indicated above, the bride's parents sometimes postponed the final stage of scarification for years.

Hleeta *and Social Perpetuation*

Hleeta plays a key role in the transmission and reinforcement of sociocultural values. That the markings are permanent signifies that the social transition made is irreversible. Only Ga'anda women are the carriers of this social and aesthetic message, a status suggested by the literal translation of the Ga'anda word for marriage, *kaxan nuu-nefca*, "marrying women." *Hleeta* is identical on all Ga'anda women, regardless of dialect subgrouping, underscoring its importance as a means of ethnic consolidation and identification. The consistency of this scarification program among women living in dispersed Ga'anda communities is further encouraged by the rules of exogamy and patrilocality around which social relationships are organized. And, the seriation of *Hleeta* binds the family not only to long-term domestic priorities, but to continuing social interactions that link dispersed communities. While all the economic and social implications of *Hleeta* cannot be dealt with

here, it is clear that in addition to the designs visible on a woman's body, the gradual process of acquiring them is significant to their meaning.

Hleeta and *Sapta*, the boys' initiation ordeal, both acknowledge that, above all, the transition to adult status (i.e., marriageability) has been paid for in pain. During *Sapta*, for example, initiates (*wankimshaa*) are mercilessly flogged with reed switches, once to formally inaugurate the three-month ordeal and later on at least three other occasions. These whippings and a succession of other physical and psychological abuses test a boy's strength and endurance. During *Hleeta*, girls undergo a series of physical transformations that entail comparable and progressive stages of pain. The last stage of scarification, *bleengup*, causes such extensive bleeding that days of recovery are required afterward. This intense and prolonged experience tests Ga'anda girls in the same way that *Sapta* tests the boys. The ability to endure either of these experiences implies the endorsement of community spirit-guardians.

The importance of these ordeals to the socializing process is reinforced during the public festivities following the completion of *Sapta* and *Hleeta*. Every seven years community festivals, called Yoxiiwa, are held after *Sapta*; annually, independent hamlets hold an event called Yowo to honor the girls who have completed *Hleeta*. Both ceremonies include seven days of feasting and celebration. At each, special modes of self-decoration provide a dramatic visual commentary about the young peoples' commitment to Ga'anda society and their acceptance by the community and its spirit benefactors.

At the start of Yoxiiwa, each male initiate is ritually washed and then rubbed with red hematite (*mesaktariya*), the ferric oxide (Fe_2O_3) obtained locally from the "deposits left on the sides of stagnant pools as they dry up" (Boyle 1916b: 365). It is ground into a powder and made into a cosmetic paste by mixing it with sesame oil. Girls who emerge from seclusion after the completion of their final marks also smear their skin with this oily red pigment. By anointing their newly scarified skin, the subtle texture of raised scars is enhanced and accentuated. Yoxiiwa and Yowo are the only occasions when boys and girls undergo this striking ephemeral transformation. Indeed with time, the visual impact of *Hleeta* gradually diminishes as the markings fade and become almost imperceptible.

Traditionally the only clothing worn by boys and girls on these occasions is a sharply contrasting white *cache-sexe*. *Sapta* graduates wear a fiber

7. *Ga'anda girl wearing rows of tight sagittal plaits (*pehla*). Boka. 1981.*

9. *Ga'anda armlets (*ro?hlon'nda*). Brass. D. 8–10 cm. UCLA MCH X85–98; X85–108.*

8. *Ga'anda cast brass triangular pendants (*tiltil*) threaded on a leather strap. 4 cm. 1981.*

belt, called a *talata*, which they braid themselves from strips of pith cut from particular shrubs. Girls wear a simple woven cloth apron, called a *takerker*. The combination of the colors red and white make important symbolic reference to social commitment and its link to spiritual affirmation. The application of red hematite (*mesaktariya*) draws special attention to the interface between secular and sacred realities.[8] *Mesaktariya* is a substance that identifies and activates spiritual intervention in a number of propitiatory contexts. It also is the medium that fosters direct contact between man and spirit on such occasions—smearing it over a spirit-charged vessel, which is then touched by a patient, transfers its associated healing power; dipping bows or arrows into it grants to hunters the protection of tutelary forces; and drinking it confirms the judicial authority of Ga'anda spirit "police." Rubbing the bodies of initiates with this same ritual cosmetic refers to the spiritual endorsement that has made social transitions possible as well as significant.

Blood complements *mesaktariya* in many of the same ritual contexts. Animal sacrifices often

activate or encourage the continuing involvement of spirit forces. The same link between blood and hematite is established through *Hleeta* and *Sapta*, ordeals that take the loss of blood as positive proof of the willingness to bear pain in order to gain social acceptance.

Like the color red, white also has sacred connotations. It is the color of *cikta*, the mixture of ground, sprouted sorghum and water used as an activating ingredient in ritual procedures and spirit libations. Some Ga'anda subgroups apply *cikta* to the navels of *Sapta* initiates to afford them spiritual protection during the ordeal. While *mesakta-riya* may be a blood substitute symbolically linked to menstruating women and their reproductive fertility, white, on the other hand, may refer to semen, the essential male ingredient of the reproductive process. Although the Ga'anda did not offer this interpretation, the intentional and striking combination of these two colors in the presentation of *Hleeta* and *Sapta* graduates may symbolically confirm their maturity, both sexually and socially

Other ephemeral transformations during Yoxiiwa and Yowo celebrate and validate the new status of young men and women. Their hair is coiffed in styles that distinguish them as adults: men wear *topro*, "a kind of comb of knobs of hair, which are left from the top of the spine to the forehead" (Boyle 1916a:249); and women wear *pehla*, rows of tight sagittal plaits (Fig. 7). They also are adorned with an array of cast brass, iron, and beaded jewelry. Particularly distinctive to women are: *musurta*, bundles of individual strands of red and white glass beads worn around the neck, which may intentionally accentuate the same symbolic color contrast as that distinguishing their bodies; *tiltil*, triangular brass charms lashed onto a band of reddened goat skin and tied across the chest (Fig. 8); and *ro?hlon'nda*, open or closed cast brass armlets with flat, wedge-shaped projecting flanges incised with designs (Fig. 9; see Fig. 11). Additionally, each girl carries an ornamental iron axe (*wurta*) in her right hand (Fig. 10), hooks an ornamental hoe (*wanketa njoxwa*) over her left shoulder, and holds a decorated gourd bowl (*njoxtiti'ba*) in her left hand. While the number of adornments reflect the relative wealth of the girl's family, the implements she carries identify the economic responsibilities associated with her new marital status.

Completing rites of personal transition not only makes young men and women eligible to marry and establish independent households, but to enjoy the rewards of spiritual protection essen-

10. *Ga'anda ornamental dance axe (*wurta). Iron L. 36 cm.*

tial to their productive and reproductive well-being. Rites of passage seem to prepare youths for accepting the maxim that powerful, controlling forces affect their future fortunes. It is possible that the excesses of pain and discomfort experienced during their ordeals induces a dimension of sensation whereby the presence and power of spirit forces are tangibly communicated. The experience of intense and repeated psychological or physical "shocks," from which the youths subsequently (but not always) recover, may palpably convey the structural complementarity of Ga'anda spirit forces who have the potential for benevolence as well as for retribution.

For example, the successful transformation of a girl's body from a mass of bleeding cuts into a texture of subtle and appealing cicatrices is regarded as the result of positive spirit intervention.[9] The spirit N'gamsa directs the hands of women who execute the marks, ensuring that the patterns created are correct.[10] It is only with N'gamsa's help and the approval of other family spirits that the cuts heal properly. If they do not, a woman's body conveys an indelible message about spiritual disgrace or rejection. Healing is especially critical following the final stage of *hleen'gup* when girls are kept isolated in small grass shelters situated in hill

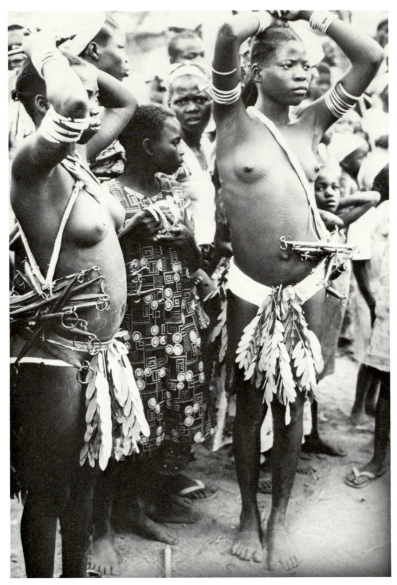

11. *Ga'anda new brides* (perra) *dancing at the annual harvest thanksgiving (Xombata). Ga'anda town. 1980.*

sites (*wanngwela*, "small mountain") for one to two weeks. They must avoid any conversation or contact with men at the risk of having their cuts swell or form unsightly scar tissue, called *kwata-kwal* ("yaws"). While in seclusion, a prepubescent girl rubs the initiate's cuts with powdered red hematite to encourage their proper cicatrization. By this means, the healing potential associated with spirits can be directly transferred to her body.

The formal spiritual confirmation of young women takes place during annual harvest festivities, called Xombata, that follow Yowo in October-November. It is not until after this event that young women enter their husbands' households and legitimately consummate their marriages.

Xombata is the only occasion when women may enter the sacred groves (*xwer'defta*) where spirit forces, localized in ceramic containers, are enshrined. They do so only once to sanctify their first marriages. The new brides (*perra*) are ceremonially led to the sacred precincts and invited to drink the ritual beer that was poured earlier into the spirit vessels as a sacrificial offering. By drinking this beer, each bride receives a direct blessing of fertility. For this critical event and the days of public dancing that follow, the *perra* (brides) are celebrated and differentiated by what they wear, as they were previously during Yowo (Fig. 11). Many of the same iron and brass ornaments are worn, but with the notable absence

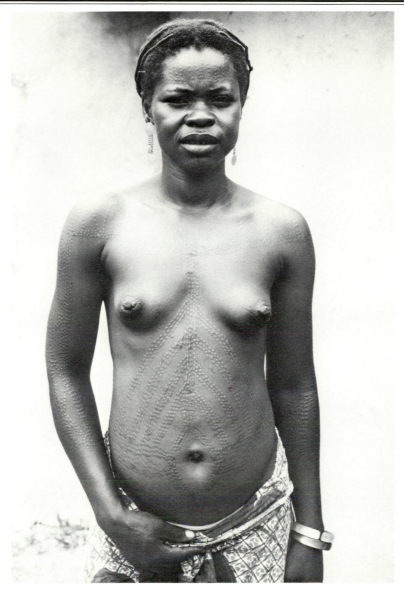

*12. Yungur woman with Sã scarification
markings. Dirma village. 1981.*

of the ritual cosmetic (*mesaktariya*) and the strands of red and white glass beads (*musurta*).

Although the cooperative efforts of both men and women are the basis of household organization and prosperity, it is notable that only women undergo such elaborate and irreversible transformations of their bodies. The importance of *Hleeta* as a tool for sociocultural integration is reflected in its striking consistency among the dispersed Ga'anda population. However, it is not only the Chadic-speaking (Afroasiatic) Ga'anda who regard an elaborate program of scarification as the *sine qua non* of marriage. The same attitude is held by their neighbors, the Gbinna and the Yungur, whose languages belong to the Adamawa (Niger-

Congo) family, and who are likely to have been aboriginal to the Ga'anda Hills.[11] The striking similarities in Ga'anda, Yungur, and Gbinna seriated scarification programs and their relationship to marriage support what the linguistic geography implies—that considerable interaction is likely to have occurred between the peoples involved (Fig. 12; cf. Fig. 2). Although the group responsible for originating this practice remains unclear, presently available evidence suggests that cicatrization can be traced to Chadic peoples living in the Mandara Mountains, a region from which the Ga'anda migrated at some point in the distant past.[12] Yet, the variations in their shared design systems today reflect the ethnic and linguistic autonomy that has

13. *Ga'anda new bride's compound (keten perra). Grass, wood, fiber, mud, and red ochre. Kwanda hamlet, Dingai village. 1981.*

prevailed despite the circumstances that fostered the adoption of scarification by such divergent groups. Interestingly, some Yungur men—but not Ga'anda or Gbinna—also can have nonobligatory forehead, cheek, and navel scarifications identical to those of their wives.

There is little doubt that the importance of *Hleeta* for the Ga'anda cannot be separated from the sociohistorical circumstances underlying its evolution. Yet, the messages *Hleeta* conveys about social and ethnic identity, however significant each may be, could be conveyed in simpler (and less painfully prolonged) terms. It is evident that the carefully phased alteration of the body allows discrete units of design to remain isolated for extended periods of time. The visual impact of single stages of *Hleeta* may be greater than the combined effect of the completed program; it is the serial acquisition of marks and not only the composite that projects meaning. This effect is especially evident in *Hleeta*'s inseparability from lengthy premarital negotiations. That the meticulous and controlled imposition of designs on a woman's body has established a pattern and provided a model for altering the surfaces of other objects used in related contexts supports this proposition. As will be demonstrated below, the

distinctive components of design that dominate *Hleeta* are used elsewhere to convey and reinforce its fundamental messages. The importance of Ga'anda scarification is clearly tied to a total artistic system oriented toward upholding the same goals of social perpetuation and spiritual propitiation.

Hleeta *and Public Arts*

Hleeta designs are evident in the decoration of the large ritual beer pots used by the groom to make substantial payments in beer to the bride's family (see Fig. 6). The shapes, as well as the names of the designs boldly drawn over their rouletted shoulders refer directly to scarification motifs—*kwardata* lozenges down the thighs and the sides of the torso (cf. Fig. 5i–j), *caxi'yata* curves on the abdomen (cf. Fig. 5j), and *kun'kanwannjinda* scallops under the navel (cf. Fig. 5j). One particularly large vessel documented in Ga'anda, said to be over 100 years old, is decorated with a striking inverted "branch" that literally quotes the column of scars worked down the center of a woman's torso (*njoxtimeta*) and the concentric chevrons worked over her navel (*hleexwira*; Fig. 5g). Likewise, the blades of ornamental axes (*wurta*) carried by girls at Yowo are

14. *Ga'anda wickerwork basket (*can'lan'nda*) ornamented especially on the occasion of a girl's wedding and used to display her decorated gourd bridewealth. Wood, fiber, dung, and leather.*

forged with chains of lozenges (*kwardata*; Fig. 10); the wedge-shaped flanges on armlets (*ro?-blon'nda*) are often decorated with a version of Design B (Fig. 9); and *tiltil* charms are rows of small, tapered triangles (Fig. 8).

It should be noted that the repetition of this limited universe of motifs is not the only stylistic device that projects meaning. Decorative consistencies are also evident in the juxtaposition of textures and in the processes used to execute them. The tiny cuts made in the skin create an even pattern of cicatrices whose impact is determined by subtle relief, as well as tactile contrasts. At the same time, these designs circumscribe areas of unmarked skin that emerge in secondary shapes. For example, when *kwardata* lozenges, *caxi'yata* curves, and *kun'kanwannjinda* scallops are transposed into other media they quote both the linear alignment of cuts and the planar shapes they outline (cf. Figs. 6, 8–10). Additionally, the drawn (or forged) geometric shapes are consistently worked against a densely textured ground.

The transposition of *Hleeta* designs into other media reinforces the proposition that aesthetic choices are governed by their social utility and

communicative value. The most highly visible demonstration of how a decorative program can be manipulated to exploit its expressive potential is evident in the special compounds, called *keten perra* ("new bride's house"), which husbands must build for their brides (Fig. 13). The compound conforms to conventional architectural specifications, but the facade is differentiated from other household structures by striking decorative attachments. A narrow border, called a *wandipe-lan'nda*, is woven from natural and acacia-dyed grasses and is tied across the top of the entry panel. It creates a contrasting strip of dark and light zigzags. Rope is used to tie a continuous row of inverted triangles or lozenges, called *hledemeta*, across the outer wall of the kitchen just below the roof junction; the geometric shapes thus formed are then plastered with a mixture of mud and red ochre.[13] The shape and color of this bold mud frieze seem to refer directly to the presentation of girls at Yowo, their scarified bodies smeared with red oil. The *keten perra*, with its concise symbolic markers of a bride's legitimate status, makes a strong public statement about the establishment of a new patrilineal household in a hamlet.

In the bride's compound, the textural counterpoint between the weave of the entry wall, the triangles tied in rope, and the smooth coating of red mud may be equally expressive. The association of this graphic and textural syntax with new brides is repeated in the wickerwork baskets (*can'lan'nda*) used for displaying a girl's gourd bridewealth (Fig. 14). Strips of smooth red-dyed goatskin are criss-crossed over a band of variegated rope to create a continuous pattern of linked lozenges.

Because these design programs refer specifically to brides, they suggest that women are particularly important agents of household solidarity. In fact, husbands may periodically renew and redecorate the outer walls of their compounds with nonobligatory woven attachments, called *njipta*, that closely resemble those worked on a new bride's house (Fig. 15). Dyed rope is tied in a frieze of lozenges along an outer wall, but the shapes are not plastered with mud. The triangular design may refer to the permanence of *Hleeta* and the sanctity of marriage, but the absence of reddened mud may clarify that the occupants are no longer newlyweds.

Such decorations are recognized both as a gesture of affection and as a means by which a husband can increase his wife's prestige. It is significant that this demonstration of loyalty be made public—it is always done on the compound facade

and not within its private, interior spaces. While providing a vehicle for Ga'anda men to acknowledge the socioeconomic importance of their wives, it also registers the importance of securing their loyalty. Such efforts are partly a response to the instability of Ga'anda marriages. Yet, more significant is the fact that women are exclusively responsible for food preparation, giving them considerable leverage in household affairs. Indeed, women will threaten to abandon their husbands if their behavior is not acceptable or if they do not satisfactorily meet their marital obligations. Meek's observations provide further insights:

> In spite of the strong patrilineality of the Gabin [Ga'anda], wives by no means occupy a position of subservience. They have their own farms, the husband helping the wife on her farm, and the wife helping the husband on his. Each has his or her own granary; but the wife, like the husband, places her grain at the disposal of the household. She may, however, sell part of her grain if she chooses; and she generally does so if her husband's stocks are sufficient for the household needs. The woman is the cook, and her husband is therefore anxious to please her in order to retain her services. If a wife chooses to leave her husband she can usually secure another without difficulty, and I observed among the Gabin many elderly men who were wifeless and were dependent for their food on the wife of a younger brother. Many elderly men have to do their own cooking. Wives are the beer-makers, and they do not hesitate to prevent their husbands distributing beer to friends of whom she does not approve. A wife may even prevent her husband from attending a cooperative day's work on a neighbor's farm (at which beer is freely distributed) if she considers that he would be better employed at home. A case came to my notice in which a man's wife prevented him from carrying out an order of the chief, until he had finished his work of hoeing her farm. I also came across an instance of a wife living with her husband and children in the home of her parents, because she could not endure her husband's relatives (1931 II:380–381).

The precariousness of Ga'anda marriages is literally objectified by stone "fidelity" oracles, carefully balanced constructions of stone spheres (actually worn-out grinding stones), called *dakwan nesca* ("stones of women"). Should one or more of the stones roll off the pile, it serves as an omen of marital breakdown. The direction the stone rolls is that which the wife will follow to seek a more satisfactory mate. The use of stone for these oracles may reflect the husband's desire for a comparably durable marriage, which indeed is an underlying objective in the scarification of

15. *Decorated outer wall of a Ga'anda household (*njipta*). Grass, wood and fiber. Jebre village. 1981.*

women. Yet, at the same time, the shape and potential instability of the spheres suggest the male conception of Ga'anda women's unpredictability and inclination toward marital transience, which even the process of scarification cannot prevent.

Men can also affirm the domestic importance of their wives through the designs painted in red slip (*wankari*) on their large sorghum granaries (*'bendewtarta*), which occupy the public space of a hamlet. The "torso" of one man's store includes an alternating pattern of lozenges and opposed curves separated by vertical stripes (Fig. 16). Not only are those shapes identifiable as *kwardata* and *caxi'yata*, but their alignment and juxtaposition with vertical lines parallels the orientation of their scarified equivalents on a woman's torso (cf. Fig. 2). Although this granary may implicitly symbolize a man's successful cultivation of sorghum, the mainstay of his family's diet, the dramatic motifs painted on its surface underscore the essential role of women in making this cultigen a digestible food. Furthermore, these decorations may strengthen the expressive link between a granary's storage capacity and a woman's reproductive potential, already suggested by the intriguing similarities in their body contours.

16. *Ga'anda hamlet of Cijera with a view of a man's (right) and a woman's (left) granaries (*'bendewa*). 1981.*

The angular shapes that dominate *Hleeta* are symbolic emblems of union and stability. The most prominent motif repeated in other media is *kwardata*, the lozenges incised over a girl's thighs to show that a marriage contract has been formally negotiated. Although the final stage of *hleengup* follows shortly afterward, it is this design that confirms a girl's family's agreement to uphold the marriage, at least for the short term.[14]

Hleeta *and Spirit Propitiation*

It is clear that Ga'anda public arts make visual statements about social realities that are nowhere more prominent than in the irreversible patterns of scarification on each woman's body. Yet, every Ga'anda man and woman also understands that his or her participation in society can provoke the positive or negative intervention of powerful spirit forces who are the final guarantors of economic and social survival. Ga'anda arts are an important tool for fostering productive interaction between human beings and spirits; they provide a common visual language through which these relationships and their parameters can be tangibly expressed and understood. It is clear that the designs con-

sistently scarified on women help secure their commitment to household affairs and to the socialization process. Decorated pots, tools, compounds, and granaries both directly and symbolically reinforce this commitment to order and stability. Likewise, the sacred arts of the Ga'anda have been created according to the same aesthetic principles, serving to localize, contact, and regulate the awesome forces that ultimately determine the courses of their lives.

The Ga'anda believe that ancestors are capable of influencing the lives of their descendants. They view death as the potentially dangerous liberaton of a spirit which must be properly contained, propitiated, and celebrated before its final release to the afterlife one year after death. As the spirit or soul of the deceased does not leave the world of the living immediately, it is temporarily relocated in a ceramic vessel, called a *hlefenda*, so it can be attended and placated for one full seasonal cycle (Fig. 17). The vessel is supported on a tall forked pole in the former sleeping room of the deceased, and both the pot and the room are treated as if the deceased were still alive: the vessel is washed and refilled with beer each time the family has an occasion to brew it; the room is

*17. Two Ga'anda ancestor vessels (*hlefenda) *with calabash cups displayed during second funeral rites, Kwefa. Gabun. 1980.*

regularly swept clean; and during the cold harmattan season fires are lit to keep the spirit warm. A small red-dyed calabash (*ti'ba*) is always kept over the mouth of the *hlefenda* so that the spirit can "drink" its libations from an appropriate cup. These procedures demonstrate that death, according to the Ga'anda, is essentially a continuation of life in another sphere. They also reveal that a positive relationship between the living and the ancestors can be encouraged by the proper treatment of spirits before their departure to the afterlife (Pan).

The form and decoration of *hlefenda* vessels substantiates the proposition that the establishment of parallels between human beings and spirits fosters communication. These ritual pots, which are always the same regardless of the sex of the ancestor involved, are characterized by blackened surfaces and a series of designs carefully incised over their "torsos" (Fig. 17). Designs are organized around a central projecting umbilicus, and reproduce *Hleeta* motifs around a woman's navel (Fig. 18). These motifs, including 1) *kwardata* lozenges, 2) *caxi'yata* curves, 3) *njoxtimeta* verticals, 4) *bleexwira* chevrons, and 5) *kun'kanwannjinda* scallops, are cut into the clay with dense rows of stalk impressions. While the designs incised on each pot are somewhat variable, *kwar-*

data lozenges are always worked as burnished shapes against a textured ground. By this means, *hlefenda* vessels seem to be intentionally scarified, reversing the raised effect of cicatrices with rows of impressions in a smooth, blackened surface. The transposition of motifs with such incontrovertible Ga'anda associations ensures that the ancestral spirit will "know" its temporary residence. As prototypical markers of social transition, *Hleeta* motifs may signify the elevation to ancestral status. Moreover, because the new body provided an ancestral spirit has manifestly female associations, it may encourage a similar commitment to social responsibilities as that which girls make when they undergo *Hleeta*. This, however, does not imply that all Ga'anda ancestors are or become women; instead, it suggests that by altering surfaces in this way, the Ga'anda can localize and thereby ensure the cooperation of potentially dangerous and unpredictable forces.

The relationship established between the Ga'anda and their immediate ancestors via *hlefenda* vessels is only temporary, however. It ends abruptly with a second funeral ceremony, called Foxta ("smashing"), held in the early dry season after Xombata harvest festivities. The *hlefenda* is taken to a designated site, called a *met foxta*

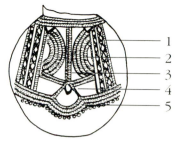

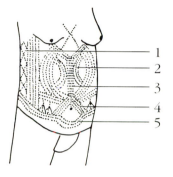

18. *Comparison of motifs incised on a* hlef-enda *vessel and those used in* Hleeta. *Numbers correspond to designs named in text.*

19. *Ngum-Ngumi vessel enshrined at Xwerun-guhla (Wetu clan), Boka. 1981.*

20. *Ga'anda spirit vessel (Ngum-Ngumi) in abandoned pot shrine in the hamlet of Kandi-xata, Coxita village. 1981.*

("place for smashing"), held by the neck, and smashed against the rocks to free the soul and dispatch it to the afterlife.

The Ga'anda recognize the supreme spiritual authority of Farta, the creator God, who is contacted through a pantheon of junior spirit intermediaries.[15] Together, these supernatural forces are responsible for health and prosperity. Of these lesser spirits who embody the positive and negative manifestations of Farta, the most historically important is Ngum-Ngumi. This spirit is conceptualized as a pot, moving on its own volition, which led the Ga'anda in their migration from "the East." Since that time, Ngum-Ngumi's movements have legitimized the right of Ga'anda groups to occupy particular sites. The power and authority of Ngum-Ngumi to influence Ga'anda well-being is defined by its ceramic form, which despite certain sculptural variations, is the same everywhere it "stopped."[16] The basic anatomical features modeled on each vessel—hands, breasts, navel, and genitalia—show the importance of humanizing Ngum-Ngumi (Figs. 19,20). However, the impressed ridges distributed over the surface and the iconographic program embodied in the raised designs best indicate the cosmic role of the spirit-

vessel. The treatment of the central panel of the Ngum-Ngumi pot suggests that rows of *Hleeta* cuts are being made in clay. Yet, where *hlefenda* vessels literally reproduced the motifs of *Hleeta*, the nature of the Ngum-Ngumi spirit does not seem to require such exact reduplication. While the decorative patterns may be different, the process used to achieve them is the same for all vessels: ridges of clay are worked on the surface and then meticulously impressed with the edge of a broken piece of calabash (*caxa*). This modeling procedure presents an interesting parallel to the way ridges of skin are lifted with a hook and then cut with a razor during scarification. In some examples, the column of vertical ridges aligned down the center of Ngum-Ngumi's torso may be a stylization of the prominent column of *njoxtimeta* scarifications worked down a girl's torso, which remains isolated for years until the final stage of *Hleeta*. These vertical markings often intersect with a series of lateral ridges that may be an abbreviation and schematization of *kun'kanwannjinda* worked under the navel. Other Ngum-Ngumi vessels are modeled with a lozenge pattern that reproduces *kwardata*. It is possible that by permanently "scarifying" Ngum-Ngumi in this way, the Ga'anda seek to link the spirit to their socioeconomic survival, as women are socialized through *Hleeta*. This correspondence suggests that, like ancestor pots, graphic and textural references to *Hleeta* do not identify Ngum-Ngumi as female, but instead reveal the spirit's commitment to social perpetuation. By humanizing and civilizing the spirit, the Ga'anda not only make such vital energies accessible, but correlate positive social action with productive spiritual involvement.

These associations are also evident in other iconographical elements modeled on Ngum-Ngumi vessels, which link the spirit explicitly to the authority of men in Ga'anda society. The masculinity of Ngum-Ngumi is evident in the male genitalia often modeled under prominent navels. Other iconographic motifs distributed over the untextured areas of Ngum-Ngumi's surface further define and reinforce his male persona. They describe the tools and weapons used by Ga'anda men to meet their social and economic responsibilities, such as axes (*wurta*), bows (*riya*), quivers (*kweceta*), or daggers (*hluuta*; Figs. 19,20).

In sum, the details of Ngum-Ngumi's form intentionally evoke a parallel between its spiritual role and the social roles and responsibilities of Ga'anda people. Through representations of tools and weapons the identity of Ngum-Ngumi may be linked explicitly to the affairs of men; yet, the embellishment of its surface may refer to socialization in general and to the determinative importance of women. What women most dramatically symbolize for social processes, Ngum-Ngumi may represent for historical legitimacy and continuity.

Hleeta *Today*

Scarification practices were officially outlawed in 1978 by the Gombi Local Government authority which administers the Ga'anda district. There is little doubt that this interdiction anticipates the eventual breakdown of traditional social patterns and ethnic allegiances, the covert intention of this official act of local control and national incorporation. In 1980, the new brides who danced at Xombata had not completed the final stage of *Hleeta* (see Fig. 11). Yet, they still appeared in full costume, wearing bunches of leaves tucked into the front and back of their "bikini briefs," and in spite of the fact that the other participants wore contemporary manufactured clothing. Indeed, the attention paid these young women confirms that among a significant portion of the Ga'anda population, traditional ways of life are still viable. It can be argued that Ga'anda arts will survive as long as the social and spiritual systems they support remain the ideological bases of material survival. It is significant that even the tradition of building a distinctive compound for one's new wife persists; grass panels are tied over the mud-brick walls of modern compounds to provide a suitable armature for decorative attachments.

Despite such continuities, however, it is clear that customary marriage patterns have been increasingly weakened by the antipathy of youths to prearranged marriages and to adulthood in remote Ga'anda village enclaves. Pressures to assimilate to a cosmopolitan urban culture have resulted in the concealment of ethnic markers, like scarifications, which associate the wearer with backward, "bush" societies. Girls who attend secondary schools with mixed student enrollments, in nearby or distant towns, or who hope to marry youths with a future outside the village, no longer want or need to undergo a procedure that has little relevance outside a Ga'anda context, either socially or ethnically. Often their parents offer little resistance as they, too, will benefit from this status elevation.

There has been pressure from the church since the 1950s to abandon *Hleeta*; its attitude is summarized by Margaret Nissen in her comments on the Ga'anda and the history of the Sudan United Mission in northeastern Nigeria:

The Ga'anda girls, like their Yungur sisters, had to undergo cicatrization before marriage. But since there are a number of Christian fathers with girls ready for this ceremony, there are mature and respected people who can help the young girls in this dilemma and support them in breaking down this age-old cruel custom (1968:221).

The widespread adoption of clothing, which only became customary among the Ga'anda after the 1950s, has also contributed to the erosion of a practice that depended, in part, on visibility. Yet, the fact that *Hleeta* persisted among many Ga'anda families until its official ban in 1978 supports the contention that the process and meaning of imposing designs on a woman's body transcend aesthetics and visibility. The social history of the Ga'anda is clearly reflected in this important tradition, which may die with older generations of women, but will endure in the less ephemeral arts still preserved by the Ga'anda.

Notes

1. I conducted field research among the Ga'anda and a number of neighboring peoples living in the Gongola-Hawal Valley and adjacent areas from September 1980–June 1981 and September 1981–June 1982. This fieldwork was co-funded by the Fulbright-Hayes Doctoral Dissertation Research Abroad Program and by the International Doctoral Research Fellowship Program of the Social Science Research Council. My thanks are due to both these programs. I am also grateful to Arnold Rubin, Department of Art, UCLA, for encouraging me to continue the survey work he did in the Lower Gongola Valley in 1970–1971. During my stay among the Ga'anda (October 1980–March 1981), I was warmly received and assisted by many men and women, whom I now gratefully acknowledge. Musa Wawu na Hammandikko, my Ga'anda field assistant, should be especially thanked for his enthusiastic support and encouragement. His personal desire to preserve the Ga'anda heritage prompted him to research and write a history of the Ga'anda (1980), which Arnold Rubin and I helped to see into print with the assistance of the African Studies Center, UCLA. In addition to my lengthy treatment of the Ga'anda (1986), information on them is included in Rubin's forthcoming monograph, *Sculpture of the Benue River Valley*, and in Boyle (1915,1916a,1916b), Meek (1931 II), and Nissen (1968).

2. Translations of Ga'anda words have been drawn from R. Ma Newman's *Ga'anda Vocabulary*, which was produced as a part of her dissertation on the Ga'anda language (1971). Most of the vernacular terms used in the following chapters have been checked for spelling against Newman's wordlists; words that were not included have been transcribed to the best of my ability. The following orthographic conventions for Ga'anda should be noted:

x = voiceless velar fricative	hl = voiceless lateral fricative
e = schwa	n' = voiced velar nasal
'b = glottalized "b"	'd = glottalized "d"
? = glottal stop	

3. Meek (1931 II:379–385) includes a detailed account of Ga'anda kinship and social organization.

4. The settlement pattern of the Ga'anda has made accurate census counts difficult to obtain. Meek (1931 II:369) reported 5,400 Ga'anda, while Kirk-Greene ([1958]1969:2) later recorded 7,641. Recent population density maps based on a 1963 census total suggest these figures should probably be adjusted to approximately 10,000–15,000 persons (at 40–60 persons per square kilometer; Aitchison et al. 1972:Text Map 12).

5. In addition to my own field notes, information on Ga'anda marriage is found in Boyle (1916b:361–366), Hammandikko (1980:13–14), and Meek (1931 II:385–386). The general pattern of marriage is the same throughout the Ga'anda region, although details vary slightly between localities.

6. The requirement that girls be scarified before marriage is noted in Hammandikko (1980:4), Meek (1931 II:384), and Nissen (1968:221). Only the article drawn from Boyle's (1916b) observations describes this procedure in any detail. Boyle also includes a number of useful drawings of the alignment of scars on the body. There are, however, a number of discrepancies between my information and that of Boyle, especially as regards which areas of the body are marked during particular stages and the specific motifs incorporated in each. It is my impression that the drawings in Boyle combine designs found on Ga'anda women with those on the Gbinna, who live west of the Ga'anda and also do full-body scarification (see p. 67 below and Fig. 12).

7. Information on *Sapta* is drawn from oral accounts collected among Ga'anda elders in 1980–1981. Notes published by Captain Boyle (1916a) are based on his eyewitness account of an "Ordeal of Manhood" in 1913. They provide a number of useful descriptive passages, as well as some perspective on the continuity and change of this tradition in this century. Brief accounts of *Sapta* are also included in Hammandikko (1980:12–13), Meek (1931 II:378–379), and Nissen (1968:219–220).

8. Bohannan's discussion of "Beauty and Scarification amongst the Tiv" (1956 and reprinted in this volume) provided insights for my analysis of Ga'anda body decoration.

9. This phenomenon is even more striking during *Sapta*. Masqueraders perform to frighten the male initiates who are told "spirits" are dancing. In addition to the visual impact of the masks (*magenshen*), this demonstration of spirit intervention appropriately complements the other miraculous "feats" that informants claimed once punctuated *Sapta*—e.g., boys leaping off high rock formations and landing "like birds" or boys setting fire to grasses while swimming in the water.

10. N'gamsa is primarily a spirit-servant of the Ga'anda rain priest, who enlists its assistance each year in summoning the rain spirit ('Yera). N'gamsa is also responsible for man's creative abilities. The aptitude for particular tasks, especially those performed in conjunction with ritual or ceremonial contexts, such as *Hleeta*, is due to N'gamsa's intervention and guidance. To meet the needs of the dispersed Ga'anda population, there are multiple points in the earth from which this amorphous force can emerge to provide local assistance.

11. More information on the scarification practices of the Gbinna and Yungur (*Sā*) is provided by Boyle (1916b:364–366), Meek (1931 II:447–450), Chappel (1977: 14,206), and Berns (1986). Meek (1931 II:435) also noted the cultural correspondences between the Ga'anda, Gbinna, and Yungur.

12. The historical relationship between the Ga'anda, Gbinna, and Yungur is developed more fully in Berns (1986). It should also be noted that Gbinna and Yungur boys undergo initiation ordeals of the same sort as Sapta, called Xono.

13. Identical descriptions of brides' houses are included in Boyle (NAK J–18:1913:34) and in Meek (1931 II:386).

14. Ga'anda women are constrained to accept the choice of husband made by their parents. The Ga'anda have an interesting legend about three upright stones perched on top of a massif (Hler) situated north of Ga'anda town, which asserts the importance of accepting the first pre-arranged marriage. This legend of Ngwalwanteriica ("Mountain of Girls") explains that a young bride, accompanied by the girl who cared for her while she recovered from her final scarifications, once ran away from her future husband. Because they tried to escape, Farta (the Creator God) punished the two girls by changing them into birds that flew to the top of the mountain where they then were turned into pillars of stone. The husband who pursued them was also changed to stone. Today the three uprights of graduated size—girl, bride, husband—are permanent reminders of the need for obedience and patience.

Later in a marriage, a woman can establish acceptable reasons for eloping with another man. Even then, Meek (1931 II:385) reports that a girl's parents must also approve of her choices. Each successive husband is required to repay the bridewealth given by his predecessor.

15. The word *farta* is translated as both "god" and "sun"; the creator god's epithet is *wat farta* or "fire of the sun." Farta and the sun share the same qualities: remoteness, omnipotence, and omnipresence. Accordingly, Farta is never worshipped or approached directly, nor does he explicitly govern the affairs and fortunes of people. Because the lesser spirits generally engage in more personal relationships with their human charges, they can be influenced by regular entreaties and ceremonies.

16. One or more vessels representing the power and authority of Ngum-Ngumi are usually enshrined in major ritual precincts maintained by the Ga'anda. Twenty-two Ngum-Ngumi vessels were mapped across the region. It often is not Ngum-Ngumi who is localized in a ceramic container, but rather one of its "spirit brethren" or intermediaries. It is they who accept libations of beer on Ngum-Ngumi's behalf. This convention contrasts with other spirit-charged vessels used by the Ga'anda, which are removed during rituals to receive offerings. Only Ngum-Ngumi must never be exposed to the sun's rays (*wat farta*), a proscription that suggests a special need to protect this beneficent spirit from direct contact with the power of Farta.

Beauty and Scarification Amongst the Tiv[1]

Paul Bohannan

Europeans seldom count scarification and tattooing among the fine arts. Amongst some African peoples, however, there is an aesthetic of body decoration which should be examined if we are to understand African artistic canons. Tiv, the large pagan tribe of the Benue Valley in Nigeria, are heavily scarred, and have a definite and largely overt aesthetic of physical beauty, including scarification.

A favorite Tiv *bon mot* is *kasev hemba kongoron kwagh*; it is one of those multiple puns in which they delight. It means both "women rub more things" and "women are more smooth"; it means that women spend a lot of time with pomades and poultices for the sake of their appearance, and has direct sexual connotations. The Tiv aesthetic of physical beauty is explicitly built on the assumption that one should make oneself attractive, and that proof rests in being looked at. Its implementation calls for (1) oiling or coloring the skin, (2) dressing up, (3) chipping the teeth in an unusual or pleasing way and (4) incising the skin.

Tiv oil their bodies with palm oil, castor oil, vaseline, or, occasionally, groundnut oil. The resultant shining quality is highly prized: it is said of a person with a glistening skin, "he glows" (*a wanger yum*). The same word is used of the sun or the headlights of an automobile. The impersonal form of the same expression, *i wanger*, means to be light and can be said of the day, of a kerosene pressure lamp or of an idea.

One of the most effective ways of glowing is to rub the skin with camwood, a red wood which Tiv import from the forests to their south. Camwood is ground and made into a paste with either water or oil, and is used as a cosmetic. It is also involved in ritual: the notion of lightening or causing to glow joins the profane and sacred worlds. The bride and groom, especially if it be the first marriage for both, are smeared with camwood so that they glow; they may wear it for several weeks. A new-born child has camwood smeared on his head. Corpses are smeared with camwood; this "lightens" them, but also (Tiv are practical people) absorbs the liquids from the corpse and keeps down odor. Whenever a person is put into special contact with a fetish force or *akombo*, camwood is necessary to the ceremony. The greatest protecting force in Tivland, *swem*, has camwood as one of its ingredients. Yet many people smear camwood on themselves merely because they think it attractive. Occasionally, if camwood is unavailable, yellow ochre may be substituted for cosmetic purposes. Today talcum powder is a cosmetic, and the same phrase is heard—"he glows." The whole notion of lightening by making oneself smooth, attractive and sacred is important to Tiv in their religious and personal lives.

Tiv say that it is possible to make oneself very light by means which are horrible and nefarious: if one smears one's body with human fat, one becomes irresistible. There are said to be men who deal in human fat: they come, with sacks across their shoulders, and sit menacingly at the side of the market; their mark is a piece of a certain grass hanging from their lips. A prospective buyer approaches circumspectly; the haggling does not take place in the market, but arrangements are

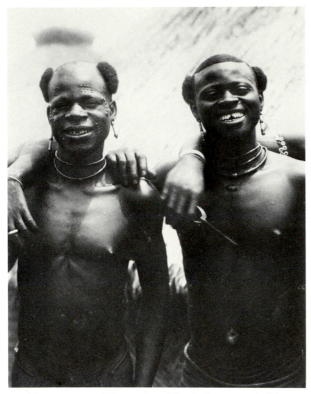

1. *Two young Tiv men with elaborate coiffures, chipped teeth, and extensive scarification. Photographed by Leo Frobenius, 1910–12, at Salatu, south of Donga. Frobenius Institut, Frankfurt/Main.*

2. Abaji *scars: a 'lumpy face.' Paul Bohannan photo.*

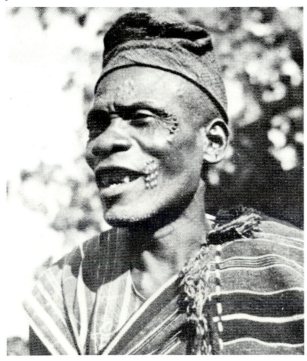

made to meet for a special "market held at night" (*kasoa tugh*). We can see that Tiv are expressing metaphorically their belief that if one man achieves too much worldly success—including too much beauty—he must have got it at the expense of another.

There are other, less drastic, magical or medicinal means of "glowing." Tiv wear charms sewn into small leather bags or bracelets, some of which make one invisible or turn bullets to one side, but many more of which protect one against witches or make one attractive in general and sexually attractive in particular.

The first notion of physical beauty, then, is that the body must "glow" or *wanger*. It is also the point of much ritual. The word means to be beautiful, to be clear, and to be in a satisfactory ritual state.

Besides being made to glow, the body must be adorned or decorated. The Tiv word for decorate is *wuha*. It means to make more pleasing anything which already glows or *wanger*. The glowing body is adorned with clothing and jewelry. Usually translated "to dress," it really means "to dress up." *Swem*, the greatest power or natural force, which itself glows, is "dressed up" whenever its representational ingredients are put together for a ritual purpose.

One of the things children do when they "dress up" is to paint designs on their faces with a vegetable juice called *mar*. When they get a bit older, they begin conscientiously to "try" various designs to see which ones fit their particular faces. There is an intricate vocabulary of names for the various sorts of facial marks which may be made with *mar*. Schoolboys write words and numbers on one another's faces; often nonsense syllables are written for the sake of design. The number "5" is a favorite.

Tiv use other cosmetics as well. They dye their fingernails and palms with henna, keeping gourds full of moistened crushed henna fastened over their wrists for several days at a time. They also use antimony or galena—the mineral which they call *tojii*—to paint eyelids, nostrils and sometimes lips, or to blacken eyebrows. Men sometimes blacken their moustaches with *tojii*.

Another type of facial decoration is *shase*, a tree which grows in Tivland (*Uapaca guineensis*). If you take a pointed twig of this tree, it leaves a spot wherever the skin is pricked; the spot stays for two or three months and then gradually disappears. *Ishase* scars are white, and are very effective on a black skin; their most common use is as a "trial run" for more permanent scarification. Ev-

ery effort is made to get patterns which emphasize the best points on one's face.

One of the most important requisites for beauty is that a person be scarred (*gber*, literally "cut"). Akiga records a legend that Tiv were originally unmarked and took up scarification to distinguish themselves from other tribes.[2] Tiv markings are very characteristic, but my informants denied that they were "tribal marks" with which they were familiar amongst Ibo and Yoruba. Rather, scarification style changes from one generation to the next. Though one's scars may mark one's generation, they do not mark one's lineage.

Akiga has, with high spirits, described the struggle between the "lumpy faces" and the "nail boys" which took place when scarification styles changed in the nineteen-thirties. Although he has, in typical Tiv fashion, overstated his point in the interest of humor, it is true that young women's preference for young instead of old men is sometimes expressed in a fondness for new types of facial marking. There are four "generations" of scarification types to be found in Tivland today. The oldest of these is called *ishondu*; they are seen occasionally on very old people, and are sometimes done today, as an "old-fashioned" gesture, on young men. They are flat, shiny scars along the arms and down the back. They are followed by *abaji*, Akiga's "lumps" (Fig. 2). *Abaji* are made by means of a hook—today a fish hook with the barb filed off. Some skin is hooked, lifted, and then cut away with a Tiv razor; a styptic agent (*alufu*) is applied to stop bleeding, and charcoal and perhaps indigo is rubbed into the wounds. *Abaji* are most commonly cut around the eyes. Akiga says that there were three or five, but most of the people I knew had six. During the time when I was in Tivland (1949–53) *abaji* markings were found on almost all men and women above the age of 35 or so. Younger men had a new sort of marking called "nail" (*kusa*) after the instrument with which they were made. Nail scars are flat and very difficult to photograph. Figure 3 is seven sketches of "nail boys" and one woman marked with nail scars.

Some years after the introduction of nail scars, another sort of scar called *mkali* became fashionable. *Mkali*[3] are very deep scars cut with a razor and colored black with charcoal. It is possible to put *mkali* over nail markings much more effectively than it is to put either over "lumps." One often sees all combinations, however. Figure 4 shows one example of combined lumps and nail markings, and five examples of nail markings and *mkali* marks. Figure 5 shows *mkali* marks super-

3. 'Nail' scarification pattern —all male except (e).

4. Scarifications of mixed types.

5. Mkali *scars superimposed on nail scars. Paul Bohannan photo.*

imposed on nail markings.

Tiv definitely associate different types of scars with different ages of men. I have heard young men accused of putting scars of the older generation on their faces in order to make people think that they are older than they are. My informants in northern Tivland assured me that youngsters who are today four or five years old will undoubtedly think of or learn a new method of scarification by the time they are old enough to be interested in it.

"Nail" marks are mainly decorative; both the *abaji* and *mkali* marks, however, actually alter the planes of the face. They are cut very deep, and their effect is on the fall of the shadows on the face. Prominent cheeks, for example, can be made more prominent by doubling the shadows cast upon them. A nose can be made longer—or shorter—by use of a deep mark. The ultimate pur-

6. *Men's chest scars.*

7. *Arm scars.*

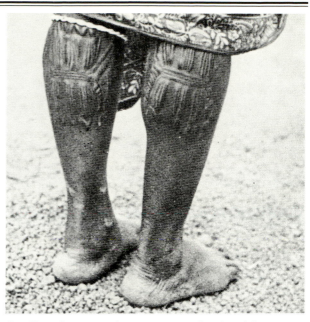

8. *Handsome calves are emphasized by scars. Paul Bohannan photo.*

pose of all scarification, Tiv insist, is to make themselves more attractive.

Complete scarification may take decades. It begins at the age of 13 or 14 and may go on until one reaches 40 or 45. I knew one woman of 35 who had saved an empty space on her forehead for the time she would leave her second husband. She had now done so, and was casting about for a design to fill the space. She spent days trying designs in ashes and gazing into the mirror. She insisted that I offer a suggestion; I was relieved when she decided against it.

Scarification in the nail style is suitable for making designs on various parts of the body. Men decorate their chests with geometric designs (Fig. 6a), to which they may add animals or birds, like the chameleons of Figure 6b. They also often cut designs on their arms; representative arm designs are seen in Figure 7; I have also seen knife scabbards of the sort usually worn on the arm, scarified in a naturalistic position.

Women have scars put on back and legs in preference to chest and arms. A girl who is lucky enough to be born with "good" legs (full calves and prominent heels) will probably call attention to them by having a design put on them, and by wearing a string of white or colored beads just be-

low the knee. Most of these designs are cut with a sharpened nail or a razor, and the resultant wounds made into raised scars by rubbing charcoal or camwood into them. Usually the design is one which the Tiv call "fringe," after edges which are left on a piece of cloth when it comes off the loom. A really handsome set of leg scars will be famous for many miles around (Fig. 8).

Somewhat more common are the scars which are put on women's backs with many fine razor or nail cuts (Figs. 9,10). These scars usually start on the neck, just below the hairline, and come about halfway down the back. The number of artists who do back scars is limited; after one has studied them for a few days, one learns to recognize the personal styles. These artists are often circumcisors as well.

Scarification designs are common to both sexes. They consist of geometrical designs or are representations of the swallow, the water monitor, the scorpion, the fish (*ishu*) or occasionally the chameleon.

Tiv admire the swallow above all birds. They build small platforms into the roofs of their reception huts especially for swallows to nest on, and say that swallows will not live with a man who has witchcraft substance on his heart. They greatly admire the swoop with which the swallow dives from the uppermost point of the roof, out under the thatch and into the free air. I have often been asked, "Wouldn't you like to be able to do that?" The swallow pattern is a conventionalized one

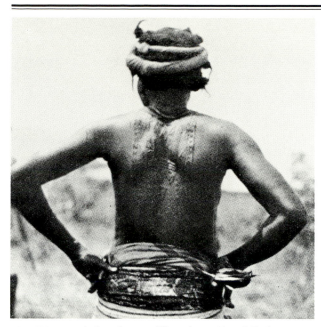

9. *Women's back scarification. Paul Bohannan photo.*

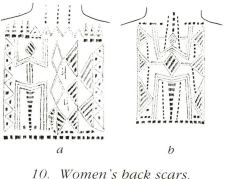

10. *Women's back scars.*

11. *Swallow, scorpion and fish patterns.*

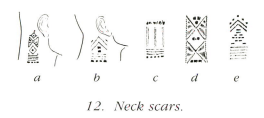

12. *Neck scars.*

(Fig. 11a); it is found over everything which Tiv do—their carved calabashes, scarification, wall paintings. Swallows are signs of agility and freedom, and more particularly of a good heart (see Figs. 3d,g,7d,10a).

The scorpion (*iyese*) is admired by Tiv for reasons which we should not consider admirable. It never gives away its position before it strikes; it is always present, always dangerous if disturbed, and most difficult to see. The basic scorpion design (Fig. 11b) is representational, and is often found tattooed on arms and faces, occasionally on a man's chest (see Figs. 3c,4d,7b). It is painted on house interiors. I have never seen a scorpion among a woman's scars.

The chameleon is the least common animal design. Tiv refuse to kill chameleons; the only reason I could ever get for their refusal to do so is that the beast can't help being so ugly and repulsive.

Lizards—actually, water monitors—are vastly admired by Tiv and are often found scarified on the arm; they also play an important part in the back-scarification of women. I do not wholly understand the symbolism of the water monitor. In the folktales, water monitor is a fool and is often the dupe of the hare. It is in part, I think, a regard for the stylization of diamonds and lines which makes it popular (Figs. 3f,h,7c,10a,b).

The fish design (Fig. 11c) is not to be confused with the swallow or with the mudfish design of belly scars to be mentioned below. The side of the neck is a favorite place for a fish (Figs. 3e,12),

but it may be found on the face (Fig. 3a) or on other parts of the body.

The most characteristic scars found on Tiv are those on the bellies of women (see *Akiga's Story*, plate facing p. 43). The belly design is called a "catfish" (*ndiar*). Abraham (*A Dictionary of the Tiv Language*) says that it is *idiar*, which means sexual lust. I have no doubt that Tiv told Captain Abraham that it was the same word—they often make puns on it. Unmarried women with particularly good scars are teased with this pun, and it is a favorite joke that the design of the tail of the fish is finished off with the clitoris. All, however, tell me that the design symbolizes the catfish or mudfish.

The head of the fish is represented by a knot of scar between the breasts. It has a long neck, and fins which are represented by the wing-like extensions of the design on both sides of the navel. The only time I ever saw these scars cut, they were cut on two girls just past puberty, and on a young woman who had been married for three or four months, whose husand wanted her to be scarred. Like circumcision, they were done early in the morning, before the sun gets hot—blood, like oil, is thicker in the morning. The operation is performed with the girl lying back in a Tiv chair (see

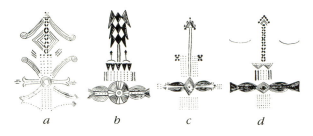

13. Women's belly scars.

MAN, 1954, 2, Plate A), with her back arched. The design is drawn in charcoal before it is cut; the lines are done with a razor, the dots with a hook and razor by a method similar to that used for *abaji* facial scars. Charcoal is rubbed into the wounds.

Like most activities amongst Tiv, scarification takes place in the middle of the compound; anyone who likes may watch it. The operator is encouraged and advised; women remind one another how much it hurts; young men may give encouragement to their girl friends.

Mudfish scars on women's bellies are said to promote fertility, but if you ask Tiv in just what way this works, they say that the scars are tender for some years after they are cut, and therefore erogenous, and that a woman who has them will demand more sexual attention than one without them, and hence is more likely to have children. Tiv are, as Frobenius put it, "ein sehr praktisch und unaberglaubliches Volk."

The mudfish patterns are of two basic sorts: they are called the "Okpoto fish," marked by a triangular motif (Fig. 13b) and the "Tiv fish" which is more cursive in design (Fig. 13c,d). A "swallow" may be added many years after the fish design; this swallow is a different stylization from that used elsewhere on the body. It usually comprises long, swooping double or treble lines which more or less center on the navel. Some women told me that these were put on after a child or two had been born in order to keep the skin of the belly firm (Fig. 13a).

The only other form of body decoration to be mentioned is tooth-chipping, which is fast dying out. The only tooth-chipper that I knew was a carpenter who worked with a chisel, file and pinchers from his tool kit. Tooth-chipping hurts—more, Tiv tell me, than scarification. When a man has his teeth chipped, it is always because his girl friend tells him he "looks like a gopher" or "like a crab," an he brings witnesses to report back to her that he withstood the pain without flinching. Tiv say sometimes that having the teeth chipped

helps one to learn languages. The two front teeth may be removed or pointed; a triangle may be cut into them or an arc taken out.

The purpose of tooth-chipping is, again, physical beauty. The effect on the face is always taken into consideration. The most effective job of tooth-chipping I know had been done on a young woman afflicted with large buck teeth. Particularly her two front teeth were large. Instead of having them knocked out, she had a nick put in each of them which gave the effect of her having four narrow teeth where the two broad ones actually were. One always looked at her, then, when she smiled, looked back at her again to be sure that one had seen correctly. I was told by someone else that her tooth operation had been successful because now everybody looked at her twice. She had, indeed, *wanger*; she glowed. The proof was that people stared at her.

Tiv do not associate tooth-chipping with cannibalism, and indeed they think it very funny that anyone should. Tiv soldiers in Egypt during the war discovered that some people were afraid of them, saying that they were cannibals because of their chipped teeth. They told me that they used grimaces to advantage in haggling over prices in Egyptian markets.

The aesthetic of beauty, in so far as it is represented by scarification and chipping of teeth, is involved with pain. I once asked a group of Tiv with whom I was discussing scarification whether it was not exceedingly painful. They turned on me as if I had missed the entire point—as, indeed, I had. "Of course," one of them said, "of course it is painful. What girl would look at a man if his scars had not cost him pain?" The effort to "glow" must be obvious; the effort to be dressed up must involve expense and trouble; scarification, one of the finest decorations, is paid for in pain. The pain is the proof positive that decoration is an unselfish act, and that it is done to give pleasure to others as well as oneself. The probable pain is the measure by which Tiv regard scarification; a second measure is the good taste with which the scars fit the face and augment the personality.

Notes

1. This article is reprinted from *Man* 129:117–121, September, 1956.
2. This and subsequent references to Akiga are from *Akiga's Story*, translated by Rupert East, London, 1939, pp. 38–49.
3. Akiga give this word as *ukali* and derives it from the Jukun town of Wukari. I heard it *mkali*, and none of my informants made this derivation.

Beauty and Being: Aesthetics and Ontology in Yoruba Body Art

Henry John Drewal

The marks Yoruba people make on their bodies are eloquent renderings of philosophical thought.[1] According to the Yoruba, lines in human flesh are primordial. An elder, pointing to his palm commented, "God told us 'Open your hand; these are lines' " (*Olorun pa sowe sile pe lagba ga yin owo, ila ni*; pc:Fadare 1975). Yoruba body artists (*oloola*), literally "those who cut lines" in flesh, elaborate on what already exists naturally on the body, making marks that express Yoruba aesthetic preferences. One aspect of that aesthetic—composition—is homologous with the structure of other arts and of society itself. More importantly, this structure articulates Yoruba concepts of being and existence and, specifically, the Yoruba concept of generative force, *ase*.

The Role of Kolo Marks

Following ancient practices, the body artist makes marks for a great variety of purposes.[2] Among them are identification marks. The "mark of sorrow" (*osilumi*), for example, designates a person who has lost someone dear (Fig. 1; pc:Ogunole 1973).[3] Other marks are for the individual's well-being.[4] However, elaborate pigmented cicatrix designs known as *kolo* are essentially aesthetic in intent. They beautify the body and simultaneously proclaim the courage and endurance of those—mostly women—who wear them. Sometime before puberty, a person chooses to have pigmented cicatrices, at least in part because of the way society regards the marks.

Yorubas comment explicitly that *kolo* are a

test. One body artist described how people praise a woman covered with body designs with words such as "she is very courageous" (*o ni laiya dada*) or ridicule one without marks with "she is a coward" (*ojo ni*). *Kolo* are the emblems of a brave individual, one strong enough to endure pain in order to enjoy society's admiration. Thus the Yoruba say, "With pains and aches are marks made on us, we become beautified by them only when they are healed" (*Tita riro ni a nkola, bi o ba san tan ni a to di oge*; Faleti 1977:27).

This notion is fundamental to the social and aesthetic value of *kolo*, since, according to Yoruba thought, all good things have unpleasant aspects. In explaining this, a diviner used the example of childbirth. When a woman is in labor, he argued, she is in enormous pain, but she must be willing to endure the pain in order to acquire the children that result. Wearing elaborate *kolo* on her body, a woman exhibits her willingness to bear pain. It is thus significant that a woman acquires such designs when she reaches a marriageable age. In so doing, she asserts that she possesses the necessary fortitude to endure the pains of childbirth, an ordeal that recurs traditionally at four- to five-year intervals (Caldwell and Caldwell 1977). Aesthetic value is bound up with the value of endurance and the willingness to bear discomfort to accomplish a greater good.

The prevalence of body markings among the Yoruba may convey underlying concepts of personhood. According to Morakinyo and Akiwowo (1981:26,36), the Yoruba "concept of the person . . . , vis-a-vis body-mind relationship, is a unitary

one. The body is mind." The Yoruba also believe that persons have both exterior and interior dimensions. Outer appearance may either hide or reveal one's inner, or spiritual, self. The Yoruba prayer, "may my inner head not spoil the outer one" (*ori inun mi ko ma ba ti ode je*) cautions one to conceal and control negative tendencies because they can affect outer appearance and, therefore, can draw hostility from others. Conversely, positive attributes such as courage should be displayed openly, for Yoruba assess an individual's personality both from physical appearance and behavior. Thus, elaborate body markings would be viewed as permanent and highly visible proof of one's courage, fortitude, and strength—qualities that parallel those of the patron of body artists, the God of Iron, Ogun (Drewal forthcoming).

While elaborate and extensive *kolo* attest to the fortitude of the person who wears them, they are judged primarily in terms of their aesthetic power—that is, how successfully they enhance appearance. In this sense they demonstrate the visual acuity, sensitivity, technical ability, and creativity of a body artist. The Yoruba define an artist (*onii-sonon*) as one who is a "skilled designer" (Abraham 1958:522). The term consists of *oni-se-onon*, "one-who-creates-art." Art (*onon*) connotes the decoration and enhancement of a thing (like embroidery on cloth)—evocative imagery, as well as craftsmanship. Nowhere is skill more important than in the work of those who cut lines in human flesh.

Body artists without exception stress aesthetics when discussing *kolo*: "We are making designs, art (*A nse onon*) . . . to make a person famous (*gbajumon*, literally, "200 faces know him"; pc:Ogunjobi 1975). Another artist puts it this way: "It [*kolo*] has no reason, just for funning . . . just to make *faari*, to make *yonga*" (pc:Fadare 1975). *Faari* and *yonga* mean ostentation, showing off, or boastful behavior like strutting or swaggering (Abraham 1958:205, 588). The emphasis is clearly on the visible display of the human body enhanced and beautified. As the artist Ogunole remarks, "It is in order to embellish, to make one beautiful, illustrious (*a fun yin sogo*) with marks . . . the women do it to enhance their beauty." An Egba Yoruba verse for one type of mark makes cryptic references to its "breathtaking" aesthetic impact and its tragic consequences: "The wife has *gbegbeemu* marks, the husband shoots himself dead" (*Iyawo fun gbegbeemu, oko re yinbon je*). As Faleti (1977:23–24) explains, a hunter's wife had an elaborate design known as *gbegbeemu* put on her abdomen while

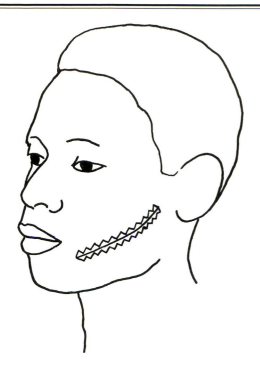

1. *The Ohori Yoruba face mark called* osilumi *indicates sorrow for the loss of a close friend or relative.*

her husband was away. When he returned, he was so struck by the sight of his wife's beauty that he stopped short and accidentally dropped his loaded gun, which exploded, killing him!

The Aesthetics of Kolo

The Yoruba have very precise terms for specific cutting techniques and distinctive types of lines made in human flesh. This vocabulary mirrors the technical proficiency required of the body artist—the ability to create marks that differ qualitatively from each other. Such skill distinguishes the "maker of marks" as an artist. He must possess finesse, control, and especially dexterity. In circumcision and excision, flesh is cut (*da*), the same verb used in the context of tapping palm wine (*de-mun, da emun*). Terms for facial scarifications distinguish types of cuts to reveal differences in the visual qualities of lines and linear patterns. Thus, *sa keke*, or literally "to slash *keke* marks" on a person, indicates broad, bold, and highly visible lines (Fig. 2); making the same pattern less distinct and visible is indicated by a different cutting verb, *wa*, and a different name for the marks, *gombo*. Other verbs that distinguish subtle differences in technique are *ko* (to cut) *ture* facial marks that are long and bold, *bu* (to cut or tear) *abaja* marks that are

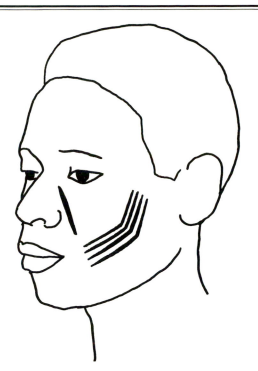

2. *The four* keke *marks of Oyo and Egbado Yoruba and the single oblique cicatrice (*baamun*) are broad and bold; after Abraham 1958:300.*

3. *Efon Yoruba marks consist of many, closely spaced lines that are said to be "split open" (*la*); after Abraham 1958:301.*

shorter and more faint, and *la* (to split open) Efon marks (Fig. 3), a series of closely spaced cuts that form a dark patch on the cheek (Abraham 1958:301). Medicinal incisions have their own terminology. The verb *sin*, for example, is used to denote cuts (*gbere*) made for the express purpose of inserting some substance. This same verb is used for *kolo* when pigment is inserted into shallow cuts. The aesthetics of *kolo* may be revealed through a consideration of line and shape, texture and color, and composition.

Line and Shape

Kolo designs consist of lines formed by a series of very short, shallow, and closely spaced hatch marks into which pigment (usually charcoal or lampblack) is inserted. The healed cuts produce a matte black pattern with a low-relief rippled texture against the semiglossy, brown skin surface (Fig. 4). The term for the hatch marks (*wenewene*) that make up the design suggests a number of visual, tactile, technical, and aesthetic qualities: slenderness (*we*), indicating short, closely spaced parallel lines (Thompson 1973:49); smallness (*wewe*) implying linear delicacy; and *welewele*, conveying a pleasing rippled texture on the skin (Anonymous 1937:228).

The *kolo* executed by the body artist require a special blade (Fig. 5) and the most elaborate and refined technique of all.[5] Speed of execution is also implied in the creation of *wenewene* marks, for pigment must be inserted before the blood coagulates and the cuts close. As one artist explains, "If the first blade is no longer sharp we begin to use the second" (pc:Alabe 1975). The word itself, *wenewene*, conveys the short, quick, and delicate downward strokes of the hand as the artist establishes a rapid rhythm in executing these closely spaced series of marks.

Delicacy and precision are other important aesthetic criteria of *kolo*. Without these qualities they fail aesthetically as well as practically. One artist warns, "He might penetrate the skin too deeply and, instead of making a design (*kolo*), he will make a big wound (*ogbe*)" (pc:Ogunole 1973). Refined technique is the difference between art and accident. The achievement of technical proficiency is recognized and rewarded in a profession which is described as "very dangerous" (*o le wu*).

The designs formed by the hatched lines consist of a small number of shapes that are altered and recombined to create a wide range of distinct yet subtly differentiated configurations. Zigzag lines are a pervasive element whose alteration and placement create a series of individual motifs: one

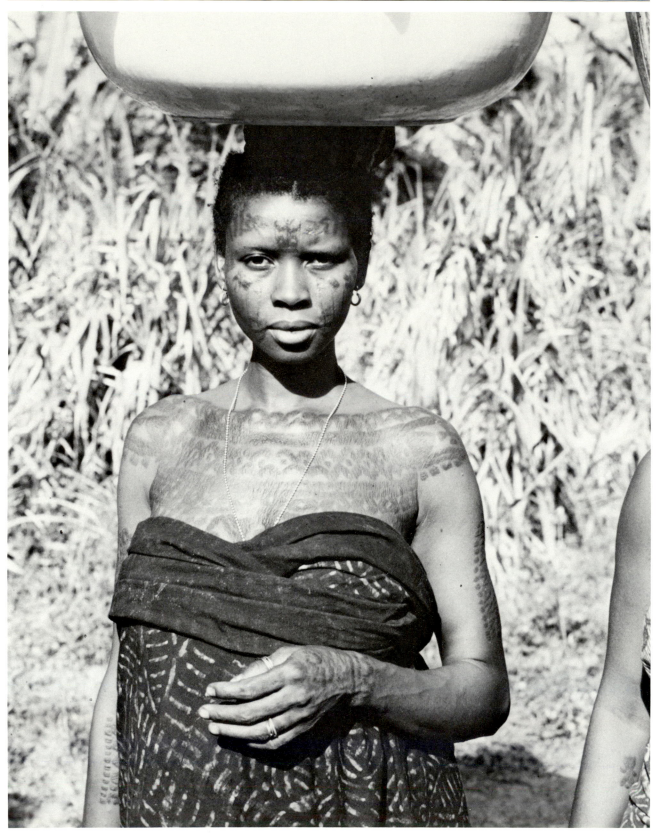

4. *Elaborate body tattoo cicatrice designs (*kolo*) show lines of hatch marks (*wenewene*) darkened by lampblack or charcoal that produce a slightly raised, rippled texture on smooth skin. Henry John Drewal photo, 1973.*

5. *The body artist Fadare holds the special Y-shaped, double-bladed knife used to make intricate tattoo cicatrice designs (*kolo). *Henry John Drewal photo, 1975.*

6. *A series of diamond shapes create a motif called "cowries" (*esa).

7. *Diamonds and lines constitute the pattern known as "lizard" (*alangba).

8. *Palm tree (*igi ope).

zigzag variant, for example, is called "legs of a cripple" (*eruku aro*). The diamond produces a design called "cowries" (*esa*; Fig. 6). The diamond shape in a different combination with additional lines produces a motif called "lizard" (*alangba*; Fig. 7). The triangle is identified by its placement, usually in a border, or "closing" motif, which is then called "arrow" (*ofa*). The semi-circle is also found in "closing" motifs, and the circle, called simply "o" or "ho," may be embellished with radiating lines. The names assigned to some of the most basic lines/shapes, e.g., "legs of a cripple," seem to be based only in part on a visual correspondence with the subject represented. The primary objective of the semantic association appears to be the labeling of motifs to facilitate the identification and transmittal of imagery.

These simple forms can be combined to create more complex representations from both nature and culture. An early account of these describes how "the skin patterns were of every variety . . . tortoises, alligators, and the favorite lizard, stars, concentric circles, lozenges, welts" (Burton 1863:104). Only one example of flora, the palm tree (*igi ope*; Fig. 8), has been documented, al-

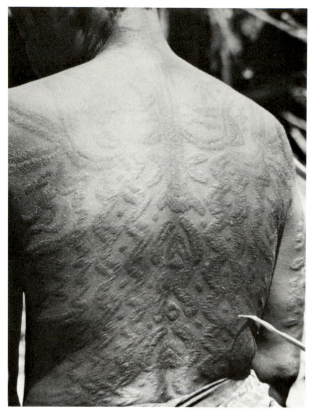

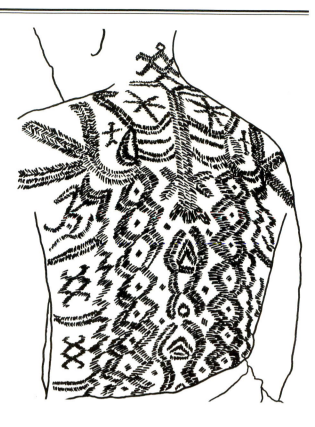

9a. An elaborate kolo *design on a woman's back shows two ostriches (*ogongo*) at the shoulder blades. Henry John Drewal photo, 1973.*

9b. A drawing of the same kolo *highlights the designs.*

though other motifs resemble leaf forms. By far, fauna is most consistently represented: specific species of birds such as ostrich (*ogongo*; Fig. 9a,b), vulture (*igun*; Fig. 10), dove (*adaba*; Fig. 11), snake (*ejo*; Fig. 12), chameleon (*agemo*; Fig. 13), centipede (*okun*; Fig. 14), and butterfly (*labalaba*; Fig. 15). Cultural items include forms with religious connotations such as *eta Ogboni*, the name given to a divination sign, a dancewand (*ose*) for the Thunder God, Sango (Fig. 16), a Muslim writing board (*walaa*; Fig. 17), the sign known as "moon of honor" (*osu ola*; Fig. 18), and arm amulet (*apa tira*; Fig. 19); symbols of status—a king's crown (*ade oba*; Fig. 20) and title staff (*opa oye*; Fig. 21); objects of everyday use like a comb (*oya*; Fig. 22), *ayo* game board (*opon ayo*; Fig. 23), scissors (*sasi*; Fig. 24), the Y-shaped blade (*abe*) of the body artist (Fig. 25), as well as more contemporary images such as a wristwatch (*agogo owo*; Fig. 26), airplane (*oko oke*; Fig. 27); and calligraphy such as a client's name or initials, those of a fiancée, or proverbs and prayers (Fig. 28).

*10. Vulture (*igun*).*

*11. Dove (*adaba*).*

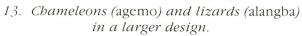

12. *Snake* (ejo).

14. *Centipede* (okun).

13. *Chameleons* (agemo) *and lizards* (alangba) *in a larger design.*

15. *Butterfly* (labalaba).

17. *Muslim writing board* (walaa).

16. *Dancewand* (ose) *of the Thunder God Sango.*

18. *Moon of honor* (osu ola).

21. *Title staff* (opa oye).

19. *Arm amulet* (apa tira).

20. *King's crown* (ade oba).

22. *Comb* (oya).

23. *Ayo game board* (opon ayo).

24. *Scissors* (sasi).

25. *Body artist's Y-shaped knife* (abe).

26. *Wristwatch* (agogo owo).

27. *Airplane* (oko oke).

28. *Calligraphy.*

Texture and Color

The aesthetic appeal of *kolo* is tactile as well as visual. As an art form pleasing to both eye and hand, it helps to expand and refine our understanding of Yoruba aesthetic concepts in body art and wood sculpture. The Yoruba preference for relatively shiny smooth surfaces (*didon*) in sculpture has been well documented (Thompson 1973; Drewal 1980). Yet the Yoruba also express an interest in nonreflective, textured surfaces. Yoruba sculpture is manipulated sculpture; it is touched, rubbed, washed, oiled, painted, dressed, and decorated regularly. Smooth surfaces please, but so also do surfaces appropriately roughened and rhythmically broken by textured patterns. In much of Yoruba art, there seems to be an intentional effort to moderate smoothness with texture. The result is a balance of surface qualities that parallels the aesthetic preference for balance (*idogba*) in composition, from *dogba*, meaning "equality" (Abraham 1958:507).

The aesthetic value of moderating shiny surfaces with textured ones is explicit in body art. An artist explains: "If a young girl does not do it [have *kolo* on her abdomen], the other women insult her with words like "Your belly is shiny' (*inun, o gbangadan*, related to *gbangba* meaning "cleared," "open" as a field or farm) When she is pregnant her stomach swells and becomes very shiny, which is improper, and she is insulted with the words, 'Your belly is like a porcelain basin.'" The tactile qualities of *kolo* can also evoke an explicitly erotic response. As one body artist playfully comments: "A woman with marks all over her body is very fine . . . when we see a girl with marks and she is [naked], we boys can easily approach her and begin to play and rub her body with our hands . . . if we see [the marks] and glance at the body, the weather will change to another thing [we will become sexually aroused]!" (pc:Ogunjobi 1975).

The balancing of dark, matte surfaces with lighter, luminous ones parallels the balance of

rough and smooth textures. The black of the pigment and the rippled texture of the *kolo* "break up" and moderate shiny skin. An *oloola* explains, ". . . to make it beautiful, one must make it black It is to change the color of the body." The aesthetic of deep black probably explains the replacement of charcoal in recent years with lampblack (*edudu atupa*) because it is viewed as "pure and blacker."

Composition

Composition, whether in individual *kolo* patterns or in their arrangement on the body, reveals several clearly defined aesthetic principles. The concepts of design unity, cohesiveness, and completeness are clearly articulated in the aesthetic descriptive terminology for certain *kolo* configurations. For example, the design at the bottom of an elaborate back pattern (Fig. 29) is literally "design that completes at the base near the vagina" (*ipeju e isale obo*). On an abdominal composition (Fig. 30), the motif at the top is "load at the top of the stomach" (*eru oke inun*) and the designs at the sides are termed *eeku* implying "the end of something." The upper portion of a thigh design (Fig. 31) translates literally as "finish at the vagina" (*ipari obo*).

The relationship of parts of a design to the whole produces a visual unit—usually a symmetrical or bilaterally balanced composition bounded by "closing" motifs. The body patterns containing such "completion" or closing elements demonstrate an awareness of design unity and wholeness. Certain patterns then are seen as discrete visual units that can be expanded or contracted to fit a particular space and completed by a motif that serves as its outer limit or boundary. The composition of individual *kolo* patterns thus demonstrates several Yoruba aesthetic principles.

The placement of different *kolo* designs on the body expresses other aesthetic preferences. While both males and females adorn themselves with *kolo*, women have by far the most varied and numerous designs placed on different parts of their bodies. The most common sites for women's *kolo* are the face, neck, chest (Fig. 4), abdomen, back, arms (upper and lower, Fig. 40), backs of hands, calves or lower legs, and thighs. Men have *kolo* on the face, neck, and arms. These sites are not in order of importance, for the client decides where patterns should be placed. Rather, the placement of designs seems to suggest an awareness of differing degrees of visibility. Face, neck, arm, and hand designs for women are fully public and

29. The closing motif "design that completes at the base near the vagina" (ipeju e isale obo) at the bottom of an elaborate back pattern.

30. An abdominal design contains the closing motifs of "load at the top of the stomach" (eru oke inun) at the top and "the end of something" (eeku) at the sides.

highly visible. Patterns on the back, chest, and abdomen, however, are less often seen though still visible in public, while patterns on the upper thigh are accessible only to intimate friends or a spouse. Some patterns seem to be more strongly associated with a particular site than others, to the extent that some are named for their location rather than for their imagery. For example, a pattern

31. *The top of a thigh design is called "finish at the vagina"* (ipari obo).

32. *The design called "husband sits on lap"* (gboko leton) *is usually placed on a woman's thighs.*

33. *Tray/platform of the chest* (opon aya).

usually placed on a woman's thighs is called "husband sits on lap" (*gboko leton*; Fig. 32), while another is termed "tray/platform of the chest" (*opon aya*) and covers the upper chest and breasts (Fig. 33). Other patterns are "back of the hand" (*eyin owo*; Fig. 34a,b), "back of the leg" (*eyin ese*; Fig. 35), and "band on the leg" (*oja ese*; Fig. 36).

Surface contour is another consideration in the placement of some patterns. Thus the design known as "corn" (*agbado*) is usually found on the upper or lower arm and encircling it (Fig. 37). This placement suggests a visual analogy between the cylindricality of the arm and the corn cob. Other patterns, like the elaborate back designs, also show an awareness of the contours created by shoulder blades and spinal column (Fig. 9a,b). For example, the motif of ostrich placed on shoulder blades creates a three-dimensional quality in the bird's body, and those along the spinal column enhance the skeletal and muscular structure. Another, known as "carving the abdomen" (*fin inun*), is a series of zigzag lines placed on the upper abdomen and chest of a young girl. When she grows up, the "swelling of her breast amplifies the patterns to a very beautiful design" (Faleti 1977:24).

The unity, completeness, and general bilateral symmetry that characterize specific patterns contrast with the compositional approach evident in the arrangement of patterns in relation to one another on different parts of the body (Fig. 4). Taken together, these discrete design units have little or no relationship to one another; their placement on a person suggests a patchwork of distinct and separate entities. The composition is seriate rather than unified. This serial structure is made of discrete units, complete and independent, capable of being expanded, condensed, and rearranged according to the situation, and therefore adaptable and flexible. Emphasis is placed on the units of the whole, rather than on a progressive development from one to another. Although the units occur in the same context, they otherwise have no relationship to each other.

Yoruba use a number of terms to communicate the concept of seriality. For example, a series is *eto*, an orderly arrangement of things, from which derives the adverb *leeto-leeto*, implying in an orderly fashion, one after the other. Another concept that relates to the idea of a series is *lootooto*, one by one separately, based upon the adjective *oto*, separate or distinct. There is also *leyoleyo*, one by one singly, based on *eyo*, a single item. All connote one thing next to the other. The above-mentioned words are similar in meaning and form. In each case the root word is

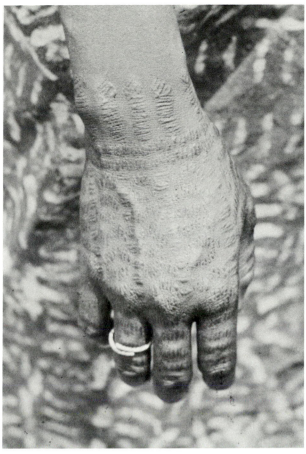

34a. *Back of the hand* (eyin owo).

b. *Back of the hand* (eyin owo). *Drawing.*

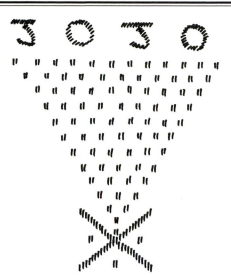

35. *Back of the leg* (eyin ese).

36. *Band on the leg* (oja ese).

37. *The placement on the upper arm of the pattern known as "corn"* (agbado) *plays on the cylindricality of the corn cob. Margaret Thompson Drewal photo, 1975.*

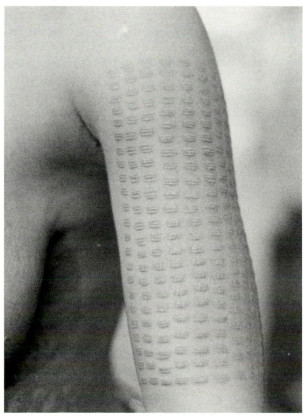

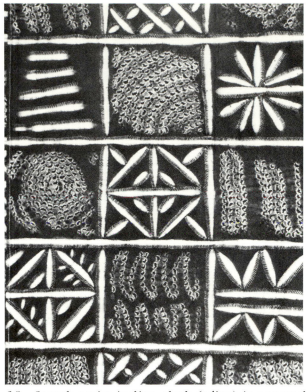

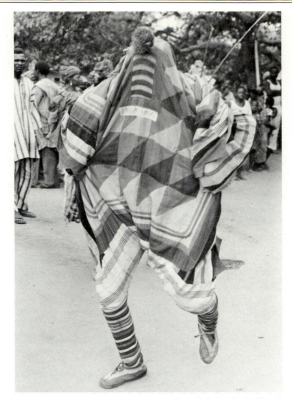

*38. Starch-resist indigo cloth (*adire*) is covered with a seriate composition of distinct and separate design squares. Henry John Drewal photo, 1975.*

*39. An Egungun masquerader (*alabala*) displays the patchwork cloth facing that diffuses focus. Margaret Thompson Drewal photo, 1978.*

repeated to form the adverb, so that inherent in the word's form itself is a serial arrangement.

In the same way, the term for the technique of creating *kolo* marks (*wenewene*) also expresses seriality. Whereas *wene* refers to a single short hatch mark, *wenewene* connotes the series of separate marks that create an overall pattern on the skin. Likewise the closing motifs in some patterns (*eeku, ipari*) suggest the autonomy of each unit and their juxtaposition as a series. At various levels of analysis, seriality emerges as a key concept. The lines (*wenewene*) that make up *kolo* are themselves seriate, yet in combination they produce a unified design. But, when these unified designs are then scattered over the body, their arrangement is again serial. In the visual arts, seriality creates compositions in which the parts are emphasized as separate, autonomous units.

Seriality and Ontology

Seriality is a basic organizational principle that derives from the Yoruba notion of a generative force, *ase* (Drewal and Drewal 1987; Drewal 1987). *Ase* is absolute power present in all things

and in words, from rocks, hills, streams, mountains, leaves, animals, sculpture, ancestors, and gods to prayers, songs, curses, and even everyday speech. Humans possess *ase* and through education, initiation, and experience learn to manipulate it in order to enhance their own lives and the lives of those around them.

The perception that each individual possesses such innate potential power is at the basis of Yoruba social organization. All lineages are structurally equal in relation to the king, but the potential for mobility and rewards creates intense competition for power (cf. Lloyd 1974:190). Success depends to a large extent on how one marshalls the forces in one's environment. The system is very fluid and dynamic, reflected in the limited rank-ordering in cults and the emphasis on equality and differentiation among members (Drewal and Drewal 1978). The belief in *ase* acknowledges universal innate individual power and potential and encourages competition, mobility, and initiative.

Ase is also the basis for structure in the arts, a structure in which the units of the whole are discrete and share equal value with the other units. In verbal and dance performance the units of the

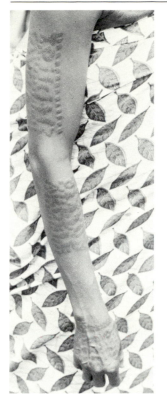
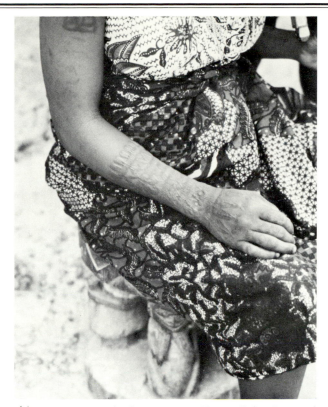
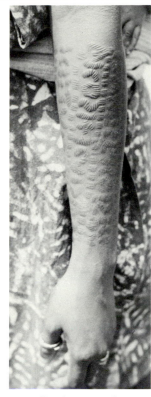

40. *Designs on the upper right and lower arm. Henry John Drewal photo, 1973.*

41. *Design on the lower arm. Henry John Drewal photo, 1973.*

42. *Design on the lower arm. Margaret Thompson Drewal photo, 1975.*

series are arranged temporally.[6] They are a series of distinct, complete units that can be condensed and expanded, a feature evident in Egungun and Gelede performances (Drewal and Drewal 1978; 1983).

Seriality is a striking feature in other Yoruba visual arts. In starch-resist cloth (*adire*; Fig. 38), designs in rectangular or square areas show unity and balance within themselves, yet they form random/patchwork or checkerboard compositions when viewed as a whole—similar to *kolo* designs placed on different parts of a person's body (Fig. 4; Drewal 1977:7). Conceptually similar is the patchwork facing of many *alabala*-type Egungun masquerades in western Yorubaland (Fig. 39). This principle of design has the effect of diffusing focus, distributing it more or less equally over the entire surface. The juxtaposition of sharply contrasting and brilliantly colored geometric shapes equal in size and intensity breaks up the surface into distinct units with no one major focal point. The result is a cloth that "shines" (*didan*). A serrated border surrounds and closes the design, like those at the limits of body designs.

Summary

The Yoruba art of *kolo* conveys both aesthetic ideals and philosophical insights. Preferences for clarity, precision, and delicacy of line; balance of color, texture, and form; design unity and completeness; and seriate composition characterize *kolo*. Just as a Yoruba carver transforms wood into images of humanity to be admired by society, so the body artist transforms people into aesthetic objects, admired for their beauty. But *kolo* do more than this. They proclaim the fortitude and endurance of the individual. Furthermore, by their seriate structure, they, like other arts and society itself, articulate Yoruba ontological concepts of a generative force and a dynamic balance between autonomous, competing powers.

Notes

1. Fieldwork for this study was carried out among the Ohori and Egbado Yoruba in Benin (R.P.B.) and Nigeria in 1973, 1975, and 1977–1978. I wish to express my gratitude to the National Endowment for the Humanities, Cleveland State University, and the Institute for Intercultural Studies for their generous financial support; the Institutes of African Studies, Universities of Ibadan and Ife, and the Nigerian Museum for providing research affiliations; Rowland Abiodun and especially Margaret Thompson Drewal for their editorial suggestions and insights; and the Yoruba individuals, especially the artists Alabe, Fadare, Ogunjobi, and Ogunole, who generously shared their knowledge of body arts. Unless otherwise indicated, all the author's drawings are after sketches by Ogunole and Fadare.

2. The practice of using facial marks is ancient among the Yoruba. A number of Ife terra-cotta and copper sculptures (ca. A.D. 1100) and Owo terra-cottas (ca. A.D. 1400) depict elaborate scarification patterns, some closely resembling nineteenth- and twentieth-century Yoruba marks. An Ifa divination tray now at the Ulmer Museum and collected at Allada in the early seventeenth century (possibly Yoruba, but probably Aja) depicts male and female figures with elaborate face, chest, and neck cicatrizations.

 D'Avezez (1845:55–59) cites an Ijebu Yoruba informant regarding early nineteenth-century traditions of scarification (*ella* [*il*]) and circumcision done by a specialist known as *alakila* (*oloola*). Facial marks seem to have been especially important during the nineteenth century, a period of widespread conflict in Yorubaland (see Johnson 1921; Ajayi and Smith 1964; Smith 1969).

3. Identification marks localize the bearer in a cultural and ontological system. Face and body scarifications communicate a variety of biographical facts about a person, among them, conditions of birth. For example, children believed to be *abiku* (literally, "those born to die"), mischievous spirit-infants who plague their mothers by being born and then dying soon after, are sometimes marked with a distinctive sign, three scars on the shoulder (pc:Houlberg 1976). If and when they are reborn, they can be recognized and treated appropriately to encourage them to remain alive. Other marks indicated the presence of younger siblings or relations. Adepegba (1976:56–57) notes the practice of sympathetic scarification (*eje gbigba*). When a child undergoes circumcision and cicatrization, his relatives have cuts made on themselves to remind them to handle the child gently. Faleti (1977:24) notes the same practice which he calls *gba eje fun*, "let blood for someone." A photograph by T. J. H. Chappel in the Nigerian Museum Archives (41.1.A.30) documents a similar practice among the Egun/Egbado Yoruba in which a large triangular pattern of cicatrices is made on the abdomen of an elder sibling to complement the incision of facial marks on the younger, for it is said that, "if an older child is marked at the same time, the baby will not suffer such pain." This triangular scar pattern is identical to cicatrice designs on *abiku* statuettes of Aja people discussed by Merlo (1975). These marks are also believed to ease a child's pain. Other cicatrices may indicate inherited occupations, such as three lines on one cheek and four on the other to identify a mark-maker. A person's cult membership may be evident from cicatrices like the double celt on the arm of worshipers of Sango, the Thunder God. All of these marks illuminate a person's history.

4. Body marks contribute to the well-being of people by altering and extending their vital power. Substances inserted into incisions enable the bearer to accomplish certain desired ends. They have both curative and protective functions. Herbal doctors, priests of the God of Herbalism, Osanyin, and body artists administer a large number of medicines via incisions on the body (Warren et al. 1978). The placement of the incisions corresponds with the intended effect of the medicines to be inserted. Thus, short vertical marks under the eyes (*gbere oju*) of some children signify that medicines have been inserted to prevent the child from trembling, a condition believed to be caused by seeing spirits (Faleti 1977:24,25). A body artist (pc:Ogunole 1973) explains: "The mother or parents will prepare a medicine and bring it to the *oloola* who will then put it in the cicatrices he makes on the child and in this way prevents the child from dying." Another medicine, *ero agba inon*, literally "relief from that which is obtained and not spent" (i.e., the acquisition of money that disappears without producing tangible results), is rubbed into cuts made around the wrists of both hands. Medicine for severe headache is put into three cuts in the forehead (Warren et al. 1973:69), and medicine to prevent snakebite is put in an incision that encircles the left ankle (which must be renewed after the person kills a snake; Tereau and Huttel 1949–50:11). Medicine to protect one from the destructive invocation of another person is inserted in a "cut in front of the patient's ear . . ." (Prince 1960:73), while medicines to make a curse effective (*afose*) are rubbed into a cut below the lower lip, so that "when the individual wishes to curse he licks his lower lip and whatever he says will come to pass" (Prince 1960:68). Similarly, the singer of hunters' Ijala chants has incisions near his mouth for the insertion of medicines to give him courage and to aid his memory (Babalola 1966:68–86).

 Such substances, efficacious in both physical and meta-physical ways, also facilitate the worship of the gods. Those initiated into cults for the gods must be prepared to receive, without danger, the spirit of their deity, that is, to become mediums in rituals of possession. To accomplish this, incisions are made on top of a devotee's head and substances that activate the vital essence of the god are inserted. A patch or tuft of hair known as *osu* often marks the spot (M. T. Drewal 1977).

5. An itinerant Yoruba body artist at Ilorin used a similar blade in 1912: "The cutting edge was indented in the middle, thus giving the blade two sharp angles with which the incisions were made" (MacFie 1913:122).

6. For example, praise poems (*oriki*) consist of a series of discrete honorific phrases, the number of which may be greatly increased or reduced depending on the inclinations of the performer. They may be elaborated by the use of repetition, or they may be condensed by dropping lines out. Sometimes they are brief because the chanter has limited knowledge. Often lines or phrases are excerpts from lengthier texts which they serve to evoke. This discontinuity may be seen as an expression of a serial structure.

Baule Scarification:
The Mark of Civilization
Susan Vogel

Studies of body art in Africa have tended to deal with scarification mainly as a record of the individual's status in society, or as a sign of group or ethnic identification. This paper will consider the larger implications of African scarification as it relates society to nature rather than as it indicates relationships within society. In particular, the paper will examine the Baule case to show how scarification can be seen as a mark of civilization in general. I will deal here with the social group as an entity, and not with the socialization of the individual within the group. What interests me is a society's definition of itself as civilized in contrast to uncivilized, raw nature. Scarification and body ornament seen as marks of civilization may be a very fundamental and widespread concept in Africa.

My interest in body art grew out of a study of aesthetic criteria I conducted among the Baule of Ivory Coast in which the most preferred sculptures were often praised with the phrase, "it looks like a human being" (Vogel 1980). Many critics commented on the scarifications and coiffures of the sculptures, and pronounced them to "look like a human being," even though most people in Baule country today do not wear conspicuous scarifications or elaborate coiffures. Male figures that were admired, for example, all had the high crested traditional coiffures which men ceased to wear around the 1930s. Extensive body scarification for women went out of favor in the mid-1940s and can be seen today only in older women (Fig. 2). These facts did not stop the critics from consistently saying that their favorite figure sculp-

tures "looked like a human being." Recently carved figures and masks for traditional cults also almost always have decorative scarifications which suggested to me that this feature was more than descriptive: that it expressed an idea or an ideal.

The sculptures that I showed to Baule critics were traditional Baule figures (Fig. 3) created for traditional cults. Baule figures are made for two purposes that I have described elsewhere but will summarize here (Vogel 1973). Many are made as spirit spouses (*blolo bla/blolo bian*), the wife or husband that everyone had in the other world before he or she was born on earth. Such figures are part of a private cult maintained by a man for his spirit wife, or by a woman for her spirit husband. Other figures are made as the abodes of nature spirits called *asie usu* that possess individuals and allow them to become professional spirit mediums, diviners, and healers. In neither case can the figures be considered to depict actual individuals. My study did not include modern sculptures which are made purely for decoration. These modern figures are more realistic than the traditional ones, and depict elements from the visible world: human figures are shown fully clothed, in naturalistic poses, with no scarification and with contemporary coiffures. The Baule admire the realism of these figures and declare that they also "look like a human being."

Traditional Baule sculptures of animals occasionally also display scarifications though modern ones do not. The Baule carve small animal face masks representing specific domestic and hunted animals that appear in realistic skits for traditional

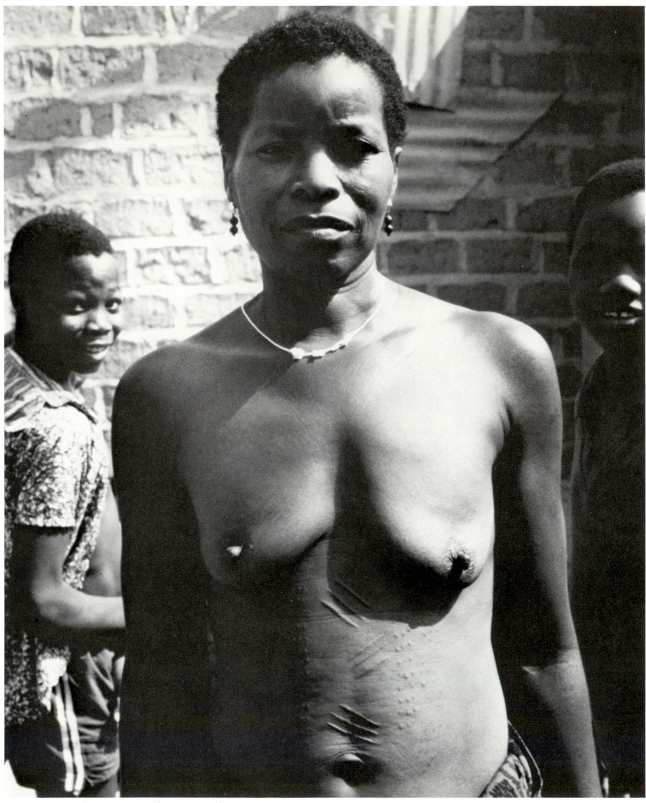

1. *Torso scarification of the most extensive, old fashioned sort, worn with typical twentieth century marks on the cheeks. The decoration of her torso was done by an Ngban subgroup man when she was in early adolescence. Note the Baule necklace she wears. Kouassikouassikro village, Agba Katienou subgroup. 1977.*

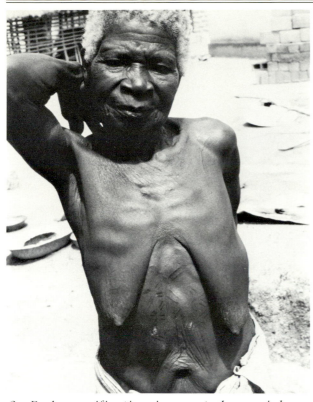

2. *Body scarification is seen today mainly on elderly people, especially women. The diagonal lines create a design of balanced asymmetry widely seen in Baule art. Ananda-Kouassikro village, Abe Ndame subgroup. S. Vogel photo, 1977.*

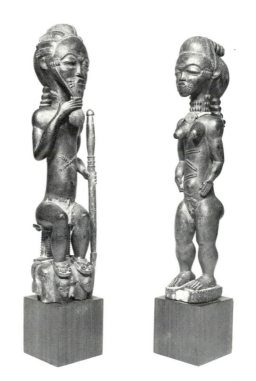

3. *Pair of Baule figures probably for* asic usu *nature spirits. Baule figures virtually always have carefully carved coiffures and scarifications. The female figure has torso marks like those seen in Figure 1. Both have* ako dya *and* ngolc *facial scarifications. Collection of UCLA Museum of Cultural History. Photograph by Richard Todd.*

entertainment dances. These masks never show scarifications, probably because they are meant to represent real animals. Another kind of traditional animal mask, large horned helmet masks called *bonun amuen*, appear in sacred dances (Fig. 4). These masks do not represent specific animals, but rather generalized images of ferocious and dangerous beasts. *Bonun amuen* masks often include the most common Baule scarification: groups of three welts placed—as on humans—in front of the ears, and at the base of the nose (Fig. 5). I believe these masks represent a civilizing force for they are the principal means of social control in Baule villages even though their performances are wild and unruly. Their appearances reinforce the social order and encourage the virtues of respect and productivity that are the foundation of communal life. It is accordingly appropriate that they wear such marks of civilization.

In the course of the aesthetics study mentioned above, critics often said of sculptures that they disliked, "it doesn't look like a human being" or "it looks like a thing from the bush." They there referred to the opposition between civiliza-

tion and the wilderness, the village and the bush, that informs a great deal of the Baule world view. This opposition is more complex and nuanced than I can here describe, but the contrasting poles are central to the argument presented in this paper (Vogel 1977). In Baule thinking, however, not all bush is wilderness just as not all villages are civilized. Non-Baule villages are not necessarily civilized and large urban centers certainly are not. Further, in the bush there are the farms, pathways, cemetaries, and water sources, which are the spheres of man and which constitute liminal enclaves between these opposing domains.

When the Baule say a figure sculpture looks like a human being, they mean it looks like an idealized, civilized person. A Baule expression, *kro snan*, means "man of the village," implying an upstanding, proper, decent, law-abiding, productive person. I believe that for the Baule, scarification is one of the signs of a civilized human being. Scarification, like coiffure, represents man's order

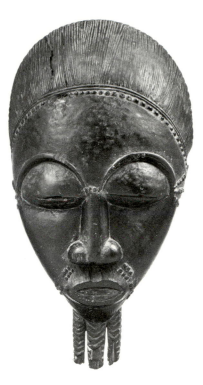

4. Bonun Amuen mask which protects the community and polices behavior and morals; it belongs collectively to men. Like many such, this animal mask has been carved with scarifications on the temples and at the base of the nose probably because it is a civilizing influence in the village. Private collection. S. Vogel photo.

5. Mblo type entertainment mask. This portrait depicts a man recognizable partly by his scarifications which include the basic ngole mark at the base of the nose and in the corners of the eyes where they take a variant form, ako dya, ("chicken's feet"). Private collection. Photograph by Jerry L. Thompson.

imposed on nature. The Maori comparison of the unscarified face to "bare boards" as reported here by Peter Gathercole expresses the same idea. The unscarified, uncivilized, unembellished, raw human being is opposed to the civilized, idealized member of society.

The Baule do not use this contrast to distinguish human beings from animals: scarification is not one of the things that defines humanity. The Baule don't deny the humanity of anybody (their definition is like our own), but they do restrict the definition of what is civilized. For example, I am sure they think I am human, but I am not sure they think that I am civilized. Baule villages are civilized; modern cities are not. Civilization for the Baule occurs where correct rules are observed, where people are productive, and share a respect for traditional conventions of belief and behavior.

Let us now examine scarification and body decoration as described and practiced by the Baule themselves. The earliest writers state that

scarification was almost entirely for cosmetic purposes (Nebout 1900:22; Labouret 1914:89; Fig. 6). There are numerous Baule subgroups or "tribes" and a later writer, (Holas 1949:457) reports that scarifications must be tribal, though he confesses that he cannot determine which marks characterize which subgroups. To the best of my knowledge there are no scars that identify an individual as belonging to a particular family or "tribal" subgroup; the Baule have no clans. The Baule never had initiation societies and I have not found scarifications that marked group membership of any kind. In keeping with the egalitarianism of Baule society, men and women at all levels of society seem to have worn the same scar patterns.

There were fashions in scars, however, that varied over time and from place to place. Hence, a particular pattern could sometimes come to be associated with an area where it had been very much in vogue, but it was never exclusive to a given place. Thus, like a regional accent, a partic-

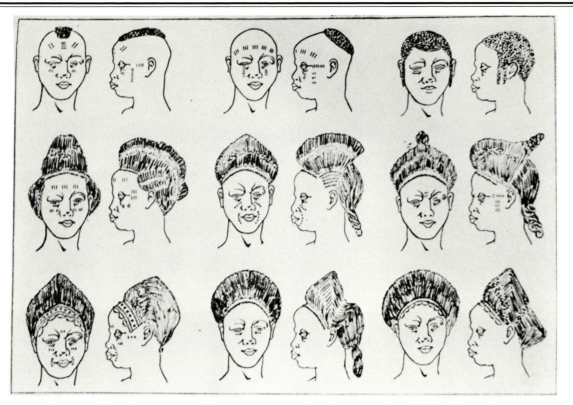

6. *Scarifications and coiffures recorded by Labouret in 1914 which, he reported, were for cosmetic purposes. Many alternative combinations of these elements exist. The last two persons have no scarifications, a common occurrence.*

ular scarification pattern might identify a person as coming from a given area, though its original purpose was not one of ethnic identification. The most common pattern, clusters of three, six or nine small marks on the temples and/or at the base of the nose, is found throughout the Baule area and beyond. Members of nearby ethnic groups such as the Anyi and Akye wore some scarification patterns identical to those of the Baule, and many Baule, Anyi and Akye people had no scars at all. Scarifications therefore could not be used to identify the region from which a person came, nor even to identify him or her as Baule.

In practice, scarifications were often done outside one's own ethnic sub-group and at different times in one's life; one Agba Baule woman I knew wore facial scars done by a man in the Ngban Baule area where she had gone as a girl with her mother, and had body scars done later in life in a distant Agba Baule village where she married. The Baule are great travellers and since both the practitioners and those being scarified moved about a great deal, mobility further contributed to the lack of fixed connections between a given area and a given scarification pattern.

I collected the names of many scar patterns and they, like names for textile patterns, gold ornaments, and hairdos, refer mainly to the form of the design. Accordingly, a crescent shaped mark on the forehead is called *ngwa*, "moon"; two lines of marks descending the cheeks diagonally from the eyes is called *nimoye*, "tears." One woman told me that the fine cuts over her hips were called *gbanflin sama*, "young man's fingers," but I saw the same marks on other parts of the body on other people (including young men) who called them by different names. Elements could be selected at random from the repertoire of Baule patterns and combined however one pleased and most motifs could be placed on various parts of the body. One thus finds identical "moon" crescents on the forehead, the back of the neck and the back of the calves, for example, on both men and women. The most basic mark, mentioned above, placed at the temples and between the brows is called simply *ngole*, "mark," with no further distinction. It is probably the oldest Baule scarification pattern.

As stated above, most marks fell in and out of fashion over time as among the Tiv, (See Bohan-

7. *Young woman wearing the most recent scarification pattern to come into fashion. Two short cuts on the cheeks, called Nzima, are apparently of Lagoon or coastal origin. Kouassikouassikro village, Agba Katienou subgroup. S. Vogel photo, 1978.*

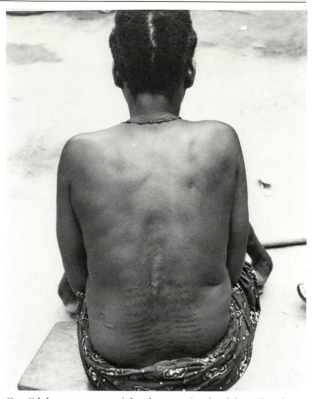

8. *Old woman with the typical old-style, low-relief scarification, often combined with tattooing to produce a subtle colored and textured area on the skin. Djina-Ngassokro village, Agba subgroup. S. Vogel photo, 1978.*

nan 1956, reprinted in this volume) and became distinctive of generations, though that was not their original purpose. The most commonly seen facial scarifications today (aside from the *ngole* mark) are marks on the cheeks that seem to have come into use after the First World War (Fig. 7). They do not occur in Labouret's (1914:90) report on Baule body decoration. These marks have no Baule name, but are referred to sometimes as "Nzima." I would conclude that they are from the Nzima people who live to the south and east of the Baule and came up from the coast with the early European penetration. One cheek often displays a cross, the other a short horizontal cut or two parallel cuts. I wonder if these are not based on the arithmetic signs—plus, minus, and equal—that had newly come to the attention of the Nzima and Baule at that time.

Baule scarification took two forms, one properly tattoo, the other depressed cuts or raised welts in low relief (Fig. 8). The high relief seen on sculpture is an exaggeration of reality. (In fact, it seems that very high relief scarification was rare in the Guinea Coast area, the evidence of sculpture notwithstanding.) My research suggests that Baule scarification was done mainly by men, though Nebout reports that women also did it. The practitioners were not professionals, nor do they seem to have been paid. They used an ordinary knife that served other purposes and had no special name.

Some Baule scarification is not cosmetic but was done to protect against disease and misfortune. Most common is three short marks between the breasts or pectorals that seem to be an inoculation: a small dose of local poison is put into the wound that probably produces antibodies. Three marks on the upper arm or wrist may also be made to inoculate against poison or snake venom. Another common protective mark consists of three or four small linear scars radiating from the corners of the mouth in the form of a fan (Fig. 9). Medicines are rubbed into them when the cuts are made, and they are called *kanga*, "slave," apparently because most slaves in the Baule territory were Senufo and these resemble Senufo marks

9. *Woman with the* kanga *("slave") marks radiating from the corners of her mouth. These imitate Senufo scarifications and are so called because at the end of the nineteenth century most Baule slaves were Senufo. Such negative marks were given to children to protect them from death. Yakouakoukro village, Warebo subgroup. S. Vogel photo, 1982.*

(Fig. 10).

 Kanga marks are given to children born after the death of several children of the same mother; they are done in the belief that the child with these undesirable scars will not be so desirable to Death. The same belief motivates parents to give such children repulsive personal names such as Houphouet, meaning "garbage." Normally scarification was only done when a person was fully grown; medicinal marks are the only kinds that were given to children. These scarifications can also be simply cosmetic in purpose in which case they are called *ako dya*, meaning "chicken's feet," and are placed on other parts of the body—commonly the corners of the eyes (Fig. 11).

 The Baule use of body paint for both medicinal and aesthetic purposes parallels their use of scarification. Kaolin may be put on a sore eye, or on the forehead of a person who has a headache; it may be put on the skin of a newborn and its mother for protective as well as decorative pur-

10. *Senufo man with cheek scarifications of the type imitated in Baule* kanga *marks. Yamoussoukro. S. Vogel photo, 1980.*

11. *Back scarifications worn by the woman seen in Figure 1. They include the radiating marks called* ako dya *("chicken's feet") which can be placed in many locations on the body. The crescent shape is called* ŋgwa *("moon") when it occurs on the forehead. Kouassikouassikro village, Agba Katienou subgroup. S. Vogel photo, 1978.*

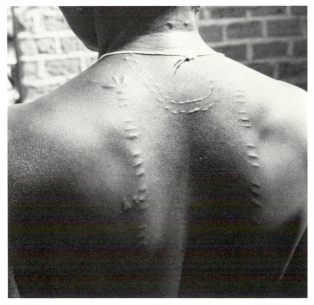

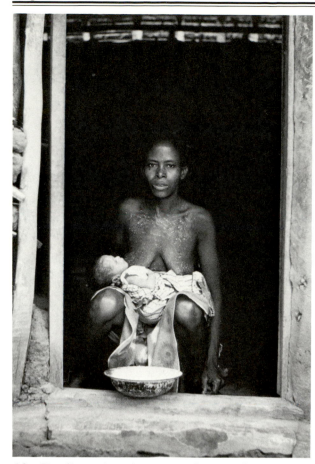

12. *Kaolin painted on a newborn infant and its mother for medicinal and decorative purposes. Green clay is also sometimes used. Kami village, Akwe subgroup. S. Vogel photo, 1976.*

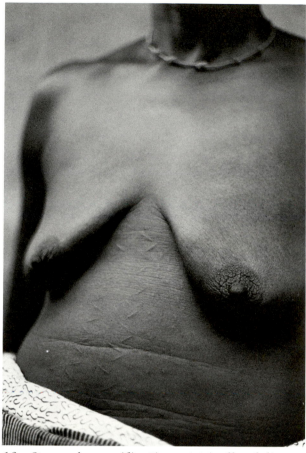

13. *Stomach scarification, typically delicate, worn mainly by women. The Baule rarely scarified the chest on or above the breasts. Bangokro village, Agba subgroup. S. Vogel photo, 1978.*

poses (Fig. 12). Babies are often adorned with kaolin or with a green clay—adults less frequently so—applied in long streaks or in the simple pattern formed by repeatedly impressing four fingers upon the skin.

Another kind of body painting, again with kaolin, serves the purpose of identifying a person in a special spiritual state, and possibly of assisting one to attain such a state. Spirit mediums, called *komien*, paint their eyes and mouths with kaolin before they perform in public as an aid to clairvoyance. The kaolin indicates that they will see and speak the truth. Similarly, persons making important sacrifices, and women participating in *adyanun* ceremonies wear white cloths and paint their bodies with kaolin.

The Baule term for scarification is *ngole* which means mark. The same word is used for raised and incised marks on pottery for example, and can be defined as any kind of intentional, aesthetic, good, pleasing mark. The clear implication

is of something deliberate, manmade and meant to be beautiful. Baule call accidental scars *kanvuen*, not *ngole*, thus distinguishing the aesthetic mark from the unaesthetic random scar. A Baule proverb says: "there are scars on all the beautiful girls," (*Kanvuen wo talua klaman kroa be wun*) meaning nobody is perfect.

Corresponding to their distinction between nature and culture, the Baule distinguish verbally between naturally occurring things, and analogous aesthetic, man-made ones. Thus the body art form of chiseled teeth is called *djeljenunutilteile* (the process of chiseling them is *dje cele*) while the natural separation between the two front teeth that is also considered a beauty mark is called *ndrele*, or *dje nu drele*. Baule tooth cutting removed the inner half of the two front incisors on the diagonal, making a triangular opening between the teeth.

Similarly, they distinguish between the merely functional man-made object, and the beautiful

decorated one. A plain whisk is appropriate even for dance occasions, but it has a different name from the decorated kind: a plain cow tail whisk is called *nandwa* while the decorated one is called *nandwa blawa*. For all of creation and for all of humanity there exist the ordinary useful version, product of nature or necessity, and the aesthetic version, sign of culture and man's ability to fashion it to his desire. In the case of human beings the Baule clearly see the difference between the plain unembellished human being who is serviceable and undoubtedly human but not necessarily civilized, and the civilized ideal of Baule culture expressed in a scarified body.

OVERLEAF: Waghari caste tattoo design sheet by Deviben Mohanilal, Chotta Udepur, Gujarat, India. UCLA Museum of Cultural History Arnold Rubin Archives.

Introduction: Asia
Arnold Rubin

In 1986 the *Los Angeles Times* reported the discovery in northwest China of fifty well-preserved non-Mongoloid bodies, with "high noses, low cheekbones and blond or brown hair," believed to be "at least 3000 years old." Five of the bodies in question were tattooed with "geometric patterns." This discovery complements the earlier recovery of the body of a Scythian chieftain, extensively tattooed with highly stylized animal motifs, which was interred ca. 500 B.C. at Pazyryk (in the area where the borders of China, the USSR, and Mongolia meet).[1] Late in the 13th century, Marco Polo encountered both figurative and geometric tattooing during his travels in Central Asia. He reported that the men of the "Province of Zardan'dan" had dark stripes tattooed around their arms and legs, "and they reckon it a distinction and an ornament to have such a stripe." In contrast, both men *and* women of the

> Province of Kaugigu . . . have their flesh covered all over with [tattooed] pictures of lions and dragons and birds and other objects . . . And this they do as a mark of gentility: the more elaborately anyone is decorated, the greater and handsomer he is considered.

Polo also noted that "many people come [to the port city of Zaiton] from Upper India" to be tattooed.[2]

Beliefs about tattoo in China and Japan contrast strongly with the association of tattoo with high status at Pazyryk and elsewhere in Central Asia. McCallum's chronicle of the history of tattoo in Japan, which begins this section, makes clear the extent to which the emerging political elite of Japan (emulating their Chinese counterparts) came to regard tattoo as barbaric. One may propose that such sanctions served—and serve—to subordinate individuality and local patterns of identity.[3] On the other hand, McCallum demonstrates the ambivalence of recent and present-day Japanese toward tattoo through an analysis of the popularity of tattoo themes in *ukiyo-e* prints, popular and elite literature, and film. The dynamic role of tattoo as a factor in a similarly complex dialectic between elite/cosmopolitan and local/traditional culture also underlies Teilhet-Fisk's paper on tattooing among the Newar of Nepal and Rubin's on Gujarat, in India. A significant contrast, however, is that women appear to be predominant among the traditional clients of tattoo in south Asia generally, whereas men form the majority in Central Asia and Japan.

The rich traditions of tattoo, piercing, and dental alteration among the peoples of southeast Asia and Indonesia are not discussed here.

Notes

1. *Los Angeles Times*, 2 Sept. 1986, Pt. I, p. 14; Sergei I. Rudenko, *Frozen Tombs of Siberia: the Pazyryk Burials of Iron-Age Horsemen* (translated and edited by M. W. Thompson, University of California Press, Berkeley 1970). Cf. McCallum's discussion of the "horserider" hypothesis in explaining the origins of the Japanese state.

2. Ronald Latham (trans.), *The Travels of Marco Polo*, Penguin Books, London, 1958, pp. 152, 161–2, 210.

3. Regarding the function of such explicit (or implicit) sanctions, also see Berns; Rubin ''Renaissance''; Rubin ''Gujarat.''

Historical and Cultural Dimensions of the Tattoo in Japan[1]

Donald McCallum

Introduction

This paper seeks to trace the history of the tattoo in Japan in order to provide comparative data for scholars concerned with tattooing in other cultures.[2] Consequently it does not pretend to embody original research into the Japanese tattoo, but rather comprises a synthesis of available scholarship. While there are some observations and conclusions here that may be new, the results presented are based on the work of earlier students of the subject. It has been my modest aim to try to place a rather large amount of diffuse data into an appropriate historical and cultural context. To this end, the paper will first deal with the tattoo from its earliest possible appearance in the Japanese islands, during the Jōmon period, through its occurence in the following Yayoi and Kofun periods, by which time Japanese cultural and political institutions had begun gradually to evolve. A careful survey of the archaeological record in Japan seems especially germane to a global study of body art, for it is amongst peoples similar to those who lived in Japan during the Jōmon, Yayoi, and Kofun periods that tattooing and related practices flourished throughout the world. In studying the early periods in Japan, we shall utilize both archaeological and documentary evidence. As is well known, archaeology is highly developed in Japan, with the result that an enormous amount of data is available. However, as we shall see in the next section, its interpretation is fraught with problems, so that our conclusions will inevitably be highly tentative. Fortunately, there are Chinese sources for the Yayoi period and Japanese sources for the Kofun which provide unequivocal evidence for the practice of tattooing during those periods, although here too we will encounter a number of difficult problems.

The later sections of the paper will deal with the historical periods of Japanese civilization, from ca. A.D. 600 to the present. Very little will be said concerning the centuries between 600 and 1600, for which the available evidence is exceedingly scanty, being generally limited to mentions of tattoo as a form of punishment. However, for the Edo period (1600–1868) there is an abundance of data, literary and visual, for establishing a rather complete picture of the uses of the tattoo at that time. A further significance of the Edo tattoo, especially as it evolved in the nineteenth century, is that it forms the basis for the tattoo in modern Japan. The historical survey will conclude with an analysis of the modern tattoo.

In laying out any sort of historical survey, the historian normally is seeking—or implying—continuity. While a degree of continuity will be noted in some sections of this paper, there are equally important discontinuities as well. With regard to the prehistoric periods, I have real doubts as to whether there was substantial continuity from Jōmon to Yayoi. Similarly, it is exceedingly difficult to perceive clear signs of continuity from Yayoi-Kofun across the millenium 600–1600 to the Edo period. Such continuity may, in fact, be there, but research up until the present has either not looked for it carefully enough or has failed to properly interpret the evidence. We shall return

to this question in the conclusion, but here I would like to emphasize the importance of not projecting a sense of continuity onto a body of material where it is inappropriate.

Socio-psychological interpretations of tattooing are particularly important and interesting, and some efforts along this line will be made throughout the paper. For the early, archaeological periods it can be assumed that tattooing had the sort of ritual significance that it has in non-literate cultures throughout the world. Since I am not capable of the level of anthropological sophistication in dealing with such issues exhibited by other papers in this volume, I shall not try to develop the arguments that would be necessary for a full account of the possible cultural meanings of the early tattoo in Japan. For the early historical periods there seem to be no substantial problems of explication, for the tattoo was clearly used, at least officially, as a severe form of punishment. However, with the Edo and modern periods we face exceedingly difficult questions of interpretation, especially with regard to the emergence of the Japanese full-body tattoo.

Jōmon Period (ca. 10,000B.C.–300B.C.)

Intensive archaeological research during the post-war years has yielded abundant evidence for an Old Stone Age (Paleolithic/Mesolithic) culture in the Japanese islands.[3] Traces of this culture are mainly in the form of stone tools, so that there is no way of determining if the people decorated their bodies in any manner, including tattooing. One might speculate that the Old Stone Age inhabitants of the Japanese islands engaged in customs and practices similar to Paleothic populations elsewhere. Thus it is not until the Neolithic—most frequently referred to as the Jōmon Period—that a limited amount of data concerning bodily decoration becomes available. Excavation of Jōmon sites throughout Japan in recent decades has been extensive, yielding an exceedingly large number of artifacts as well as the raw material for developing hypotheses concerning Jōmon culture (Kidder 1968). In the next few pages I shall survey this material briefly, focussing on those artifacts that may suggest the presence of tattooing during Jōmon times.

Prior to any discussion of the Jōmon period, it must be made clear that our only data for Jōmon culture is what can be derived from archaeological investigations. Although the Chinese were literate, and producing documents, by the end of the Jōmon period (ca. 1000B.C.–300B.C.), there is no

indication that they were aware of the Japanese islands or their inhabitants. Moreover, there would seem to be little, if any, continuity between the Jōmon peoples and cultures and their successors in the Japanese islands, so it is implausible to assume that any sort of cultural "memory" would extend from Jōmon to later periods. My hypothesis here is that the Jōmon population was of pre-Japanese ethnic stock. They presumably consisted of tribal groups who arrived in the Japanese islands at a very early date, perhaps when the "islands" were still joined to the continent. A culture—and an ethnic stock—which can be reasonably characterized as Japanese does not appear until the following Yayoi period, the subject of the next section. Consequently, in terms of a strict definition, the Jōmon material should not be included within a discussion of the Japanese tattoo if "Japanese" is used as a cultural rather than a geographical term. (At times the outsider cannot help feeling that Japanese scholars fail to clearly make this distinction.) And yet, the Jōmon material would seem to have such great potential significance as to warrant its inclusion in the survey. Moreover, if those scholars who assume a substantial degree of continuity from Jōmon to Yayoi are correct it would seem necessary to provide the evidence from the earliest period.

Jōmon culture, of course, was based on a hunter-gatherer pattern of subsistence. In this respect it resembles a cultural pattern seen amongst numerous groups throughout the world. Jōmon is unique by virtue of the ubiquity of various types of ceramics from its inception onwards. Normally hunter-gatherer societies do not utilize pottery vessels for storage and cooking because they are inconvenient for highly mobile groups constantly on the move searching for new sources of food. The available evidence suggests that while the Jōmon people were pre-agricultural, they were relatively sedentary, generally occupying a base-camp and only foraging outward to a limited degree. The richness of the Japanese ecology, particularly in terms of shell-fish and other marine products, goes a long way toward explaining this lifestyle. In addition to sea products and hunting, it has been recognized recently that nuts, such as acorns and chestnuts, were a very important component of the Jōmon diet (Watanabe 1984:1–11). Some scholars have argued that development of pottery vessels may have been associated with the processing and cooking of such foods.

When the C^{14} results indicating extraordinarily early dates for Jōmon pottery production were first released, they were greeted with considerable

skepticism, although at present they are generally accepted. While the early date for the beginning of Jōmon ceramic technology was what was most surprising, perhaps more significant—and virtually unparalleled—is the fact that with Jōmon pottery we possess an essentially uninterrupted, pristine sequence extending over many millenia.

There are two basic categories of ceramic production during the Jōmon period: vessels, and figurines, referred to as *dogū*.[4] The pottery vessels, of which hundreds of thousands have been recovered, have been very intensively studied. The sequence of vessels forms the essential foundation for an understanding of the temporal and geographical parameters of Jōmon culture. The *dogū* category, on the other hand, is much smaller, consisting of a relatively few examples in the first three periods of Jōmon culture (Earliest, Early, and Middle) and only increasing substantially in the fourth (Late) and particularly the fifth (Latest) periods. Interpretation of the *dogū* figurines has been the subject of much discussion, with suggestions ranging from toys or dolls to representations of spacemen! However, there is now a general consensus that they must depict deities associated with fertility, since practically all of the extant examples exhibit female traits such as sexual organs, breasts, or indications of pregnancy.

Markings on the faces of many of the *dogū* are most relevant to the present study. It must be admitted at the outset that there is no *definite* proof that these markings are, in fact, indications of tattooing. Various other possibilities exist, including scarification and facial paint. It is by no means certain, however, that whatever the facial markings on *dogū* are, that they replicate markings that also appeared on human beings. The peculiar, often grotesque, characteristics of many *dogū* might suggest that they are fundamentally the products of the imagination, not strongly rooted in the visible world. Yet there are some indications that the *dogū* might relate to contemporaneous forms of human decoration (Kidder 1965). The most detailed investigation of Jōmon period tattooing—Takayama Jun's *Jōmon-jin no Irezumi* (1969) ("Tattoos of the Jōmon People")—compared the facial markings of the *dogū* with those of cultures in Taiwan, Southeast Asia, and the Pacific islands and concluded that these markings are, in fact, representations of tattoos.[5] Takayama's rich ethnographical analysis makes a quite convincing case for tattooing amongst the Jōmon population.

Dogū are infrequent during the first (Earliest) and second (Early) Jōmon periods, so our survey can begin with the third (Middle) period. An in-

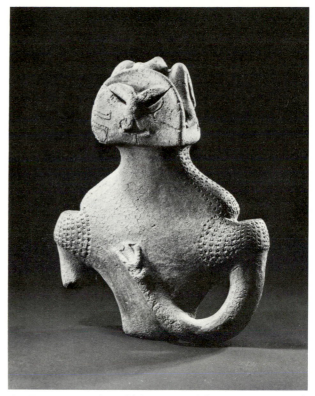

1. Dogū, Head and Torso. Middle Jōmon Period. From Yamanashi Prefecture. Clay, 25.5 cm. Tokyo National Museum.

teresting piece, consisting of a head and upper body (broken at the waist) comes from Yamanashi Prefecture (Fig. 1). It would seem to represent some sort of subhuman being, with vaguely feline facial characteristics. Around the eyes and mouth, and particularly on the right side of the face, are markings that may be depictions of tattooing or, perhaps scarification. Additional decoration on the shoulders, consists of rows of punchmarks. I am less certain as to how these should be interpreted although they certainly could be tattoos. (In the discussion of *dogū* I will limit my analysis to the faces since a consideration of the significance of body marks would lead us into too many complicated problems.)

From the fourth (Late) Jōmon period there are a number of *dogū* with depictions of facial markings. A piece from Ibaragi Prefecture, belonging to what is called the "ridge-jaw" category, appears to have markings around the mouth (Fig. 2). Ethnographical evidence for mouth tattoos amongst Ainu women makes it very tempting to interpret these data in the same terms. While acknowledging the necessity for caution, I would suggest that the Ibaragi *dogū* can plausibly be associated with the tradition of mouth tattoos.

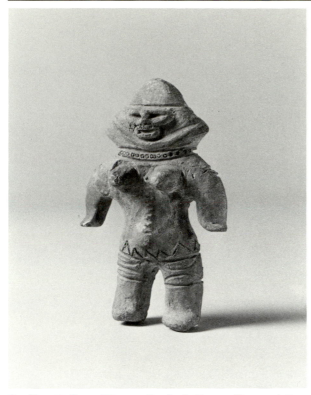

2. *Dogū. Late Jōmon Period. From Ibaragi Prefecture. Clay, 12.1 cm. Osaka City Art Museum.*

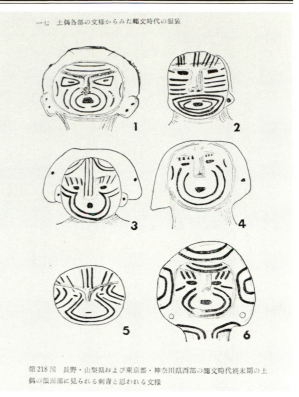

3. *Facial markings on Dogū of the Jōmon Period. After Esaka (1967.309).*

The largest amount of evidence suggesting tattooing is found in the fifth (Latest) Jōmon period. The archaeologist Esaka Teruya diagrammed the evolution of facial markings on *dogū* from the third through the fifth periods (Fig. 3). While those of the third and fourth periods tend to be relatively simple, frequently consisting of parallel oblique lines, those of the fifth period show increased complexity (Esaka 1967:305–309). In particular, two bell-shaped figurines display striking facial ornamentation. The first example, from Kanagawa Prefecture, has lines across the brow (which join to form strong horizontal lines extending from the brow down the nose), short oblique lines over both eyes, and a more complex arrangement of paired lines running from each ear across the cheeks and then looping down below the mouth (Fig. 4). While it is impossible to prove that tattooing is depicted, it certainly seems to be such. The second of the bell-shaped vessels, from Nagano Prefecture, has a slightly less complex organization of lines on the face, although the pattern is very similar in character, especially in the way the lines loop around the mouth (Fig. 5).

Fifth period *dogū* with complex facial markings tend to be found in areas transitional between developed Yayoi culture and continuation of Jōmon patterns. Some scholars have argued that these markings perhaps reflect a response on the part of the indigenous peoples to the strong threat presented by the constant northward movement of the Yayoi population. Takayama (1969:212–213) cites evidence for the practices of tattooing women in order to make them less attractive objects of capture. This is possible, although it is likely that tattooing was essentially based on traditional ritual practices. Since the vast majority of *dogū* represent females, it is difficult to make statements about the possibility of similar facial marking on males.

Our discussion of the Jōmon figurines must conclude, as it began, with a frank acknowledgement of our lack of certainty as to what the facial markings on *dogū* signify. They may be tattoos, or scarification, or even representations of face painting, although this seems the least likely possibility. Moreover, as noted above, the occurence of such markings on the *dogū* cannot be taken as definite evidence for their occurence on human beings. Nevertheless, the cumulative results of an analysis of the *dogū*, combined with data derived from ethnographic comparisons, leads very

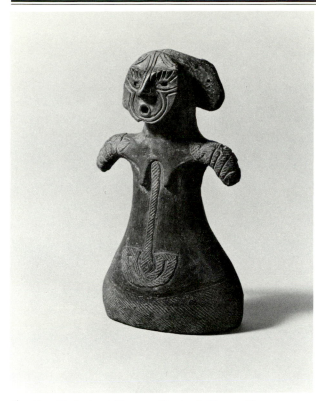

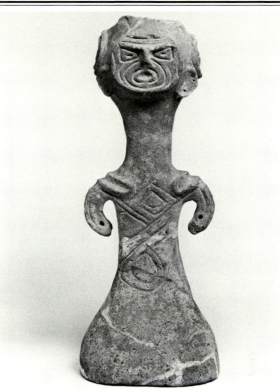

4. *Dogū. Latest Jōmon Period. From Kanagawa Prefecture. Clay, 26.7 cm. Private Collection.*

5. *Dogū. Latest Jōmon Period. From Nagano Prefecture. Clay, 36.6 cm. Tokyo National Museum.*

strongly to the conclusion that the Jōmon peoples did, in fact, practice permanent modification of the skin, perhaps tattooing, perhaps scarification.

The Yayoi Period (300 B.C.–A.D. 300)

The extremely long Jōmon period, as noted above, is entirely pre-historic in the sense that there are no documentary sources referring to the Jōmon peoples and their customs. Our only evidence for their cultural practices is what can be reconstructed from archaeological research. The range of information available is much more extensive during the following Yayoi period, however, for there are brief but important references in ancient Chinese texts which describe the appearance and certain customs of the Yayoi people. Before examining this textual material it might be helpful to briefly characterize Yayoi culture as a background for discussing their tattooing.[6]

In distinction to the hunter-gatherer way of life of Jōmon, Yayoi was an agricultural society. Some time in the fourth century B.C. the techniques of rice cultivation were introduced into northern Kyushu, presumably from the southern part of the Korean Peninsula. Rice agriculture, along with ferrous and non-ferrous metallurgy are the diagnostic features of Yayoi culture. Following their appearance in northern Kyushu, Yayoi patterns gradually spread further through Kyushu to Shikoku, and northward up the main island (Honshu) through the Kansai, Kanto, and Tohoku regions. Since rice cultivation was not practical in Hokkaido, the northern-most island, in pre-modern times, Yayoi culture came to an abrupt halt in Aomori Prefecture, at the northern tip of Honshu.

The hunter-gatherer system of Jōmon would have been characterized by a low population density, with concentrations in the more desirable areas. The advent of rice agriculture contributed to a substantial increase in population, however, and the establishment of villages containing much larger groups of people than those of earlier times. Such population increase leads naturally to more complex institutions of social organization, particularly in the case of an economy based on rice agriculture, which requires extensive controls over access to irrigation as well as very intensive labor and a high degree of cooperation at crucial stages of cultivation and the harvest. Such structures would necessarily entail some degree of

social stratification, placing some individuals in leadership positions and the majority in subordinate roles. The available evidence suggests that Yayoi Japan was organized into tribal groups, of moderate size, led by chieftains who perhaps also had religious functions.

The question of Jōmon-Yayoi continuity is far too complex to deal with satisfactorily here. One group of archaeologists has argued for a significant degree of continuity from the earlier to the later period, while others have maintained that the transformation from Jōmon to Yayoi culture was so fundamental that it is unlikely that there was significant carryover of important traits. I am inclined to accept the latter viewpoint, particularly because the bones discovered in Yayoi burials are more similar to those of the historical Japanese populations than those of Jōmon. This suggests that the Yayoi ethnic stock is closely related to the later Japanese population and it has also been suggested that the language that developed into Japanese originated during the Yayoi period. While the preceding is somewhat speculative, there is general agreement that the Yayoi population was essentially identical, ethnically and culturally, to the population occupying the Japanese islands from the historic periods beginning in the sixth century A.D. onwards. Consequently, an analysis of tattooing practices during the Yayoi period should be understood as dealing with a "Japanese" group, unlike the situation during Jōmon where the inhabitants of the islands cannot really be classified as Japanese.

There are three crucial references to tattooing in Yayoi Japan included in the Chinese dynastic histories.[7] These are found in the sections dealing with the barbarians that the Chinese knew about in regions outside their own territory; such notices tend to be condescending and often highly critical in tone. The first two references are in the History of Wei (*Wei Chih*), part of the *History of the Three Kingdoms* (*San Kuo Chih*), which was compiled by Ch'en Shou in A.D. 297.[8] The *Wei Chih* deals with the kingdom of Wei, an area in northeastern China which was an independent state from A.D. 221 until 265. The text first states, referring to the inhabitants of Japan:

> Men, young and old, all tattoo their faces and decorate their bodies with designs.

This brief statement is soon followed by a more extensive account:

> A son of the ruler of Shao-k'ang of Hsia, when he was enfeoffed as lord of K'uai-chi, cut his hair and decorated his body with designs in order to avoid the attack of serpents and dragons. The Wa, who are fond of diving into water to get fish and shells, also decorated their bodies in order to keep away large fish and waterfowl. Later, however, the designs became merely ornamental. Designs on the body differ in the various countries . . . their position and size vary according to the rank of the individual (Goodrich 1951:10).

In analyzing this passage, one notes first that the author tries to put his material into context by referring to a Chinese prototype from the largely mythical Hsia Dynasty, which is supposed to have preceded the historical Shang Dynasty (ca. 1500 B.C.–1000 B.C.).[9] He then shifts to the "Wa"—the Chinese designation for the inhabitants of the Japanese islands—and suggests that they too decorated their bodies for protective purposes.[10] While this account seems implausible as regards "large fish and waterfowl" being repelled by tattoos, this reference may be based ultimately on some broader apotropaic symbolism carried by the markings.[11] Most important, perhaps, in this long passage is the assertion that "the designs became merely ornamental," and that their pattern differs in various areas ("countries") and in accordance to the rank of the individual. In contrast to the seemingly mythical character of the first half of the passage, the second has the ring of historical plausibility.

The next reference occurs in the *History of the Later Han (Hou Han Shu)*, an account of one of the great dynasties of China, which governed the entire empire from A.D. 25 until 220. Although the Han Dynasty preceded the Wei, just mentioned, the history of the dynasty was not written until 445 and thus the text, at least in terms of its date of compilation, is later than the *Wei Chih*. The *Hou Han Shu* essentially confirms the earlier descriptions of the Yayoi Japanese, stating:

> The men all tattoo their faces and adorn their bodies with designs. The position and size of pattern indicate the difference of rank (Goodrich 1951:1).

While the quotes cited here may seem to the reader essentially neutral and descriptive in character, one must recognize that the Chinese regarded the practice of tattooing, or any other type of skin-marking, as despicable and abhorrent, worthy only of barbarians. Consequently, by focussing on the custom of tattooing amongst the Yayoi people the historian was making an explicit

statement as to their savagery from a Chinese perspective. There is no reason to doubt the veracity of these texts, especially since one can find evidence for tattooing in the subsequent periods in Japan, so it is entirely reasonable to conclude that tattooing was a significant component of Yayoi culture.

Only very limited evidence survives for the appearance of Yayoi tattooing, and what evidence we do have is primarily on objects from transitional zones between Yayoi and Jōmon cultures in the far north. While the more advanced Yayoi culture quite rapidly overwhelmed the Jōmon peoples in the southern part of Japan, the Yayoi way of life was not as well adapted to conditions in the northern Kanto and Tohoku regions. Consequently, one sees the co-existence and mixing of Jōmon and Yayoi elements there at a stage long after the complete triumph of Yayoi in the south. A particularly striking example of such an eclectic monument is a late Yayoi pottery vessel with a human head at its lip, from Ibaragi Prefecture (Fig. 6; Kidder 1965:fig. 54). While the symmetrical shape of the vessel is characteristic of Yayoi pottery, the face at the top is distinctly reminiscent of Jōmon period figurines. It seems certain that this object, and a few others known, represent a continuity with the Jōmon. For our purposes, the precisely incised lines around the eyes and the mouth look very much like tattoos. Naturally, they could also depict scarification, although in this case their relief character would seem to preclude an identification as facial painting. In any event, I would suggest that this object, and related pieces, are best interpreted in terms of regional continuity with Jōmon culture, rather than as specific evidence of new currents coming in with the Yayoi complex.

In short, there is no precise evidence for the configurations of the tattoos described in the Chinese texts, nor can we determine their origin. One can summarize the logical possibilities concerning the origin of the Yayoi tattoo with a full awareness that convincing proof may never be forthcoming:

1. Continuity from Jōmon.
2. Reflecting influence from Northeast Asia, via the Korean Peninsula.
3. Reflecting influence from southern areas, including South China, Taiwan, the Philippines, and Southeast Asia.

Because it is widely assumed by archaeologists, folklorists, linguists, and other specialists that Yayoi culture is a mixture of northern and southern components, there is no *a priori* reason to

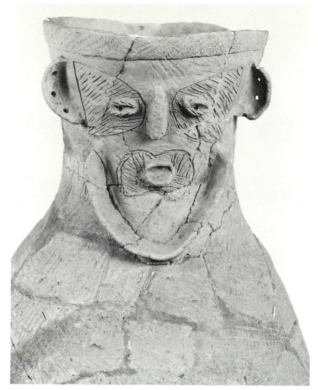

6. *Pot, detail of rim. Yayoi Period. From Ibaragi Prefecture. Clay, 68.5 cm. Tokyo National Museum.*

reject either possibility (2) or (3). As stated, I personally am doubtful about (1), at least as regards the mainstream of Yayoi culture, although it too is surely within the range of the plausible. As unsatisfying as is our lack of a firm hypothesis to account for the origin and character of the Yayoi tattoo, we at least can conclude that at the onset of Japanese culture there is unequivocal evidence for tattoo.

The Kofun Period (A.D. 300–600)

The six hundred years of the Yayoi period witnessed, in short, the emergence of a culture that can be classified as Japanese; there were still no large scale political structures or institutions which could reasonably be identified as a Japanese state. However, during the three centuries of the Kofun period a number of local political units coalesced into confederations which can be referred to as "states", providing that that term is not taken as remotely equivalent to the scale of such structures during the historical periods (Kidder 1964; Kiley 1973). How exactly the process of state formation took place during the Kofun period is an exceedingly vexing problem, one that cannot

be dealt with here in detail. I personally find the "horseriders" theory most persuasive, for it specifically roots the formation of a large-scale Japanese kingdom within the nexus of political developments on the continent, particularly in the Korean Peninsula.[12] This theory hypothesizes that an army of mounted warriors, most convincingly identified with an ethnic group called the Puyo, swept down the Korean Peninsula in the later fourth century. They first established the kingdom of Paekche in the southwest area of the peninsula and then crossed over the straits to northern Kyushu, gradually working their way up the main island (Honshu) until they reached the traditional heartland of Japanese civilization in the Kansai region (present day Nara and Osaka prefectures). The presence of a conquest dynasty is associated with the enormous mounded tombs (Kofun) of the fifth century from which the period derives its name.

Many, perhaps most, Japanese archaeologists and historians reject the "horseriders" theory, often for what seem to be nationalistic reasons. However, it is universally accepted that monumental tombs reflect a developed political structure during the fifth and sixth centuries that had the power and resources to organize and control large groups of people. The state centered in the Kansai region, usually referred to as the Yamato polity, certainly did not exercise hegemony over the rest of the Japanese islands, although it must have been the strongest single state existing at that time. In interpreting the textual sources relating to Kofun Japan we must keep these factors clearly in mind, and not be misled, for example, by references to an "emperor" who might be assumed to be presiding over an "empire."

Primary resources for the Yayoi period were limited to Chinese dynastic histories, but Japanese books of the early eighth century refer back to the Kofun period. The first of these books, the *Nihon Shoki*, was compiled in something approaching its present form in A.D. 720 on the basis of earlier records, now lost.[13] The *Nihon Shoki* traces the "history" of Japan from her legendary origins at the time of the descent of the Sun Goddess until the end of the seventh century; not surprisingly, accounts of later phases are more plausible. Nevertheless, the entire text is governed by a dominant imperial ideology formulated in the early eighth century (on the basis of Chinese prototypes) which includes frequent fictitious references to a supreme "emperor" making decisions as to his realm. One passage refers to an event that took place during the 27th year of the legendary em-

peror Keiko (A.D.71–130). This year is theoretically equivalent to A.D.97, although it can be more plausibly assumed to refer to some event during the middle of the Kofun period. The text reads:

> 27th year, Spring, 2nd month, 12th day, Takenouchi no Sukune returned from the East Country and informed the Emperor, saying: "In the Eastern wilds there is a country called Hitakami. The people of this country, both men and women, tie up their hair in the form of a mallet, and tattoo their bodies. They are of fierce temper, and their general name is Emishi. Moreover, their land is wide and fertile. We should attack them and take it" (Aston 1972:200; Sakamoto 1967:297; Van Gulik 1982:4).

Several observations about this interesting passage are in order. First, the mythical minister Takenouchi no Sukune was a long-lived prodigy who is supposed to have served numerous emperors over the course of several hundred years. Clearly he must be viewed as a culture hero embodying the general role of advisor to the Kofun period rulers ("chieftains" rather than "emperors"). Second, the reference to the Eastern country is highly significant, for it is a direct acknowledgement that the territory of the so-called emperor was in fact limited to the central region. He had authority in the Kansai area, but certainly not in the Kanto or Tohoku regions. Third, and most important for our theme, is the reference to tattooing. By the time that the *Nihon Shoki* was compiled, Chinese attitudes were prevalent amongst the elite of the central region. Thus, the ascription of tattooing to the barbarians of the east (Emishi) must be understood as an indication of the latter group's savagery, reflecting a more general conception of civilized as opposed to barbarian practices by the early eighth century at the latest amongst the central elite.

If the preceding discussion does not fully establish that the prevailing attitudes toward tattooing were patently negative, the next passage to be cited will unequivocally clarify its negative character. It occurs in the section of *Nihon Shoki* devoted to the reign of "emperor" Richū (A.D.400–405) during the year theoretically equivalent to 400. However, here too it is more appropriate to assume a general mid-Kofun date. The text states:

> 1st year, Summer, 4th month, 17th day. The Emperor summoned before him Hamako, Muraji of Azumi, and commanded him, saying: "Thou didst plot rebellion with the Imperial Prince Nakatsu in order to overturn the State, and thy offense is deserving of death. I will, however, exercise great

bounty, and remitting the penalty of death, sentence thee to be tattooed." The same day he was tattooed near the eye. Accordingly the men of that time spoke of the "Azumi eye" (Aston 1972:305–306; Sakamoto 1967:424–425).[14]

A third entry in *Nihon Shoki* also refers to the punitive application of tattooing. This passage is under the eleventh year of "emperor" Yūryaku, theoretically equivalent to A.D. 467, and reads:

> Winter, 10th month. A bird of the Bird-department was bitten by a dog belonging to a man of Uda and died. The emperor was angry, and tattooing him on the face, made him one of the Bird-keepers guild (*be*) (Aston 1972:359; Sakamoto 1967:486–487; Van Gulik 1982:8).

In this account it can be seen that for a relatively minor offense a man was tattooed on the face and degraded to a position of very low status as a bird-keeper.

The second of the early Japanese texts relevant to this discussion is the *Kojiki*, compiled in 712.[15] In contrast to the *Nihon Shoki*, just discussed, the *Kojiki* places a great deal more emphasis on mythology. The following story tells how "emperor" Jimmu came to marry a princess called Isuke-yori. As the story begins O-kume-no-mikoto, one of the great lords attending Jimmu, sees a group of seven maidens walking on a plain, and asks Jimmu which of the maidens he wishes to marry. Jimmu tells O-kume-no-mikoto that he wishes to marry princess Isuke-yori, and then sends O-kume-no-mikoto to see the princess.

> Then, when O-kume-no-mikoto announced the emperor's will to Isuke-yori-hime, she saw the tattooing around the eyes of O-kume-no-mikoto; thinking it strange, she sang:
> "Ame-tutu
> Tidori masi toto—
> Why the tattooed eyes?"
> Then O-kume-no-mikoto sang in reply:
> "The better to meet
> Maidens face to face
> Are my tattooed eyes" (Philippi 1968:180–181; Aoki 1982:130–131).

"Emperor" Jimmu is thought of in orthodox history as the true founder of the Japanese state, for it was he who led his followers from Kyushu through the Inland Sea to the Japanese heartland, Yamato (the Kansai region). Accompanying Jimmu on his eastward passage was O-kume-no-mikoto, which clearly indicates his historical significance. Nevertheless, the princess, who subsequently became Jimmu's "empress" is surprised by O-kume-

no-mikoto's tattoo, suggesting that the compilers of the *Kojiki* had some difficulties in dealing with this fact.

A later story, said to have taken place during the reign of "Emperor" Ankō (453–456) states:

> When they arrived at Kariha-i in Yamashiro, as they were eating their provisions, an old man with a tattooed face came along and seized their provisions (Philippi 1968; Aoki 1982:267).

The context of this story (together with the later execution of the tattooed man) indicates clearly that he had originally received his tattoo as a punishment for some sort of crime.

These five passages, three from the *Nihon Shoki* and two from *Kojiki*, are important references to tattooing. In my opinion, there is a significant contrast between the two earlier accounts and the three later ones. If one looks at the earlier stories, one notes that neither is connected with criminal activity. In the early *Nihon Shoki* passage tattoos are noted as typical of the people of Hita-kami in the East—decidedly barbaric, but clearly not criminal. The earlier *Kojiki* story, just discussed, refers to a tattoo on a man of very high status—"strange," but again not criminal. On the other hand, the three later accounts are clearly associated with crime. The first of these (*Nihon Shoki*) refers to a case of treason, with the usual death penalty being commuted to the lesser penalty of tattooing. The second (*Kojiki*) is decidedly more tawdry, referring to a common thief who bears a tattoo and who is subsequently executed for his crimes. The third (*Nihon Shoki*), dealing with the death of a bird, again relates to tattooing as a punishment.

The chronological complexities of the arrangement of the relevant sections of the *Nihon Shoki* and the *Kojiki* are beyond the scope of this study. For our purposes here it is perhaps adequate to note that the earlier parts of both texts tend to embody the more archaic components. Thus the nearer one comes to the time that the two texts were compiled, the closer the narrative adheres to contemporary attitudes and standards. For this reason, I would like to suggest that our two "early" passages reflect, perhaps somewhat distantly, a period when tattooing was an acceptable, even desirable or necessary, attribute, while the three "later" passages must be understood in terms of Chinese conceptualizations of the tattoo as a particularly severe form of punishment.

The Kofun counterpart to the Jōmon *dogū* figurine is the *haniwa*. Thousands of these survive

to this day, in forms ranging from cylinders and in-animate objects through various animals and birds to representations of human beings, which show red, painted designs on the face.[16] Although it has occasionally been suggested that these designs represent tattooing, most scholars believe that face painting is indicated. The main reason for this con-clusion is that the red pigment is applied in broad areas, rather than having the more linear character typical of the tattoo. While there may be impor-tant connections between the practices of face painting and tattooing, it is the permanency of the latter which is its most salient characteristic. Thus there would seem to be no direct relations be-tween tattooing practices described in the *Nihon Shoki* and *Kojiki* and facial painting seen in the *ha-niwa*. Kidder has argued that this facial painting is related to shamanistic practices of the Kofun pe-riod, which would suggest that it goes back to the fourth or fifth centuries (Kidder 1965: 156,162). However, the vast majority of *haniwa* represent-ing human figures, including those with designs on the face, date to the sixth century, and even later in the Kanto region. In any case, by this stage in Japanese culture it is quite likely that Chinese ideas about the tattoo as a punishment had become institutionalized among the elite, making it ex-ceedingly unlikely that the *haniwa* display tattoos.

Thus, in surveying the documentary and ar-chaeological evidence from the Kofun period, one may be able tentatively to identify two stages. During the earlier stage, at the beginning of the period, the tattoo persists as a socially acceptable practice. However, in the later stage, perhaps from the middle of the Kofun period onward, the tat-too seems to have taken on negative associations, which continue into later periods.

Historical Periods (Pre-Edo) and Contemporary Non-Japanese Groups

There appears to be very little information about tattooing during the historical periods from ca 600–1600, prior to the Edo period (1600–1868). Some sources indicate that it continued to be a form of punishment during these periods, and there are also indications that out-castes were tat-tooed.[17] Further, although not directly related to the mainstream of the Japanese population, there is clear evidence of tattooing during the period amongst the non-Japanese population both to the north and south of the main regions. The earliest observers of the Ainu, the indigenous inhabitants of Hokkaido, noted the presence of tattoos on the women, particularly around the mouth (Fig. 7).[18]

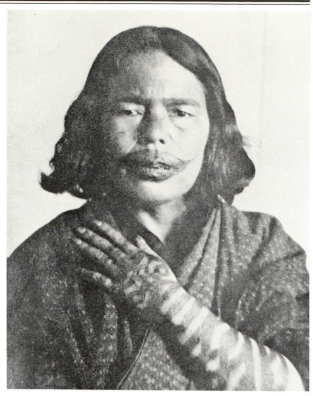

7. *Ainu Woman, Tattooed mouth and arm. Af-ter Batchelor (1901.21).*

Although the history and evolution of Ainu tattoo-ing is uncertain, it is apparent that it is a traditional practice with roots deep in the past. Whether and how it can be related to the tattooing of the Jō-mon, Yayoi and/or Kofun periods is a problem far beyond the scope of this paper. To the south of Kyushu, in the islands extending to Okinawa and on to Taiwan there are frequent occurences of hand tattoos amongst the local peoples (Fig. 8).[19] Again, this must be a tradition with very early roots and, just as with the Ainu tattoo, it is difficult to determine how this southern tattoo is related to forms found in the Japanese islands. Given the importance of a southern current in Japanese cul-ture during the Yayoi period, alluded to above, it might reasonably be concluded that the tattooing customs of the southern islands ultimately have a distant association with a wave of influence which at that time flowed into Japan.

In the next section we shall consider the rather startling growth of the tattoo during the Edo period. While it is conceivable that this flourishing tradition essentially developed out of a void, such a possibility seems to me implausible. Certainly there is evidence for the tattoo as a form of punishment prior to 1600, but this seems an un-likely source for the rich development seen in the

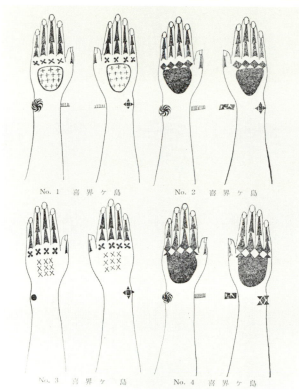

8. Hand Tattoos. From Kikaigajima. After Obora (1962.95).

are important literary references to the practice of tattooing. One of Japan's most famous writers, Ihara Saikaku (1642–1693), includes a rather risqué reference to a tattoo in his famous novel *The Life of an Amorous Man* (*Koshoku Ichidai Otoko*) published in 1682 (Keene 1976:167–215). The episode in question deals with the relationship between two homosexuals, one of whom is a Buddhist priest. Following the actual story there is a later recounting of the events:

> On that occasion Sansaburō made a clean breast of his life with the priest. He even had the word *Kei* tattooed on his left arm as proof of his devotion to the priest, whose name was Keisu. This, therefore, is not fiction but a true story (Hamada 1964:149).

The most important detail of this story is that it refers to a tattoo in the form of a character rather than to a pictorial tattoo. In that respect, this tattoo would have had more in common, at least formally, with punitive tattoos than to the later pictorial type.

The standard term for tattoo in modern Japanese is *irezumi*, "ire" meaning to "insert", (i.e., the inserting of pigment) *zumi* referring to the pigment itself (*sumi*, or charcoal ink). The type of tattoo mentioned in Saikaku's story is called an *irebokuro*, *ire* as in *irezumi* and *bokuro* (*hokuro*) referring to a "mole." Among the courtesans of the pleasure quarters of Edo and Osaka, this type of tattoo had the specific connotations of a love pledge, wherein frequently the name of the courtesan's lover would be tattooed on her upper arm or inner thigh.[20] A print by Utamaro, one of the most famous Ukiyo-e artists, shows just such a situation, although in this case we see the woman tattooing her lover, who is wincing with pain (Fig. 9; Stern 1969:208–209).

In tracing the history of the Edo tattoo, it is essential to recognize that this practice was harshly sanctioned by the authorities. The Tokugawa *bakufu* (military government) was exceedingly conservative, basing its philosophical ideas on Chinese Confucian philosophy. As was mentioned above, the Chinese had long regarded the tattoo as a particularly severe punishment; the Japanese government, in adopting such ideas, could hardly be expected to approve of the non-punitive utilization of the tattoo amongst the populace. In some respects, the history of the Edo period reads like a contest between the governmental authorities, who were constantly issuing sumptuary regulations and various prohibitions, and significant groups of the population who sought means to

Edo period. Perhaps there was already a pre-Edo undercurrent of non-punitive, voluntary tattooing. This is a highly speculative suggestion put forth with some trepidation. If such practices existed amongst the lower orders of society it is most likely that they would have gone totally unrecorded, and thus we shall never know. Only with the new and vital popular culture of the Edo period, when all classes of society had artistic and literary forms mirroring their activities, do we have enough information to adequately survey the development of the Japanese tattoo.

The Edo Period (1600–1868)

The Japanese tattoo, as we know it today, is a product of the Edo period. As noted, my conjecture about the possibility of continuity between a pre-Edo "underground" tattoo tradition and that of the Edo period is entirely speculative. Consequently, it is necessary to look rather closely at developments which took place during the seventeenth, eighteenth, and nineteenth centuries. In contrast to the preceding periods, however, there is abundant evidence, both documentary and visual, for the Edo tattoo.

By the end of the seventeenth century, there

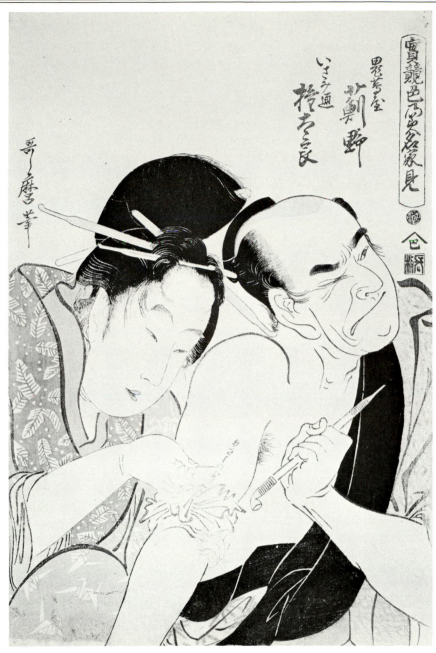

9. *Utamaro. "Azamino of Onitsutaya Tattooing Gontaro." Edo Period. Boston Museum of Fine Arts.*

evade these edicts. The fact that the edicts were repeated at frequent intervals suggests that they were not entirely effective, although it should be pointed out that there were from time to time exceedingly harsh crackdowns on activities that the government deemed undesirable. At the highest economic level of society, merchants were constantly being criticized for extravagance and ostentatious display. More on the level that includes groups likely to indulge in tattooing, there were frequent restrictions, even prohibitions, on cul-

tural forms such as the Kabuki drama, Ukiyo-e wood-block prints, and various types of popular literature. It is within the world delineated by these genres—the "floating world"—that the Edo tattoo grew and flourished. The tattoo was in essence a plebian practice, utilized particularly by those on the periphery of society. Individuals in this category apparently regarded tattooing as a way to define their own character or being, perhaps also conceiving of the tattoo as a protest against the austere and staid regulations of the

Tokugawa *bakufu*.

The most fascinating problem in the study of the Edo tattoo concerns its apparent development from rather limited imagery and content (often consisting of characters) to the full-scale pictorial tattoo covering large areas of the body. In attempting to understand this evolution one factor must be kept clearly in mind, especially by readers coming from Western culture. In Japan the tattoo is, and was during the Edo period, considered to be an entirely inappropriate practice for members of "decent" society. The prohibitions are, and were, so deep that no ordinary person would have conceived of having a tattoo applied to his or her body. In this respect, little or no distinction would have been made between a comparatively modest work and a full-scale body tattoo; in fact, the distinctions were categorical: one either was tattooed or one was not. Consequently, if one chose to be tattooed there was essentially no reason to limit oneself to a small, discreetly placed design, since the mere act of beginning the process committed one to a very definite statement. This attitude contrasts with the Western conception which places tattoos on kind of a spectrum. A small tattoo, even in a visible location, does not necessarily place the contemporary American or European "beyond the pale," so to speak; frequently they are explained away as youthful indiscretions, and this appears to be generally perceived as an adequate excuse. On the other hand, a modern Japanese full-body tattoo might be harder for the average Westerner to cope with, for work on this scale raises other questions which do not arise in the Japanese context. Be this as it may, the evolution of the tattoo in Japan from the later eighteenth century onward was toward the full-body pictorial tattoo, and there are few occurrences of less extensive coverage.

Most commentators have associated the development of the Japanese full-body tattoo with a specific work of Chinese literature, the *Shui-hu Chuan*, a long novel written or compiled in the fourteenth century by a person using the pseudonym Shih Nai-an.[21] It deals with the activities of Sung Chiang and his rebel companions, 108 in all, during the years 1117–1121 at the chaotic end of the Northern Sung Dynasty. While this band was outside the confines of normal society, they were a virtuous group, aiding the poor and downtrodden against a corrupt government. The relevance of this novel for our study is that a number of its most important characters were tattooed. The *Shui-hu Chuan* reached Japan in the early eighteenth century. One might assume that the Toku-gawa censors would have suppressed a work of this character, but apparently it escaped that fate because it was considered to be a classic of Chinese literature. Moreover, only the most highly educated members of society were able to read it in the Chinese original, so perhaps it was not initially conceived of by the authorities as bearing a potentially subversive message. Okajima Kanzan (d. 1727), an interpreter of Chinese, published part of the *Shui-hu Chuan* in a punctuated version which allowed it to be read in Japanese. The first ten volumes were released in 1727, the year of his death, and an additional ten volumes came out in 1759 (Keene 1976:376). By the later eighteenth century a number of books in Japanese based on the *Shui-hu Chuan* were published, and the novel and its theme became increasingly popular amongst the townsmen of cities such as Edo (Van Gulik 1982: 45–46).

The novel is called *Suikoden* in Japanese, a transcription of the Chinese characters; the title is rendered into English as *The Water Margin*, although it is better known by the title *All Men Are Brothers* of Pearl Buck's (1933) translation. From the beginning of the nineteenth century a phenomenally popular version of *Suikoden* began to appear in Edo under the title *Shinpen Suiko Gaden* ("Newly compiled illustrated *Suikoden*"). Work on this version began in 1805 and it was not completed until 1839 (Van Gulik 1982:46–47). The first sections were the work of one of the most famous masters of vernacular fiction, Takizawa Bakin (1767–1848),[22] with illustrations by the most prominent Ukiyo-e artist of the time, Katsushika Hokusai (1760–1849) (Hillier 1957). After Bakin dropped out of the project, apparently as a result of a quarrel with Hokusai, the literary work was continued by Takai Ranzan (Hillier 1957:38). In addition to his illustrations for this book, Hokusai also produced a separate volume of illustrations of the *Suikoden* heroes called *Ehon Suikoden* in 1829 (Hillier 1980:80). Exploiting the fashion for representations of *Suikoden* characters, another Ukiyo-e artist, Utagawa Kuniyoshi (1797–1861),[23] began to publish an immensely popular series of prints called "108 Heroes of the *Suikoden*" (*Tsuzoku Suikoden Goketsu Hyakuhachinin no Hitori*) in 1827 (Robinson 1982:102–104).[24] Whereas the previously cited works by Hokusai were in book format, Kuniyoshi's series consisted of independent sheets which could be sold and collected separately.

It is instructive to compare the representations of tattooed figures in the wood block prints of Hokusai and Kuniyoshi in the context of the de-

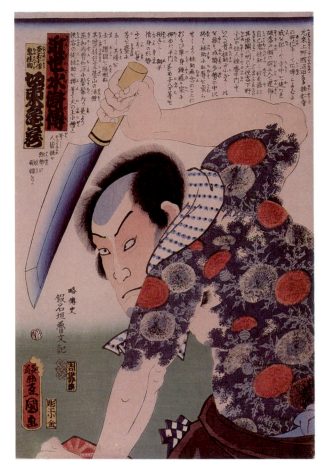

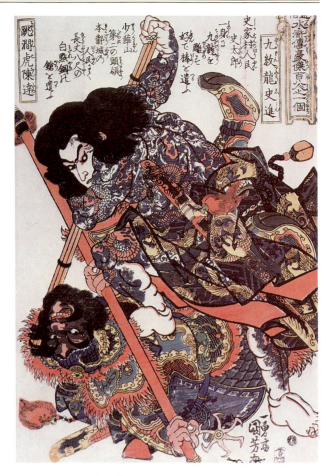

10. *Utagawa Toyokuni III. ''Hinotama-kozo Oni Keisuke.'' Edo Period. Ohwada Collection.*

11. *Kuniyoshi. ''The dragon-tattooed Shishin engaged in a fight.'' Edo Period. Ohwada Collection.*

velopment of the full body tattoo during the first half of the nineteenth century. The earlier wood block prints, by Hokusai, are relatively restrained in the way that they depict the tattoo. For instance, his representation of the nine-dragon tattoo of the character Shishin shows quite small-scale dragons which cover only a limited area of the available skin surface (Van Gulik 1982: 12–15). Compared with this, the later depictions of the same character by Kuniyoshi show extremely flamboyant dragon designs which fill the entire surface available for decoration (Fig. 11; Van Gulik 1982:22–23). It is, of course, this very quality that is the characterizing feature of the Japanese full body tattoo, and thus it is frequently suggested that the configurations of tattoos were largely derived from Kuniyoshi's graphic representations. While this is undoubtedly true, I wonder if the process of development of the full body tattoo was not somewhat more complicated, perhaps involving a reciprocal relationship between prints and tattoos. It seems plausible to assume that

Hokusai was basing his depictions on things he may have seen, and that they in turn may have led to more complex tattoos. Similarly, Kuniyoshi could have seen tattoos of this next stage of development and, in turn, increased the complexity of his representations, thus further stimulating the practice of tattooing. It is evident that further research will be necessary into this problem before we achieve a satisfactory understanding of the reciprocal relatinship between wood block depictions and actual tattoos.

Needless to say, Hokusai and Kuniyoshi were not the only Ukiyo-e artists who included the tattoo in their work. A major compilation of Ukiyo-e prints with tattooed figures includcs work by artists such as Kunisada (1786–1864), Yoshitoshi (1839–1892), Kunichika (1836–1900), and others (Fig. 10,12; Gunji 1977).[25] The Osaka artist Hirsada did a print showing a Kabuki actor with an elaborate tattoo on his arms and upper body, while another Osaka master, Hokuei, executed a magnificent tetraptych showing four *Suikoden* charac-

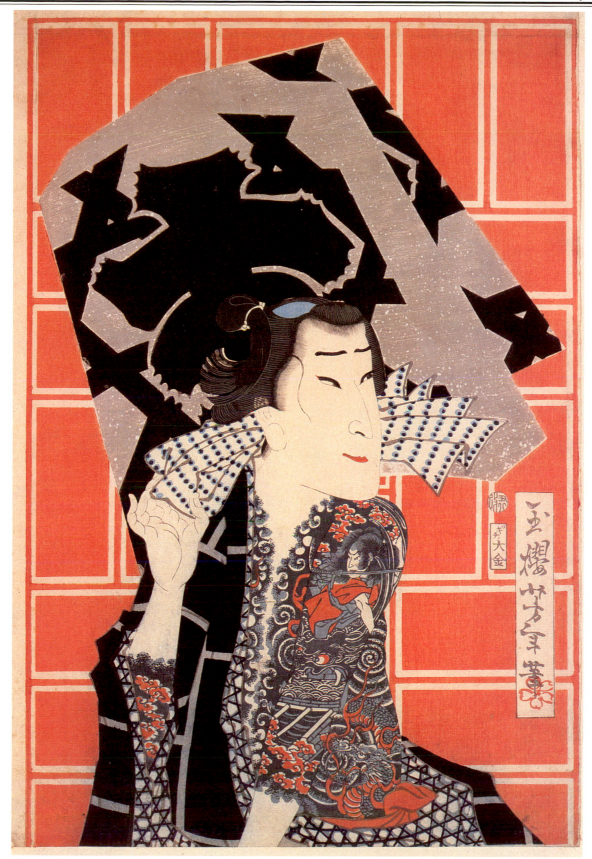

12. Yoshitoshi. "Isami no Kotobuki." Edo Period. Los Angeles County Museum of Art.

ters, two of whom bear elaborate tattoos (Keyes and Mizushima 1973:146–147, 182–183).

Who were the clients for tattooing during the later Edo period? It appears that fire-fighters were especially enthusiastic about the practice.[26] Large Japanese cities, such as Edo and Osaka, were made up of wooden houses, packed closely together, which obviously constituted a severe fire hazard. Fire-fighters were frequently recruited from amongst young rowdies and ruffians, and their somewhat *macho* behaviour reflected, in a sense, the heroic activities of the characters of *Suikoden*. Thus it is not surprising that they chose to have themselves tattooed; interestingly, different groups of fire-fighters apparently utilized specific designs, although all generally incorporated water symbols of some type (e.g. fish or dragons). Other important clients for tattooing were men who carried palanquins or were otherwise involved in transport, for they discovered that a good tattoo would often attract a customer. Finally, many Edo-period craftsmen, such as carpenters, were tattooed. As a whole, the groups who received tattoos tended to be known for rowdy behavior. Certainly their active life-styles reflected the boisterous high spirits that permeated the plebian quarters of a great city such as Edo, contrasting strongly with the staid Confucian moralism which was the official ideology of the Edo *bakufu*.

The Modern Period (1868–present)

The late Edo period, especially the first decades of the nineteenth century, was probably the "golden age" of the Japanese tattoo. The situation changed radically with the end of the Tokugawa *bakufu* and the beginning of the modern period in 1868. This transition is referred to by historians as the Meiji Restoration, for it saw the end of the feudal shogunal government and the restoration of the emperor as the head of state. Ironically, the Meiji Restoration was the Meiji "Suppression" as far as the tattoo world was concerned, for the new central government, highly sensitive to the way Japan was perceived by the Western powers, concluded that tattooing would be seen as a sign of barbarism.[27] Consequently, rigorous efforts were made to close tattoo establishments and discourage its practice. The irony increases greatly when it is realized that it was foreigners, in fact, who were particularly impressed by the Japanese tattoo, and wished to have themselves tattooed (admittedly, not usually in the traditional full-body format!). The heirs to the British throne (George V) and the Russian throne (Nicholas II) both were

tattooed by Japanese craftsmen, and innumerable sailors, from the highest to the lowest ranks, availed themselves of the services of tattooists in the ports of Yokohama and Kobe (Thayer 1983: 350). Theoretically, at least, Japanese citizens were not allowed to have themselves tattooed, but these restrictions did not apply to foreigners. In practice, tattooing was still seen amongst certain peripheral groups in Japanese society. In short, the years from 1868 until 1945 were difficult for tattoo artists and their patrons, although it is apparent that the craft was never totally suppressed. For example, there is some indication that after the disastrous Kanto earthquake of 1923 there was a resurgence of interest in tattooing amongst urban craftsmen.

It is interesting to reflect on the fact that the period between 1930 and 1945 was characterized by the rise of militarism in Japan. Based on Western practice, one might imagine that soldiers and sailors would allow themselves to be tattooed in the course of their military service. In fact, the highly conservative, rigidly controlled Imperial forces were the last place one would find a tattoo since the implications of tattooing were totally contrary to the ideals of the militarists. While I have no statistics, I suspect that the largest percentage of tattoos seen in the Western world were received as rites of passage by young men in the armed services. This practice would have been out of the question for their Japanese counterparts.

With Japan's defeat in August, 1945 and the subsequent establishment of the American Occupation (until 1952), many of the oppressive regulations and laws of the previous government were overturned. Tattooing now became legal—if not socially acceptable—and the craftsmen were allowed to practice their art without harassment. However, this new freedom did not exactly lead to a renaissance of the art of tattooing, for many of the traditional artisans had died without leaving disciples trained in the old techniques to carry on the work. Other traditional Japanese crafts faced a similar situation, but in their cases a government agency artificially perpetuated their practice by designating distinguished masters as "Living National Treasures." Financial support and the very high status associated with this designation guaranteed the continuation of traditional crafts such as paper-making or sword-forging. Despite the fact that the Japanese tattooing tradition is widely considered to be the most important extant form of the art in the world, it is absolutely inconceivable to anybody familiar with Japanese society and attitudes that a tattooist would be designated a "Liv-

ing National Treasure!"

The alternative to institutional support is a reasonably large clientele, but here too the situation may not be particularly favorable. With the leveling of Japanese society, and the universal requirements of education, virtually all Japanese regard themselves as middle-class. The lively, lower-class urban culture that survived up until the war years is now largely gone, a victim of Japan's economic miracle. Some working-class youths still have themselves tattooed, but the majority, as in other countries, are more likely to be watching television or listening to rock and roll music than to be considering having a tattoo! One hears occasionally of non-traditional patrons—wealthy or professional people—being tattooed in Japan. With such a development it is probably fair to say that the Japanese tattoo has lost its roots and is venturing out into a modern world that has little, if anything to do with traditional Japanese culture.

The significance of the tattoo for modern Japanese culture is best expressed by the appearance and treatment of tattooing themes in a number of literary works by well-known authors. To the best of my knowledge, this is a unique phenomenon in twentieth century literature and thus warrants examination. It seems certain that the very strong taboos directed against tattooing made it a subject of particular interest to a wide spectrum of authors. By far the most famous example of this genre is the 1910 short story by Tanizaki Junichirō (1886–1965), titled "The Tattooer" ("Shisei") in its English translation. For the reader unfamiliar with modern Japanese literature, it is essential to point out that Tanizaki would generally be placed amongst the five or so most important writers of the modern period (Keene 1976:720–785). Repeatedly in this study I have emphasized that those who execute and receive tattoos are peripheral members of society; thus it is highly significant that a central figure of the Japanese literary world would choose tattooing as a theme. For this reason I believe Tanizaki's story deserves careful analysis.

Tanizaki's early work is frequently characterized by decadent, erotic fantasy, and "The Tattooer" is a perfect example of this mood (Hibbett 1970). The story is set in the pleasure quarters of Edo in about the 1840s.[28] After briefly describing the leisurely, exceedingly frivolous lifestyle of this world, Tanizaki turns to the theme of the story:

> People did all they could to beautify themselves, some even having pigments injected into their precious skins. Gaudy patterns of line and color danced over men's bodies (Hibbett 1970: 160–161).

He explains possible motivations for being tattooed, including the hope of palanquin bearers to receive more business. He also refers to contests that took place where people compared tattoos. (Tanizaki's introductory material thus relates closely to the historical reality discussed in the preceding section.)

Tanizaki next introduces his hero, known only by the given name Seikichi. Although still young, Seikichi is already a master tattooer; it is suggested that his great talent is based on the fact that he had previously worked as an Ukiyo-e painter of the schools of Toyokuni and Kunisada. (As noted earlier, this fictional connection of the tattooer with the world of Ukiyo-e also reflects an important aspect of the historical Edo tattoo.) While it is indicated that Seikichi has fallen in status by becoming a tattoo artist, the "unrivaled boldness and sensual charms" of his work are attributed to his Ukiyo-e background. Because of his great talent and devotion to his craft, Seikichi is highly selective as to whom he will take as a client.

The more specific themes of the story are introduced when we are told of Seikichi's secret pleasure and secret desire. With regard to the former, he takes great delight in inflicting intense pain on his clients. As to his secret desire, he wishes to create a tattoo masterpiece on the body of a beautiful woman. Although he has frequent opportunities to satisfy his sadistic tastes, he is long frustrated in his search for the perfect female subject. Four years into the search he sees the stunningly beautiful foot of a young woman who is entering a palanquin, and realizes that she is the person he has been seeking. Although he pursues her palanquin, the chase ends in failure when he loses sight of it. (The motif of foot-fetishism is a frequent feature of Tanizaki's writing, not specifically related to the tattoo theme considered here.) Entranced by the girl—he has seen only her foot—Seikichi passes another year in frustration. Then one day, quite by a chance, a young girl of fifteen or sixteen comes to his house on an errand; seeing her feet, Seikichi realizes that she is the one he has been longing for. Needless to say, she is perfect in every respect.

In the following section, Seikichi initiates the girl into the decadent and sadistic eroticism that is central to the story. He first shows her a painting depicting a cruel Chinese princess watching the horrible, sadistic torture of a man. Repelled by

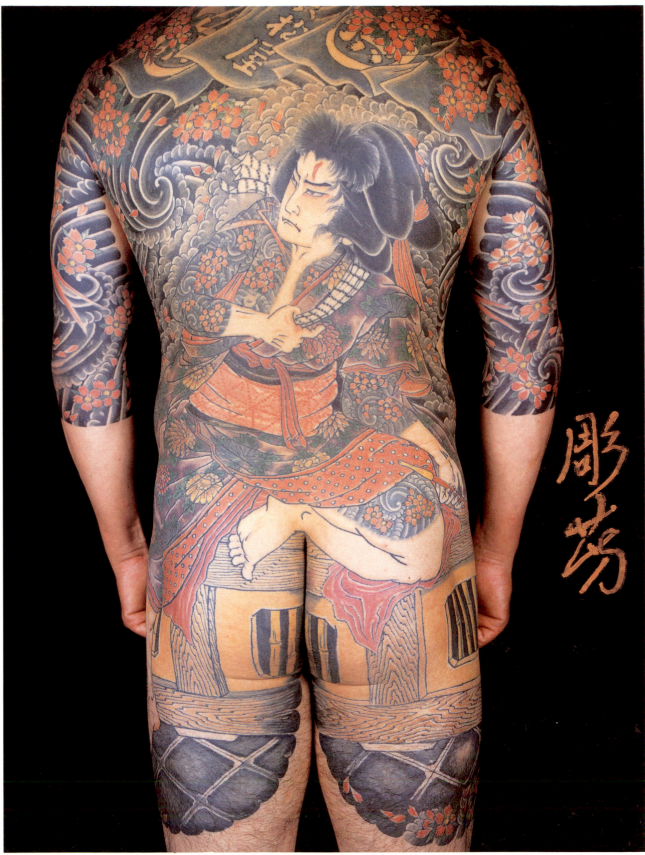

13. *Tattoos by Horiyoshi II. Photograph by Shigeru Kuronuma, courtesy of Ed Hardy.*

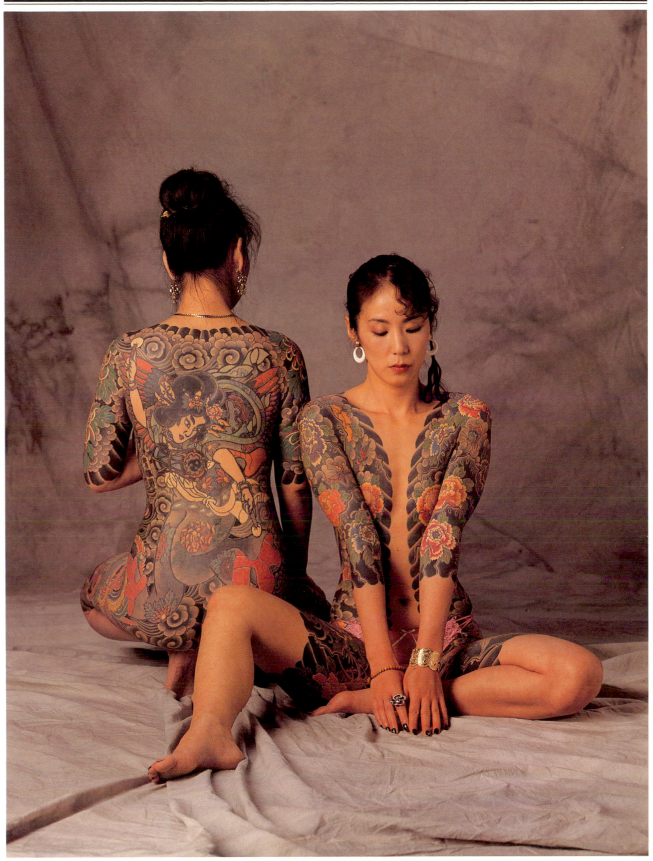

14. *Tattoos by Horitoshi I. Photograph by Richard Todd.*

the gruesome evil of the scene, the girl at the same time cannot resist looking at it, and Seikichi tells her that she is identical in character to the princess. He next shows her a painting entitled "The Victims" in which a beautiful girl is shown gloating over the corpses of a number of men whom she has victimized. When Seikichi informs his girl that the painting predicts her own future she says, "Yes, I admit that you are right about me—I *am* like that woman. . . . So please, please take it away" (Hibbett 1970:166). Presumably the girl's acknowledgement of her own evil desires functions as a justification for Seikichi's subsequent actions.

The girl is overwrought by this intense stimulation and begs to be allowed to leave, but Seikichi will not let her go. Instead,he sedates her with an anesthetic. After contemplating her beautiful body for a long time, he begins work on the tattoo, laboring through the whole day and night. By the next morning an enormous black-widow spider covers her entire back. Seikichi tells her:

> "To make you truly beautiful I have poured my soul into this tattoo. Today there is no woman in Japan to compare with you. Your old fears are gone. All men will be your victims" (Hibbett 1970:168).

The girl feels severe pain as a result of the tattooing; she enters the bath to set the tattoo and soothe the pain, and when she finally returns to the room where Seikichi is waiting he realizes that she is a totally transformed person.

> "All of my old fears have been swept away—and you are my first victim!" She darted a glance at him as bright as a sword. A song of triumph was ringing in her ears.
> "Let me see your tattoo once more," Seikichi begged.
> Silently the girl nodded and slipped the *kimono* off her shoulder. Just then her resplendently tattooed back caught a ray of sunlight and the spider was wreathed in flames (Hibbett 1970:169).

This is the end of the story. Of course we are not told that Seikichi dies, but we know that he does, inevitably.

This lengthy analysis of "The Tattoer" is not intended to demonstrate certain sado-masochistic tendencies in Tanizaki's writing. Rather, it seeks to focus on what I take to be highly ambiguous Japanese responses to the tattoo. Anybody who questions contemporary Japanese about the subject will probably be struck by their very harsh condemnation of tattooing in general and, specifically, of those bearing its marks. And yet the very harshness of the criticism forces one to ponder a moment, for it seems too strong, too intense. I suspect that there is a high degree of ambivalence about the tattoo; it would seem to be a forbidden fruit with strong erotic overtones blending into the sadomasochistic fantasies developed by Tanizaki. A superficial survey of popular erotic literature or lower-class motion pictures will quickly reveal the frequent appearance of tattooed men and women. While such manifestations clearly lack the aesthetic distinction of Tanizaki's fiction, they obviously reflect—and cater to—the same sorts of emotional responses.

A number of other authors, including Okamoto Kido, Kunieda Kanji, Hirabayashi Taiko, Takagi Ashimitsu, and Mishima Yukio, have published fiction which deals directly or indirectly with the subject of tattooing (Japan Tattoo Institute 1983:154–162). While it might be an exaggeration to refer to a specific genre of "tattoo literature," the fact remains that the theme has a place of some importance in modern Japanese writing. While there is no space here to analyze the tattoo-related works of these writers, I would suggest that a full account of the significance of tattooing in modern Japan would have to include a careful study of this material. In this connection, there are a few examples of tattoos represented in the works of "fine" artists, although it is my impression that such appearances are neither as numerous nor important as in literature.[29]

In the discussion of Edo-period tattoo an effort was made to indicate the types of people who would have had themselves tattooed, as well as their motivations. When we turn to the modern period, it can be assumed that the basic clientele is quite close to that of Edo—essentially members of the urban lower classes who are frequently alienated from polite society. While palanquin bearers no longer exist, there are numerous laborers and hangers-on at the fringes of society who are likely candidates for tattooing. This brings us to one of the key issues in the discussion of the modern tattoo, for if one asks an ordinary Japanese who the people are who have themselves tattooed, almost invariably the response will be "*Yakuza!*" The *yakuza*, of course, are the criminal element of contemporary Japan—those involved in gambling, shakedowns, prostitution, drugs, and the entire spectrum of anti-social activity ranging from petty crime and harassment to murder (Kaplan and Dubro 1986). A whole mythology surrounds the *yakuza*, relating primar-

ily to the codes of behaviour that are said to determine their activities. For our purposes, the most significant identifying trait of *yakuza* membership is the tattoo, and it is this emblem to which the average Japanese is responding when he or she associates tattooing more or less exclusively with *yakuza*.

In an important sense, this exclusivity, if true, would be highly useful, for it would enable the law-abiding members of society to condemn as a single, unified phenomenon, two socio-cultural traits which are both considered to be exceedingly undesirable, even repugnant. The situation becomes more complicated—and harder to deal with—if it turns out that there is a significant group of tattooed people who are not *yakuza*. While I know of no statistics concerning non-*yakuza* tattoos—they probably do not exist—casual observation has usually concluded that many people who are not gangsters affiliated with *yakuza* groups bear tattoos. This observation, if correct, would suggest that the *yakuza* theory, while partially true, is inadequate as a comprehensive explanation for the presence of the tattoo in modern Japan. Consequently, I believe that further research is necessary concerning who in modern Japan has tattoos, and why. Donald Richie (1980:26) has offered some exceedingly interesting speculations about these matters, but his methodology is basically impressionistic, not rooted in empirical investigation. Given the prejudice of most Japanese toward the tattoo, I am not very sanguine about the possibilities of a scientifically conducted research project, although a social scientist specializing in "deviant" behaviour might be motivated to carry out the appropriate research.

Since the emphasis in this paper is on the historical and social aspects of the tattoo in Japan, not much has been said about the formal and iconographic characteristics of examples from the various periods. While I do not intend to shift the focus here and offer a detailed analysis of the modern tattoo, it might be useful to offer a few brief comments about its general configuration and subject matter. Needless to say, there is a good deal of continuity from the nineteenth century into the modern period, so the observations which follow will also relate to some extent to the Edo tattoo.[30]

As has been discussed above, the modern Japanese tattoo is not a small-scale unit, or aggregate of units, but an overall, unified composition that covers large areas of the body (Fig. 13). During the Edo period it seems that the tattoo covered the entire upper body, including the chest,

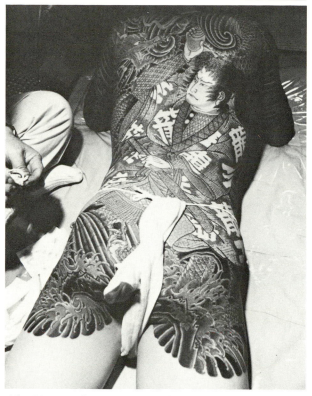

15. *Horiyoshi II at work, Tokyo. Photograph by Akiko Nishimura, courtesy of Ed Hardy.*

but in more recent times an undecorated zone has been left from the neck down the front of the chest (Fig. 14). The function of this untattooed area is to allow the individual to wear an unbuttoned sports shirt without the tattoo being visible. For the same reason, the tattoo usually does not extend below the upper part of the arm. When the patron decides to be tattooed, he or she selects a design from the tattooist's copy books. These are pre-determined iconographies. Since tattooing is thought of as a traditional art form governed by the sorts of canons typical of such traditions, the client does not normally request unusual or eccentric designs. It should be pointed out that the type of "individualism" characteristic of Western society is not at all common in Japan, so that the typical client is likely to be quite satisfied with the standard repertory of designs.

After the subject matter has been agreed upon, the tattooist outlines the main elements of the design, and then, in the course of numerous sessions extending over a period of months, fills in all the areas of the composition (Fig. 15).[31] It is interesting to note that normally the most significant part of the design is at the back, presumably because this area allows the broadest canvas for the tattooist's art (Figs. 13–15). An important result

of this format is that the individual cannot see his or her tattoo, except in a mirror, suggesting that the basic function of the tattoo is display. Great care goes into its design and execution. For this reason, ugly, grotesque, bizarre, or intrinsically anti-social motifs are not seen in Japanese tattooing. While certain motifs, including some Buddhist deities, dragons and serpents, or warrior heroes might initially strike the inexperienced Western observer as in some way violent, unappealing, or unattractive, virtually all of the elements seen in the tattoo occur in other forms of mainstream pictorial art. At another level, beauty is in the eye of the beholder, and the normal Japanese response to a tattooed individual—whatever the subject—is revulsion; however, it is not clear to me if this response is related to the aesthetic properties of the tattoo *per se* or if it is primarily determined by exceedingly negative attitudes toward the mere act of having oneself tattooed.[32] I suspect that taken out of their specific context, the designs would generally be acknowledged as being attractive and interesting.

Amongst people throughout the world interested in tattooing, the Japanese tattoo enjoys a very high reputation; one occasionally hears comments that appear to assume that tattooing is an acceptable art form in Japan. It should be apparent by this stage in our discussion that this is emphatically not the case—the tattoo is totally rejected by the vast majority of Japanese. Nevertheless, one may still wonder about the nature of its stylistic development. Here it is necessary to point out that tattoo designs and stylistic features are essentially derivative, most frequently coming from the Ukiyo-e context described above. This should not be surprising, for a minor craft such as tattooing is not likely to produce significant innovations in style and iconography. Moreover, the Ukiyo-e tradition is so rich in subject matter and stylistic dynamism that it is an inexhaustible resource for the tattooist and his clients. Of course, the urban, lower class origins of Ukiyo-e amount to an ideal source for tattoo designs because of the congruity of attitudes and practices motivating the two traditions. Perhaps it is useful to recall that not long ago the Ukiyo-e print occupied a very minor position in the hierarchy of the Japanese arts. (This is not to anticipate that the tattoo in Japan will move from the unacceptable to the revered category, for it certainly will not!)

Donald Richie (1980) has presented a general survey of the major iconographical elements of Japanese tattoo.[33] Readers interested in this subject may refer to his book, although at times it must be used with caution as there are some errors. As Richie points out, the range of motifs is rather limited. A group of floral elements, including the peony, chrysanthemum, cherry blossom, and maple leaf, all have specific symbolic meanings in Japanese culture, although their significance may be more generalized and decorative in tattooing. From the animal kingdom one sees tigers, lions, carp, as well as mythological creatures such as dragons; these, like the preceding, have standardized meaning, all of which are overwhelmingly positive. In the religious domain deities such as Kannon and Fudō are frequently seen. While Kannon exemplifies mercy and generosity, Fudō is a ferocious deity who utilizes his sword to subdue the enemies of Buddhism and his lasso to capture the recalcitrant. As was pointed out above, it would be a very grave error to associate a figure such as Fudō with evil—he has absolutely nothing to do with the western idea of a devil or satan, but is a highly positive deity working for the advancement and expansion of the Buddhist religion. In addition to the religious figures, there are a number of subjects from mythology and history which are also exemplifications of positive virtue.

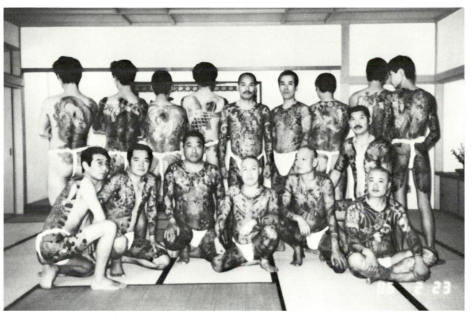

*16. Tattoo Association meeting, Tokyo.
Photograph courtesy of Ed Hardy.*

Conclusion

The story told in this paper extends over at least two millenia, and even longer if the validity of the Jōmon material as evidence for tattooing is accepted. The longevity of tattooing in the Japanese islands is, indeed, amazing, although we must return here in our conclusion to the vexing issue of continuity and discontinuity. Perhaps the most cautious approach would be to assume four periods of tattooing: Jōmon, Yayoi-Kofun, 600–1600, Edo-Modern. If there actually was tattooing during the Jōmon period, it would most certainly have been of the type associated with other hunter-gatherer peoples throughout the world. Presumably it would have had deep ritual foundations, perhaps relating to group-membership and the initiation of the young into adulthood. Since the agricultural subsistence of the Yayoi culture is so radically different from Jōmon hunter-gatherer society, I am assuming little, if any, continuity between the two periods. However, since the Chinese texts inform us that tattooing was practiced amongst the Yayoi peoples it is necessary to address the question of its origins. Above, I surveyed the various possibilities, although it had to be acknowledged that no definite conclusions could be reached.

At this point in the present discussion, I would suggest that there were significant continuities in the practice of tattooing from Yayoi to Kofun, although by the end of the Kofun period it seems likely that Chinese ideas concerning the tattoo as a punishment were becoming dominant. Thus, with regard to the long historical span, ca. 600–1600, the only real hint at continuity in the tattoo is in connection with its punitive function. Another fairly abrupt disjunction is encountered in dealing with the Edo-Modern period, for within that time span there is an extraordinary development of the non-punitive decorative tattoo amongst certain segments of the population, a development which does not seem to emerge from any known antecedents. Are we dealing with four distinct phases of tattooing, or are there continuities across the periods? Only further research will answer this question.

Pre-Edo tattoo seems to fall clearly into the two relatively uncomplicated categories of "primitive" and "punitive": Jōmon, Yayoi and part of Kofun being the former; late Kofun and the period 600–1600 the latter. However, with the "popular" tattoo of the Edo and Modern periods there are very great problems of explication. The foreign student of the various aspects of Japanese culture is normally able to draw on a very extensive secondary literature dealing with virtually any topic chosen; in fact, the very volume of material available often bogs down the scholar and inhibits imaginative research. In preparing this paper I have faced the opposite problem, for there appears to be a distinct paucity of substantial scholarly investigations of the tattoo, its practitioners, and its clients. What is available is predominantly in the form of large picture books, lavishly illustrated, with relatively subjective and impressionistic texts written by authors who are strongly committed to the practice of tattooing.[34] More objective studies carried out according to standard social science methodologies are clearly needed. Lacking data derived from such rigorous research, it is unlikely that substantial progress will be made in the understanding of Japanese tattoo. Nevertheless, some attempt must be made to assess the broader significance of the tattoo in Edo and modern Japan.

The fundamental problems are why Edo and modern tattoo became so popular in certain small circles, anathema to everybody else, and why it developed in such an extravagant manner. Some suggestions were offered above as to these matters, and here we shall simply summarize the previous discussion and present a more synthetic account. Fundamentally, the tattoo is a practice limited to the urban lower classes during the Edo and Modern periods. To the best of my knowledge, it was not practiced amongst the largest lower-class group, the peasantry. Even in the case of the urban groups who were tattooed, it must be stressed once more that the practice was restricted almost exclusively to those of marginal or peripheral social status. This is not to say that those who had themselves tattooed were economically deprived, for that was clearly not the case. Most men who had themselves tattooed belonged to trades which were reasonably well compensated, and some, who were involved in activities of doubtful legality, may have had quite a lot of money. Today a full-scale tattoo is a relatively expensive proposition because of the artisan's considerable expenditure of time. We can assume that in the Edo period as well, one could not be impoverished and have oneself tattooed. Consequently,

the client did not simply decide to be tattooed, he had also to have the necessary funds.

On what basis would the decision to submit to the economic, social, and physical ordeal of being tattooed be made? All studies of Japanese culture stress the pressures to conform to various norms, usually exerted by one's peers. While the vast majority of Japanese have profoundly negative feelings about tattooing, obviously tattoos are common amongst certain groups. Thus an individual within such a group would presumably experience more or less intense and overt pressure to be tattooed as a symbol of solidarity. Some categories—firemen during the Edo period or the *yakuza* today—may have a very high percentage of tattooed members, while others, such as craftsmen or laborers, could be substantially lower. Obviously, it is the latter group which is the more difficult to explain, for its members have greater freedom in making a decision as to whether or not they wish to be tattooed. On this level we are beginning to approach issues of individual psychology, and I do not believe that there is enough scientifically collected data to allow more than informed speculation.

Turning from the tattooist and his clients to the larger context of Japanese society in the nineteenth and twentieth centuries, it might be worthwhile to conclude with a consideration of the broader significance of the tattoo. From the perspectives of both society as a whole and the individual or groups bearing tattoos, it is apparent that tattooing is imbued with intensely felt meanings. It can be fairly claimed that virtually nobody in Japan is neutral about the subject. Consequently, the tattoo must be analyzed in terms of its being a highly unusual manifestation within a society that more or less rigidly enforces conformity to a standard way of life. I suggested above that tattooing may be partially determined by pressures exerted as a result of membership in a specific group, but I would further argue that the rather eliptical concept of "conforming to nonconformity" is inadequate for an understanding of the tattoo in Japan. This is because the degree of non-conformity associated with the tattoo is so great that it cannot be thought of in the same terms that might be applied to fads related to such things as clothing, hairstyle, cosmetics, etc. Both the person tattooed and society recognize the tattoo as an extreme statement that challenges fundamental premises of Japanese culture.

And yet, as proposed in my discussion of Tanizaki's short story, responses to the tattoo must also be analyzed on a deeper psychological level.

It is quite apparent that erotic and sado-masochistic impulses motivated Tanizaki's writing, and is unlikely that such motivations are unique to him. Rather, I would suggest that the very deviance of the tattoo—its perversity—has exerted an influence on conventional society. It may not be proper to admit an attraction to tattoos—much less to consider having one—but it would appear that there is more interest in the subject than conventional morality would like to admit.

The length of this paper—and the nature of the preceding comments—might lead the unwary reader to the conclusion that I am attributing a very high significance to the tattoo in modern Japanese society. This is by no means my intention. Tattooing is a minor art, limited to a quite small group of clients. The vast majority of the Japanese population presumably spend virtually no time thinking about tattoos. Nevertheless, the very extremity, from a Japanese perspective, of having oneself tattooed warrants more careful investigation than it has yet received. When such research is accomplished it will definitely not offer us the key to an understanding of Japanese culture, but it will provide useful insights into a small but significant aspect of that culture.

Notes

1. My colleague Arnold Rubin encouraged me to write this essay and furnished numerous books from his collection which were essential to its completion; I am most grateful for his patience and enthusiasm. Because this topic is far from my usual areas of research, I have had to call on a number of people for assistance, especially in finding photographs. I would particularly like to thank Professor Richard J. Pearson of the University of British Columbia, Professor Esaka Teruya of Keio University, and Mr. Tanaka Yoshiyasu of the Tokyo National Museum for their help with the archaeological material. Mr. John Thayer of the Peabody Art Museum kindly arranged for me to use material from the collection of Mr. Ohwada, and Dr. Money Hickman of the Boston Museum of Fine Arts and Mr. George Kuwayama of the Los Angeles County Museum of Art provided photographs of works in their collections.

2. The most detailed study in English of the tattoo in Japan is Van Gulik (1982). This volume is especially strong on the later Edo period, and includes an extensive discussion of Ainu tattooing (1982:181–245). The section entitled "Tattooing in Prehistoric Japan: Some Implications and Cross-Cultural Perspectives" (1982:246–280) is extremely speculative, and should be used with caution by those not familiar with Japanese archaeology. Richie and Buruma (1980) is a good general introduction, including excellent color photographs. Thayer (1983) gives some interesting data. Van Gulik provides a lengthy bibliography, but it should be noted that he misses some sources cited by Richie and Buruma, and by Thayer.

3. The best general survey of Japanese archaeology in English is Kidder (1966). See also Elisseeff (1973) and Egami (1973). Since this paper has been written primarily with a non-specialist audience in mind, I will generally cite English sources when reliable ones are available. Japanese sources will be referred to when nothing is available in English, or if they contain specific material necessary to the argument. Recently an extremely comprehensive collection of essays has been published which will be highly useful for all scholars concerned with Japanese archaeology. See Pearson (1986).

4. Kidder (1965) provides a good survey of the figurines. For a much more detailed account see Esaka (1967).

5. This book is not cited by Van Gulick and appears not to have been noticed in the literature dealing with the tattoo in Japan.

6. Good surveys of Yayoi culture are Befu (1965) and Bleed (1972).

7. The important Chinese texts referring to Japan, translated by Ryusaku Tsunoda, can be found in Goodrich (1951). New translations can be consulted in Van Gulik (1982).

8. There is an enormous literature in Japanese dealing with the *Wei Chih* account of Japan. For a good survey of the issues see Yamao (1972).

9. Van Gulik (1982:246–249) analyzes this and related passages. Following the research of Torii Ryūzō, he points out that the story of the son of the ruler of Shao-k'ang of Hsia is based on an account of the first of the Chinese histories, the *Shih-chi* of Ssu-ma Ch'ien.

10. Although the term *Wa* (Chinese "Wo") is usually taken to refer to the people of Japan, it is important to note that it also can refer to the inhabitants of the southern part of the Korean peninsula as well as to other peoples.

11. It should be noted here that the history of the Sui Dynasty (A.D. 581–618), the *Sui-shu*, has a quite similar story concerning the Japanese: "Both men and women paint marks on their arms and spots on their faces and have the bodies

tattooed. They catch fish by diving into the water''
(Goodrich 1951:30–31). It is not clear if this account is
based on new material, or simply a repetition of the infor-
mation contained in *Wei Chih*.

12. Ledyard (1975) summarizes the evidence for the theory
first put forward by Egami. For a recent critique of the
theory see Edwards (1983).

13. For the English translation of *Nihon Shoki* I have utilized
Aston (1972), with occasional modifications. References
for the Japanese text are to the Iwanami Shoten series, *Ni-
hon Koten Bungaku Taikei*, volumes 67–68, edited by
Sakamoto Taro, et al., Tokyo, 1967 (abbreviated to
NKBT). The textual history of *Nihon Shoki* is of extreme
complexity; for an introduction see Yamada (1979).

14. Van Gulik (1982:7–9) presents a detailed analysis of this
passage in terms of Chinese ideas concerning slavery.

15. Philippi (1968) provides a general discussion of *Kojiki* and
a full translation. References for the Japanese text are to
the Iwanami Shoten series, *Nihon Shisō Taikei*, ab-
breviated NST (Aoki Kazuo 1982).

16. Kidder (1966:198–199) has a good diagram illustrating
some of the main varieties of face painting designs. For
color illustrations see Kidder (1965:pl. XII) and Miki
(1974:pl. 98).

17. Van Gulik (1982:10–18; Fig. 2) examines the scanty evi-
dence for the utilization of tattooing as a punishment. He
states that the Jōei Code of 1232 has a reference to facial
tattooing as a punishment.

18. Van Gulik (1982:181–245) has a detailed discussion of
Ainu tattooing, with extensive bibliographical citations.

19. See Obora 1982. This very important monograph is one
of the extremely rare examples of a scholarly study in
Japanese dealing with the subject of tattooing.

20. Van Gulik (1982:25–38) provides a detailed discussion of
the *irebokuro*.

21. A detailed study of the development of this novel is Irwin
(1953). An imaginary portrait of Shih Nai-an can be seen in
Hillier (1980:80–81).

22. For information on Takizawa Bakin, also called Kyokutei
Bakin, see Keene (1976:424–428).

23. For a general discussion of Kuniyoshi see Robinson
(1961).

24. The best source of illustrations for Kuniyoshi's prints
depicting *Suikoden* is Riccar Art Museum (1979).

25. For a detailed discussion of Yoshitoshi see Keyes and
Kuwayama (1980).

26. For the relationship between firefighters and the practice
of tattooing see Van Gulik (1982:115–180).

27. Tattooing was prohibited by government order in 1872,
just four years after the Meiji Restoration (Sekai Daihyakka
Jiten 1981:463).

28. Keene (1976:726) quotes Tanizaki as having written that
''The Tattooer'' was originally conceived of in a contem-
porary setting, but later placed in the Edo period.

29. Perhaps the most famous example is the painting
''Woman with Tattoo'' of 1919 by the very well known
Japanese-style painter, Kaburagi Kiyokata (1878–1972).
This work shows the woman dropping her kimono to re-
veal a butterfly on her left forearm and a floral motif on
her back. See Kobayashi (1975:21–22,112–113).

30. For early photographs of Japanese tattoos see Van Gulik
(1982:46–49,61–66).

31. Richie (1980:85–114) presents a well illustrated account of
the technical process. See also Van Gulik (1982:89–111).

32. It should be pointed out here that in Japan there is a very
strongly held belief that one's body is given to one by
one's parents, and that it is exceedingly disrespectful to
alter it in any way. Within this context, the tattoo is
viewed in highly negative terms.

33. Van Gulik also presents a very detailed analysis of the dra-
gon tattoo (1982:69–72,115–178).

34. See Iizawa and Fukushi (1973) and Japan Tattoo Institute
(1983).

The Spiritual Significance of Newar Tattoos[1]

Jehanne Teilhet-Fisk

In the kingdom of Nepal, nine miles east of Kathmandu, is the ancient city of Bhaktapur (Bhadgaon), "the City of Devotees." According to some traditions, Bhaktapur was founded in the ninth century by King Ananda Deva. Bhaktapur is well-known for its medieval temple architecture and its ornately carved representations of the Hindu/Buddhist pantheon. Architecture and sculpture in wood, stone, gilded brass, and bronze were created by anonymous masters during the reign of the Mallas (ca. 1200–1768). While much has been written about these elite art forms, little research has been done on the popular and folk art traditions, particularly body adornment and tattooing.

The indigenous population of Bhaktapur is referred to as Newar. They are predominantly Hindu, though there are several Buddhist cloisters (*baha*) in the eastern section of the city. It is an agrarian society; farmers (*jyapu*) account for eighty percent of the population. Today, *jyapu* belong to different castes, but all share agrarian concerns as well as a somewhat low social status. Gardeners (flower growers) and dancers, for example, belong to *gatha*, a low caste, as do the makers of pottery, *prajapati*.

This paper is a modest survey of the way tattoos and tattooing are perceived by Newar men and women in Talako *tole*, a *gatha* and *prajapati* district in Bhaktapur. The cultural meaning of this phenomenon has been examined through a collection of recorded interviews and with the assistance of a translator/informant. Published ethnographic research on tattooing in Nepal is virtu-

ally nonexistent. It is evident, however, from Arnold Rubin's article (this volume) that the art of tattooing among the Newar shares certain similarities with that of the peoples of Gujarat State in northwestern India. While Nepal and India are related culturally, Nepal has established her own variations of Indian themes, and this is apparent in the Newar interpretation of the spiritual significance of tattooing.

Newar tattooing is considered to be an ancient custom. How ancient and whether its origins lie in India is not known by present-day Newar. In former times, a person would apply his or her own tattoos when necessary. Even though there were professional artists and artisans in other media among the Newar, there were no professional tattooists. Today, many Newar still execute tattoos by hand, although there is a growing tendency to go to Kathmandu to have tattoos executed by a professional with an electric machine.

Once a woman has decided to make her own tattoos she chooses the designs carefully and draws them on her body with ink (pc:Ratha Mia Prajapati 1974). Some women manage to paint the backs of their lower legs and inside their ankles; other women ask women friends or an uncle on their mother's side to help them (Fig. 1). When a woman is satisfied with the designs and their placement on her body, she (and/or her helper) begin the tattooing process. The pigment, composed of ashes mixed with kerosene, is applied to the designs. The skin is pricked with an ordinary needle, and the pigment mixes with blood and flows into the minute punctures. The kerosene

1. *A hand-made tattoo, placed on the back of a Newar woman's legs.*

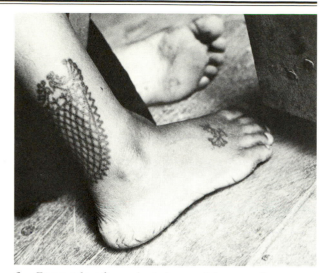

3. *Example of an electric-machine made tattoos with peacocks. Shanka Laxmi Dumuria.*

2. *Architectural elements framing doors and windows are very common in Bhaktapur as typified by this example. Some of the designs, such as Garuda seen over the doorway, are found in tattoos.*

and ashes are thought to act as disinfectants, and the puncture wounds begin to heal in a few days (pc:Ratha Mia Prjapati 1974). The color is blue/black and is distinctive against the peoples' light brown skin. According to one informant, blue/black is a tantric symbol for ''energy and power'' (pc:Visnu Bahadur Citrakar 1974; see Teilhet-Fisk 1978). Newar informants acknowledge this belief, but do not relate it to their tattoos. Of more relevance to them is the fact that tattoos do not fade. ''The tattoo will not fade and when we die, the tattoo stays with us'' (pc:Asha Maya Dumuria 1974). Tattoos may be added, but they are never touched up. Men who tattoo by hand use the same process as women and when necessary they are assisted by an uncle, brother, or male friend (pc:Krishna Banamala 1974).

In a city known for its panoply of religious ceremonies, it may be assumed that the tattooing process would involve a special ceremony or *puja*. There are, however, no associated rituals, nor does tattooing mark the transition from childhood to adulthood or from natural being to social being. Tattooing is done in any season and at any age, though in fact most Newar wait until maturity so the tattoo will not become distorted as the body changes. The majority of women interviewed were tattooed at the age of 17 or 18 years, before marriage. When asked if they must be tattooed before marrying, they said it really did not matter; the time is up to the individual woman (pc:Shanka Laxmi Dumuria 1974).

Tattoos chosen by the Newar seem to come from several different sources: traditional ''folk'' images also carved in architectural elements (pedi-

ments, window screens, and archways; Fig. 2); popular images chosen from a sheet owned by the professional tattooist; Hindu gods and goddesses; and contrived images.[2] The most popular designs are simply referred to as "flowers" and "birds" (Fig. 5). Flowers may have four, six, or eight petals; these may be reduced to a single "X" on the hand or serial groupings of Xs crosshatched on the calves (Fig. 7). Crosshatching resembles the carved latticework found on window screens and shutters. The top of the tattoo can be edged with birds, petals, or triangles, giving the impression of a net-bag or ornate flower pot (Fig. 3). The women, however, said only that flower tattoos were ornamental and made no reference to windows, bags, or even the eight-petaled polyswan (*parijat*) flower.

The peacock (the mount for the divine Brahma and Lakshmi) is the only bird the Newar specifically refer to when describing tattoos (Teilhet-Fisk 1978). It is often incorporated into flower designs on the calf. The peacock, often associated with compassion, is a popular image as exemplified by the prevalence of the "peacock window" in architecture (Fig. 4). Birds represented in profile resemble peacocks or roosters whereas a bird facing front with outspread wings represents Garuda the mythical mount of Visnu; Fig. 2). Certainly the rooster and Garuda would be permissible images to tattoo and perhaps once would have been recognized as such, but today such identifications are not generally made (Fig. 6).

Representation of the gods and goddesses are still important, however, and one must take care in selecting them from the Hindu pantheon. Any person can create any tattoo they want as long as it does not represent a powerful Hindu god or goddess, as is evident from the following. One female informant went to Kathmandu to be machine-tattooed (pc:Shanka Laxmi Dumuria 1974). She chose her designs from a book. For the back of her legs she chose the peacock-flower tattoo (Fig. 3). For her right forearm she selected the image of Krishna and his wife Radha.[3] The placement of an image of a god or goddess is important to the Newar. According to the informant:

> The image of the god must be placed on the forearm or hand, usually the right forearm because we believe the god must be on our right side. When people tattoo a god on their forearms, it is a special thing. It means that we will always have the god on our forearm and we believe that the god will always do good things for us. If a person chose a more powerful form of a god, such as Hanuman (the monkey-god, trickster), they must be very careful. Why? To wear a tattoo of Hanuman, one must be careful not to offend him, if

4. *A peacock window in Bhaktapur.*

5. *Home-made flower tattoo.*

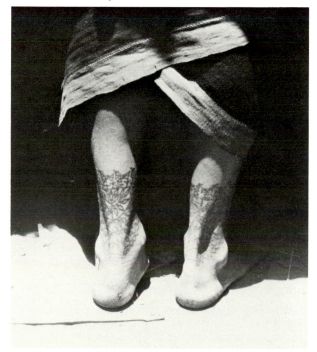

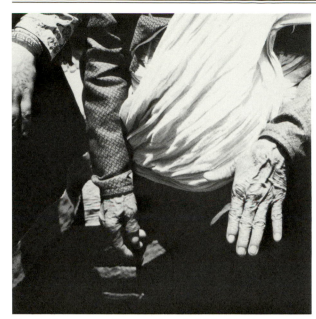

6. *Both women have a frontal bird tattoo on the left hand.*

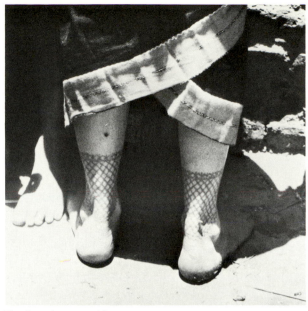

7. *Lattice motif tattoo.*

someone wears a wrong thing against the regulations of the gods, it is believed that that god may trouble that person (pc:Shanka Laxmi Dumuria 1974).

Of all the gods, Krishna is most frequently tattooed. Krishna and his wife Radha symbolize the ideal relationship between the soul and god. Śiva and Pārbatī (Pārvatī) are never tattooed "because they are too powerful. Bhimsen [the god of wealth] and Vishnu in his incarnation as Krishna, Rama and Narayan are used as a tattoo more often than Hanuman" (pc:Shanka Laxmi Dumuria 1974).

A male informant had the image of Bhaktapur and Radha machine-tattooed on the inside of his right forearm. He explained

> The most beautiful tattoo should be on the right arm. Newar men do not tattoo their legs and if they did, no image of a god would ever be tattooed on the legs. The legs and feet are dirty, they are disrespectful and untouchable parts of the body, that is why the women only tattoo decorative designs on their legs and feet (pc:Krishna Banamala 1974).

Newar tattoos are placed on areas of the body that are usually visible, with the exception of forearm tattoos, which are not visible when a person is formally dressed. The Newar custom of tattooing differs from those of the neighboring Tamang mountain people and the Taru plains people. Unlike the Newar, the Tamang and Taru tattoo their thighs, necks and on occasion, their faces. Newar

women place tattoos just below the hem of the *sari* on the exposed backs of their legs. "This is because we wear the *sari* in a special style, a scissor style that crosses in the back so the calves of our legs are exposed" (Figs. 5,7; pc:Asha Maya Dumuria).[4] When formally dressed, men wear jodphurlike pants that conceal the legs above the ankles. Both men and women wear tight-fitting shirts that wrap around the body and are tied. The long sleeves of these shirts prevent anyone from seeing the tattoos on the forearm. The Newar were hesitant to show or have photographed their tattooed images of the gods and goddesses because they believe it might offend the deities involved.

With the introduction of machine-tattoos, images of gods and goddesses seem to have become more popular. The Newar say the gods and goddesses are difficult to reproduce by hand, and they must be rendered correctly so as not to anger the gods. In addition, there is definitely an element of prestige and pride associated with having a machine-tattoo. "The tattoos are larger, they are clean. . . ." Clean? Clearly defined? "Yes . . . and they look better" (pc:Shanka Laxmi Dumuria 1974).

When asked why they wear tattoos, one informant replied that

> It was for beautification. The tattoo process is a little painful, but it is necessary—for beautification and we believe we will go faster to the other world because we will sell them on the way (pc: Ratha Mia Prajapati 1974).

Some said they tattooed their bodies for "beauty" but also believed they must have some wound. "The wound will bring us good luck in the next life. Tattooing gives us some pain and it leaves a permanent mark; this will give us good luck" (pc: Krishna Banamala 1974). When one woman was asked why she wears tattoos, she replied:

> It is beautiful and it is necessary to have a wound in this life because it will be good for the next life. Also the tattoos will not fade and it is said that when one dies, who has been tattooed, that person can sell their tattoo in the heavens. I do not know exactly why one sells their tattoo; maybe they sell it if they are having a difficult time getting into the heavens (pc:Shanka Laxmi Dumuria 1974).

In summary, Newar tattoos reveal to others the wearer's social position. Tattoos embellish and beautify much like jewelry, but they are permanent and therefore an intrinsic sign of the individual. Tattoos can signal to other Newar the wearer's relatively low status, but they also signal the wearer's sense of pride. Tattoos are not, however, the exclusive prerogative of only one caste; a number of castes may wear tattoos if they wish. The complete absence of tattoos sets apart members of very high castes. High status Newar are subject to strict sanctions against ritual pollution, blood-shedding, and bodily impurities. Tattooing is viewed by the Newar as a form of blood-shedding, a wounding process. From their point of view, it is important for them, as Hindus, to accrue religious merit through deeds and actions in this life in order to ensure an improved situation in the next life. Tattoo may be seen as a penance performed to affect future incarnation. The choice and placement of tattoos reflect this conscious desire for a better next life as well as symbolizing good luck, protection, compassion, and an ideal relationship between the soul and god in the present. In addition, it is believed that tattoos accompany the individual to the heavens where they maybe "sold"—to whom, or why is not known—to expedite the individual's transition to a better next life. And finally, the Newar take pride in the beauty of their tattoos. They would agree that not all tattoos are equally beautiful, but all tattoos have religious merit and therefore an inherent spiritual beauty.

Notes

1. The author is grateful to Dr. Robert I. Levy for confirming some of the interpretations given here from his own field notes on Bhaktapur. This paper could not have been written without the help and patience of Vishnu Bahadur Citrakar, Krishna Banamal, and Shanka Luxmi Dumuria. Field work was partially funded by an Academic Senate grant from the University of California, San Diego, for six months in 1974.

2. The only original tattoo the author saw was a geometric motif placed on the left hand.

3. In Nepal, Krishna worship is based on love, joy, and action which contrasts with the severe asceticism of some of the Shaivite cults.

4. Asha Maya Dumuria also said that the calves of the legs must have the same tattoos, whereas those on the hands and forearms could be different. The author, however, has seen a woman with different designs tattooed on her calves.

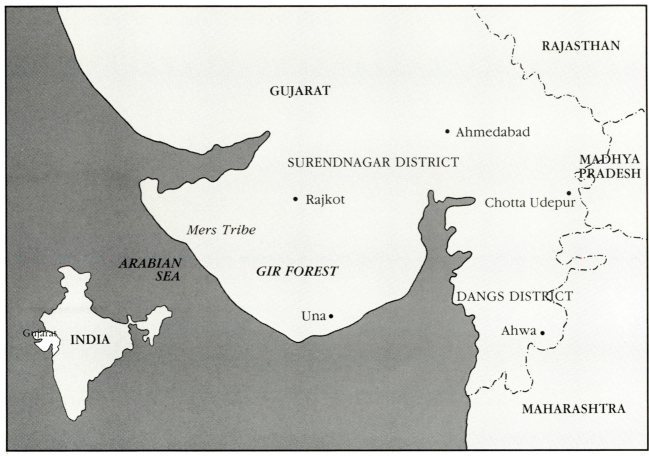

Map of Gujarat

Tattoo Trends in Gujarat
Arnold Rubin

Rama O Rama, my tattoos are of [the] colour of
 "*Hingalo,*" O Rama;
Listen, O Rama, uncle, brothers and grand-father,
 O Rama;
Mother and aunt and all return from the gateway,
 O Rama;
These tattoos are my companions to the funeral
 pyre, O Rama;
Rama O Rama, my tattoos are of the colour of
 "*Hingalo,*" O Rama.
(Mer women's song, Khistri (Saurastra), Gujarat)[1]

In twentieth-century India, as in most parts of the world, generalized national or international styles are replacing locally or ethnically distinctive dress and adornment.[2] Present-day attitudes, beliefs, and practices centering on tattoo among the peoples of Gujarat State in northwestern India, reveal the operation of this process.[3] One tradition is declining: tattoos done by hand, by women for women, using punctate, abstract designs, in a rural setting, as a social transaction. Simultaneously, a local version of the "International Folk Style" of tattoo (see Rubin 'Renaissance') has emerged: done with electric machines, by men for men, using linear, representational designs, in an urban context, as an economic transaction.[4]

Two previous studies of body art provide a conceptual framework for this investigation. For the Tiv of Nigeria, Paul Bohannan (1956, reprinted here) sketches the profound social, cultural, and psychological importance of scarification in demarcating the sexes, delineating the generations, and defining individual identity within each generation. For women in rural India, Doranne Jacobson (1971) elucidates the importance of jewelry in providing economic and, by extension, social security. Drawing upon these perspectives and the insights they provide, tattoo trends in Gujarat can be correlated with what seem to be fundamental changes in the conditions and parameters of individual and collective identity. The nature and character of changes within tattoo design inventories will be discussed, but emphasis is essentially on changes in practice: who tattoos whom, with what types of designs, using what equipment, for what return.[5]

This paper begins with an examination of tattoo in the Saurastra area of western Gujarat, emphasizing the Maldari (cattle-herding) castes: Rabari, Charan, Ahir, Bharward, and others of the Gir Forest and neighboring districts (Map). Among these comparatively remote rural peoples, the traditional patterns of tattooing of older generations of women survive alongside subsequent phases. Transplanted communities of these cattle-herding populations operate "urban dairies"—herds of cattle maintained on small tracts of land in residential and commercial districts of many towns and cities. Data from Ahmedabad and Rajkot reveal the influence of an urban way of life on the tattoo traditions of these herding peoples. Next, the more limited tattoo traditions of the Kokani and several other farming peoples of the Dangs district of southern Gujarat are surveyed. Third, consideration of tattoo among the Rathwas of the Chotta Udepur area of eastern Gujarat clarifies the key role of itinerant, specialized artists belonging to the Waghari caste in making the transition be-

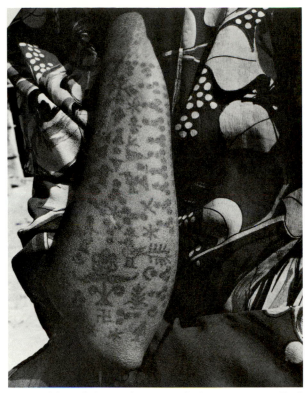

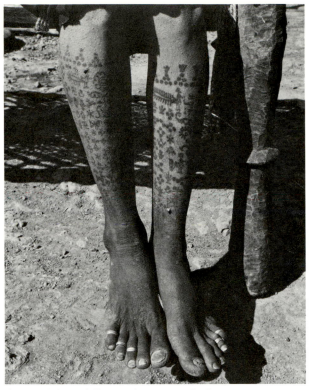

1. *Maldari (Charan) woman's forearm; Dudhala Nes (compound), ca. 16 km. from Sasengir, Talala Taluka, Junagadh District; photographed 20 February 1984.*

2. *Maldari (Charan) woman's legs; as 1.*

tween traditional and modern tattoo. Information on how the Wagharis are perceived as participants in the social and economic matrix of the region provides a framework for biographical sketches of three Waghari tattooists. The concluding section addresses some of the wider implications of tattoo trends in Gujarat.

Ideally this sort of study should be extended to changes in other aspects of dress and adornment, particularly jewelry, for which Jacobson (1971) provides an excellent foundation. For India, a key factor in precipitating this broad spectrum of changes seems to be the role of the mass media—particularly magazines and films—in disseminating current models for female self-design. Intriguingly, an editorial in the *Times of India* of 20 November 1983 (IV-4) regretted the general deterioration of the visual environment in India, noting that "the Indian aesthetic sensibility, it would appear, has always found its best expression in personal adornment, especially of our women." One wonders whether the writer would include the endangered medium of women's tattoo in this generalization.

Saurastra

The fairly extensive body of information available on tattoo among the Mers—settled farmers of the Sorath District—provides a useful point of departure for discussion of tattoo among the peoples of Saurastra (Trivedi 1952; Fischer and Shah 1970). As in the song introducing this essay, Mer women are poignantly aware of the inalienability of their tattoos and the importance of tattoos in defining individuality: 'After death, only the tattoo marks will accompany us, not prosperity or wealth. We may be deprived of all things of this world, but nobody has power to remove the tattoo marks' (Trivedi 1952:125).

The process of tattooing begins for Mer girls at seven or eight years of age with forearms and hands; the marks are eventually extended to cover feet and lower legs, neck and chest. Tattooing amounts to a girl's preparation for marriage, since "otherwise her mother-in-law is apt to taunt her that her parents are mean or poor" (Trivedi 1952: 123). Designs, composed of combinations of dots and lines, may be categorized as follows:[6]

Religion: image of a holy man; written name/ image of Ram, Krishna, Hanuman; footprints of

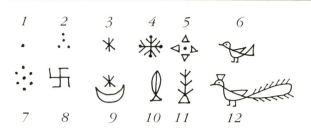

3. *Maldari women's tattoo designs. Recorded Feb. 1984 at Dudhala Nes, Talala Taluka, Junagadh District, 16 km from Sasengir.*

 1,7: laduda/ladudi: confectionary ball(s)—
 usually on hands.
 dot on cheekbone: trajvu ("tattoo")
 dot on chin: lardo
 2: deradi ("small temple")
 3: tradio ("star")
 4–5: pful ("flower")
 8: sathio ("swastika")
 9: bij ("second day of the bright side of the
 month; crescent moon")
 10: pandadu ("leaf")
 11: jar ("tree")
 6: chakali ("small bird; sparrow")
 12: mohr ("peacock")

Ram, Laxmi; blanket of Bhim; Shravana carrying his elderly parents in slings to the centers of pilgrimage; small shrines*; *Nature*: tiger, lion, horse, camel, peacock, scorpion, bee, fly; coconut tree, mango tree, date and other palms; flower*; almonds*; *Domesticity*: women carrying water-jars*; pedestal*; bullock-yoke*; saddlebags*; throne*; cradle*; well; step-well* (an architectural configuration typical of northern India); anchor; sowing-machine[sic]*; drum*; tray; sweetmeat*; pack-frame*; churn-cover; chain; patterns of food-grains*.

Traditionally tattoos were executed for Mer women by experienced women of the same tribe, although some were done by women of nomadic tribes—notably the Vagharis [sic] and Nats—in exchange for grain. Increasingly, however, the work is carried out by itinerant male professionals from Porbandar who use machines and are paid in cash. Mer males are rarely tattooed; their designs, executed in "linear style," are limited to a chainlike ornament around the wrist or occasionally a camel on the back of the hand or on the right shoulder. Other motifs include names or stylized representations of Rama, Krishna, or Hanuman.

Devmurari's (1979:89–99) more recent inventory of tattoo designs worn mostly by women among the Maldaris of Panchal, Surendnagar District also emphasizes combinations of dots. Refer-

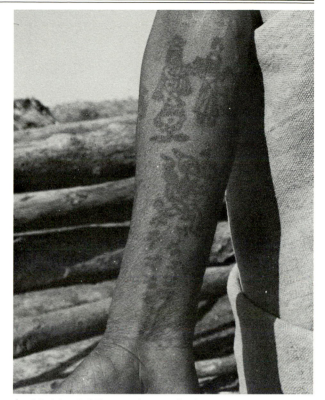

4. *Maldari (Charan) man's forearm; as 1.*

ences to nature and domesticity predominate, although radio, padlock, key, airplane, and parasol attest to the impact of the material culture of modernity. Devmurari reports that women believe tattoos are fascinating to the opposite sex and that men believe that tattooed women are more faithful.

Elements of modernity in dress, adornment, and other aspects of material culture are evident, particularly among the younger generations, in the isolated and remote Maldari compounds near Sasengir (Charan caste) and Jasandhar (Ahir caste) on the periphery of the Gir Forest Wildlife Reserve. Nevertheless, one senses a deep commitment to traditional ways, including tattoos. Young girls begin the tattooing process between six and ten years of age on hands and arms, followed by feet and legs, throat and chest (Figs. 1,2). Formerly the work was done by hand by older women of the family, or friends, but nowadays Waghari tattooists based in Una or other large towns tour the area. They previously also worked by hand, but more recently use battery-operated machines. Sometimes the client, sometimes the tattooist, decides on the designs. Geometric designs are still preferred, although previous arrangements of dots have given way to linear motifs among women between about fifteen and thirty years of age (Fig. 3).

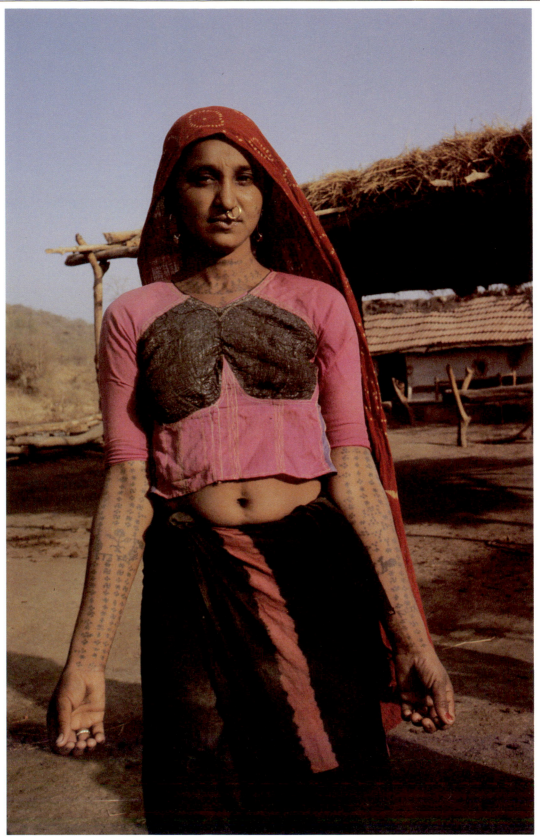

5. *Maldari (Charan) woman's arms; Panchali Nes, ca. 22 km. from Sasengir, Talala Taluka, Junagadh District; photographed 20 February 1984.*

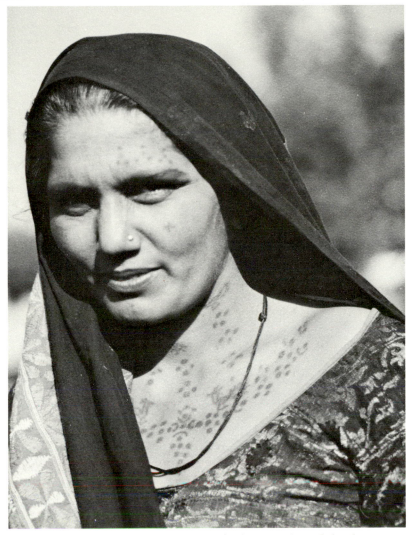

6. *Rabari (Bartia) woman's throat; Ahmedabad;
photographed 8 November 1983.*

Those few males who elect to be tattooed (usually at ten to fifteen years of age) choose one or two isolated designs, such as scorpion or peacock, or representations or the written names of Krishna, Rama, or Hanuman for the inside of the right fore-arm (Fig. 4). Increasing numbers of young people, especially those who go to school or who have experienced the larger cities, are declining to be tattooed.

Broadly similar patterns are evident among the Bharwad community settled in Rajkot: girls traditionally begin the process of being tattooed at about seven years, for "custom and beauty." Tattoos may be refused, but "if somebody is not tattooed, she will be reborn as a camel." The work is done with electric machines by predominantly male, itinerant Waghari specialists, usually at religious fairs but sometimes at home with a group of friends and relatives. Usually the tattooist decides on the designs, although the client may assert her preferences. A few men choose to be tattooed with, for example, a wristwatch, or (on the inside of the right forearm) the name or image of Ram or Krishna, *om*, a swastika, or a wife's or friend's name. Among both the urban Bharwads of Rajkot and the urban Rabaris of Ahmedabad, earlier generations of women were extensively tattooed with patterns of dots on hands and arms, feet and legs, throat and chest (Figs. 5,6). Younger women are increasingly disinclined, however; a Rabari girl of about sixteen years had only one dot on her forearm, and it is considered likely that the next generation—now about seven years old—will not be tattooed: "We are now city people, and tattoos are old-fashioned."[7]

Dangs

Dangs is generally regarded as among the most backward and impoverished areas of India. Traditional tattoo among the peoples of Dangs appears to have been much more limited in scope than in the Saurastra area and different in other respects as well. Present-day trends are similar, however.

For the Kumbis (Kokanis) and Warlis of Dangs, Koppar (1971) discusses the primacy of arboreal/vegetal motifs tattooed in the center of the forehead at the base of the nose (for both men and women) in terms of vestigial totemism or tree-worship.[8] The motif involved, sometimes with arches above the eyes down to the temples, is done in fairly large, widely spaced dots; sometimes a lotus symbol (a central dot surrounded by smaller dots) is added on the cheeks. Personal beauty is identified as the primary rationale for the tattoo, but "they believe that a woman without [tattoos] will not go to heaven." Further, "the tattoo is considered to be the art of the woman. The tattoo for men is made by men and for young girls and children by women. Generally they are made early in childhood . . ." (1971:81–82). Koppar later notes, however, that many tattoos are done by professionals in the Dangs Durbar, a great fair held annually at Ahwa during late February or early March.

Interviews with members of the Kokani, Warli, Kathode, and Bhil communities in the villages of Baripara, Golcund, and Borkul did not support Koppars' association of forehead tattoo marks with arboreal totemism. However, all configurations were invariably characterized as representations of vegetable forms (tree, wheat-stalk, millet-stalk), usually with some allusion to ethnic exclusivity. Recent preferences were toward smaller and increasingly condensed designs, in some cases reduced to a single dot (Fig. 7). Some older men and women had ornamental tattoos (peacock, wedding-crown, images of Shiva, Krishna) on forearm or chest. A few older women had a cosmetic dot tattooed on their chins or between nose and eye, or angles tattooed at the outer corners of their eyes. Tattoos were done—first by hand, later by machine—by outsiders called Gonari (or Gondbhil) who came from Maharashtra or from other parts of Gujarat. The work was done in the local market or, if there were enough children, at home, which was preferred since the markets were far away. Marks were voluntary and obtained without ceremony, "for beauty," according to personal taste, although

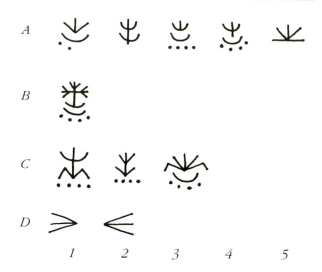

7. Dangs forehead tattoo designs, center of forehead, base of nose (March 1984. Single dot: D (= Dangli language) tik; G (= Gujarati language) chandlo.

 A 1–4: *Baripara village, Warli women (related to Kokani)*
 D guhu, "wheat stalk"
 A 5: *Borkul village, Kokani schoolgirl: "modern" version of guhu*
 B: *Warli woman from Sewermal village: D bajiri, "millet stalk"*
 C 1–2: *Baripara village, kokani women: D char, "tree"*
 C 3: *Borkul village, Kokani schoolgirl: "modern" version of char*
 D: *Warli women from Sewermal, Bripara villages: angles at corners of eyes: D pakali, G kuna ("angles")*

several informants mentioned that the marks would go with them to paradise; and, in one case, "if one is not tattooed and after death goes to God, a red-hot plowshare will be used to make the mark." Yet, the same informant asserted that, although marks were widespread until about ten years ago, the next generation, educated or in contact with the wider world, will not be marked: "People have improved now, so they don't get tattooed; those who are educated say this is a bad practice."[9] This opinion was echoed everywhere and reinforced by an informal census of the students in one village primary school: of the group of thirty-seven boys and fifty-three girls (aged eight to fourteen, approximately), five boys and fifteen girls were tattooed; of these, three boys and twelve girls had only the forehead dot, and the remaining children each had a small flower.

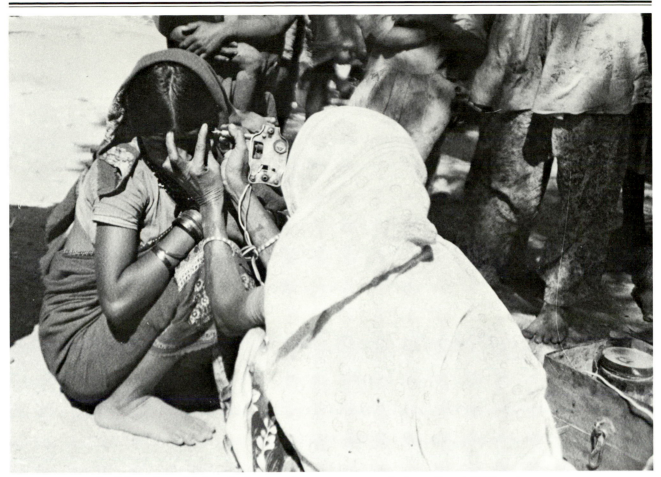

8. *Dhaniben Mohanilal tattooing eye-corner designs for a Rathwa woman;*
Devhat market, near Chotta Udepur; photographed 1 March 1984.

Chotta Udepur

Although still predominantly rural in character, eastern Gujarat seems to be comparatively prosperous, with extensive agricultural development, construction, and mining projects under way. Much of the surplus income realized by workers on these projects—both men and women—appears to be invested in dress and adornment, including jewelry and tattoo.[10]

Among the Rathwa farmers of Raisingpur and neighboring villages, some tattoos can be described as virtually "tribal," while others are entirely optional and ornamental. An upward curving line is tattooed at the outer corner of each eye for practically all boys and girls in their early teens (Fig. 8; cf. Parmar 1981:150,152). This mark is usually paid for by the child's parents: "If we don't have it, people will ridicule us." On the other hand, people are aware that tattoos identify them as tribal, and hence inferior; at an *ashram* school assembly near Devhat, I saw not a single fa-

cial tattoo of any type. Men living a more traditional life may add a name or a small ornamental motif (mango tree, horse, peacock) on the forearm, but the practice is reportedly dying out. For cosmetic reasons, "for beauty," women who worked as laborers and had sufficient money of their own might add (before marriage) one to three dots at the inner corner of one eye, a triangle made of dots on the chin, and single or double triangles (made with lines, representing a mango tree, often combined with other motifs, such as a peacock or step-well), on the inside and outside of their ankles, inner forearm, or back of hand (Figs. 9–11). Formerly women tattooed their female friends (or male relatives) by hand, but most work is now done professionally with machines in the markets. One itinerant female Waghari tattooist named Dhaniben Mohanilal, based in Chotta Udepur, appears to have been responsible for tattooing most of the young people of neighboring villages.

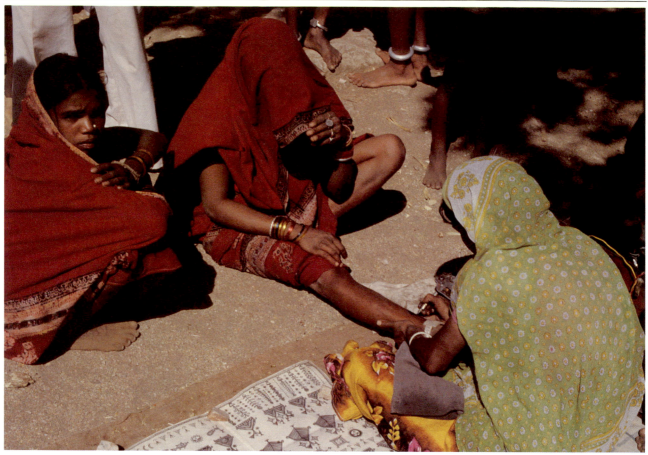

9. *Dhaniben Mohanilal tattooing a Rathwa woman's ankle; as 8.*

10. *Ankle design (fig. 8) finished.*

11. *A Rathwa woman's ankle designs (healed; similar to fig. 9); Raisingpur village, near Chotta Udepur; photographed 2 March 1984.*

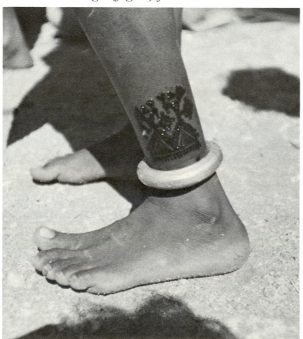

ceptional among the castes of India in that they are nonspecialized, i.e., can follow many occupations, especially those associated with commerce, so long as their social prestige is not lowered.[11]

P. G. Shah (1967) presents essential historical and ethnographical background on the Wagharis. In 1952 their population was estimated as about 12,400,000, concentrated in Saurastra but found as far away as Bombay and Delhi. Shah characterizes the Wagharis as highly assimilated landless traders who link forests and plains, Hindus and tribals. He considers that they do not themselves constitute a "tribe." Noting that the Wagharis were previously classified as a criminal caste, he suggests that their intelligence and versatility, their "instincts, habits, and customs," indicate instead that they "form the residual of an ancient Hindu predatory group." Quarrelsome, unaccomodating and aggressive, stigmatized as meat-eaters and drinkers of spirits, "they are greedy and are interested in anything which bring [sic] in immediate monetary returns. . . . Their life is found to be very irregular and insecure." Shah quotes the 1931 census in describing the traditional occupations of the Wagharis as hunting and fowling in transition to gardening, petty trading, cattle-rearing, agricultural labor, repairing of grindstones, begging, and porterage; also "they catch birds and make rich Jains and Hindus pay for letting them go." Shah noted their then-current occupations as seller of vegetables and *ghee* (often adulterated) and farm-laborers, with many of them moving into urban factories. Some traditional occupations were noted as continuing, such as making and selling chewing-sticks for cleaning the teeth and trading kitchen utensils for old clothes which are refurbished and sold in village markets. Intriguingly, tattoo is nowhere mentioned.[12]

Except in Dangs, itinerant professional tattooists mentioned in the foregoing narrative were invariably identified as Wagharis. The following biographical sketches of the three tattooists I encountered in the field—all of whom were Wagharis—amplify these data.

Bikabhai Dhantani, about sixty years of age, lives in a shantytown on the bank of the Sabarmati River in Ahmedabad, the state capital and industrial hub of Gujarat (Fig. 12). A friend of his father's taught him to tattoo about forty years ago. He made his own machines and design-sheets. He works exclusively as a tattooist, traveling regularly to rural markets and religious fairs. He has had no apprentices. On his own, about ten years ago, he began to create micro-miniature tattoos on fingernails. Most of his work is traditional, however,

12. Bikabhai Dhantani with tattooing equipment; outside his house, Sabarmati riverside near General Hospital, Ahmedabad; photographed 24 February 1984.

The Wagharis

At Rajkot, Jaymarbhai Parmar (pc:9 November 1983), an expert on local folklore, informed me that until thirty-five or forty years ago there was no clear distinction between urban and rural populations in Saurastra and Kutch, and tattoo was ubiquitous among herders, farmers, and rural people generally. Haku Shah (pc:8 November 1983) brought focus to this evolution for present purposes, pointing out that while tattooists still tend to congregate at pilgrimage centers, religious fairs, and markets, working predominantly for rural women, their traditional clients, they are also found around railroad stations and other gathering points in the large cities, working for urban male clients. He also pointed out the importance of the Waghari caste as providing the tattooists who are the agents of this shift. Siddharaj Solanki (pc:24 February 1984) clarified the socioeconomic basis of this trend by characterizing the Wagharis as ex-

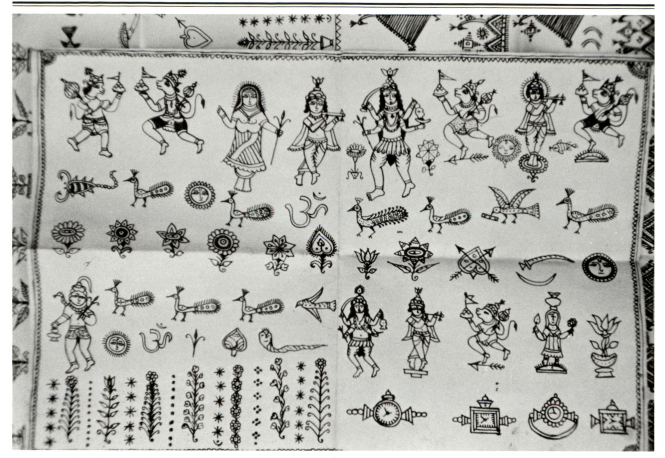

13. *Tattoo design sheet by Dhaniben Mohanilal: Hindu deities, peacocks and other birds, floral motifs, wristwatches, etc.; Chotta Udepur, photographed 2 March 1984.*

done on village Rabari girls of about ten years of age. He considers that his business is increasing, with clients from all castes. Designs preferred by his clients relate to love, friendship, and deities.

I met Dhirubhai Bhanubhai tattooing on the sidewalk outside the Rajkot railroad station. He has been tattooing for about forty years, first at Muli in Surendnagar District and for the past twenty-five years in Rajkot. He tattoos full-time, traveling regularly to fairs and markets in the surrounding area. His father was not a tattooist. As a child, he and his friends tattooed each other by hand. At about fifteen years of age, on a visit to Baroda, he bought an electric machine and began tattooing commercially. He made the design-sheets and machine he is presently using and five machines for other tattooists. He knows of "eight or ten" other tattooists—all Wagharis. His eldest son tattoos part-time, along with trading in stainless steel utensils. Most of Dhirubhai Bhanubhai's work is still done for young women of the Ahir, Bharwad, Korali, Mer, and Patel tribes/castes, mostly as preparation for marriage. He says that if

a bride were not tattooed, her in-laws would protest that she had been sent to them "like a man" (cf. Fischer & Shah 1973:110). Dots predominated when tattooing was done by hand, but machines make possible more complicated designs. Nowadays, names of friends or deities are most frequent, but there is generally less work than formerly, when he regularly tattooed even Brahman and Banian men and women with good-luck/religious designs. Both village women and urban Hindu female prostitutes are getting fewer tattoos than before. In the city, he notes a general shift to male clients and representational, predominantly religious designs.

As noted earlier, Dhaniben Mohanilal appears to have been responsible for tattooing most of the young people of the Chotta Udepur area; she was working almost without interruption during the day I met her at Devhat market (Figs. 8–9). She grew up at Vasna, near Sarkhej, in Ahmedabad District on the boundary of Saurastra, where her father supported the family by exchanging kitchen utensils for old clothes which they repaired and

sold. She was taught to tattoo by her former husband, who had been taught by his elder brother; both died of a lung disease that she believes was brought on by the wet cells they used to generate electrical current for the machine. (All other tattooists I observed used dry cells.) She herself has a chronic cough and expects to die soon; for this reason, she refuses to teach tattooing to her current husband (who acts as her assistant) or any of her children. Her former husband died about nine years ago, after they had lived in Chotta Udepur for about twenty-five years. She uses his equipment and designs (Fig. 13). She began tattooing about five years after marriage, and currently spends most of the year (excepting the four months of heavy monsoon) tattooing in nearby markets. Most of her clients are female tribals who prefer geometric designs; Hindus and more cosmopolitan people from Saurastra and Kutch prefer representations of deities.

Conclusions

The foregoing survey of tattoo trends in Gujarat was introduced by the proposition that two collateral traditions or modes can be perceived in terms of a set of oppositions which can now be expanded somewhat: on the one hand, tattoos done by part-time specialist females by hand, predominantly for female friends and relatives, in a rural setting, using highly abstract designs mostly depicting domestic motifs and based on combinations of dots, primarily as a social transaction; on the other, male operators working as paid professionals, on male strangers, in an urban setting, using electric machines and linear calligraphic or representational designs in which religious (i.e. Hindu) themes predominate. A transitional stage—nomadic women tattooing their neighbors as an economic specialization—is also evident. All tattoos—traditional tattoos for women, "modern" tattoos for men—are executed without ostensible ceremony, but are clearly aspects of "coming of age" for both sexes. In particular, the importance of tattoos for women as a preparation for marriage situates tattoo squarely within the distinctive, spectacular complex of dress and adornment associated for both sexes in India with weddings (Elson 1979; Fischer and Shah 1973:111). The visual aspect of this high point of social and cultural fulfillment in the life of the individual may help to explain the frequency of the peacock, a paradigmatic image of resplendence, as a tattoo motif for both sexes.[13] Thus, tattoo in Gujarat is bound up with defining

the parameters of collective identity on the one hand, and amounts to preparation for (and attests to completion of) a key rite of passage for the individual, on the other. An observation made by Gupte (1902:298) elucidates the numerous references which I heard to the importance of tattoos for entry into heaven (and, conversely, of the undesirable consequences of *not* being tattooed, such as branding or rebirth as a camel): "The fear of losing one's identity in heaven among these wandering tribes is due to the fear of being abducted or lost on earth in the jungle. . . . The marks migrate to heaven [with the soul]. . . ." For the neighboring Bhils of Madhya Pradesh, Parmar (1981:151) reports a belief "that the figures drawn on the body are the evidence of good deeds which go with a person to his post-mortem existence. With them he is in a position to explain his past."

More specifically and profoundly, however, traditional tattoo clearly fostered and focused identity and individuality for women. This conclusion is supported by Dhirubhai Bhanubhai's comment that an untattooed bride's in-laws would complain that she had been sent to them "like a man." Even more striking in this regard is the haunting poem with which this essay began: The woman addresses the dominant male principles in her life, particularly those who function as custodians (and, after marriage, defenders) of her person and all of her family's heritable property (except her own personal jewelry, which also eventually passes from her control [Jacobson 1971]). She observes that even her closest female relatives will not accompany her beyond the gateway on the road that leads to her funeral pyre, that only her inalienable tattoos are uniquely hers, and her. Finally, the vermillion color of her tattoos, is also the color of the pigment applied to her hair-parting which identifies her as a married woman, the color of blood, and the color of the flames which will consume her body after death.

Association of tattoo with identity and individuality as well as the protective function of representations of Hindu deities probably underlies the increasing frequency of name tattoos. However, Siddharaj Solanki (pc:24 February 1984) warned me against the assumption that tribal and Hindu cultures are cognate. Indeed, one aspect of the tattoo trends among the tribal peoples of Gujarat may be described as Hinduization(a corollary of modernization or Westernization), a general shift from independence to interdependence —to "all-India" values—in cultural and social life. Srinivas (1956:197,202,209) identified a process of

religious and cultural change, which he called Sanskritization, whereby a low-ranking caste might be able, "in a generation or two, to rise to a higher position in the hierarchy by adopting vegetarianism and teetotalism, *and by Sanskritizing its ritual and pantheon*" [emphasis added]. Further, during the period of British rule, "the development of communications carried Sanskritization to areas previously inaccessible, and *the spread of literacy carried it to groups very low in the caste hierarchy*" [emphasis added]. Finally, Sanskritization, as a mechanism for fostering social mobility and cultural change within the caste system, "canalized the change in such a way that all-Indian values are asserted and the homogeneity of the entire Hindu society increases."[14]

Placement of men's tattoos on the right forearm may relate to the importance of the right hand in Hindu belief; for Hindus, the right hand is generally associated with "good omens" and used for all forms of interaction with the natural and supernatural worlds, such as eating, writing, sacrificing and, for Brahmins, tying the sacred cord. The process of Hinduization among the tribal peoples of Gujarat appears also to be reflected in the increasing importance of writing in the rural/tribal tattoo repertoire (cf. Parmar 1981:151).

This line of analysis may help to explain the character of the tattoo designs themselves. Haku Shah (pc:8 November 1983) suggested that Gujarati women's traditional involvement in sewing, quilting, and embroidery may help to explain the punctuate character of their tattoos.[15] Conversely, the flowing, cursive character of the *dev negri* script in which vernacular languages are written may provide a visual basis for the highly ornamented linearity of representational tattoos.

The foregoing spectrum of historical and cultural factors centering on tattoo trends in Gujarat seems to coalesce in the statement by Parmar (1981:156–157) about the peoples of Malwa, in neighboring western Madhya Pradesh,

> The complicated patterns of the floral type, which are frequently seen over the bodies of many women, are not very old. The figures of the monkey-god Hanuman, God Shiva or Lord Krishna fascinate the menfolk of this region but they are also not genuine as they do not come under the category of the traditional tattoo marks—the marks which are associated with the crude method of needle-pricking. Such figures came into vogue only after the First World War.

I have found no comparable observations regarding the tattoo of Gujarat but believe that the data presented here probably indicate similar associations and the same chronology.

Notes

1. Trivedi (1952:125) identifies *hingalo* as a vermillion pigment derived from mercury [sic] oxide, but adds, "I have not seen any Mer with red tattoo marks during my fieldwork. It is likely that the song refers to a practice which no longer exists."

 The research reported here is based on a total of about one month of intensive fieldwork carried out at intervals between November 1983 and March 1984 during my tenure as a Fulbright Research Fellow. The grant was administered by the United States Educational Foundation in India (Mrs. Sharada Nayak, Director), in affiliation with the Department of African Studies, University of Delhi (Dr. V. P. Luthera, Head). I gratefully acknowledge the extraordinary efficiency, sensitivity, and hospitality of these institutions and their personnel at all levels.

 I also wish to extend my gratitude to Dr. R. B. Lal, Associate Director of the Tribal Research and Training Institute, Gujarat Vidyapith, Ahmedabad, who organized my investigations in Ahmedabad, the Chotta Udepur area, and Dangs. I was privileged to have Dr. Siddharaj Solanki of TRTI as collaborator and associate during my fieldwork in eastern and southern Gujarat. I greatly benefited from the experience and insights of these scholars; of the TRTI Director, Dr. T. B. Naik; and of Haku Shah, whose contributions to the study of the art and culture of village and tribal India are well known. Kantilal Makawana assisted me during my work in Ahmedabad.

 Eberhard Fischer generously shared with me his long experience of Gujarat and other parts of India. Dr. O. P. Joshi of the HCM Institute of Public Administration, Jaipur, and a longtime student of tattoo and other forms of folk art, introduced me to his friend and colleague Dr. Haribhai Patel of the Department of Sociology, Saurastra University, Rajkot, with whom I collaborated in Rajkot and the Gir Forest area. Vasant Bharve and Dr. Sudhaker Khomne of Ahmednagar College coordinated a brief period of comparative work among the Nandiwallas of the Ahmednagar area of Maharashtra; the hospitality of Dr. Plamthodathil Jacob, Principal of the College, must also be acknowledged. Cecelia Klein, Cliff Raven, and Frances Farrell helped with critical readings of earlier drafts of this essay, and Robert Brown directed me to key sources in several unfamiliar areas of the Indian bibliography. Finally, I am grateful to the tattooists mentioned here, and to their clients, for their patience and generosity in sharing their art.

2. See Joshi 1976; Faris 1972:2–3.

3. Regarding the history and ethnography of Gujarat, see the bibliographical essay in Pearson (1976:161ff.) and, for a brief introduction to village life in Gujarat, Durrans (1982). Elson's (1979) survey of dress and adornment in Kutch supplements the present study but emphasizes textiles and jewelry. Many ethnographies of Gujarat include brief references to tattoo, sometimes including descriptions of technique, e.g., Lal 1979:74; Mathur 1963:35; Trivedi 1952:124–125; Koppar 1971:83; Ruhela 1968: 136–137; Fischer & Shah 1973:107–109; Parmar 1981:157.

4. The elements of these oppositions were sketched out by Haku Shah (pc:8 November 1983). According to Bikabhai Dhantani (pc:24 February 1984), a Waghari tattooist, a distinction is made in the Gujarati language between hand-made tattoos, called *trajava*, and those made by machine, *chundana* (cf. Fischer & Shah 1973:107,112). Both types

are executed solely in black, usually a suspension of carbon in the form of soot. Trivedi (1952:122) noted the predominance in western India of tattoos developed through combinations of dots, in contrast to the linear character of designs elsewhere on the subcontinent.

Requirement of modesty in relations with male outsiders complicated access to younger married women, and tattoos of older women tended to be difficult to read. Electric tattoo machines in India are similar in design to those used elsewhere in the world (see Rubin 1985). Dispersed throughout Europe and the United States during the early twentieth century, they employ a modified, battery-operated electromagnetic "doorbell" circuit that vibrates a needle-tipped rod through a paint-charged tube into the skin (Tuttle 1985:25).

5. Design catalogues and inventories are standard features of studies of Indian tattoo; see e.g., Joshi 1976; Trivedi 1952, Fischer & Shah 1973:112–118; Parmar 1981:151–154.

6. An asterisk indicates a design composed mostly or entirely of dots. According to Fischer & Shah 1970:219, the most common designs are triangles and crosses composed of dots, flower, mango tree, peacock, lion, and dromedary. Trivedi (1952:124–125) describes the process as employing "a reed stick having two or three needles inserted at one end in such a way that only about ¼ of a centimetre of the points remain visible." The skin is stretched, the instrument is dipped into the pigment, the design is pricked into the skin, and more pigment is rubbed in. The traditional palette included black, green, and (reportedly) red colors, but see note 1 above. Fischer & Shah (1973:108–110,113–118) provide detailed information on hand-tattooing technique among the Harijan and Rabari communities of Kutch and a catalogue of designs which generally corresponds to Trivedi's.

7. A similar pattern was encountered among Karadia Rajput farmers near Jasandhar: no tattoos among younger women who would traditionally already have had extensive work; a few representational tattoos among old men; no tattoos among younger men. The reason given for this decline was that "society is changing." Conversely, at an urban dairy in Surat in southern Gujarat, female Bharwad immigrants between about fifteen and thirty-five years of age from the Bhal area had extensive dot-work, mostly done by Waghari tattooists while the women were visiting their home area.

8. Robert Brown (pc:18 October 1984) suggested that the vegetal associations of such marks "must relate to a very popular and widespread form associated with the *Kala* or monster face seen throughout South and Southeast Asia" and referred me to Bosch (1960:40). Siddharaj Solanki (pc:4 March 1984) identified the Kokanis as the largest of the five major populations inhabiting Dangs. Koppar (1971:86) notes that "the Bhils, Gamits, and Nakias do not have tattoo marks, except of course where they have been influenced by other dominant tribes. Elsewhere in south Gujarat, the tribes like Dhodias, Dublas, Dhankas, Naikas and others do not have any tradition of tattooing."

9. Siddharaj Solanki (pc:4 March 1984) attributed this negative judgment to the influence of elite models espousing Ghandi's denunciation of all forms of ostentation and ornamentaton as signs of provincialism and backwardness.

10. In India, female laborers do most of the heaviest work on roads, building construction, and similar activities.

11. Among excluded occupations are those of sweeper and scavenger. Solanki has written a monograph (in Gujarati) on the Wagharis, entitled *Gujaratna Waghario*, Tribal Research and Training Institute, Ahmedabad, 1979.

12. Shah 1967:iii,vi–ix,1,3–5,41. The women of the nomadic Killekyatha and Kunchi Korava of northern Karnataka State similarly discharge a number of economic functions (including tattoo by hand) for the settled populations among whom they move; see Morab 1977:27–28; 1982: 256–257; also Parmar 1981:156.

13. An informant in Rajkot explained the frequency of the scorpion motif as a covert reference to the intense sensations of physical love. I was unable to confirm this explanation elsewhere, however.

14. Staal (1962:225) demonstrates that the term Sanskritization applies strictly to linguistic change, and reinforces Srinivas' own assertion that Hinduization is a more valid term for anthropological and historical analysis. I am grateful to Robert Brown for calling these two articles to my attention.

15. Cf. earlier references to Waghari involvement in the repair of old clothes; also Morab 1977:27; 1982:256 regarding Killekyatha women's economic importance for their neighbors as quilters as well as tattooists.

OVERLEAF: Bontoc male with tattoo, Northern Luzon, Philippines. Early twentieth century photograph by Charles Martin in UCLA Museum of Cultural History Artemas Lawrence Day Archives.

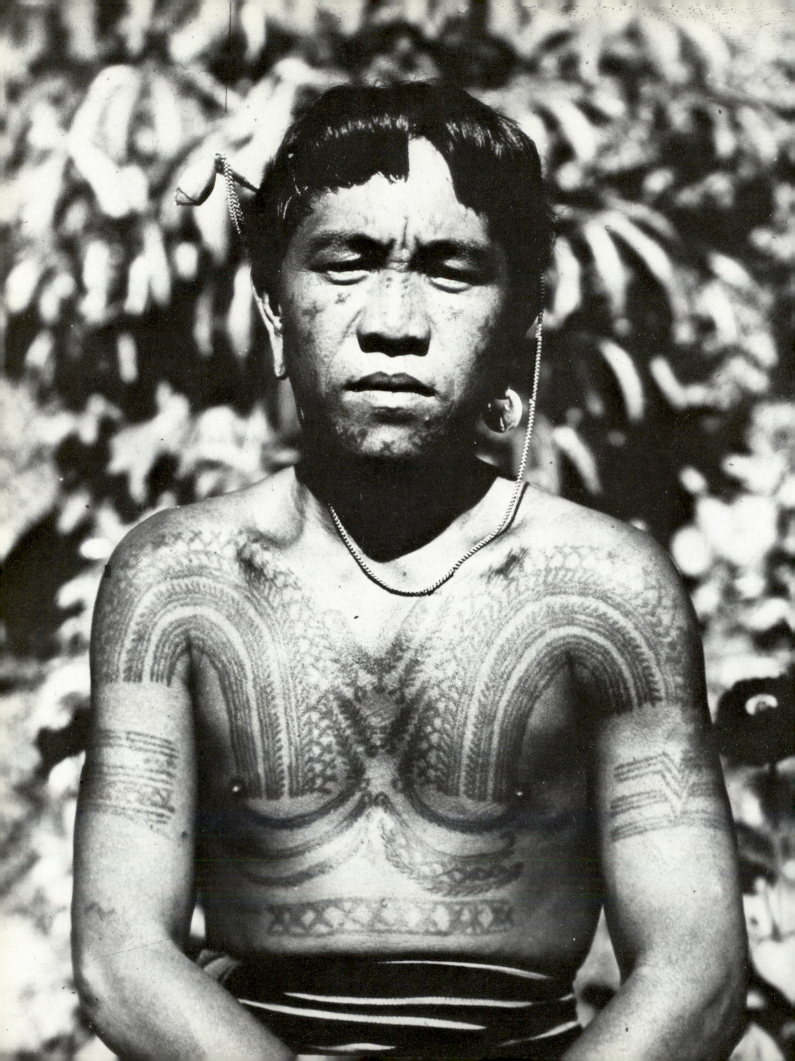

Introduction: Oceania
Arnold Rubin

According to a myth analyzed by G. B. Milner, a pair of female deities—originally Siamese twins—introduced tattooing to Samoa. They swam to Fiji where they were instructed in the medium by two male artists and given a formula "which they were to memorize and take back to their own country:

Tatau fafine, ae le tatau tane
Tattoo the women, but don't tattoo the men.

On the return journey, the twins kept repeating this message as they swam. As they were nearing the coast of Samoa, however, they spotted a tridacna shell (a large edible bivalve) lying on the sea-floor inside the reef, so they dived down to get it. When they came up again, they went on repeating the message, but it had become jumbled. It now ran:

Tatau tane, ae le tatau fafine
Tattoo the men, but don't tattoo the women.

And that is why, down to this day, Samoan men are tattooed but not Samoan women."[1]

Milner's (1969:21) structural analysis of this myth leads to the following conclusions:

The function of tattooing . . . is to restore the balance between the sexes. Or to put it in Levi-Straussian terms, the institution of tattooing mediates between nature and culture, man and women, pleasure and pain, life and death, and is typified by a monster in the shape of two female Siamese twins, joined back to back, whose function is to give pain to man and joy to woman to a degree which is notionally equivalent to the pain that child-birth gives to woman, and to the joy that child-birth gives to man.

Immediately apparent is the striking contrast of this interpretation with the principles which seem to underlie African cicatrization of women, attesting to the astonishingly wide range of meanings which can be invested in these media. The Samoan myth also encapsulates a number of themes more broadly relevant to an understanding of the nature and significance of tattoo and other irreversible forms of body-art in Oceania—notably, the importance of the seaborne migrations which brought people, ideas, and practices to the major island groupings, and the many ways they provide for ostentatiously emphasizing distinctions in status and between the sexes.

Gathercole notes the apparent antiquity of tattoo in west-central Polynesia, a major center of dispersion within the Polynesian triangle, as proposed by Bellwood and Green. This conclusion is based on the discovery of bone tattooing chisels with "Lapita associations in Tongan archaeological contexts of the late second millenium B.C.," and resemblances between Lapita pottery designs and more recent bark cloth and tattooing motifs. The extraordinary seafaring skills and inclinations of Polynesians (and, for that matter, other Oceanic peoples) are well known. In migratory contexts, they faced the necessity of sustaining a sense of the roots of their culture across vast distances while, so to speak, re-creating and re-integrating these roots in the new circumstances in which they found themselves. Since the amount of

material culture which they could bring on such voyages was limited, mental culture, including traditional design patterns and techniques would become of primary importance. This proposition would seem to be particularly true as regards forms closely bound up with social structure, with distinctions in role and status—including those based on sex—as would be the case with tattoo and other forms of body art.

The importance of such distinctions is richly developed in Kaeppler's analysis of Hawaiian tattoo and Gathercole's discussion of Maori *moko*. Of comparable importance is the remarkable pattern of historically and culturally determined consistencies and divergences evident in these two papers. Of the divergences, the symmetry and pronounced individualization of Maori tattoo may be set against the asymmetry and corporate associations thereof in Hawaii. Among the most intriguing of the consistencies is the conceptual importance to tattoo in both New Zealand and Hawaii of the lizard (*moko, mo'o*), the emphasis in early accounts on straight lines for facial tattoos in both areas, and the general elaboration of men's tattoos in traditional contexts in both areas (and generally throughout Polynesia and Micronesia), in contrast to the limited development (but remarkable persistence) of tattoo for women. Especially interesting in this regard is the distribution of chin tattoos for women among the Maori, the Ainu of Japan, the Inuit of Alaska, and a number of other Native American peoples.[2]

Neither the rich and diverse body-art traditions of other Polynesian peoples, nor those of Australia, Melanesia, and Micronesia are represented here.

Notes

1. G. B. Milner, "Siamese Twins, Birds and the Double Helix," *Man* (Journal of the Royal Anthropological Institute), n.s. vol. 4 (1969), pp. 5–23. I am grateful to Malcolm McLeod for calling this article to my attention.

2. See McCallum; Gritton.

Hawaiian Tattoo: A Conjunction of Genealogy and Aesthetics

Adrienne Kaeppler

Sources for the study of Hawaiian tattoo are few and unrevealing. Except for a few isolated examples, tattoo was essentially a thing of the past by the middle of the nineteenth century, and clear statements about its use or relationships to other Hawaiian two-dimensional art forms are nonexistent. In spite of this paucity of information, it is worthwhile to reexamine the available data in order to make at least speculative statements about the function, design relationships, and aesthetics of Hawaiian tattoo.

For the purpose of this study, the arts will be defined as cultural forms that result from creative processes which use or "manipulate" words, sounds, movements, spaces, or materials in such a way that they formalize the nonformal. Aesthetics will be defined here as evaluative ways of thinking about these cultural forms, including the products and the processes involved in their creation. Only with such broad definitions can we make statements about Hawaiian art. Art in the modern Western sense of the word was not a conceptual category of traditional Hawaiian culture, but skillfullness or cleverness (*no'eau*) was a part of all activity. The art of tattoo (*kakau i ka uhi*; literally, "to strike on the black"), emphasized the process rather than the product; it used pigment and human skin in such a way that design elements were formalized into meaningful combinations which were done with skill and served some purpose in traditional Hawaiian society. The aesthetics of tattoo refer to the evaluative ways of thinking about formalized tattoo designs and the processes that created them.

While some writers have concluded that Hawaiian tattooing was strictly decorative, it will be argued here that it was not and that the early demise of tattoo was a function of the rise of Kamehameha and a new social order. The hypotheses are that, like other Hawaiian art forms, tattoo was a visual manifestation of social relationships among people, the gods, and the universe that changed over time; that tattoo was primarily a protective device and a function of genealogy; and that evaluative ways of thinking about tattoo (aesthetics) can be related to ways of thinking about other Hawaiian art forms in motifs, processes, and an important aesthetic concept dealing with veiled or layered meaning known in Hawaiian as *kaona*.

Sources for the Study of Hawaiian Tattoo

The early literature on Hawaiian tattoo was summarized by H. Ling Roth (1900) who cited journals from the voyages of Cook, Portlock, and Kotzebue (including those of Choris and Chamisso); writings of the missionaries Ellis and Campbell; Pickering, who traveled on the U.S. Exploring Expedition; and remarks by Brigham, the first director of the Bishop Museum. Krämer, visiting Hawai'i in 1899, added a bit more information. All of the above were discussed in more detail by Emory (1946), who included information from Heddington, Freycinet, Mathison, Tyerman and Bennet, Bennett's whaling voyage, Paris, and Arning. Emory also added Hawaiian points of view including traditions from Fornander's *Hawaiian Antiquities* (1918–1919); a Hawaiian newspaper

account; and notable Hawaiians Lahilahi Webb, Mary Kawena Pukui, and her mother Paahana Wiggin. Most important, however, Emory discussed the tattooing of several Hawaiian mummified body parts found in caves during the 1930s.

In 1973 the motifs from these sources were compiled by John McLaughlin (manuscript in the Bishop Museum Library), and a few additional remarks by Mary Kawena Pukui were found in the Huapala Mader materials which were deposited in the Bishop Museum Library in 1981–1982.

Finally, Roger Green (1979:30), in a paper on the continuity of Lapita pottery design in bark cloth and tattoo decoration, noted the retention of what he considered a Lapita motif in Hawaiian tattoo along with seven Lapita motifs in Hawaiian bark cloth design.

Because information is so limited and scattered, it seems worthwhile to repeat some of it here in chronological order and to note where tattooing was seen. The first reference is from Captain Cook on the island of Kaua'i, February 2, 1778:

> Tattowing or staining the skin is practiced here, but not in a high degree, nor does it appear to be directed by any particular mode but rather by fancy. The figures were straight lines, stars etc. and many had the figure of the *Taame* or breast plate of Otahiete,[1] though we saw it not among them (Cook in Beaglehole 1967:280).

Cook (Cook and King 1784:192,216) further notes that in Kaua'i "some were punctured on the hands, or near the groin, though in a small degree" and that at Ni'ihau "one of the men had the figure of a lizard punctured upon his breast, and upon those of others were the figures of men badly imitated."

Captain King (Cook and King 1784:135) on Cook's voyage noted that the face was tattooed "in straight lines, crossing each other at right angles" (Fig. 1) and that "the hands and arms of the women are also very neatly marked." Trevenen (quoted in Emory 1946:238) adds that tattooing "is not so common a custom here as at the Society or Friendly islands. I do not recollect to have seen any man whose business it was to tattoo others, nor do I believe that any of our people got a single additional mark here."

David Samwell and surgeon William Ellis, also on Cook's voyage, make important remarks about Maui tattooing. Samwell notes in November, 1778, that Kahekili, the high chief of Maui,

1. *Hawaiian man with tattoo, 1778–1779. Drawing by John Webber, artist on Cook's Third voyage. Bishop Museum Library. Photograph, Bernice P. Bishop Museum.*

is a middle aged man, is rather of a mean appearance, the hair on each side of his head is cut short and a ridge left on the upper part from the forehead to the occiput, this is a common custom among these people, but each side of his head where the hair was off was tattooed in lines forming half circles which I never saw any other person have (in Beaglehole 1967:1151).

On February 4, 1779, Samwell adds remarks about Hawaiian tattoo in general:

> They are tattawed or marked in various parts; Some have an arm entirely tattawed, others more frequently the Thighs and Legs, the Lines being continued from the upper part of the Thigh to the foot with various figures between them according to their fancy; their bodies are marked with figures of Men and other Animals; Some few among them had one side of their faces tattawed, & we saw 2 or 3 who had the whole of the face marked, differing something from the New Zealanders in being done in strait not in spiral Lines. Most of the Chiefs were entirely free from these marks on every part of them, tho' we saw a few who had them, but never any marked on the face. This Custom of tattawing seems to be used among these people as a Mortification or at least in remembrance of the dead; Most of those

2. Village scene, 1792–1793. Drawing by Thomas Heddington, artist on Vancouver's voyage. Bishop Museum Library. Photograph, Bernice P. Bishop Museum.

who were tattawed informed us that they bore those Marks in Memory of Ke owa and Arapai, both great Chiefs & probably the Kings of the island, as the present Heir to the throne of Ouwhaiee, Kariopoos' Son, is called after the former; one Man had frequently marks upon him in memory of two or three Chiefs. They seemed to be done in figures agreeable to their own fancy & not so as to distinguish the bearer of them to be a Vassal or dependent on such or such a Chief, for the same device was often found done in memory of different Chiefs, so that it shou'd seem that tho' this custom is almost universal among them it is not imposed upon them as a necessary duty (in Beaglehole 1967:1178).

And Ellis notes (1783:151–152):

The custom of tattowing prevails greatly among these people, but the men have a much larger share of it than the women; many (particularly some of the natives of Mawwhee) have half their body, from head to foot, marked in this manner, which gives them a most striking appearance. It is done with great regularity and looks remarkably neat: some have only an arm marked in this manner, others a leg; some again have both arm and leg, and others only the hand. The women are for the most part marked upon the hand, and some upon the tip of their tongue, but of these we saw but few. Both sexes have a particular mark, according to the district in which they live, or is it rather the mark of the aree, or principal man under whose jurisdiction they more immediately are.

Nathanial Portlock on O'ahu in 1786 notes that "many of the warriors were tattooed in a manner totally different from any I ever took notice of amongst the Sandwich Islands [i.e., Hawai'i Island]; their faces were tattooed so as to appear quite black, besides a great part of the body being tattooed in a variety of forms" (1789:77). Dixon, in command of the companion ship, records (1789:98,276) that one of the nephews of the high chief of O'ahu had his legs, thighs, arms, and various parts of his body tattooed "in a very curious manner" and that "both sexes are tattooed, but this custom is more generally practiced by the men, whose bodies are frequently punctured in a very curious manner."

A drawing by Thomas Heddington, a midshipman on Vancouver's voyage, depicts tattoos from the island of Hawai'i in 1792–1793 (Fig. 2). The outside of a right leg is tattooed in straight lines with triangles, and there are tattoos around an ankle, around a wrist and upper arm, a cross-

Lithᵉ par Franquelin d'après Choris *Lith de Langlumé r de l'Abbaye N⁴*

Danse des hommes dans les îles Sandwich

3. Hawaiian Men dancing, 1816. Engraving after Louis Choris, artist on the voyage of Kotzebue. Photograph, Bernice P. Bishop Museum.

hatched thigh, a thigh with curved lines, and other marks.

Kotzebue and his artist Choris, visiting Hawaiʻi in 1816–1817, sketched several tattoo motifs (Figs. 3–5) including straight lines, a checkerboard pattern, a coconut tree, a rifle, a bird, goats, and three petroglyphlike men. These designs, however, seem to have been placed indiscriminately when the engravings were prepared. Engravings of other subjects made after Choris's sketches are also quite untrustworthy and there is little reason to trust the placement of the tattoo designs in these published illustrations. Nevertheless, the designs themselves are probably quite accurate. Chamisso, naturalist on the same voyage, says, "It is remarkable that this national ornament [tattoo] has borrowed foreign patterns. Goats, muskets, even letters of the alphabet, name and birthplace, are frequently tattooed along the arm" (in Kotzebue 1821 III:251). On his return voyage to Hawaiʻi in 1824–1825, Kotzebue (1830 II:174, 245) says, "Their faces were frequently marked with lines crossing each other at right angles, and some even had their tongues tattooed; pretty drawings were frequently seen on the hands and arms of the women." Later he notes that Kaʻahumanu (the favorite wife of Kamehameha) had the date of Kamehameha's death tattooed on her arm. "Otherwise they are not tattooed, which indeed few are, and those only the most aged people" (1830 II:245).

Arago, however, visiting Hawaiʻi in 1819 with Freycinet, noted (1823:92) that Kaʻahumanu was elegantly tattooed on her legs, the palm of her left hand, and her tongue. Arago also illustrated a number of scenes in which individuals were tattooed, but according to Emory (1946:241) at least two of the scenes were based on hearsay. The finished illustration, therefore, cannot be accepted uncritically, but the design motifs may be quite accurate. Arago states (1823:149) that the women:

> make drawings of necklaces and garters on the skin in a manner really wonderful: their other devices consist of hunting-horns, helmets, muskets, rings, but more particularly fans and goats. Those of the men are muskets, cannon, goats, and dominos; together with the name of Tammeamah [Kamehameha], and the day of his death.

Arago's other notes on tattoo design are also of interest:

> The designs are neither so regular, nor so well

Intérieur d'une maison d'un roy dans les îles Sandwich

4. *Tattooed Hawaiian Chief, 1816. Engraving after Louis Choris. Photograph, Bernice P. Bishop Museum.*

5. *Inhabitants of the Sandwich Islands, 1816. Engraving after Louis Choris. Photograph, Bernice P. Bishop Museum.*

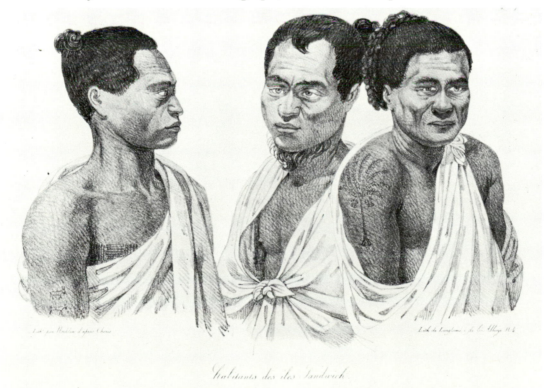

Habitants des îles Sandwich

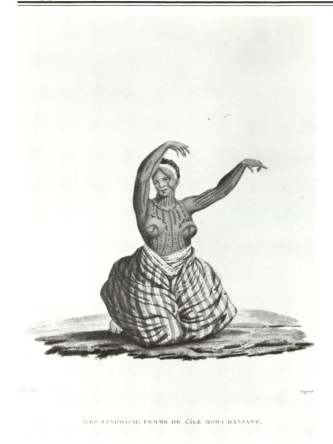

6. *Hawaiian dancer, 1819. Engraving after Jacques Arago, artist on the voyage of Freycinet. Photograph, Bernice P. Bishop Museum.*

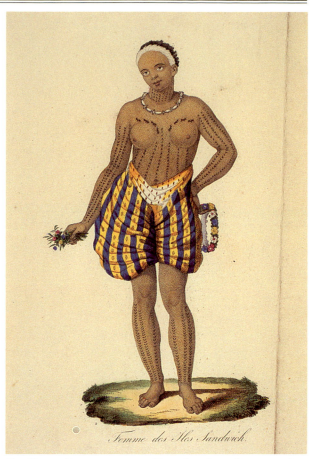

7. *Hawaiian woman. Hand colored engraving after Jacques Arago. Bishop Museum Library. Photograph, Bernice P. Bishop Museum.*

made, as those of the Carolinians. Sometimes a part of the body is tattooed, sometimes a foot, or palm of the hand, sometimes even the tongue, as in Kookini's wife, and [Ka'ahumanu] the favorite widow of Tammeamah. In general the designs represent birds, fans, draftboards, and circles with several diameters; but more frequently numerous rows of goats, and almost always on the inner part of the arm, of the leg, and of the thigh. I have seen several of the inhabitants tattooed only on one side, which produces a very singular effect; they looked just like men half burnt, or daubed with ink, from the top of the head to the sole of the foot. Frequently, from some inconceivable whim, they leave a design unfinished, as if the painter had been discouraged (1823:76).

Further, in speaking about female tattoo, he notes:

the row of goats is constant. A young woman without goats on her body would perhaps be dishonored. But after these animals, the designs which are the most favored are the checker boards, fans, birds, with which they adorn their cheeks, the upper part of the head, the shoulders,

and the breast. They are also fond of the hunter's horn, which they have traced on their posteriors At Kayakakooah, as well as at Koiai, I was constantly occupied making designs on the legs, the thighs, the shoulders, the head and breast of women of the people, the wives of the governor, and even the princesses, and I assure you I drew my inspiration solely from caprice or from my studies at college (1840 II:75).

And again,

The designs which ornamented her [Ka'ahumanu] voluminous breast were traced with perfect taste. She was tattooed on the tongue; the name of Tamahamah [Kamehameha], the date of his death, could be read on her arms; the sole of her feet and the palm of her hands, so delicate, carried figures which I suspect were traced by the artist of the expedition commanded by Kotzebue.

. . . When I finished my work, she begged me to ornament her with several new designs, and Rives informed me that she strongly desired a hunter's horn on her posterior, and a figure of Tamahamah on the shoulder, to which I consented with great pleasure (1840 II:102).

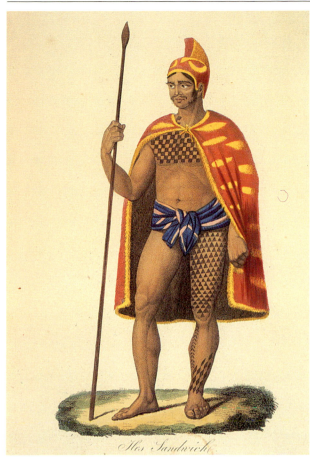

8. *Hawaiian chief. Hand colored engraving after Jacques Arago. Bishop Museum Library. Photograph, Bernice P. Bishop Museum.*

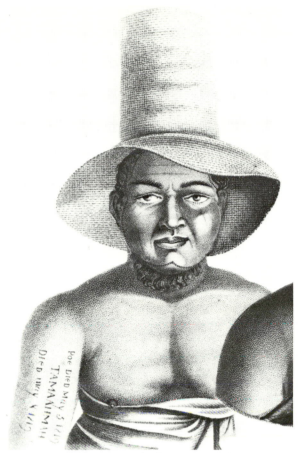

9. *Keeaumoku II, Chief of Maui, 1819. Drawing by Pellion, artist on the voyage of Freycinet. Photograph, Bernice P. Bishop Museum.*

Arago (1823:76,147) concludes that ''the devices are unmeaning and whimsical, without taste, and in general badly executed'' and that ''all of them, without exception, have their bodies or some of their limbs tattooed.'' He also notes (1823:92) that Ka'ahumanu's ''legs, the palm of her left hand, and her tongue, are very elegantly tattooed; and her body bears the marks of a great number of burns and incisions she inflicted on herself at the death of her husband. The wife of governor Kuakini and her sister-in-law were ''elegantly tattooed; one of them even had her tongue tattooed'' (1823:67).

The illustrations of tattoo from Freycinet's voyage on the *Uranie* are by Arago and Pellion (Figs. 6–9) and include depictions of Kamamalu (wife of Liholiho, Kamehameha II); Keeaumoku, a chief of Maui; a female dancer; a Hawaiian officer or one of the principal chiefs of the island of Hawai'i; as well as fourteen other illustrations of individuals and scenes, giving a substantial visual record of tattoo designs of traditional as well as

newer images. Used in conjunction with the remarks of Arago, the Freycinet voyage tattoo information suggests elements of persistence and change as well as island provenance.

During Freycinet's visit and during the 1820s, the goat seemed to be a favorite new motif. Makoa, one of Reverend Ellis's guides, had goats tattooed on his face (Fig. 10), and Ellis describes him thus: ''His small eyes were ornamented with tatued vandyke semicircles. Two goats, impressed in the same indelible manner, stood rampant over each of his brows; one, like the supporter of a coat of arms, was fixed on each side of his nose, and two more guarded the corner of his mouth'' (Ellis 1827:71–72). Ellis also notes that several Hawaiians of Honuapo on Hawai'i Island had one lip tattooed and that ''there was more tatauing here than we had observed at any other place; but it was very rudely done, displaying much less taste and elegance than the figures on the bodies of either New Zealanders, Tahitians, or Marquesians, which are sometimes really beautiful'' (1827:138).

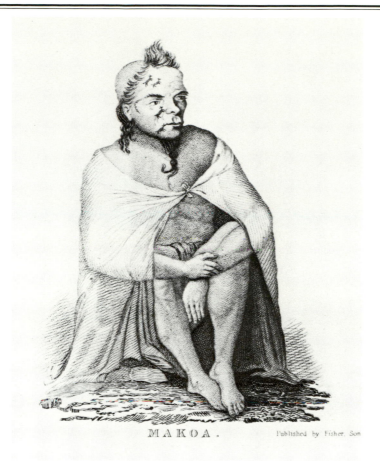

10. Makoa, guide to Rev. Ellis, 1820s. From Ellis (1827). Photograph, Bernice P. Bishop Museum.

Tattooing of the tongue as a gesture of grief was documented by Ellis when Kamamalu was in mourning for her mother-in-law Keopuolani:

> A few days after the interment, I went into a house where a number of chiefs were assembled, for the purpose of having their tongues tataued; and the artist was performing this operation on hers when I entered. He first immersed the face of the instrument, which was a quarter of an inch wide, and set with a number of small fish-bones, into the colouring matter, placed it on her tongue, and giving it a quick and smart stroke with a small rod in his right hand, punctured the skin, and injected the dye at the same time. Her tongue bled much, and a few moments after I entered she made a sign for him to desist. She emptied her mouth of the blood, and then held her hands to it to counteract the pain.
>
> As soon as it appeared to have subsided a little, I remarked that I was sorry to see her following so useless a custom; and asked if it was not exceedingly painful? She answered, He eha nui no, he nui roa ra kuu aroha! Pain, great indeed; but greater my affection!
>
> After further remarks, I asked some of the others why they chose that method of shewing their affectionate remembrance of the dead? They said, Aore roa ia e naro! That will never disappear, or be obliterated! (1827:122–123).

Ellis' fellow missionaries Tyerman and Bennet, visiting Hawai'i in 1822 noted that

> the people whom we have seen were generally tattooed, an operation performed here very early in life. The goat is the favorite figure, which they bear on their legs and arms; but the artists are not so expert as those of the Society Islands, neither are the designs so curious, nor are the colours so clear and delicate as the latter employ and execute (1831:389).

Another missionary, John Paris, in Ka'u on the island of Hawai'i in 1841 noted (1926:13–14) that he was lifed out of his landing boat by "a great, strong native Samson, whose entire dress was a mal [loincloth] and who was tattooed from head to foot." Paris was then served roast pig by two men tattooed from head to foot.

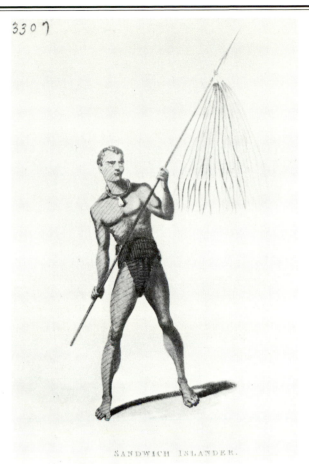

*11. Half-tattooed man, 1821. Engraving
from Mathison, 1825. Photograph,
Bernice P. Bishop Museum.*

Gilbert Mathison, visiting O'ahu in 1821, noted that "their bodies were often, but not universally, tattooed. I observed one man, who had the exact half of his body ornamented in this manner from the top of the forehead to the sole of the foot" (1825:399). One such half-tattooed man is depicted carrying a ritual spear with feathered attachments which he brandished before an image made in remembrance of Captain Cook (Fig. 11).

F. D. Bennett on a whaling voyage of 1834 noted that

the custom of tatooing the skin was never very general amongst these islanders and is now almost obsolete. The primitive tatooed marks, as displayed on the persons of the older natives, are less elegant than those exhibited by the Society Islanders, and are chiefly representations of cocoanut trees, birds, sharks, fans, and anomalous dots and lines, thinly scattered over the trunk and extremities; the face being seldom marked (1840 I:212).

Pickering in Hawai'i 1840–1841 on the U.S. Exploring Expedition, noted that the

natives are unable to form any conjectures as to the origin or object of the practice of tattooing. Formerly, the body was much more covered with these markings than at present, one side often being completely blackened; and, to a certain extent, it would have been possible to designate individuals by the copy of the pattern. . . . At present, letters are frequently inscribed; and I remarked in some instances, the name of the individual (1848:92).

Eduard Arning, in Hawai'i from 1883 to 1886 under the aegis of King Kalākaua to study leprosy, noted:

Hina, a 60–70 year old Hawaiian man was the only native I ever saw with a tattoo. The tattoo was on his chest and consisted of four groups. In each group were two half moons placed vertically and facing each other. The groups were placed in a row with the bottom tip of the outermost half moon ending at each nipple. Even if the half moon design is found on feather cloaks,

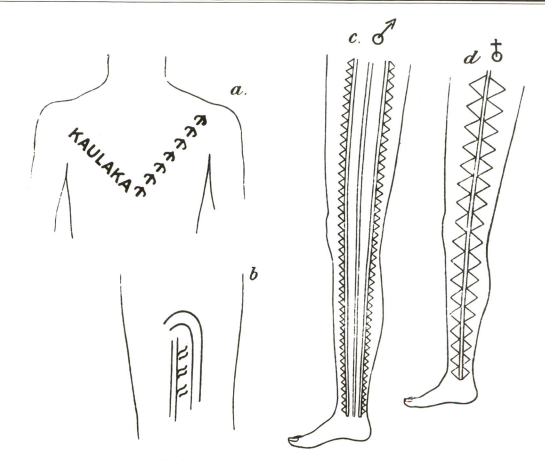

12. Tattooing from Kaua'i. Illustrated in Krämer in 1899. Photo Smithsonian Institution.

it is questionable as to whether its origin is Hawaiian as Hina was a seaman (1931).

Visiting Hawai'i in 1899, Augustin Krämer met an elderly man on Kaua'i who had the name of his deceased wife tattooed diagonally from his right shoulder to the center of his chest. On the opposite diagonal, balancing the seven letters of "KAULAKA," were seven birds, which the Hawaiian said were tropic birds (*koa'e*; Fig. 12). This man also had a tattoo on his arm. Krämer also illustrates designs on the inside of two legs (Fig. 12) and quotes Mr. Deverill of Kaua'i who says that old men and women were tattooed on the outside of their legs with long stripes (1906:93–94).

Dry-preserved, "mummified," body parts with tattoos found in Mummy Cave and Kanupa Cave on the island of Hawai'i verify a number of design motifs and their organization that were illustrated and described by late eighteenth- and nineteenth-century writers. The designs are checkerboards, long lines elaborated with triangles, and "birds" which were organized asymmetrically on the body (Fig. 13).

Final important sources for the study of Hawaiian tattoo are the accounts of nineteenth-century Hawaiian historians and knowledgeable modern Hawaiians such as Mary Kawena Pukui. S. M. Kamakau (1964:70) associates at least some tattooing with the descendants of the gods of thunder, while Fornander (1918–1919 V:156) traces the introduction of tattoo to Olopana from Tahiti. Emory (1946:250) illustrates ten patterns tattooed on the backs of women's hands remembered by Mary Kawena Pukui and her mother Paahana Wiggin from Ka'u and Puna. Other notes from Pukui state that tattoo was primarily a mark that designated individuals as part of a village, devotees of the same god, or descendants of a common ancestor. Pukui's gandmother was marked with *hala* blossoms and bands on her finger, and according to Pukui, the *kauwa* ("slaves") were tattooed on the forehead and at the edge of the eyes (Mader notes, Bishop Museum Library).

After digesting the conflicting information and minimal interpretation in these sources, one

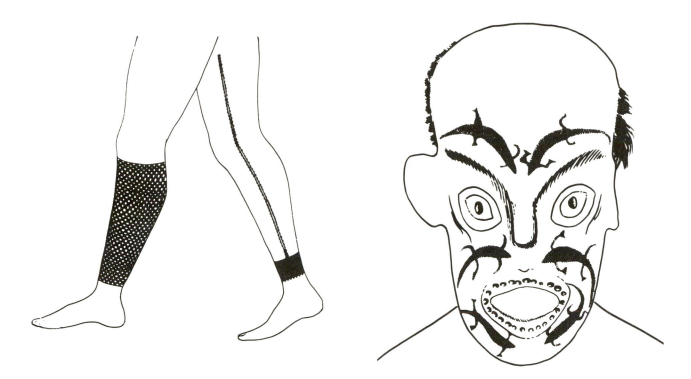

13. *Leg tattooing reconstructed from a dessicated body found in a cave on the island of Hawai'i. Illustrated in Emory 1946. Photograph, Bernice P. Bishop Museum.*

14. *Detail of wooden image with painted lizards* (mo'o) *from O'ahu. Bishop Museum (132). Illustration by Jo Moore.*

still has no clear understanding of the meaning or function of tattoo or its place in traditional Hawaiian society. Outside observers often noted that Hawaiian tattoo designs were poorly done, were less elegant than elsewhere in Polynesia, appeared to be unfinished, and were placed curiously. Such remarks are understandable in view of the familiarity of these travelers with other Polynesian tattoos, which were usually symmetrically placed and orderly. Among other Polynesian groups, the design elements were often spiral or curvilinear and were related to an overall design scheme; the ultimate purpose was to cover the whole body or large parts of it for high-ranking individuals. None of this occurred in Hawai'i, and observers were at a loss to understand this seeming lack of aesthetic sensitivity. It appears that a more inclusive and abstract view of Hawaiian cultural forms might assist in understanding Hawaiian tattoo.

Function and Aesthetics of Hawaiian Tattoo

I have argued elsewhere that the term *mo'o* is a key to understanding Hawaiian genealogical concepts (Kaeppler 1982:101). In addition to being a general name for all kinds of lizards, *mo'o* also refers to geneaological succession; a series of ancestral gods; and in combination with other words, to a descent line (*mo'okū'auhau*), scars (*mo'oali*) and a connected narrative of events (*mo'olelo*). The word for backbone, a very prominent feature of lizards, is *iwikuamo'o*, which also means family. One of Kamehameha's ancestors, Keawe'ai, was said to have been tattooed with lizards (*mo'o*) on the eyebrows, cheeks, and chin (Stokes Ms. in Bishop Museum Library). Keawe'ai was sacrificed voluntarily at the dedication of Hale-o-Keawe, an outdoor temple (*heiau*) of the Hale-o-Lono type (a place of worship for the god Lono) and a burial place for chiefs of the Keawe chiefly line. I hypothesized that the backbone, the sacred top of the head, human hair, gourds, and pigs were symbolically associated with Lono and

the 'aumākua (ancestral gods) and metaphorically related to genealogy, all of which could be substituted for each other (Kaeppler 1982). These concepts could be visually manifested as lizards, stepped designs, chevrons, and crescents, as well as by vertebrae and carved-out backbones.

An 'aumakua image found at Waimea, O'ahu, in 1855 has six lizards painted on its face (Fig. 14). There is no association of this image with the Keawe or Kamehameha line. This, in addition to Cook's reference to a lizard tattoo on Ni'ihau, suggests that mo'o as a tattoo motif occurred sporadically in time and space, preserving, perhaps, an ancient association of lizards and tattoo. The Maori term for tattoo is moko, the same word as mo'o, and is also associated with lizards (see Gathercole, this volume).

At the time of European contact, Hawaiian tattoo designs (or at least those seen by early explorers) were primarily linear, made up of rows of triangles, chevrons, and crescents/arches or lizards. The crescent/arches (hoaka) are the same designs found on late eighteenth- and early nineteenth-century Hawaiian drums (pahu) and may be symbolic of human beings joined together as lineal and collateral descendants who trace their relationships back to the gods (Kaeppler 1980:9; 1982:94). The fact that Kahekili's shaved head was tattooed on either side of the central hair arch with such arches (hoaka), suggests the extension of the backbone over the sacred top of the head and his genealogy back to the gods. His geneaology was his sacred protection.

The zigzag or stepped/triangle and chevron designs seem symbolic of the backbone and associated genealogical concepts. This design is sometimes realized by coloring in the "background" and the motif is formed by negative space (much like some bark cloth designs). The stacked triangles usually known as lei hala (lei = necklace or wreath, hala = fruit of the pandanus plant) seem to be the same motif found on the headdresses of some Hawaiian images.

Although such design associations are suggestive, it may be speculated that there is a further significance to the tattoos. This deals with the importance of the process of tattoo as well as its placement on the body which, as we have seen, is often asymmetrical on the face or front of the body, on the inside or outside of the arms and legs, and on the outside of the hands.

The contention is made here that before the adoption of European weaponry, one of the primary functions of male tattoo was protection in battle and that the tattooing process was carried out in conjunction with the chanting of sacred prayers that protected the warrior, especially those of high rank. The process of puncturing the skin during the recitation of a prayer could capture the prayer and envelop the owner with permanent sacred protection. The placement of tattoo on the front of the body underscores this contention in that tattooed chiefs wore feathered cloaks which protected their backs (the cloaks are thought to have been netted during protective prayers; see Kaeppler [1985]). During battle, a chief's shoulders, back, and head were protected by feathered cloaks and helmets, but the front of the body, the spear throwing arm, the inside and outside of the legs, the ankles, and the hands needed protection. These body parts were afforded protection by chants captured in the punctured skin (Fig. 4). Tattoos may have been done in anticipation of specific battles and afterwards served to commemorate those battles. Further, designs used by specific chiefs and imitated by their warriors might have enabled these warriors to partake of the chief's sacred protection. Thus, the chief protected his warriors with sacred power while his warriors protected the chief with physical power.

These concepts can be illustrated by examining the protective devices used by two chiefs—Kahekili and Kamehameha. Kahekili, the high chief of the island of Maui, was a great warrior. Descended from the thunder god Kanehekili, Kahekili was tattooed solid black on the right side of his body (a form called pahupahu), as were his warrior chiefs and his household companions (Kamakau 1964:70). As indicated above, both sides of Kahekili's hair crest were tattooed with half circles, that is, crescent arches called hoaka. His feathered cloak appears to be one that is now in the British Museum. This straight necklined, sacred red shoulder and back covering combines designs of triangles and circles (Kaeppler 1985). All vulnerable body parts were thus protected with geneaological and sacred designs entrapped in his skin and his cloak of red feather-covered, knotted fiber. He was covered in sacred protection. Kahekili was a strictly traditional chief. Kamehameha, the high chief of the island of Hawai'i and later the whole Hawaiian chain, on the other hand, apparently did not rely on protection in these traditional ways. Kamehameha, with less elevated genealogical connections, was a man of the modern world. Although he did not accept Christianity, he relied on protection by guns rather than sacred body coverings. He apparently was not tattooed, and his feathered cloak was not the traditional red straight-

neckline type. Instead, his cloak had a "modern" shaped neckline and was completely yellow, which must have been symbolic of political rather than sacred power.

With the overthrow of the state gods (*akua*) in 1819, it appears that at least some of their traditional functions were absorbed by the ancestral gods ('*aumākua*). Tattooing became a recognition sign for descendants of some '*aumākua*, such as the incident described by Emory (1946:250) of a woman tattooed with a row of dots around her ankle, as a charm against sharks. Rather than accounting for the "charm" as a way of capturing a protective prayer into the punctured skin, Emory emphasizes the visual aspect of tattoo in relating a "story about a woman whose ankle was bitten by a shark, which was her guardian god (*aumakua*). Once, by mistake, he seized her ankle while she was swimming. When she cried out his name, he let go, saying 'I will not make that mistake again, for I will see the marks on your ankle.'" It appears that the protective power of tattooing was continued into the nineteenth century as charms and symbols associatted with '*aumākua*. The tattooing of the backs of women's hands was probably also related to '*aumākua* as visual symbols and protective charms.

Hawaiian aesthetic principles, especially *kaona* (veiled meaning) and symmetry/asymmetry, can also be found in tattoo. Designs made by puncturing human skin with dye-dipped bone points are comparable to those designs impressed into bark cloth with carved wooden beaters and seen to best advantage when the bark cloth is held up to the light. In bark cloth these impressed designs were all but hidden by the designs stamped or painted upon the surface of the cloth, just as tattoo design was often hidden by clothing (Kaeppler 1975). The two layers of design found in tattoo and clothing may have been related to the concept of layered meaning which *kaona* expresses.

While the unraveling of traditional Hawaiian usages of symmetry and asymmetry is only in the beginning stages, it does appear that asymmetry is associated with sacred ritual while symmetry is associated with the nonsacred. This is emerging in the author's study of Hawaiian dance and may also help to explain the placement of tattoo. Asymmetry seems to have been important where tattoo was primarily a protective device. Symmetry seems to have been introduced when tattoo became primarily decorative, such as in Arago's illustration of a female dancer (Fig. 6) and a few other instances illustrated during the nineteenth century (although this symmetrical placement of designs

may have been added by the European artist). Pukui associates the female dancer with the Puna area because of the *hala lei* design which was associated with Pukui's Puna ancestors—thus even the "decorative" designs were thought to be genealogical. Also related is the genealogical association of tattoo markings with the *kauwa* ("slaves"; see pg. 166).

Tattoo was also a genealogical commemorative device, especially of the death of important related persons of high rank. It was a widespread Polynesian practice to show unbounded grief at the death of a chief. In Tonga, for example, finger joints were cut off. In Hawai'i sharktooth knives were used to cut oneself, hair was cut on one side of the head (Kamakau 1964:34), and the tongue was tattooed as noted above in the example of Kamamalu at the death of her mother-in-law. This convention evolved into the nineteenth-century practice of tattooing a chief's name and date of death on one's arm as illustrated by Arago and Pellion (Fig. 9). Tattoo soon became primarily decorative; goats became a fashionable exotic motif, and ships' artists were pressed into service to provide a variety of introduced designs including hunting horns for the posteriors of female chiefs.

It appears that during the eighteenth century tattoo was most important on Maui, less important on Kaua'i and O'ahu, and least important in Hawai'i. There are no references to the Hawai'i island chiefs Kalan'ōpu'u or Kamehameha having tattoo. The victory of the Hawai'i chiefs over the chiefs of Maui and later O'ahu was probably instrumental in making tattoo in its traditional form unfashionable. The late eighteenth and early nineteenth-century primacy of the "style" of Kamehameha touched even such things as tattoo, emphasizing once again the necessity of tying tradition and its transformations to specific points in time and place, and to individuals of prestige, authority, sanctity, and power. Those tattooed to commemorate Kamehameha's death (Fig. 9) illustrate the last stage of this changing cultural form, which evolved from genealogically associated ritual protection, the painful commemoration of genealogically important individuals, and the indication of special status in society, to whimsically decorative motifs of goats and other introduced designs.

This evolution from protection to decoration is also found in Hawaiian feather work and can be related to social and conceptual changes that removed artistic forms from involvement in social action. The end of the ritual importance of tattoo with its emphasis on the process of tattooing oc-

curred during the rise and flourishing of Kamehameha I. By the end of his reign in 1819, new tattoos were primarily decorative and even those that commemorated his death appear to have been "modern" (in that they included imported writing) and did not involve the painful tattooing of the tongue. After the overthrow of the state gods in 1819, remnants of traditional tattoo became charms and visual associations with ancestral *'aumākua*. Unlike objects, which after their ritual importance had ceased could be inherited as works of art, only drawings and reminiscences remained when tattoo fell out of fashion. From these we can only speculate about the meaning and function of this cultural form and its place in Hawaiian society.

Notes

1. Cook is referring to the arched design as seen on the shoulder in Figure 1.

Contexts of Maori *Moko*[1]

Peter Gathercole

In a striking phrase, James Cowan (1910:188), one of many writers on *moko* (Maori tattooing), describes the Maori as "pre-eminently the face-carver of mankind." The basis for his statement is clear. *Moko* was remarkable because the designs were normally cut into the skin of the face with chisels, not punctured with needle-combs as was the usual case with Maori body tattoo—and indeed with tattooing elsewhere in Oceania. This carving technique obviously links *moko* with wood and other forms of Maori carving and suggests wider comparisons with other aspects of Maori traditional culture. The latter is explored later when possible meanings of *moko* are discussed. Initially, a summary of the historical and ethnographic information concerning the practice is presented, bearing in mind that the application of male *moko* died out in the second half of the nineteenth century, perhaps by 1865, but that of female *moko* persisted. Indeed Simmons (1983: 242) argues that "in the latter part of the nineteenth century, female tattoos grew in importance as the male tattoo became rarer" and that today both men and women are taking the *moko* as a symbol of identity (1983:243).

To judge from the evidence of bone tattooing chisels recovered with Lapita associations in Tongan archaeological contexts of the late second millenium B.C., tattooing in Polynesia is as old as the culture itself (Bellwood 1978:253–254, figs. 9.18, m–p). It is found, historically, throughout almost all the islands, but patterns show much diversity and it would be pointless to seek a hypothetical point of origin (Buck 1950:297–298). On the other hand, Lapita pottery and more recent bark cloth and tattooing have certain decorative motifs in common (Green 1979:25–31), providing at least stylistic evidence that tattooing was an important practice of considerable antiquity in Oceania.

In parts of eastern Polynesia, tattoo extended over much of the lower part of the body (Buck 1950:298–299). Among the Maori, however, it was generally restricted, in the case of males, to the face and between the waist and knees; for women, it was usual for only the lips and chin to be tattooed, but these restrictions were far from absolute. There are instances reported of women bearing male *moko*, and both sexes were sometimes quite extensively tattooed on other parts of the body, including the tongue and genitals (Simmons 1983:234,240; Robley n.d.:No. 38). Economic considerations must have greatly influenced the popularity and distribution of *moko* (Firth 1929:290). The operation was done after puberty and was carried out by male specialists (*tohunga-ta-moko*). Since the activities of these specialists often cut across tribal boundaries, decorative styles were not necessarily tightly localized, and were probably related to broad, originally prehistoric, regions or "culture areas" (Skinner 1974:19–26).

Numerous writers have argued that both the incidence within a tribe and the amount and quality of *moko* on an individual were linked to status. Whether or not this was always the case, it does seem that very elaborate facial tattoo was usually confined to the high-born who, on being tattooed, often needed a special feeding funnel when the resultant swelling around the mouth made eating

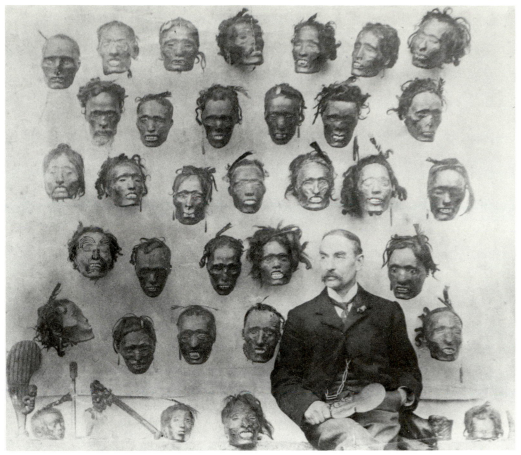

1. *Major-General H. G. Robley with his collection of Maori heads. From a photograph with the Robley scrapbook, Fuller Collection, Bernice P. Bishop Museum, Honolulu. This photograph was probably taken in 1902 at Addle-stone Lodge, Addlestone, Surrey, England, by Henry Stevens, owner of Ad-dlestone Lodge and of Stevens' Auction Rooms, 38 King Street, Covent Garden, London. According to Allingham (1924:204–205), Robley arrived at Addlestone with "four large portmanteaux" containing thirty-three heads. A bizarre scene was then enacted. "As if proud of such trophies, Mr Stevens arranged a large sheet across the little Japanese tea-house on the lawn so as to throw the heads (which he hung on butcher's hooks, there in readiness) into relief, and then he took one of those interesting photographs for which he is so well known." Photograph, Bernice P. Bishop Museum.*

difficult—a practice which reflected their enormous *tapu*. Other writers, however, stress that extensive facial *moko* was a normal male attribute, even though it might be partial and incomplete in any one instance. Indeed, according to Cowan (1910:190), "the term for a face devoid of *moko* is 'papa-tea', which may be interpreted as 'bare-boards,'" i.e., lacking decoration. Some designs may have possessed tribal affiliations, but it was certainly the case that individuals regarded their own *moko* as particular to themselves, well illustrated by the way some nonliterate chiefs of the

early nineteenth century drew their *moko* on documents, etc. as formal signatures (Robley 1896: 10–16).

Bearing these points in mind, it appears wrong to assume too automatic an association between the nature and extent of an individual's *moko* and his or her status. Practices probably varied over time and place. It is generally accepted, for example, that during the fierce tribal wars of the 1820s captives might have been tattooed, or their existing tattoos enhanced, and their decapitated heads then sold to European traders.

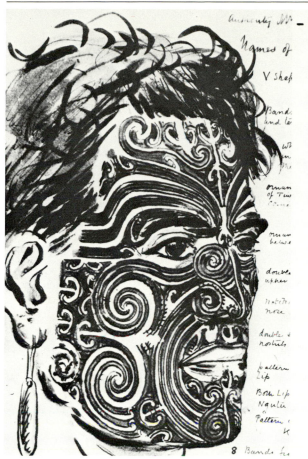

2. *Descriptive drawing by H. G. Robley to illustrate the male facial* moko *(after An Encyclopaedia of New Zealand, 1966, pl. 57A; from original in Hawke's Bay Museum and Art Gallery, Napier, New Zealand).*

The extent of this practice is not fully known, but the sale of heads became sufficiently notorious for their import into New South Wales to be banned in 1831. What is not often brought out, however, is that occasionally a person was of such high status that he or she would not be tattooed at all because to do so would break the integrity of the *tapu.* (For an instance of this, see Salmond 1976: 36–37.) Such an apparent departure from the norm was not, of course, an infringement, but an enhancement, of convention. It underscores the point being made, however, concerning the differing character of *moko* in particular groups at different times.

It is often assumed that the curvilinear designs widely publicized by Major-General Robley in his well-known work, *Moko* (1896) are the epitome of a "classical" style that attained final fruition at the time of the New Zealand wars of the 1860s (Fig. 1). Thereafter, it is presumed, male *moko* lost

its traditional significance because of European influence. It is likely, however, that the situation was rather more complicated. Not only was there probably no axiomatic link between *moko* and status, but also we do not know in detail either the prevalence of tattooing, or how its regional forms were affected during the period of great social change, especially by tribal warfare, between Cook's visits in the 1770s and the 1860s. It is also unclear how widespread and how old the "classical" curvilinear style actually was, although it is likely to have been of broadly the same age as curvilinear wood carving, i.e., of growing predominance in the North Island and the northern third of the South Island between the sixteenth and nineteenth centuries.

This curvilinear style contains the following elements, as used on the male face (McEwen 1966: 428): spiral chin patterns; sets of parallel curved lines from the chin to the nose; multiple spirals on the cheek; nose spirals; and sets of curving lines from the inside edge of the eyebrows, rising above the brows and turning downwards over the ears. Patterns on the forehead and the area between the ear and the cheek spirals completed the designs on a fully tattooed male (cf. Fig. 2). These designs, together with those usually found on the buttocks and thighs, and sometimes elsewhere, have close parallels to designs used widely in wood carving and in what is called "rafter" painting (in the latter case, both in meeting houses and on certain artifacts, such as canoe paddles and gourds). These parallels support the interpretation that facial *moko* was essentially a carving technique. It is important to note that a similar association existed between curvilinear carving and incising and painting in North Island rock art (Trotter and McCulloch 1971:46).

Curvilinear design in facial *moko* is also associated, in at least three examples recorded in 1769, with a noncurvilinear style. On Cook's first visit to New Zealand, his artist, Sydney Parkinson, drew a Cape Brett, North Island man whose tattoo comprised a series of vertical parallel lines running from above the cheekbones to the jaw and a number of "superimposed" free-flowing curvilinear "rafter" patterns (Fig. 3). Strictly speaking, this design (*puhoro*) is a *combination* of linear and curvilinear elements, but it also recalls the *juxtaposition* of similar straight and curved elements found in designs on rafters of nineteenth-century meeting houses—a relationship emphasized by the parallel lines of reeds that normally lay between the rafters, and so formed part of the thatching of the house. In the Murihiku area of the South Is-

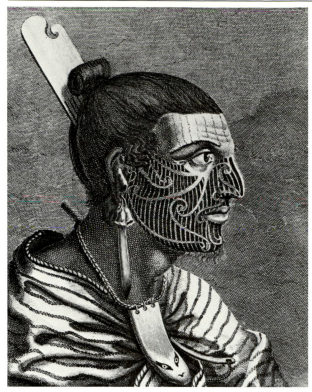

3. *Man with* puhoro *design on face. Engraving after drawing by Sydney Parkinson, Cape Brett, Bay of Islands, 1769. (Hawkesworth 1773:plate 13). Photograph, Bernice P. Bishop Museum.*

5. Moko Kuri *(after Robley 1896).*

4. *South Island Maori Tattooing, from sketches at Moeraki, Otago, 1905 (after Cowan 1910).*

land, however, one style, probably the usual one, was entirely linear. There Skinner (1974:21–22) and Cowan (1910:192–193) recorded horizontal *moko*, which Cowan localized to the Ngai-Tahu people. He drew two old men at Moeraki, Otago, in 1905, who "were tattooed in parallel straight lines horizontally across their cheeks, a fashion unknown in the North" (Fig. 4). Whether or not this design was indeed "the last relic of their Eastern Pacific fatherland," as Cowan thought, this horizontal pattern, and the vertical pattern recorded by Parkinson in 1769, bring to mind the unusual and apparently old form (*moko kuri*; Williams 1971:207) illustrated by John White (1889 I: frontis; cf. Robley 1896:fig. 54). Here a woman's face is tattooed with short horizontal and vertical lines, arranged in groups of threes (Fig. 5). The design recalls a mat or plaitwork pattern (Simmons 1983:227–228, with references).

It is now appropriate to draw this scattered evidence together in order to ask the question so far implicit in this survey: what are the possible meanings of *moko*? In his paper on symbolism and composition in Maori art, Jackson (1972:70) notes some of the many explanations offered: that it made facial painting more enduring, that it disguised age by marking the natural lines of the face, and that it was a way to differentiate chiefs or tribes from each other. Some of these reasons suggest at least the possibility of *post hoc* rationalization. More plausible are the numerous recorded instances in the literature of Maori men saying that without complete *moko* they are not complete persons. While the absence of tattoo was usually a sign of nakedness (Cowan 1910:189–190), the wearing of *moko* on only one side of the face was sufficiently distinctive to bear a particular name— *papatahi*, meaning "one side" (Buck 1950:299). King reports the reasons that old women living in 1968 still underwent the ordeal of tattoo.

> When I asked women who had wanted the *moko* why they took it, the most common answer was "because it is the Maori way." Nohinohi Heu of Kawhia put it even more strongly. "It is my *Maoritanga*," she said. The *moko* was seen by these people as a visible embodiment of Maori culture, as an assertion of Maori separateness in a world that was becoming increasingly European in orientation (1972:n.p.).

Similar reasoning may have justified male and female *moko* during the early- and middle-nineteenth century, but what was the rationale for its practice in pre-European times, on both North and South Islands, probably over many centuries?

In other words, is it possible to find the meaning or meanings of *moko* in prehistory, given that any evidence will be indirect?

Jackson (1972:70) answers the question in structural terms. He sees *moko* "as a stylised facial mask," marked out first in the ritually equivalent colors of red and blue, which have strong death-in-life symbolic associations.

> In many myths and stories the colour red, and also the arts of tattooing and carving, originate in the underworld. . . . Thus the death-in-life symbolism of red which has been related to *pare* [i.e., carved lintel] symbolism also obtained in the case of facial painting. As in the chromatic symbolism of the *pare* the colour red had both mortuary and fertility connotations. . . . Applied to chiefs . . . the continuity and connectiveness of Maori kinship is expressed and affirmed. Moreover, since *moko* is situated half-way between impermanent painting and permanent carvings or sculptures it mediates and acts as a link between the natural realm of decay and the human realm of continuity and cultural permanence. . . . *Moko* thus brings the force of art closest to the individual person and links him with his cultural heritage and social identity. For there are *two personae* involved, namely the *natural* and the *cultural* person [emphases added]. They are resolved in the identification which the mask has with the flesh and bony structure of the face itself (1972:70–71).

Moreover, according to Jackson, paraphrasing Lévi-Strauss, the mask has left and right complementary elements which can "open up," in a structural sense, to reveal the human face beneath. In profile, i.e., when "opened up," these elements recall *manaia* designs, commonly carved as terminals on *pare*.

There is much in favor of this structural analysis, which seeks examples of left/right binary opposition in Maori carving in order to understand the latter in a symbolic context. Binary opposition is a recurrent theme in many aspects of traditional Maori society, particularly in life/death, male/female, or *tapu*/non-*tapu* relationships. With regard to *moko* itself, there is no doubt that it was perceived as possessing left and right components, pre-eminently on the face. It can be argued, therefore, that *moko* achieved completeness only when the components were put together, and so expressed the unity of "the natural and the cultural person," as Jackson put it, in what I would term a fully social personality.

On the other hand, structural analyses are often notoriously abstract and unhistorical, or at least ahistorical, in application. Although intellectually attractive because of their analytical ele-

gance, they must be tied to other investigative procedures to reveal their value. In the passage quoted above, Jackson extends, and to some extent transforms, his argument when he refers to the mythical origins of *moko* and carving in the underworld. One may take his argument further and link *moko*, its incidence and its varied stylistic forms, to wider contexts of Maori tradition.

Moko is often most extensively demonstrated on carved figures, especially on the much respected figures of the ancestors found in meeting houses. If one regards the ancestors as ideal beings, ancestor *moko* may be surmised to express the ideal social personality of the Maori in the form of a "mask," superimposed, like the technique of tattoo itself, on the human face. The suggestion that *moko* might be a symbolic representation of the ideal social personality in this sense is reinforced by an account recorded by Cowan (1930:148–149), who described the use of a face mask (*mata-huna*) which was both a copy, and a transformation, of an actual human *moko*.

> The late Mere Ngamai, a venerable lady of Te Atiawa . . . told me of the *mata-huna* worn by her grandfather, the Puketapu (Taranaki) chief Rawiri te Motutere. Rawiri, a warrior of the early part of the nineteenth century, who died about 1860, had a very light skin for a Maori . . . and his face was beautifully tattooed. He was very proud of his complexion and of his perfect *moko*, and he wore on special festive occasions, and also when travelling, to shield his face from the sun, a mask made of thin but strong rind of the *hué*-gourd. This mask was tattooed exactly like the *moko* on his face, and it was decorated at the sides and top with black and white feathers. It was fastened at the back of his head with cords of flax. Great was the admiration at public gatherings when bold Rawiri, tall, straight, martial, paraded up and down with *taiaha* in hand, addressing the assemblage through the mouth-opening in his grim black-tattooed *mata-huna* mask waving with feathers, the wonder and delight of his fellows.

Note that Rawiri's mask was made from a gourd, was exactly like his own *moko*, and yet was "black-tattooed." It thus served the dual purpose of both protecting his vanity and also expressing with remarkable panache his conventionally acceptable, and thus ideal, social personality.

The possibility that *moko*, representing the ideal social personality, i.e., the ancestor, could demonstrate a link with the mythical past is also suggested by other, albeit fragmentary, clues. *Moko* designs composed of vertical, horizontal, or a combination of vertical and horizontal lines have been mentioned above. In the latter case, namely the example recorded by White of the woman with *moko kuri*, it was noted that the design recalls mat or plaitwork. But, if so, why not also weaving, especially in view of the association demonstrated in myth between *moko* and weaving? According to Best (1974:206) and Buck (1950:296), knowledge of tattooing was brought back from the underworld by Mataora, who, Best (1974;206) says, also returned with ". . . a famous cloak and belt. . . . These two prized possessions were utilized as pattern garments by the women of this world, who have ever since continued to weave garments in a similar manner." (Cf. Simmons [1983:238], who records a female *moko* design [*tu*] in the form of a belt around the waist.) Other myths associate the origins of tattooing, weaving, and carving with the underworld realm of Hine-nui-te-po, Goddess of Childbirth (Best 1974:206; Buck 1950:296; Jackson 1972:70–71; Metge 1976:28). Thus these practices are linked within a complex which is associated with the symbolism of birth and, because of the association of the color red with mortuary as well as fertility connotations, equally with death. In connection with this red color symbolism, Luomala has a comment in her study of *Maui-of-a-Thousand-Tricks* that is suggestive in its link, via *moko kuri* (horizontal and vertical lines), with Jackson's argument. Maui had turned his brother-in-law, Irawaru, into the first dog (*kuri*), because the latter had been more successful on a fishing expedition than he had. Maui tattooed the dog's muzzle black, using this design. Luomala describes the *moko kuri* as recorded by John White and adds: "A flock of tern, fascinated by Maui's design on Irawaru, painted it in red on the sky where it can still be seen at certain times" (White 1889 2:126; Luomala 1949:122).

At another level, this birth/death symbolism is suggested by the fact that *moko* also means lizard (skink and gecko), classified by the addition of qualifying terms for different species (Williams 1971:207). Lizards were feared by the Maoris, and were linked with both the dreaded mythical dragonlike *taniwha* and the very real *tuatara* (*Sphenodon punctatus*). The *tuatara* and the lizard shed their skins. In other words, their natural actions enact a metaphor, whereby they continually cycle from life to death to life, and so on, dropping one "mask," one might say, in order to assume another. In connection with the word *tu-atara*, it may be relevant that one of the Maori words for genitals is *tara* (Williams 1971:386), and as noted above, there is evidence for the tattoo-

ing of genitals. As far as this evidence goes, therefore, it might be said to support the structuralist argument suggested by Jackson.

In 1921 Cowan recorded a Maori as saying, "You may be robbed of all your most-prized possessions; but of your *moko* you cannot be deprived" (1921:242) By that time only a very small number of men still wore the precious insignia. Clearly, by then its significance lay at least partly in it being a visible if rather general and abstract expression of *Maoritanga*. But the earlier meanings of *moko* may not be elucidated either so directly or so completely. Given the limited, scattered, and fragmentary character of information about the prehistory of the practice, these insights may remain beyond recovery or reconstruction. On the other hand, if *moko* is regarded as one expression of the way the Maoris saw themselves in relation to their whole present and their whole past, its meanings may have possessed the pervasive existential characteristics discussed in this paper.

Notes

1. I am grateful to Dr. Adrienne Kaeppler for her comments on an earlier version of this paper and to Hardwicke Knight, of Broad Bay, Dunedin, New Zealand, for his detailed remarks on the incidence of *moko* recorded in photographs of nineteenth-century Maoris. I also thank Irina Averkieff for her helpful and considerate editorial advice.

OVERLEAF: Hidatsa tattoos c. 1840 by Road Maker on Poor Wolf as depicted in a painting by Frederick N. Wilson, 1911. Courtesy Minnesota Historical Society.

Introduction: Native America
Arnold Rubin

The peopling of Oceania and Native America from eastern Asia justifies consideration of these areas as comprising a culturally unified "Pacific Basin."[1] Unlike the great stretches of open sea which separated and, for long periods, isolated the island groupings of Oceania, however, the vast contiguous land-mass of the Americas offered a wide range of ecological options and facilitated the movements of populations and ideas. Archaeological remains and travellers' accounts deriving from the early contact period attest to the wide distribution of irreversible forms of body art. In many areas, for example, skulls were modelled through some form of compression in infancy. Shaped skulls preserved in collections of Native American skeletal materials verify the often somewhat incredulous testimony of European visitors as to the appearance which resulted from these techniques.[2] The Maya practice of chipping and scoring the upper and lower incisors in a variety of shapes, and sometimes inlaying them with jade plugs or discs, is also evident in the archaeological record.[3]

While modifications of soft tissue (such as piercings) do not ordinarily survive in archaeological contexts, the locations of certain categories of ornaments in burials may yield presumptive evidence. Labrets and ornaments for pierced ears and nasal septum—both representations in art and the actual objects, for both men and women—occur with impressive frequency in archaeological and ethnographical contexts throughout the Americas. Thus, while it is fortuitous that the two papers included here deal in historical and cultural depth with lip-piercing in two adjoining areas of North America—Gritton's for southern Alaska, Jonaitis' for the Tlingit of the Northwest Coast—the actual distribution of these and related forms is much wider.[4] For example, Fr. Duran's 16th century account of the Aztecs of Mexico included a description of the coronation of the emperor Tizoc:

> In his ears were green stones, round, set in gold, very resplendent; in his mouth, a fine emerald also set in gold. Another green stone, very transparent, traversed his nose; from each end of it projected some small, irridescent, green-blue feathers, which moved elegantly and delightfully.[5]

A remarkable ear-piercing convention for males in southeastern North America involved separation of the helix from the concha of the ear, with the resulting loop of flesh wrapped with wire or hung with pendants.[6]

Tattoo was also widely distributed in the Americas, usually connected with ethnic identity, social role, or status. In western North America, lines tattooed on women's chins (as discussed here by Gritton for the Inuit) usually indicated group membership and/or marital status.[7] More elaborate and extensive representational body-tattoos for women, reflecting high status, were reported by the earliest visitors to Virginia and Carolina, and as far north as the Ontario Iroquoians.[8] Along the Northwest Coast, tattooing for most groups was simple in design and casually performed, but young people of high rank were tattooed with elaborate crest-designs in connection with major potlatches. Such work was particularly extensive among the Haida, covering the backs of the hands and upper surfaces of the feet, both arms from wrists to shoulders, chests, thighs and lower legs, and sometimes also cheeks and back.[9] Men's tattoos in the southeast typically had martial associations. In Louisiana, killing an enemy or other war honors entitled a man to have a tomahawk or war-club tattooed on his shoulder above a symbol identifying the nation against which his accomplishment was realized. Outstanding warriors among the Chickasaw were distinguished by their tattoos; men who affected marks they did not deserve were publicly humiliated and forced to suffer their removal.[10]

Terence Grieder has proposed that tattoo was one of the traits carried by the third of the five waves of settlement from northeastern Asia which he reconstructs for the Americas; he dates the migration in question to the period between 5000 and 1500 B.C.[11] Although Grieder's analysis is somewhat schematic and attenuated, it represents

the only attempt to date to synthesize the vast, scattered corpus of archaeological and ethnographical data for Native America tattoo. A comparable effort for the wider spectrum of Native American body-art remains to be undertaken.

Notes

1. See "Introductions" to Asian and Oceanic sections.

2. Shaped skulls are in the collections of the Smithsonian Institution and the American Museum of Natural History. Such techniques appear to have been comparatively rare in other areas of the world, but cf. head-binding among the Mangbetu of northeastern Zaire. Philip Drucker (*Indians of the Northwest Coast*, American Museum of Natural History Press, Garden City, NY, 1963 (1955), p. 93) describes three "styles" of skull-modelling on the Northwest Coast, from the Lower Columbia River northward through the Kwakiutl. See also the well-known painting (ca. 1847) by Paul Kane of a "Flathead" (Salish) mother and cradleboarded child, reproduced in the *The World of the American Indian*, National Geographic Society, Washington, D.C., 1974, p. 231. Regarding the distribution of skull-shaping in the southeast, see John R. Swanton, *The Indians of the Southeastern United States*, Smithsonian Institution Press, Washington, D.C., 1979 (1946), pp. 537–41. See also the *Handbook of North American Indians* (cited here as *Handbook NAI*; relevant topics ear-piercing, nose ornaments, tattooing, and other forms are indexed under "adornment") and *Handbook of South American Indians* (cited here as *Handbook SAI*; relevant topics indexed individually); skull-modelling was practiced in three areas of South America: the Caribbean coast through the Antilles; the coastal portions and adjacent Highlands of Ecuador, Peru and Northern Chile; and the Rio Negro and other Patagonian Valleys of the Argentinian coast (*Handbook SAI* vol. 6 p. 43; also vol. 2, pp. 31, 236–7). I am grateful to my colleagues Zena Pearlstone, Cecelia Klein, and Johannes Wilbert for guidance into these areas of the Native American bibliography.

3. Examples are in the collections of the Peabody Museum, Harvard, the Smithsonian Institution, and the University of Pennsylvania Museum. *Handbook SAI* (vol. 6 pp. 46–7) relates similar dental inlays (using gold rather than jade) from Esmeraldas in Ecuador to Maya influence, and (*passim*) widespread tooth-chipping to post-contact African influence. Regarding the rich traditions of body-art among the Maya, see Alfred M. Tozzer (ed. & trans.), *Landa's Relacion de las Cosas de Yucatan*, Papers of the Peabody Museum of American Archaeology and Ethnology, Harvard University/Kraus Reprint Co., vol. XVIII, 1975 (1941; indexed under "Personal Ornamentation"); and J. Eric S. Thompson, "Tattooing and Scarification among the Maya," *Notes on Middle American Archaeology and Ethnology*, Carnegie Institution, Washington, No. 63, 1946, pp. 18–25.

4. See Jonaitis, notes 3,4,7.

5. Diego Duran, Historia delas Indias de Nueva Espana e Islas de Tierra Firme, ed. Angel Garibay K., Tomo II, p. 309 (1967, Editorial Porrua, Mexico). I owe thanks to Cecelia Klein for locating and translating this passage. During his travels in what is now the southern United States between 1527 and 1537, Cabeza de Vaca observed labrets in lower lips from the Colorado River along the Texas Coast to the west coast of Florida; Buckingham Smith (trans.), *Relation of Alvar Nunez Cabeza de Vaca*, Readex Microprint Corp., 1966 (1871), pp. 75, 78 n. 3; Frederick Webb Hodge, *Handbook of American Indians North of Mexico*, Smithsonian Institution Bureau of American Ethnology, Bulletin No. 30, Rowman & Littlefield, N.Y., 1971 (1905), vol. 1, p. 750; Swanton, *Southeastern*, pp. 115–16. Cabeza de Vaca also saw one instance of men with pierced nipples, identified by W. W. Newcomb, Jr. (*Handbook NAI*, vol. 10 (Southwest), 1983, p. 363) as the Karankawa of the area between Galveston and Corpus Christi. Smith (loc. cit.) also quotes a missionary's description (dating to the second quarter of the 17th century) of a practice among the "Acaxee" of Sinaloa, Mexico, wherein the lower lip of a man-killer was pierced for insertion of a labret made from a small bone taken from the body of his victim.

6. E.g., Ives Goddard, "Delaware", *Handbook NAI*, vol. 15 (Northeast), 1978, p. 229; Elisabeth Tooker, *an Ethnography of the Huron Indians, 1615–1649*, Smithsonian Institution/Huronia Historical Development Council, 1967 (1964), p. 123; Swanton, *Southeastern*, pp. 510–14.

7. See above, "Introduction: Asia"; Edith S. Taylor and William J. Wallace, *Mohave Tattooing and Face-Painting*, Southwest Museum Leaflets, No. 20 (1947); D. W. Light, *Tattooing Practices of the Cree Indians*, Glenbow-Alberta Institute, Calgary, Occasional Paper No. 6, 1972; Wendy Rose, *Aboriginal Tattooing in California*, Archaeological Research Facility, Department of Anthropology, U.C. Berkeley, 1979; Drucker, *Northwest Coast*, pp. 92–3; *Handbook NAI*, vol. 6 (Subarctic), 1981, pp. 498, 517, 522, 571, 629; *Handbook NAI*. vol. 10 (Southwest), 1983, pp. 34–5, 57, 62, 110, 242.

8. Quoted in Swanton, *Southeastern*, pp. 532–536; also Tooker, *Huron*, pp. 15, 21. For similar conventions among the Chaco tribes South America, see *Handbook SAI* vol. 1 pp. 280–2; in vol. 1 p. 526, a "sewing" tattoo, technique which sounds intriguingly similar to that of the Inuit of the far North is described.

9. Drucker, *Northwest Coast*, pp. 92–3, 141–2. Illustrated in Mallery, 10th Rep. B.A.E., 1893, reproduced in Hodge, *Handbook . . . Mexico*, vol. II, p. 700.

10. James Adair, *History of the American Indians*, Johnson Reprint Corp. N.Y., 1968 (1775), pp. 389, 421; M. Le Page du Pratz, *The History of Louisiana . . .* , Claitors, Baton Rouge, 1972 (publ. in French 1758; first Engl. ed. 1774), p. 346; Swanton *Southeastern*, pp. 533–6. According to *Handbook SAI* vol. 3 pp. 116, 126, Tupinamba women were tattooed at menarche, men after killing an enemy; in parts of southern Central America, slaves and the followers of *caciques* were tattooed with identifying marks (*Handbook SAI*, vol. 4, pp. 201, 254).

11. Terence Grieder, *Origins of Pre-Columbian Art*, University of Texas Press, Austin, 1982, pp. 155–68 *et passim*. See also *Handbook SAI* vol. 4 pp. 8–9, vol. 5, p. 695.

Labrets and Tattooing in Native Alaska
Joy Gritton

Tattooing and the wearing of labrets were widely practiced by the Eskimos and Aleuts of Alaska in prehistoric and early post-contact eras. Yet, both of these customs disappeared within three generations after significant interaction with Europeans and Americans, despite the fact that other aboriginal arts continued to flourish, albeit altered in content and intent. The decline of these two permanent modes of adornment has generally been attributed to intense efforts on the part of Christian missionaries to eradicate aspects of dress, grooming, and ritual that they found offensive. A closer look at the cultural patterns underlying the history of Western Eskimos and Aleutian tattooing and labret usage, however, yields additional insights into the meaning of these practices in traditional society and supplies more articulated explanations for their demise.

Lines generally considered to resemble historic tattoos appear on numerous prehistoric carved objects, and some representations of the human face show indication of labrets as well (Larsen and Rainey 1948:114–119; VanStone and Lucier 1974:1–9). In addition, stone and bone labrets, cheek plugs, and nose ornaments have been recovered from archaeological sites in the Aleutian Islands (Jochelson 1925:figs. 84–97). Those thus far retrieved, however, are the large oblong labrets and hat-shaped lateral plugs that in historic times were typical of areas further north, and not the more delicate single or double "winged" labrets that appear in the ethnographic data from this region. The larger of the labrets excavated are thought to have been carved for inser-

tion into funerary or dance masks (Jochelson 1925:99–100). Lateral stone and ivory labrets were also uncovered in conjunction with burials at the northern Alaskan Ipiutak site of Tiagra at Point Hope; the largest measured 11.9 cm and weighed 7 ounces. With a few exceptions, it is difficult to determine the sex or age of the labret-wearer from archaeological evidence (Larsen and Rainey 1948: 114–119).

The first descriptions by Europeans of the use by Alaskan peoples of tattoo and labrets refer to the Aleuts and Pacific Eskimos. Information recorded during the early period of contact following Vitus Bering's arrival in 1741 is scant and, at times, seemingly contradictory. A drawing of an Aleutian dance ceremony made between 1769 and 1775 depicts women with cheek tattoos consisting of lines and dashes extending from the mouth to the jaw line and from the nose to the ear, and men with medial lower lip labrets (see Ray 1981: fig. 2). The Unalaskan man portrayed by Webber in 1778 wears a similar single "winged" labret as well as a nose ornament that runs parallel to the mouth (Fig. 1; Cook and King 1784). His female counterpart exhibits tattoos on the cheeks (two barbed lines from nose to ears) and chin (one wide band). In addition, she wears a medial lower lip labret, not unlike those worn by men, and an extraordinary nose piece comprised of a long looped strand of beads that dangles over the mouth and chin (Fig. 2). Langsdorff (1817:338) observed that on festive occasions strings of beads would be attached to the ends of the simpler nose ornaments. Beads and other appendages could be made from

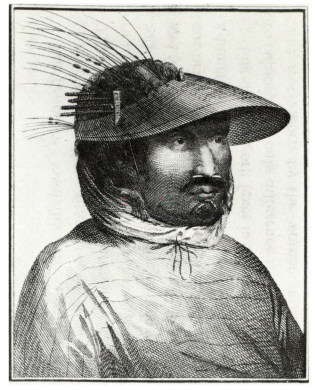

1. *Unalaskan man. 1778. John Webber. From Cook 1784:pl. 48.*

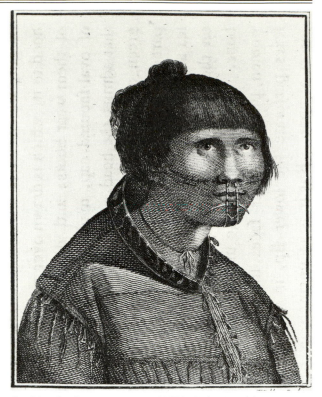

2. *Unalaskan woman. 1778. John Webber. From Cook 1784:pl. 49.*

bone, mussel shells, coral, glass, or amber, the last of these being of considerable economic value (Lisiansky 1814:195; Jacobi 1937: 116,127–128; Sauer 1802:154–155; Sarytschew 1806:9). The smaller labrets that adorn the lower lips of Webber's man and woman from Prince William's Sound (Figs 3,4) are rarer, but in 1805 Lisiansky noted an apparently similar practice on Kodiak Island of placing small bones in "apertures in the lower lip" which "resembled a row of artificial teeth" (1814:194; Cook and King 1784 II: 369–370).

There are at least two recorded instances of the use of paired lateral labrets by Unalaskan women (Figs. 5,6). Both of these women, illustrated by Sarytschew from the Billings expedition, have double bead-strands descending from their nostrils and almost identical cheek and chin tattoos; the young woman encountered in 1786 also has three lines composed of a series of dashes tattooed across the forehead. The man shown with her exhibits neither labrets nor nose ornaments, and Sarytschew (1806:9) maintains that the men "leave their faces as nature has formed them" while the women alone "disfigure" themselves. In contrast, Sauer (1802:pl. VI) illustrates a man from Kodiak Island, seen in 1791, who not only wears

a nose ornament and medial labret from which hang three strands of beads, but also is tattooed with six horizontal lines extending across the cheeks and nose (Fig. 7).

There are also references to a group of males on Kodiak who were tattooed on the chin as part of a complete adoption of a woman's role within the community:

> Boys, if they happen to be very handsome, are often brought up entirely in the manner of girls, and instructed in all the arts women use to please men. Their beards are carefully plucked out as soon as they begin to appear, and their chins tattooed like those of the women. They wear ornaments of glass beads upon their legs and arms, bind and cut their hair in the same manner as the women, and supply their places with the men as concubines (Lansdorff 1817:345).

Though this phenomenon had begun to die out by the beginning of the nineteenth century, these *schopans*, as they were called, were previously much valued by Eskimo households. Lisiansky (1814:199) recounts one incident in which a *toyon*, or "chief," brought a *schopan* to the local church with the intention of marrying him, only to be thwarted in his efforts by an interpreter present at the ceremony who happened to recognize

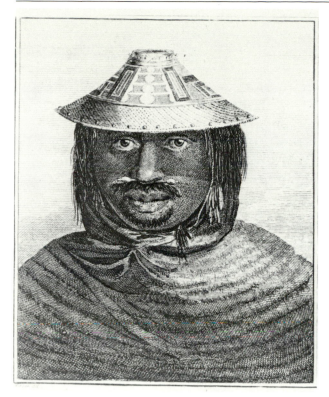

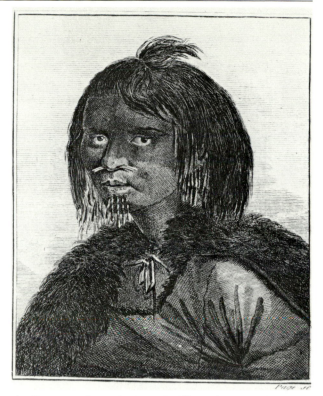

3. Man from Prince William's Sound. 1778. John Webber. From Cook 1784:pl. 46.

4. Woman from Prince William's Sound, 1778. John Webber. From Cook 1784:pl. 47.

the *toyon*'s partner as male and alerted the surprised priest.

Tattooing seems to have been more prevalent among women than men in southern Alaska and was not limited to the face. Mention is made of tattooing on the neck, arms, hands, and feet in Unalaska, while there are references to breast and back tattoos among the women of Kodiak Island (Lansdorff 1817:339; Lisiansky 1814:195; Jacobi 1937:116). Chin tattoos were acquired by girls at the age of puberty, but Merck (in Jacobi 1937: 116,128) concludes that lines and dots which were subsequently tattooed or painted onto other parts of the face and body were decorative and were intended to "please the men." Veniaminov (in Ray 1981:29), however, associated certain designs with ancestors' hunting or war exploits.

Both Sarytschew (1806:9) and Langsdorff (1817:339) characterize the method of tattooing as being based on puncturing: soot was rubbed into wounds made by a sharp instrument (see also Jacobi 1937:128). This technique was also used by the Central Eskimo of Canada, in contrast to the "sewing" procedure of northern Alaska (Birket-Smith 1959:119; Boas 1964). Incisions for the single medial labrets were made in the lower lip twenty days after birth following a purification

5. Woman of Unalaska Island. 1790. From Ray 1981:fig. 14; Sarychew 1806:18.

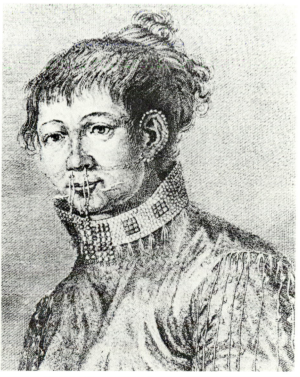

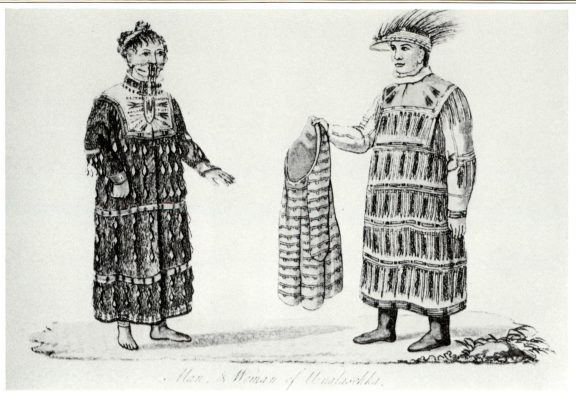

6. *Man and Woman of Unalaska. 1786. From Sarytschew 1806:8.*

bath given the infant. The nasal septum was also perforated at this time (Lisiansky 1814:201). Tattooing and the wearing of labrets and nose ornaments were all beginning to disappear from Eskimo life in southern Alaska as early as 1786, however, and were considered rare twenty years later (Sarytschew 1806:9; Langsdorff 1817:357).

In the area between the Yukon and Kuskokwim rivers, as well as on the island of Nunivak, both men and women wore labrets and nose ornaments. Women had one or two incisions cut just above mid-chin and commonly wore single or double sickle-shaped labrets, which often had holes drilled in them for the attachment of strands of beads (Fig. 8, Nos. 1–8). The men wore small hat-shaped labrets with curved flanges that rested against the teeth. These were fitted with a central pin, which in turn was adorned with a bead or stone (Fig. 8, No. 12).

A woman's labret of serpentine from Nunivak Island is carved in the shape of a whale's tail (Fig. 8, No. 10). This ornament is very similar to one collected in the Bering Strait on King's Island (Fig. 8, No. 9), and Nelson (1899:47) suggests that these labrets are probably based on an ancient form, now virtually extinct, that previously enjoyed widespread distribution. The "winged" labrets of Unalaska could also be interpreted as abstract ver-

sions of whales' tails. On Nunivak Island, piercing of the lower lip and nasal septum took place during childhood, or even after marriage, and wealthier families sponsored a sweatbath and a small feast to mark the occasion. Tattooing was apparently limited to women and included face and wrist designs (Lantis 1947:3; 1946:225).

Among tribes north of the Yukon, a comparatively strict division of types of ornamentation based on sex was observed. Only women were tattooed on the chin, and only men wore labrets, though there are indications that women formerly wore labrets as well (Larsen and Rainey 1948:114; Stefansson 1914:167,224). Both men and women could be tattooed on the face (other than the chin) and body under certain circumstances.

In this region labrets were acquired at the age of puberty. When a boy's voice changed he was provided with men's clothing and soon afterwards received his first labret cuts. The operation was performed by an older man—not a relative—skilled in making incisions. He was not paid for his assistance. The boy would lean back into the man's lap, hands over ears, with a piece of wood in his mouth, and the man would drive a slate knife through the flesh. After the wounds were properly rinsed with urine, small cylindrical pins of ivory with flanges at one end were inserted into

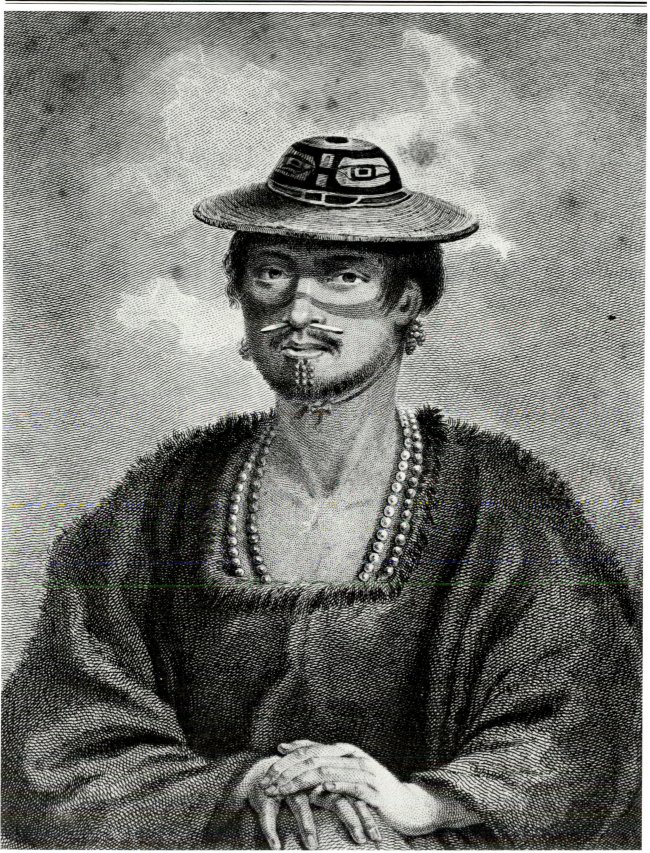

7. Kodiak Man. 1791. From Sauer 1802:pl. 6.

the cuts (Spencer 1959:241–242).

As the body adjusted to these plugs, labrets of a progressively larger size would be inserted to widen the incisions. For this stretching process a man might go through six to twelve such pins. The graduated set would then be pierced and strung on sinew, occasionally decorated with engravings, and given to the man's wife to be worn as an ornament on her belt or needle case (Fig. 8, Nos. 23,25; Nelson 1899:48). Adult males had incisions up to one-half inch in diameter which could be stretched even wider. The cutting of the lower lip in this manner was perceived as the final initiation into the adult world of marriage and hunting.

Labrets could be made of a variety of materials: stone (quartz, agate, jadite, serpentine, or slate), graphite, glass, bone, wood, or ivory. Stockton even describes the use of coal and commercial glass bottle stoppers as lip plugs at Point Hope in 1889 (1890:197). Labrets made of common materials, plain and small, were worn every day, while labrets carved from precious stones, adorned with beads or otherwise decorated, and larger in size, were generally reserved for festive occasions. North of the Yukon the everyday group consisted of hat-shaped ornaments that "buttoned" into the lower lip (Fig. 8, Nos. 19–21). The more ornate labrets of the same region can be divided into two varieties: large, flat, oblong ornaments (Fig. 8, Nos. 14,15) and round, disc-like ones onto which a bead could be glued with seal oil or blood (Fig. 8, Nos. 13,17,18; Figs. 9,10). The larger stone labrets weighed down the lower lip, exposing teeth and gums, and thus had to be removed in cold weather to prevent the lip from freezing. The ornaments were also occasionally taken out before eating and sleeping (Nelson 1899: 49–50).

There are indications that the size, material, and type of labret worn could signify not only age, but also social status (Beechy 1831:422; Spencer 1959:242; Stefansson 1914:200). Certain blue stones and beads were especially admired and coveted, and labrets adorned with these were objects of considerable value. Descriptions of such labrets do not always make clear whether the blue insets are of natural or manufactured materials. Kotzebue (1821:211) notes that the blue beads worn by the Eskimo of Schismareff Bay in 1816 were very similar to those he had seen in Asia and were probably obtained through trade with Russians or Siberian Eskimos. In addition to manufactured beads, however, there are references to blue *stones* and several myths describe the origin of these stones. All versions resemble in content a

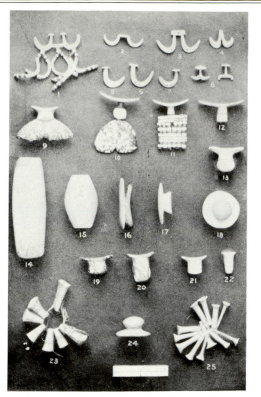

8. *Labrets. 19th century. From Nelson 1899:pl. 22.*

tale, recorded by Stefansson (1914:200) in 1908, that had been recounted some years before by a man from Kotzebue Sound: a woman who had been mistreated by her husband ran away, fleeing across the ocean to the north until she came to an uninhabited island where the beach was covered with blue stones. She filled a mitten with the pebbles and returned home. Because the stones represented great wealth, her husband, who had by then remarried and had children, discarded his new family and accepted his former wife back into the household.

Blue beads—of glass or stone—were eagerly sought trade items of astounding value at the time of contact. This was true not only in the north but also in some southern areas, such as Kodiak Island, where Merck (in Jacobi 1937:128) saw blue beads decorating nose ornaments as well as labrets. Whole beads were never split to make a labret; rather, halves of beads accidentally broken were used for this purpose. In the early 1900s, one blue bead could be traded for two silver foxes, twenty slabs of bone, a sled with a team of five dogs, and five cross foxes (Stefansson 1914:200). A pair of labrets with beads was equal in value to an *umiak*, a large boat used for transportation, in whaling, and as a makeshift shelter (Spencer 1959:156).

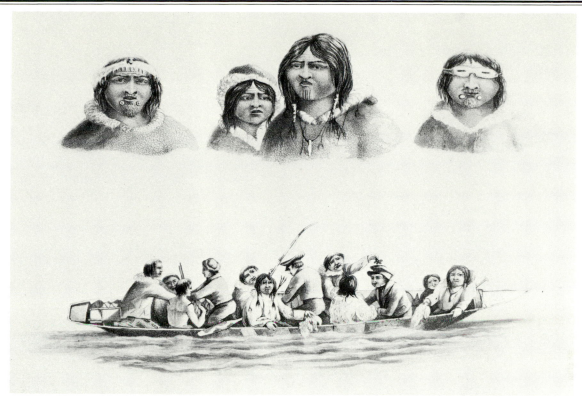

9. *Eskimos from Cape Thompson. 1826–27. From Beechey 1831:pl. 1.*

10. *Eskimos from Kotzebue Sound. From Choris 1822.*

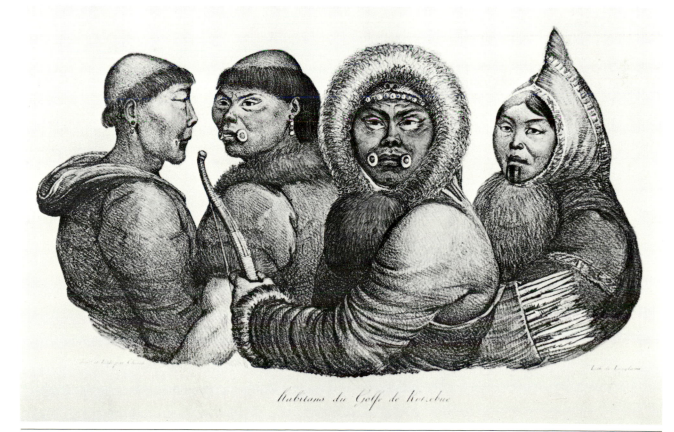

Habitans du Golfe de Kotzebue

Wearing such ornaments would, thus, obviously reflect a certain reserve of wealth, and wealth (or a surplus of goods) was one—but not the only—criterion of status. Spencer (1959:242) maintains that only an *umealiq*, or whaling crew leader, "of note" could wear the most expensive blue bead labrets. The *umealiq*, along with the shaman, enjoyed particularly high status in traditional Eskimo hunting societies. He was respected for his whaling expertise and was depended upon for material support in lean times. The role of leader was not fixed or permanent; any boat owner with the necessary leadership qualities, familial support, and surplus commodities could assume the position. The leader's wife shared in his status and had certain tasks and taboos for which she was responsible.

According to Nelson (1899:44–45), labret usage was experiencing rapid decline as early as the 1880s in St. Michael: not only did fewer young men have the requisite incisions, but older men had stopped wearing their labrets as well. Further north, changes were slower in coming, but labrets apparently disappeared even before the decline in popularity of women's chin tattoos, which occurred at the turn of the century.

A girl was tattooed on the chin, following a brief period of isolation at the time of her first menstruation, by drawing a thread blackened with soot through the skin, a method derived from Siberia (Birket-Smith 1959:119). Women usually were marked with one to five lines that radiated downward from the lower lip (Figs. 9,10). There are some indications that the design may have been additive, with supplementary markings applied over a period of time, perhaps to designate different stages in the woman's life, i.e., puberty, marriage, and children. Beechey (1831:384; see also Anderson and Eells 1935:175) describes a girl of eleven who had one line and a mother of twenty-three with three lines. Girls who expressed a desire to be tattooed were warned that once so marked men might rape them (Spencer 1959:243). Clearly, chin tattoos were a sign of a girl's nubility. There are also references to tattooing of the hands, wrists, and forearms (Anderson and Eells 1935:174; Nelson 1899:50). As in the south, women's tattoos are usually characterized as decorative, but there are at least two reports of the designs having previously served to distinguish men from women in hand-to-hand warfare (Ray 1977:23; Anderson and Eells 1935:175). In addition, a missionary told Anderson at Cape Prince of Wales in the early 1930s that girls were tattooed to avoid the horrid *post mortem* fate of being

11. *Man with tattooed cheeks. 1887–88. From Murdoch 1892:fig. 87.*

turned by evil spirits into a drip-container for the seal-oil lamp. A very similar explanation was recorded by Hans Egede (in Thalbitzer 1912:608) in West Greenland in the mid-1700s.

A special group of markings—both painted with soot and permanently tattooed on cheeks, noses, foreheads, shoulders, backs, and chests of men and women—was clearly linked with the ritualistic complex of behavior associated with whaling. Though the literature is confusing as to specifics, whalers, their crew leaders, and their wives were smeared with soot before, during, or after the hunt (Murdoch 1892:139–140,272,275; Ray 1977:23; Stefansson 1914:389–390; Spencer 1959:340). In some cases these marks were tattooed on the skin to denote a hunter's success—either in a general sense or as a specific tally of whales caught. A few appear to have been representational, such as the whale flukes tattooed on a man's chest mentioned by Murdoch, but most consisted of horizontal lines or formations of dots across the cheek, nose, and forehead, or dots at the corners of the mouth or on the temples (Fig. 11). Spencer (1959:340) maintains that status within the community was the deciding factor in determining who was painted and who tattooed, stating that if the harpoonist and crew leader enjoyed sufficient status they could have their whaling marks permanently applied. In light of the transitory nature of social standing within the Eskimo community, however, it seems more plausible to surmise that the temporary soot markings were used in conjunction with preparation for the hunt, and that tattoos indicated an unchangeable, completed action, i.e. a whale caught.

Whatever the relationship, both soot markings

and tattoos were probably concerned with the same concept—that of protection from, or manipulation of, the spiritual world. It is known, for example, that in the nineteenth century both a shaman and a number of men who had murdered other men bore tattoos resembling those worn by whalers in order to protect themselves from the revenge of a deceased person's spirit (VanStone and Lucier 1974:6; Petitot 1876:xxv). Among the St. Lawrence Islanders, a boy's joints were tattooed when he had killed his first walrus, polar bear, or whale to "charm" him against evils (Anderson and Eells 1935:175). Stefansson reports from Canada that the Eskimos of Victoria Island marked killers of whales and killers of men with similar tattoos:

> They agreed that in general to kill a man was about the equivalent of killing a whale, though they were a little doubtful whether the killing of an Eskimo was to be considered quite so much of an achievement as the killing of whale; but an Indian was quite up to a whale. In either case the one who did the killing was entitled to two tattoo lines across his face. If a whale was killed, the man had a line tattooed from the corners of the mouth to the lobes of the ears; but if an Indian had been killed the tattoo lines were from the nose to the ears (1914:367).

In Greenland, Johan Petersen (in Thalbitzer 1912:608) recalled a man who had been tattooed between the eyebrows to prevent a shark he had harpooned from recognizing him. A pivotal concept in Eskimo hunting ritual in general is the traditional belief in animal reincarnation. It is thus feasible that tattoos were one method of "branding" a hunter in anticipation of subsequent encounters with the souls or spirits of animals he had stalked and killed. In any case, it seems reasonable to suggest that certain soot markings and tattoos represented an attempt by the Eskimo to come to terms with the most dangerous aspect of the hunt: the taking of the life of a creature who possessed a spirit not totally unlike his own. Since the hunter's wife took part in the hunt vicariously, it is understandable that she, too, required protective measures.

References to the hunter's prey are also found in certain facets of labret usage in the north. There is an aspect of sympathetic association revealed in the wearing of labrets shaped like whales' tails. Likewise, an obvious visual affinity exists between the paired lateral labrets and walrus tusks, with the latter possibly having provided the formal and conceptual origins for the former. In some instances, references to the walrus were reinforced by clothing, as with the white gores on parkas worn in the Bering Sea region (Fitzhugh and Kaplan 1982:186). In historic times certain shamans were known to have worn special labrets that apparently closely resembled actual tusks, as is related in this folktale recounted by Spencer from the Point Barrow region:

> There was once a boy at Barrow who did make fun of some shamans. They were the shamans who wore a special kind of labret, which looked like a walrus tusk. This boy made as if he had such labrets and followed a shaman around. The shamans agreed to make the sticks which the boy was using to imitate the shaman's labret cleave to the boy. They worked magic. The boy was unable to open his mouth and died (1959:317–318).

There are numerous reports of man/animal transformations involving the walrus, and the walrus was one of the shaman's possible tutelaries. On Nunivak Island, it was said that once while a shaman was being burned in a show of power "his voice could be heard like that of a walrus" (Lantis 1946:201). As the shaman maintained closer contact than ordinary people with the animal realm—readily assuming animal forms and attributes and visiting the whale and seal at their homes in the sea—it seems appropriate that his ornaments should more closely resemble the actuality of the animal's appearance.

It is clear, then, that throughout Alaska individual body arts had specific functions within the structure of the hunting society—functions that included initiation, protection, status-definition, association and/or transformation. Labrets marked a young man's initiation into the adult world as a hunter, and chin tattoos signified a girl's eligibility to become a hunter's wife. If the young hunter was unusually successful, he could earn the right to wear the most prestigious and valued labrets. In addition, both he and his wife could be tattooed to reflect his accomplishments. Tattoos safeguarded them from perilous supernatural power.

The abandonment of tattooing and labrets between 1800 and 1900—first in the Aleutian Islands and then, gradually, northward to Point Barrow—parallels in space and time other developments within Eskimo society. Early in the nineteenth century, the peoples of the southern regions had already experienced prolonged and brutal exploitation at the hands of Russian fur dealers. The fur trade was of such intensity that game quickly became scarce and groups of Aleut and Pacific Eskimo were sent by the Russians into neighboring

regions in search of more bountiful and less abused animal reserves. This resulted not only in changes in subsistence patterns but also in a mixing of the various groups in the islands and new settlement patterns.

In 1838 the northern whaling grounds were discovered and whaling activity which had previously been confined to the southern seas was expanded to include the Bering Strait and Arctic Ocean (Chance 1966;13). The demand for the baleen of the bowhead whale, which was used in Europe and the United States for buttons and corset stays, transformed the whaling industry into an amazingly lucrative enterprise. By 1852—a peak year—whaling vessels in the Bering Sea numbered 278 and their income reached an estimated 14 million dollars (Jenness 1962:5).

With commercial whaling came Western technology, which was to prove to be both a boon and a curse to the Eskimo. The traditional harpoon and lance were replaced by the more efficient dart and shoulder guns. High-powered rifles were introduced and quickly adopted, making it easier to obtain the caribou meat and furs which could be traded to the whalers for such items as flour, tea, clothing, molasses, and matches. Many young men deserted their own hunting activities in order to work as deckhands or guides on the whaling ships. These "advances" in Eskimo means of subsistence were to spell disaster for the natives when, at the beginning of the twentieth century, newly developed products made whale oil and baleen obsolete (Chance 1966:14). Both sea and land animal resources had been depleted to the extent that they could no longer support the Eskimo population. Thus, not only could the Eskimo not afford the Western goods which had become necessities, but the traditional sources of food and raw materials were exhausted as well.

It is within this context that an understanding of the ties between tattooing and labrets among the Alaskan Eskimo and Aleut groups and the hunt becomes crucial. The functions of these art forms —essentially manifesting one's place or role within the hierarchy of hunting life—became obsolete as the way of life itself disappeared. Western technology and Christian prayer rapidly displaced the amulet, chant, and recourse to the shaman as means of insuring hunting success and mitigating fears of the unknown or uncertain. Eskimo children were now "initiated" into a far different world than that of their parents—a world in which the visible signs that denoted competency and certain futures were ones of Western demeanor, dress, and grooming. In the mission schools established in the 1800s, these young Eskimos were taught the virtues of literacy, punctuality, and neatness, rather than the traditional skills of game stalking, skin preparation, or weather prediction (Collier 1973:39). For many of these children it became a question of identity —their "sense of self" was now oriented toward the role they hoped to assume within the white man's world. The marks of a hunter or hunter's wife served no purpose in their new lives and were understandably abandoned.

Deprived of their original cultural base, these modes of body art similarly had no relevance to the evolving categories of tourist and souvenir arts. Other art forms—carving or basketry, for example—could shift from a basic subsistence value to a money economy. Souvenir hunters and anthropologists kept many native traditions alive by providing a new market. Body art had no such market and tattooing and labrets became superfluous and devoid of meaning. They were, in effect, casualties of "progress," of an ongoing adaptation to a particularly severe environment.

Women, Marriage, Mouths and Feasting: The Symbolism of Tlingit Labrets[1]

Aldona Jonaitis

In the records of his travels, Jean Françoise de la Pérouse made the following comments on the Tlingit women wearing labrets he had seen in 1786:

> Their faces would be tolerably agreeable [were it not for their labrets]. This whimsical ornament not only disfigures the look, but causes an involuntary flow of saliva, as inconvenient as it is disgusting. . . . I could hardly have believed [this custom] had I not seen it. All without exception have the lower lip slit close to the gum the whole width of the mouth, and wear it in a kind of wooden bowl without handles, which rests against the gum, and which the slit lip serves as a collar to confine, so that the lower part of the mouth projects two or three inches. . . . This custom [is] the most disgusting perhaps that exists on the face of the earth. The girls wear only a needle in the lower lip: the married women alone have the right to wear the bowl (Pérouse 1799, quoted in Laguna 1972:123,433).

At the time of their first contact with Europeans at the end of the eighteenth century, virtually all adult Tlingit women wore in their lower lips pulley-shaped labrets of stone, bone, wood, or ivory, ranging in size from two to ten centimeters (Fig. 1).[2] Although some sources assert that young girls, even infants, received incisions in their lower lips, most travelers agree that the initial slitting occurred at a ritual celebrating the onset of a girl's menses. Several sources also mention that the girl's first labret was an indication of her marriageability and that larger and larger labrets, inserted over time, indicated the increasing status of their wearer. Most reports also describe a sumptuous feast celebrating the insertion of a girl's first labret.[3]

Eighteenth-century visitors, affirming the Eurocentric views on beauty prevalent at that time, judged that a labret disfigured the rather attractive face of the Tlingit woman. Although they commented upon this simple adornment's relationship to feasting, sexuality and marriage, and position in the status hierarchy, early visitors displayed no interest in analyzing the labret's social and psychological significance. In contrast, the contemporary student of Northwest Coast Indians finds the question of the labret's attractiveness irrelevant and focuses instead on the meaning the ornament had to the Tlingit people. Despite the recent increase in scholarly interest in the art of the body, little work has been done on the relationships between piercing and societal concerns.[4] And, while much has been written on Northwest Coast art, no one has yet analyzed the intriguing symbolic relationships between the labret and important aspects of Tlingit social organization.

In order to decipher these relationships we must necessarily undertake an analysis that does justice to the complex question of labret symbolism by examining it from several perspectives. The labret was the hallmark of an adolescent girl's rite of passage into adulthood at menarche. Thus we can say that on the most obvious level the labret symbolized social maturity by indicating a girl's eligibility to be a wife. Beyond this nominal level, the ritual of marriage and the role of wife expanded and enriched the significance of the labret. This analysis must also extend to the question of

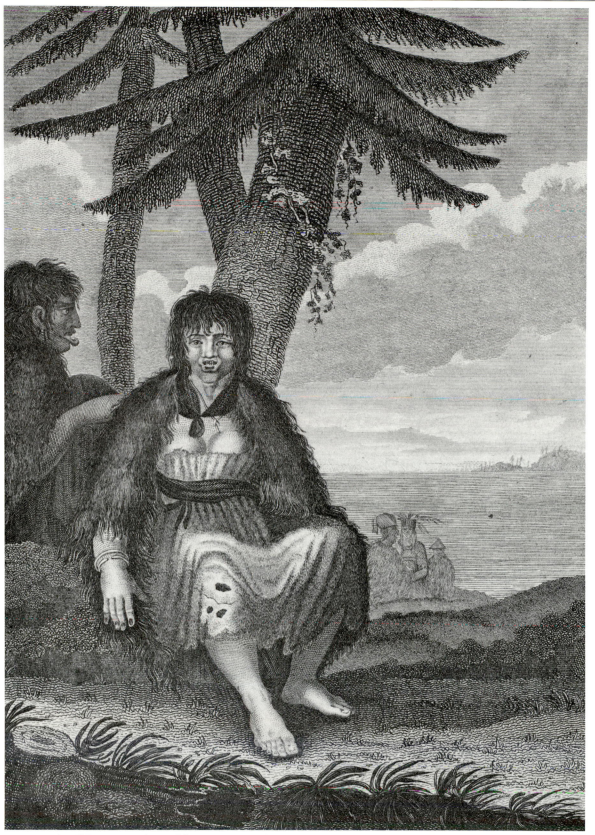

1. *"Front and Profile Portrait of the Woman of Port des Français, one of the new Discoveries of M. la Pérouse." Engraving first published in 1799.*

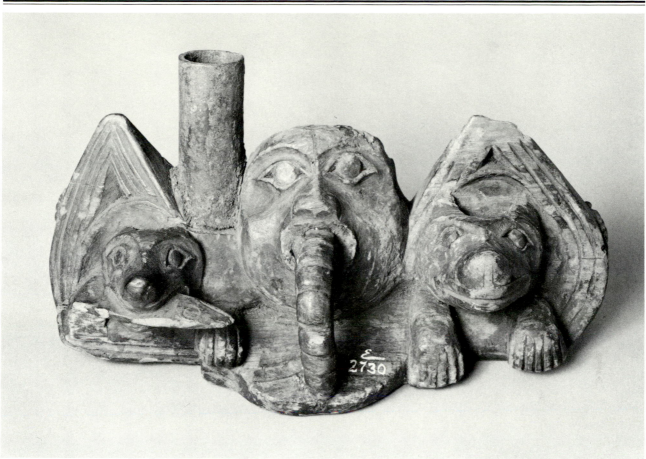

2. *Tlingit pipe said to represent a fresh-water lake. In the center is an anthropomor-phic face with a segmented, wormlike object emerging from the mouth, on its right is a mammal with a fish in its mouth. Collected by Lt. George T. Emmons before 1888. American Museum of Natural History E/2730. Michael Petroske photograph.*

why the Tlingit chose to decorate the mouths of adolescent women rather than scarifying their bellies, tattooing their arms, or elongating their necks.

A substantial amount of the literature on the nature of symbolism proposes that concern with certain parts of the body indicates that sociological importance is imputed to those specific body parts.[5] According to this view, the Tlingit adornment of the mouth reflects a general emphasis, shared by most of the other Northwest Coast peoples, on orality.[6] Indeed, a concern with mouths and eating pervades the culture. A glance at a representative sample of Tlingit art reveals a proliferation of gaping mouths, protruding tongues, and devouring figures, all of which focus attention on the oral orifice. The pipe in Figure 2, for example, depicts an anthropomorphic being with a segmented wormlike object emerging, tonguelike, from its mouth and a mammal with a fish in its mouth. Numerous myths describe eating as a major event and the culture-bringer Raven as an in-

satiable being with a voracious appetite. At the most famous Northwest Coast ritual, the potlach, hosts served their guests vast quantities of sumptuous food in magnificently decorated dishes and bowls, eaten with equally beautiful ladles and spoons. Since eating and mouths are so significant for the Indians of this region, we may assume that the decoration enhancing the mouth, namely the labret, is one more expression of the orality so pervasive on the Northwest Coast.[7].

This paper will argue that the piercing and altering of a young woman's lips symbolized not simply the ritual of marriage and the importance of orality, but in a deeper sense was associated with the oppositions, associations, and priorities that structured Tlingit society. The symbolism of the labret will be related to the following:

1. The girl's emerging sexuality
2. The ritual celebrating her coming of age
3. The psychological tensions between the girl and her future mother-in-law

4. The aggression between groups that derived in part from the moiety organization and matrilineality of Tlingit social organization
5. The reciprocal exchanges, such as potlaches and marriages
6. The means by which those tensions and aggressions were mediated.

Studied from the perspective of both the individual woman who wore it as well as the society that ascribed it meaning, the Tlingit labret will be interpreted as an element in a complex and elaborate symbolic system that linked, often in implicit ways, women, marriage, mouths, and feasting as major societal concerns.

Social Oppositions, Alliances, and Hierarchies

As the Tlingit girl's first labret signified her availability as a wife, it is of interest to discuss the social significance of marriage in this culture. Like the other northern Northwest Coast groups, the Tlingit belonged to exogamous matrilineal moieties, each composed of several clans. A girl inherited her clan affiliation from her mother and had to marry a man from a clan of her father's moiety. Ideally, she would marry a member of her father's clan. Although the Tlingit perceived their two moieties, which they called the Wolves and Ravens, as opposites, they engaged in numerous reciprocal exchanges that created alliances between these structurally opposed social units. High-ranking Wolf clans created alliances with high-ranking Raven clans by means of exchanges —of gifts, food, and women in marriage.

One of the principal means of reinforcing such an alliance was marriage. According to Swanton (1908:424), clans "showed respect for each other" through marriage; Shotridge (1929:132) claims that marriage created peace and friendship between clans of the two moieties. The ideal relationship between moiety-opposites took the form of a man giving his sister in marriage to a man of equal status from the opposite moiety, who then gave his own sister to the man who was now his brother-in-law. The Tlingit endeavored to maintain the alliances thus created. When a man died, the son of his sister was obliged to marry his widow; when a woman died, her sister's daughter was expected to marry her widower. If these arrangements were not possible, the clan of the deceased had to find as close a relative as possible to marry the survivor (Krause 1956:155; Laguna 1972:524–526). Since Tlingit society, like that of other Northwest Coast groups, was highly stratified, clans endeavored to arrange marriages between individuals of approximately equal rank. This was particularly important for aristocratic lineages that maintained their status by establishing marriage alliances with equally prestigious lineages. The opposite-moiety families that exchanged women reinforced their alliances by numerous ceremonial acts performed by members of one moiety for members of the other, such as potlaching and, as shall be seen, lip-piercing.[8]

Despite the close affiliation of moiety-opposites achieved through marriage exchanges, such bonds tended to be only partial and incomplete. Marriage was no guarantee of peace between the combative Tlingit clans; at times those clans that intermarried engaged in hostilities. Even clans of the same moiety were known to fight with each other, but battles most often occurred between opposite-moiety groups (Olson 1967:69). During such periods of warfare, the individuals sometimes said to be most dangerous to a clan were those opposite-moiety wives whose allegiances were often more to their own clans than to those of their husbands. Since it was feared wives would reveal battle plans to their own clans, opposite-moiety females were usually kept uninformed about their husbands' military strategies (Krause 1956:170). An especially dramatic example of the potentially lethal role wives could play in interclan hostilities is described in a Tlingit myth (Swanton 1909:90–91). In this story a chief massacred the clan of his wife. Apparently more loyal to her blood kin than her husband, this woman—with the help of their children who belonged, of course, to her clan—managed to destroy not only the chief but also the entire village. We can conclude that although a woman given in marriage was conceived of as a social link between groups involved, she also could exacerbate tensions between them. Two opposing beliefs about the Tlingit labret allude to the role of wife as simultaneously aggravator and mitigator of aggression. Some Tlingit subgroups believed that by blowing through the hole in her lip, a woman could pacify a hostile bear; here the labret is associated with peace and calm. In contrast, another belief holds that wearing a labret prevented a woman from talking too much, and thus kept her from engaging in the kind of gossip that caused "dissension and war" (Laguna 1972:444,827).

An institution that bore important structural similarities to Tlingit marriage was the potlach. Like marriage, the potlach involved reciprocal exchanges between moiety-opposites. During this extraordinary eight-day ceremony, the host group distributed vast quantities of goods such as

blankets, coppers, and artworks to, and lavished sumptuous cuisine upon, clans from the opposite moiety. Among the Tlingit the potlach was held to compensate formally those opposites who had rendered services during and after the funeral of an important member of a clan. Such services included cremation of the deceased, erection of a grave monument, and rebuilding or refurbishing a lineage house. The Tlingit potlach also served to validate the status of the successor to the deceased notable commemorated at the affair. Status among Northwest Coast peoples was a combination of inheritance and achievement, and the potlach, with its lavish display of prestige and power, was important in maintaining the social prestige of its aristocratic-lineage sponsors. One of the most significant symbolic expressions of status was the salmon eaten during the festivities; this food, the mystical analogue of copper, embodied great value and enhanced the prestige of those serving it (Mauss 1967:114).

Despite the unifying purpose of the Northwest Coast potlach, an unfriendly side of the feast also existed. Many descriptions of potlaches include references to hostility, aggression, and warfare. During a potlach described by George Swanton (1908:438 ff.) two sets of guests were invited, those from the host village and those from a remote community. The guests who lived far from the host village prepared to travel to the potlach by abstaining from sex and acting as if preparing for a battle. When they arrived at the host village, the leader of the host clan greeted them wearing military costume. Olson's (1967:66) description of another potlach includes references to the host asking his guests "Whose war is that?" and participants wearing military garb and singing war songs. In a myth about the trickster Raven attending a potlach, Raven held a spear in his hands, meaning "he was going to invite [people] to a feast next." When he finally sponsored a feast, he greeted his guests with a bow and arrow. In the footnote to this myth, the approaching guests are referred to as "enemies" (Swanton 1909:117–119).

Because of these and other references to antagonism as characteristic of Northwest Coast potlaches, some interpreters have concluded that they were somehow connected to warfare. Mauss (1967:4,5) stresses that an antagonistic spirit of rivalry characterized the potlach; Codere (1950) suggests that the potlach actually originated in warfare; McClellan (1954:96) proposes that there is an "intriguing relationship between the potlach, the peace ceremony and warfare." The relationship of potlaching to actual warfare is still a matter of discussion; what is certain, however, is that hostility was expressed during the ritual in which opposites united themselves in feasting and gift-giving.

Marriages and potlaches shared basic features. Both mediated between moiety opposites by exchanging things of value, and both generated alliances between groups which consequently became more cooperative. At the same time, it was clearly recognized that antagonism was an unavoidable element in such a moiety structure. The struggles, tensions, and affinities between social opposites were all expressed, and even to some extent celebrated, in the Tlingit marriage and potlach. There was always a delicate balance between the desire of individuals in clans to remain independent and the social necessity for cooperation between groups.

Rite of Passage Symbolism

A Tlingit girl entered into this complex system of alliances, hostilities, and exchanges at pubescence, when she received her first labret. The ritual that celebrated her change from an adolescent to an adult was a rite of passage that, like most transitions, involved three phases: separation, liminality, and incorporation. A study of this rite of passage provides some further insight into the symbolic signficance of the labret.

Beginning with the premise that changes in status can be potentially disturbing to society, Arnold van Gennep (1960) proposes that each group organizes its rites of passage in a similar fashion. The purpose of the Tlingit girl's puberty rite was to celebrate her change in status from asexual childhood to sexual maturity, while at the same time structuring that transition to protect society from the potentially disturbing consequences of a disorganized passage.

The three phases of the rite of passage eased the individual undergoing transtition out of her previous status and into her new one. The first phase, that of separation, celebrated the departure from the initial status. The initiate did not, and indeed apparently could not, go directly from one social position to the next, but instead, had to leave temporarily the profane structured world which determined status placement within the group and enter a sacred state "betwixt and between" social positions. This second phase was a liminal venture into an undefined position between social statuses. After residing temporarily in this profoundly powerful state of liminality, the initiate entered the third, incorporative phase, which integrated her into a new, adult, marriage-

able social position.[9]

The isolation of the Tlingit adolescent girl at the onset of menses was an act of separation. For a period that ranged from four months to a year, the girl sat, as still as possible, in a darkened hut or isolated room.[10] Although accounts differ slightly, it appears that at the beginning of this seclusion a female member of the opposite moiety from the girl—preferably her father's sister in this matrilineal society—cut a small slit into her lower lip and inserted a small pin to prevent it from closing (Krause 1956:152–153; Oberg 1973:83; Laguna 1972:518 ff.).[11] (This is yet another example of intermoiety exchange of services.) For the first four days of this seclusion, the girl ate and drank absolutely nothing; at the end of the fourth day, she was given a small morsel and some liquid. Then, for four more days she fasted. Although after this rigorous eight-day abstention from food, the girl could eat and drink on a regular basis, her intake was quite restricted.

Actions of separation often included secluding the initiate from her group and enforcing prohibitions against the intake of food (Gennep 1960:74); the Tlingit girl symbolically separated herself from her childhood by sitting as still as possible and eating barely any food in a dark, isolated room. The prohibition from physical activity and from life-sustaining eating, combined with a darkened environment, suggests a deathlike condition that occurs in numerous rituals of separation during other initiation rites.

Liminality, that ambiguous intermediary position between former and future statuses, was often characterized by supernatural potency on the part of the novice. This was certainly the case with the Tlingit girl who throughout her isolation was considered spiritually powerful. Since, if she looked at the sky she could cause inclement weather, she had to wear a broad-rimmed hat to prevent her from glancing upwards. And, since her Medusa stare could transform living things into rock, she was forbidden to look at anyone other than her closest female relatives (Krause 1956:152; Emmons notes, American Museum of Natural History 19/192).

Tlingit myths convey the enormous power of adolescent girls. In the waters around Yakutat there is a large rock called "to the mainland was swimming the bear"; this stone was thought to have been a live bear which the glance of an adolescent girl had petrified (Laguna 1972:64). A myth told by Swanton describes the seclusion of an adolescent girl and refers to the potency of her sight:

> At that time [the boys'] sister had just reached puberty and was shut up in the house with a mat curtain hung in front of her. . . . They also made her drink water through the leg bones of geese and swans so that she should not touch the drinking cups. Her mother put a large hat upon her so she should not look at anything she was forbidden to see. If someone shouted that a canoe was coming, or that anything else was taking place that she wanted to witness, she did not dare to look out (1909:104–106).

After this description of the taboos associated with the seclusion, the myth goes on to relate the consequences of disobeying those rules. At one point, the girl's mother says that her brothers seem to be in danger as they cross a stream, and nervously expresses the fear they might drown:

> Upon that, the girl raised her covering a little and looked out at them, and immediately they turned into stone. The pack that one of them was carrying fell off and floated down a short distance before petrifying, and it still may be seen there.

In a footnote to this tale, Swanton (1909:106, note b) comments that this story was told to adolescent females to remind them of the consequences of disobedience and to reinforce the importance of traditional restrictions.[12]

The final phase of the rite of passage is incorporation. The young woman left the darkened hut, as if reborn from within it. Described as weak-legged and white-skinned, the girl seemed much like a newborn child, manifesting the incorporative symbol of rebirth. Incorporation also was a reaffirmation of the girl's social status; at that point her family burned the clothes she had worn over the months in liminal, statusless darkness and dressed her in a new elegant costume emblazoned with crest images that visually expressed her clan membership. The family then presented their daughter to the members of the opposite moiety at a great feast, yet another indicaton of incorporation. It was at this ceremony that the girl's father's sister who had earlier made the incision in the lower lip (which a small pin had prevented from closing) inserted the initiate's first labret. More than anything else, the labret communicated to all that this girl was now ready for marriage. Because the strict chaperoning necessary to ensure a bride's chastity was burdensome for Tlingit families, young women were married off as quickly as possible after their coming out. At marriage, the newlywed received a slighty larger labret that indicated her new status; then, over the years, moiety-opposites inserted larger and larger labrets, with the largest reserved for the highest-ranking

women in the community (Krause 1956:152–153; Emmons notes, American Museum of Natural History 19/192,E/2493; Oberg 1973:33,83,86; Laguna 1972:519 ff.).[13]

Psychological Symbolism

As Barbara Myerhoff (1982:118) has demonstrated, the actual experience of the neophyte herself is of central importance for understanding the significance of a rite of passage.[14] It is true that among the Tlingit, marriage was primarily viewed as a means of allying members of opposite moieties, and the labret, celebrating the marriageability of a young girl, referred to the social dimensions of sexual union. It would be wrong, however, to restrict our analysis solely to these social aspects and to ignore subjective experiences as well as psychological meanings associated with the labret. Freud (1950) considered sex and aggression to be the two principal motivating forces in human culture; whether or not we can accept such a universal claim, it may be that sex and aggression are relevant to an understanding of the Tlingit labret.[15]

The act of piercing a hole and inserting a labret into the lips of a pubescent girl can be interpreted as a manifestation of psychosexual symbolism. Creating an orifice in the soft skin, which is then filled with a hard object, may be a reference to the sex act in which the girl will soon engage with her future husband. The relationship of this new orifice to sexuality is further suggested by its proximity to the mouth which, for many peoples throughout the world, is an analogue for the vagina. In his analysis of Northwest Coast art, Duff (1981:214) describes the relationship of the mouth to the vulva in sculpture, suggesting an equation of the two orifices. If one accepts such an interpretation, the Tlingit girl, after coming out, can be thought to have three sex-related orifices: her vagina; her mouth, which is analogous to her vagina; and her lip piercing, which is symbolically a newly created and already filled vagina. As such, the labret visually highlights the girl's future acts of sexual union with an opposite-moiety male.

The appearance of the labret itself refers perhaps to sexuality as well. The thin protuberance in the vicinity of the mouth looks somewhat like a tongue. Among the Tlingit, as well as other Northwest Coast groups, the tongue was the embodiment of life-force that could be transferred from one individual to another. In that way it could be considered analogous to the phallus. As Duff (1981:218) points out, figures on raven rattles and certain argillite carvings often unite with

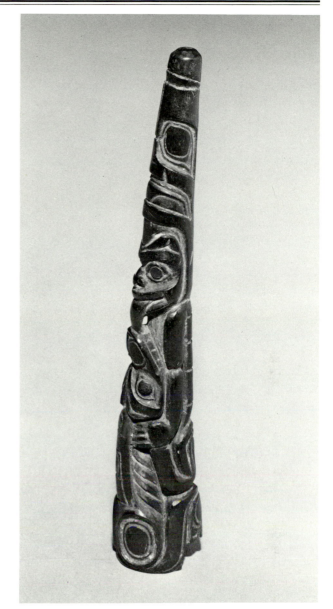

3. *Tlingit spoon handle representing a land otter and shaman connected by a tongue. Collected by Lt. George T. Emmons before 1888. American Museum of History 19/1122. Michael Petroske photograph.*

each other by sharing a tongue in what might be interpreted as a symbolic representation of sexual union. Figure 3, a detail of a spoon handle, depicts a land otter joined to a shaman with a tongue. The phallus/tongue appearance of the labret strengthens the suggestion that the labret is analogous to a filled vagina: the profile view of this ornament (Fig. 1) includes the girl's vagina-like mouth and protruding, tongue/phallus labret. According to this interpretation, maleness and femaleness are united by the appearance of the labret when worn.

Another psychological dimension of the labret comes to mind when one considers the actual process of labret insertion. The piercer, who had herself been subject to this operation in her youth, presumably knew that cutting the soft, sensitive skin around the lips was painful. The psychological significance of this act becomes suggestive when we recognize that this individual inflicting the pain was none other than the girl's future mother-in-law (or some other very close relative of her future husband). One Tlingit myth describes the tensions between female in-laws. Although a mother-in-law ideally educated her willing and cooperative dauther-in-law, this myth reveals that the ideal was not always realized (Laguna 1972: 493,893–894). In the story, the daughter-in-law cooked herring but refused to share it with her mother-in-law who requested a portion to eat. In one version (Swanton 1909:176), the younger woman placed a hot rock in her mother-in-law's hand, while in another version (Swanton 1909: 299), she gave her hot herring milt (male fish sperm); in both cases the older woman's hand was severely burned. After the mother-in-law complained to her son, he asked his wife go to fetch some more herring. The wife, agreeing to this task, told her husband that she needed a basket in which to carry the fish; he and his friends ignored her, angry at her treatment of his mother. As the wife slowly turned into an owl, her husband said, "You put milt into my mother's hand. For that you can become an owl" (Swanton 1909:300).

This Tlingit myth, in describing the unpleasant interchanges between a woman and her daughter-in-law, makes a connection between food distribution and personal antagonisms. When the young wife, who should have labored to ensure her mother-in-law's food supply, refused to procure food in an act of hostility toward her husband's mother, she lost all her value to her husband, and was banished from the human world. During the process of labret-insertion, the mother-in-law might have been painfully reminding her future daughter-in-law of the latter's status: the young woman was an outsider from an opposite clan and had value only as long as she provided items of exchange, like food and children.

The myth of the ungenerous daughter also alludes to another facet of labret symbolism. Tensions between social units, expressed in myth, ritual, and even behavior, were dangerous in that they could be socially disruptive. Exchanges which were designed to bring the potentially hostile opposites amicably together needed to be associated with strong sanctions that would en-

courage everyone to participate and discourage those less than willing to do so.[16] In the myth just described, the young woman refused to engage in a proper exchange of food with her opposite-moiety mother-in-law, and was consequently stripped of her humanity, a fitting punishment for the woman who will not behave properly according to the rules. It is proposed here that the Tlingit labret also embodied the social rules and structures that ensured the continual operation of exchanges. The myth of the wealth-bringer Lenaxxidaq, although not specifically about labrets, provides a key to this facet of the Tlingit labret symbolism.

The Myth of Lenaxxidaq

Lenaxxidaq, the Tlingit female wealth-bringer or Property Woman, appears in various Northwest Coast mythologies, including the well-known Kwatiutl Dzonokwa (Lévi-Strauss 1982). The Lenaxxidaq myth touches on various themes relevant to the interpretation of the labret—the positive and negative dimensions of women in marriage, the aggressive and unifying qualities of gift exchange, the relationship of ingestion to marriage and exchange, injury to the skin and subsequent filling of the injury. It also refers to the establishment of order through correct exchanges. Several versions of the Lenaxxidaq myth exist (Swanton 1908:460; 1909:173–175,292–293,366–368; Laguna 1972:821); the following will be a "complete" rendition of the myth, a consolidation of its several available versions.

A beautiful woman, Lenaxxidaq, lived in the lake with her babies. A man saw the woman and kidnaped one of her children. When his village slept, the child plucked out the man's eyes and the eyes of almost everyone else in the village, and ate them, getting a "bellyful of eyes." Only one woman, who had a baby herself, was left alive; the woman killed Lenaxxidaq's child by sticking a cane through its eye-filled stomach. This survivor became Lenaxxidaq. (To distinguish between the two Lenaxxidaqs, I shall call the former Lenaxxidaq I and the latter Lenaxxidaq II.) Because her village had been wiped out, Lenaxxidaq II left, putting a copper (a shield-shaped object of beaten copper that signifies wealth) on either side of her body and carrying her baby on her back. She combed the shoreline for mussels and nursed her baby when it cried.

When a man saw Lenaxxidaq II, he pursued her, trying to kidnap her baby. To defend herself, the woman scratched her assailant with long cop-

per fingernails, causing deep wounds. When the man succeeded in kidnaping the baby, its mother offered him coppers in exchange for it, a bargain he ultimately accepted. The scab that developed from the wound inflicted by Lenaxxidaq's fingernails became an extremely precious item since it contained the power to make him wealthy. During the bargaining process, the man had to be careful to say correct words, since one individual who asked Lenaxxidaq to "make him burst with riches" was eventually killed by her children slicing his stomach open with copper.

The Lenaxxidaq myth alludes to the themes of women, marriage, potlaching, and feasting. Lenaxxidaq, in both forms, was a beautiful, sexually attractive woman as well as a productive mother, and any interaction with her on the part of a male had to take her sexuality into account. Even though the myth does not specifically refer to marriage, we must assume that the woman had been married (because she had children) and could become married again (because she was beautiful and currently without a husband). The interactions between Lenaxxidaq and men were both productive and destructive, especially as mediated by children. In case of Lenaxxidaq I, the child killed its kidnapper; in that of Lenaxxidaq II, the child ultimately brought him great wealth. The violence of kidnaping was coupled with its failure; the first man was killed, the second man returned the child. This aspect of the myth could be a reference to the fact that among the Tlingit, no man "owned" his children; they always belonged to his wife's moiety. He might wish to "kidnap" his offspring but knew that he ultimately had to relinquish possession of them. It also highlights the occasionally aggressive nature of the relationship between the sexes. The child/copper exchange could also be understood as an allusion to the gift-giving that structured Tlingit social life, for families that exchanged women in marriage and consequently produced children also potlached and exchanged coppers.[17]

The myth also contains references to ingestion and explusion of food. Men were sometimes attracted to Lenaxxidaq by the sound of her infant suckling and sometimes by the sight of her gathering mussels. In this food-conscious society, it was significant that she both gave and received food. In these examples, food has a positive connotation, which is not always the case: in the early episode, the child of Lenaxxidaq I ate all the eyes of the villagers, an act that can only be considered aggressive and hostile. Food and the process of eating, therefore, have both constructive and destructive aspects in this myth.

This myth also involves numerous instances of the creation and filling of an orifice, an act which, like so much else in the Tlingit world view, had ambiguous value. In some cases, orifice-creation has aggressive aspects. After having been kidnaped from his mother, Lenaxxidaq I's child created new orifices on the villager's faces by plucking out their eyes; he filled his own stomach with those eyes. The sole surviving woman, who became Lenaxxidaq II, poked a hole in the child's stomach, creating a new orifice that exposed all the villager's eyes. The selfish man who wanted to burst open with riches was killed by a copper (wielded by Lenaxxidaq's children) which opened up a stomach-orifice similar to that of the eye-eating child. In these examples, orifices connote hostilities and death.

Orifice creation could, on the other hand, have positive consequences. When a man tried to kidnap Lenaxxidaq II's baby, she scratched his face, creating a bloody orifice that later filled with a scab that ensured him great wealth. When the kidnapper engaged in an appropriate exchange—of a baby for copper—he survived and, indeed, prospered. However, if he tried to make an inappropriate exchange, namely, a baby for too many coppers (asking to burst with riches), he died. Thus we can conclude that, in the Lenaxxidaq myth, orifice creation and filling were strongly related to exchanges and could have positive or negative consequences depending on whether the exchange followed the social roles governing it.

Why does this myth focus so implacably on orifices? The orifice is an opening and thus a vulnerable point in the human body, but it is also a liminal zone of interaction with the outside. Dangerous substances and objects from the outside can penetrate the body through an orifice and thus cause harm, just as dangerous substances harbored within the body can leave it only via an orifice. The Lenaxxidaq myth suggests this dangerous nature of the orifice by its descriptions of injuries and death. The orifice is not, however, simply a dangerous opening. It is the only means by which positive exchanges can take place between the person and the outside world. The two most significant types of exchanges that have a social dimension—exchange of women and exchange of food (both of which are, of course, gifts)—are realized through the body orifices related to sex and eating. Since these exchanges are beneficial, orifices have positive connotations in addition to their negative ones.

How do the specific orifices that appear in the Lenaxxidaq myth relate to Tlingit society? Numer-

ous references are made to the mouth and the stomach, which can be associated with the potlach as a ritual during which eating plays an extremely significant role. The theme of violence that pervades the Lenaxxidaq myth might be considered analogous to the theme of warfare at the potlach, where tensions and hostilities are at least partially resolved, as status is validated by a simultaneous display of wealth.

The mouth and the stomach are of course parts of the body's gastro-intestinal tract. As the entrance and exit points for the movement of food into and out of the body, they are involved in the natural process of food ingestion and digestion. Several other orifices mentioned in the Lenaxxidaq myth are created not by nature but instead by the actors in the myth: the ripped open belly of Lenaxxidaq I's child, filled with eyes; the greedy individual's stomach, sliced open by a copper; the wound caused by Lenaxxidaq II's long fingernails. This last artificially-created orifice, that is ultimately transformed into a wealth-producing scab, can be interpreted as having an intriguing symbolic significance.

To puzzle out the symbolic meaning of this orifice, it is of interest to review the actors who played a role in the creation of the wound and the scab. There was a beautiful woman who already had a child and thus was presumably fecund and could produce more children. There was a baby, the product of sexual union. And there was the man who acquired wealth by means of the scab that developed after he first took, and then returned, the baby from its fecund mother. It is possible that in this myth, sex roles are muddied, as the man seems to become temporarily analogous to that woman with her child. The man acquires, as a result of Lenaxxidaq's scratch, a wound that slowly becomes filled up with a wealth-generating scab. The woman, at a time prior to the activities described in the myth, had produced from her own womb-orifice a child which became, during the mythic episode, an item of great value, worth exchanging a copper for. Thus, the man/wound/scab can be considered as analogous to the woman/womb/baby. That which fills an orifice as a result of some transaction involving male and female opposites can have tremendous value, so long as the proper rules that govern exchanges are followed.

When Lenaxxidaq II scratched her assailant, she created a deep, bloody wound. Like the mother-in-law's piercing her son's future bride's lip, this was an aggressive act. However, the item that sealed up this new orifice, the scab, was the very item that provided victim thereof with great wealth. Wealth of this sort enabled the man to achieve social success and, at least temporarily, to ensure social order by a proper combination of reciprocal exchange and hierarchy. Through an elaborate process that included references to eating, alliance and aggression, male and female exchanges, orifice-creation and orifice-filling, and strict adherence to the rules of social interaction, a woman in myth gave man the possibility of social control. The myth suggests the perpetuation of social stability by the interaction of newly formed orifices and symbols of wealth. The Tlingit labret perhaps alludes to these themes as expressed in the legend of Lenaxxidaq.[18]

Convergence of Symbolic Patterns

The Tlingit labret ornamented the mouth, which can be thought of as the body-part most intimately associated with eating, potlaching, and marriage: with eating (and survival) because food enters the body through this orifice; with potlaching because feasting was one of the major events at that ceremony; and with marriage because on the one hand the labret indicated the nubility of a young woman, and on the other hand because the mouth was analogous to the woman's sexual orifice through which the nuptial union would be consumated. The mouth itself is liminally located between opposites; it is the passageway between the interior of the body and the exterior world. As such, it can be thought of as embodying positive (unifying) and negative (divisive) qualities of its referents: women, marriage, potlaching, and feasting. The oral-genital association with the labret can be thought of as refering to a complex process which simultaneously assures the nourishment of the individual, survival of the lineage, and security of the community, while recognizing and even celebrating those forces that work against such physical and social well-being.

If we understand the mouth from this perspective and draw on our analyses of the ritual and psychological significance of the labret, the possible meaning of this ornament becomes clearer. During the process of a girl's rite of passage into adulthood, an opposite-moiety woman, in an act of both sexuality and aggression, created a second mouth/vagina. According to one Tlingit belief, the young girl with a recently slit lip had to fast or else the hole would spread and cause her mouth to disappear (Swanton 1908:437). The initial incision was so potentially destructive that if anything related to eating approached it, the entire face could be radically deformed. Thus this newly created

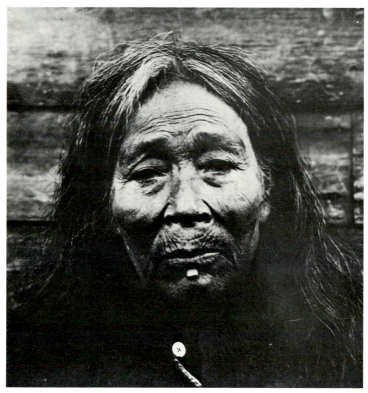

4. Nineteenth-century Tlingit woman with pin in lower lip. American Museum of Natural History negative number 13960.

orifice had immense power to destroy a person who chose to ignore a particular rule about food. Indeed, it could very well be that the Tlingit girl's lip incision was a constant reminder of the necessity to obey all rules, particularly those related to exchanges.

As was pointed out in the discussion of orifice creation and filling in the Lenaxxidaq myth, that which fills an orifice has great value, particularly in a system of exchanges. The lip incision, so closely related to sexuality and food, is filled with an extremely valuable item of human manufacture; together the orifice and its labret appear to signify a wide range of interrelated themes: the necessary but dangerous marriage exchange; the rewarding yet risky potlach; the ambiguous relationship between mother-in-law and daughter-in-law. The insertion of this object into an orifice seems to acknowledge all the ambiguities and tensions of Tlingit society while reinforcing the rules of exchange and reciprocity that assure its perpetuation.

The Decline and Persistence of the Labret

While the large labret that caused such intense reactions from European visitors became quite rare by the mid-1800s, its symbolic significance remained intact until the beginning of the twentieth century. When Pérouse and others sailed the Alaskan waters at the end of the eighteenth and the start of the nineteenth centuries, almost all adult, nonslave women wore labrets up to ten centimeters in diameter. Although both sexes pierced their noses and earlobes, only women pierced their lips (Emmons notes, American Museum of Natural History E/2655, E/2779). Due to intense pressure from whites, labret wear became less frequent during the first half of the nineteenth century and extremely rare in the second half. When German geologist Aurel Krause explored Tlingit territory in the 1880s, he saw only one very old woman with the pully-shaped lip plug "which bore out full the unpleasant descriptions" of the earlier travelers (Krause 1956: 100).

Although Tlingit women stopped wearing the large labrets, they by no means rejected the concept of labret; they simply modified their lip plugs as a response to white pressure. Krause (1956:99–100) describes how in the 1880s women inserted silver or bone pegs into their lower lips at adolescence and wore them all their lives (Fig. 4).

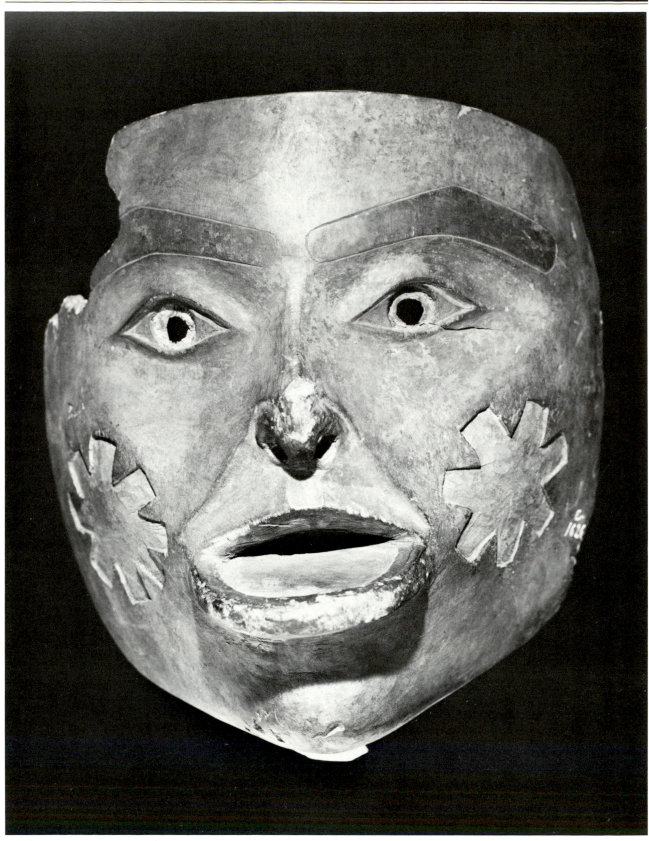

5. *Tlingit shaman's mask representing a woman wearing a labret. Collect in Dry Bay by Lt. George T. Emmons before 1888. American Museum of Natural History E/1626, negative number 330967.*

6. *Tlingit shaman's mask representing an old Tlingit woman wearing labret. Collected in Dry Bay by Lt. George T. Emmons. Field Museum of Natural History 79255. Photograph courtesy Field Museum of Natural History.*

Frederica de Laguna's informants (1972:444) remembered women in the late nineteenth century wearing small silver pins in their lower lips. Thus, even after women ceased wearing the large labrets, they continued to pierce their lips and insert foreign objects into those incisions. We can therefore conclude that the idea of creating an orifice under the mouth and filling it with a hard object persisted throughout the nineteenth century; during the first years of that century the object was the large, traditional labret, while for the remainder of the century it was the modified silver pin.

Although the custom of wearing the large labret declined by the mid-nineteenth century, these full-size ornaments remained profoundly significant symbols of women in the minds of the Tlingit throughout that century. Ethnographers, like Krause and George Emmons, who studied the Tlingit during the 1880s, collected substantial amounts of information on lip plugs and their symbolic relationships to women's roles in society from informants who had rarely, if ever, seen them worn. And, when the late-nineteenth century artist wished to depict a "woman" in sculpture, he invariably showed her wearing a large labret. Many shaman's masks depict female spirits, for example, with a shelflike labret projecting out from underneath the mouth (Figs. 5 and 6). Long after the actual practice of wearing labrets had died out, the interconnections between femininity and labrets remained strong among the Tlingit. The symbolic relationships of piercing to women, marriage, mouths, and feasting clearly remained deeply entrenched in the Tlingit world view and the evocative qualities of this form of body art persisted for many years.[19]

Notes

1. I gratefully acknowledge the valuable critical reading given this manuscript by Dr. Stanley Freed, Department of Anthropology, American Museum of Natural History.

2. The labret was striking to most eighteenth-century visitors. Captain Dixon has the following to say about labrets:

 > When girls are about fourteen or fifteen years old, the center of the lower lip in the thick part near the mouth is pierced and a piece of copper wire inserted to prevent its growing together. The opening is lengthened from time to time, in line parallel to the mouth and the wooden plugs are increased in size accordingly, until they are three or even four inches long and approximately of the same width (Dixon 1789, in Krause 1956:96).

 Nathaniel Portlock, who visited the Tlingit coast in the 1780s, comments:

 > One old woman who especially attracted my attention had [a labret] as large as the saucer of a teacup. The weight of this ornament pulled down her lower lip so that it covered her chin and left exposed the teeth and gums of the lower jaw in a most disagreeable manner. In eating they usually take more in their mouths than can be swallowed at once. When they have chewed their food they are apt to use the labret for a plate on which to lay the masticated food and for this purpose it is occasionally removed. The custom of wearing this wooden labret seems to be a universal practice among the local women, even two-year-old girls already have their lower lips pierced and a piece of copper wire inserted. This remains until they are thirteen or fourteen years old; then it is removed and a wooden labret put in, which at first is only the size of a button (Portlock 1789, in Krause 1956:96–97).

 A Russian captain, Urey Lisiansky, also was impressed by Tlingit labrets:

 > A strange custom prevails respecting the female sex. When the event takes place that implies womanhood, they are obliged to submit to have the lower lip cut and to have a piece of wood, scooped out like a spoon, fixed in the incision. As the young woman grows up the incision is gradually enlarged by larger pieces of wood being put into it, so that the lip at last projects at least four inches, and extends from side to side six inches. Though this disfiguring of the face renders to our eyes the handsomest woman frightful, it is considered here a mark of the highest dignity, and held in such esteem that the women of consequence strive to bring their lips to as large a size as possible (Lisiansky 1814, in Dall 1882:87).

3. In his monograph, "Masks, Labrets and Certain Aboriginal Customs" (1882), William Dall identifies two areas of the world where labrets are, or were, worn: Central Africa and the Americas. Labret wearers of the New World include Brazilian natives, some of whom still wear them; the Aztecs of central Mexico, who ceased the practice not long after Cortez conquered their empire; and inhabitants of the Pacific Coast from the Queen Charlotte Islands and the Nass River to the Bering Strait, then eastward to the Mackenzie River. Northern Pacific Coast people who wore lip decorations include the Haida, Tsimshian, Tlingit, Aleut, and Alaskan Inuit (Eskimo) (see Gritton). No group south of the Tsimshian, east of the coastal range and Mackenzie River, or west of the Bering Strait wore labrets.

 The Haida, Tsimshian, and Tlingit had similar customs pertaining to labrets; in all three groups lip-piercing indicated a girl's eligibility for marriage and was accompanied by feasting. In addition, in all three hierarchical cultures, the largest labrets were reserved for the women of highest status (Gunther 1966:61–62, 1972:11; Boas 1916:299–300). Among the north Alaskan Inuit, only men wore lip plugs that, unlike the single central labret of the Tlingit, were situated under each corner of the mouth. Dall calls this the "lateral" style of labret. Among the Aleut and Chugach, who lived between the Inuit and northern Northwest Coast peoples, both men and women wore both types of labrets (Dall 1882:88–92). These latter two groups are clearly transitional between the Inuit and the Tlingit, Tsimshian, and Haida.

4. Dall's monograph remains one of the most comprehensive studies on the subject. Keddie 1981 provides detailed information on labret wear on the north Pacific rim. Although some works on labret wear have been written since Dall (Colette 1933; Labouret 1952; Charlin 1950), only two articles, one by Lebeuf on the Fali of Cameroon (1953) and the other by Seeger on the Suya of Brazil (1975), are seriously analytical.

5. For literature on body symbolism, see Mauss 1979; Fischer and Cleveland 1958; Turner 1967; Douglas 1966 and 1970.

6. The importance of the mouth in Northwest Coast culture has been the subject of several studies, most of which deal with the Kwakiutl. These analyses tend to use mythology as a means of understanding the Kwakiutl concern with mouths, eating, and orality in general. Irving Goldman (1975) describes the sacred nature of cannibalism, a particularly Kwakiutl form of orality, and studies its relationships to the cosmic principle of transformation. Susan Reid (1979) presents a subtle psychoanalytic argument on how cannibalism relates to the desocialization phase of the boy's rite of passage during the Winter Ceremony. Carol McLaren (1978) advances Goldman's discussion of the relationship of devouring and transformation, while Stanley Walens (1981) describes the importance of eating to the world view and the social structure of the Kwakiutl.

7. The one essay on Native American piercing that is interpretive, "The Meaning of Body Ornaments: A Suya Example" (Seeger 1975), draws on the theories of Mauss, Turner, and Douglas. Seeger takes the position that a society ornaments a particular part of the body because that body-part has symbolic meaning. Thus, if a group values hearing, it ornaments the ears; if sight is critical, eyes are decorated; if speech is significant, lips are enhanced. Because hearing and speech were the quintessential human faculties for the Suya, they inserted plugs into their ears and lips. This accentuation of the lips and ears maintained the ethnic identity of the Suya because it separated them from those neighboring groups who did not wear plugs and thus were not fully human. The labrets also distinguished the Suya from the witches who had sharper sight and from animals with keener smell. If these people had decorated their eyes and noses, they would have communicated an undesirable connection with witches or animals.

 Suya lip and ear plugs also communicated the social roles of their wearers. Both women's and men's ears were pierced at the first sign of sexual maturity. Lip piercing, however, was restricted to men and delayed until the late teens when males were mature enough to enter the men's house. Thus, in addition to communicating the ethnic identity of the Suya, Seeger concludes that labrets also conveyed the sexual maturity of women wearing ear plugs and the maturity of men wearing lip discs.

8. See Mauss (1967), Lévi-Strauss (1969), and Rosman and Rubel (1971) for further discussion of the role of women in alliance systems.

9. Gennep (1960) discussed all the phases of the rite of passage, while Victor Turner (1967) focuses on the symbolism of liminality.

10. Laguna (1972:519) states that the maximum or optimum amount of time for seclusion is two years, a cycle of eight seasons for the "eight bones of the body."

11. Portlock's description (see note 2) states that very young girls were pierced, while Emmons (notes, American Museum of Natural History 19/192) states that piercing occurred at the end of the seclusion. All, however, agree that the insertion of the labret took place at the coming-out ritual.

12. The practice of confinement stopped at the end of the nineteenth century. Most of Laguna's informants, except for one born in 1897 and another born in 1909, never experienced seclusion (Laguna 1972:519).

13. In an intriguing article on the Kwakiutl, Susan Reid (1981) discusses how the isolation of pubescent girls in that society is related to the discovery of what it means both to be human and to be a woman.

14. For a variety of psychological interpretations of rites of passage, see Freud (1950), Bettelheim (1954), and Young (1965). Until recently, those who describe initiation rites have focused on those of men rather than women. See Brown (1963) for more on female initiaton rites.

15. It is most unfortunate that so little information exists on the attitudes that young girls and future mothers-in-law had towards each other. Since the eighteenth-century visitors to the Northwest Coast failed to ask labret-wearing women their attitudes towards this kind of body art, we cannot know how they viewed the painful process of piercing.

16. This notion of sanctions is one of the primary themes in Mauss' book *The Gift* (1967). Mauss argues that it is the gift itself and the social rules of the group that assure continual exchange, which then guarantees social cohesion. The process of union by gift is an interesting one. We might think of a gift as altruistic and volitional, but Mauss proves that, at least in primitive societies, there is absolutely no freedom in the gift exchange. Instead, he proposes a threefold set of obligations associated with exchanges: the obligation to give, the obligation to receive, and the obligation to reciprocate. Among the Northwest Coast groups, these obligations are certainly operative, for an elite group did not just one day decide it would be nice to host a potlach, or similarly decide not to bother; they had to sponsor these feasts periodically or risk losing their status. Those they invited could neither decline nor refuse later to reciprocate, for failing to perform these obligations almost always resulted in their losing their high social position. According to Mauss, these socially sanctioned obligations are strengthened by the innate supernatural powers of the items circulating as gifts; in other words, the well-known potency of coppers, blankets, and salmon is ultimately a means to ensure the continual exchange of gifts that unifies disparate social units, while recognizing their distinctions by means of the ritualization of hostilities.

17. For an interesting discussion of the possible symbolic meaning of coppers, see Widerspach-Thor (1981).

18. For a discussion of orifice imagery in northern Tlingit art, see Jonaitis 1986.

19. In note 3 it was mentioned that only the northern Northwest Coast groups wore the labret. It is striking that labrets were not found among the other Northwest Coast groups who shared so many cultural elements with the Tlingit, Haida, and Tsimshian: the West Coast People (Nootka), Bella Coola, and especially, the Kwakiutl. These groups all had female puberty rituals, a great concern for orality, elaborate feasting, hierarchical social ordering, and many types of reciprocal exchanges, much like those of the northern Northwest Coast societies. Why they did not pierce the lips of their young women is something of a puzzle. Although the reasons for this are probably quite complex, it is noteworthy that the Kwakiutl and their more southerly neighbors did not have the matrilineal descent patterns of the Tlingit, Haida, and Tsimshian. Thus some of the tensions specifically related to the women in the northern social systems were perhaps not shared by groups farther south.

OVERLEAF: Business card assortment of contemporary tattoo artists. UCLA Museum of Cultural History Arnold Rubin Archives.

Introduction:
Contemporary Euro-America
Arnold Rubin

At one level, contemporary Euro-America body art—tattoo, piercing, and other relatively extreme forms—may be said to represent a compendium of practically everything known about such forms from other times and places. At another level, contemporary Euro-America body-art represents a distinctive and highly idiosyncratic synthesis, wherein the past *is* demonstrably prologue. In particular, several contributors to the discussion following the 1983 symposium at UCLA recognized a fundamental difference between the alienation and anti-social character which came to be more or less typical of Euro-American body-art during the first half of the twentieth century, and the high prestige and social centrality associated with similar forms in other cultures.

Yet, significant changes seem to be taking place in the contemporary Euro-America sphere, reflected in the increased frequency of nostril piercings and multiple ear-piercings for women, ear-piercings for men, and nipple- and genital-piercings for both sexes. Although the majority of Euro-America tattoos still reflect "International Folk-Style" models (see Rubin), the outcaste status of Chicano tattoo (see Govenar) and of much "International Folk Style" practice (see Sanders) is increasingly giving way to a new, broad-based investigation of the expressive possibilities embodied in tattoo. Eschewing conventionalized designs, artists well versed in the history and ethnography of tattoo, technically skilled and conceptually innovative, increasingly mediate processes of deep introspection for their clients. Conversely, the uniquely personalized visual results of these highly individualized explorations have been characterized as comprising the hallmarks of a "new tribalism," a bond of aesthetic elitism which cuts across considerations of class, sex, and age.[1]

The laws against tattoo still in place in many areas of the United States, and the anxieties they reflect, thus seem increasingly, intolerably anachronistic. But such laws can also be understood as psychosocial relics of an earlier phase in the clash of two essentially antithetical ideas about aesthetic dimensions of the existential status of the human body. The first of these, originating in the Judeo-Christian experience, dictates that the body, made in God's image, the temple of the soul, be maintained inviolate. The second, more broadly distributed, treats of the body as a vehicle for experience, a *tabla rasa* upon which individual and cultural messages are inscribed.

The pervasive importance for the individual and society of resolving these contending points of view underlies Stephen Kern's revealing chronicle of the often rather shocking surgical, technological, and behavioral interventions which have characterized Euro-American treatments of the body as ways of controlling and channelling sexuality. His conclusion, however, is more broadly comparative and anthropological, and quite explicitly addresses the interface between sexuality and aesthetics:

> The modern age is still trying to find a "healthy" sexual morality. As long as physical beauty determines sexual choices, human relations will be guided by fortuitous, pleasing compositions of

bone, muscle, and skin. Elites of the beautiful will continue to live privileged lives, and character and "inner" beauty will continue to take second place in the contests for sexual partners. It is tempting to condemn this rewarding of physical beauty by pointing to the riches and fame we shower on fashion models and athletes while the aged and the deformed are hidden away in poverty and neglect. But perhaps our condemnations are in bad faith and even a bit silly. Vanity and the appreciation of bodily excellence occur in all cultures, and they are the source of those energies that make possible the continuation of life . . . Though erotic stimuli vary from one age to another, they are always based on physical attraction, and as long as that is the case, we will remain dominated by the mysterious and enduring power of the body to generate sexual tension and release sexual pleasure.[2]

Within this framework, body-art in all its forms may be viewed as a way to enhance one's natural physical endowments. As regards irreversible modes, the earliest modern Euro-American manifestations of this strategy were stimulated by exposure to a variety of non-European traditions. These pioneering initiatives were reinvigorated following World War II on the West Coast of the United States, and subsequently spread to the rest of the United States, England, western Europe and the Pacific Basin. For the future, it will be interesting to note the ways in which traditionally trained body-artists in the cultures which originated many of these conceptions deal with their return in reinterpreted forms.

Notes

1. Fresh approaches to photographic documentation, providing surprising and richly sensuous images for exhibitions and high-quality publications, have fostered this reassessment; see especially the work of the Japanese photographer Masato Sudo.

 David Kunzle movingly concluded his comments on the contemporary Euro-American papers on the second day of the UCLA Body Art Symposium by reading the poem "Tree" by Deena Metzger, celebrating the tattoo with which she covered her mastectomy scar.

2. Stephen Kern, *Anatomy and Destiny: A Cultural History of the Human Body* Bobbs-Merrill, Indianapolis, 1975, p. 256.

The Variable Context of Chicano Tattooing

Alan Govenar

Tattooing by hand is widespread among Chicanos in the urban *barrios* of Texas, New Mexico, Arizona, and California. Yet the practice has been rarely documented, and discussion has focused chiefly on professional tattoo artists working with electric machines and their clientele. A broader view is represented by Sylvia Orozco, who interprets tattooing in general, and hand tattooing in particular as an expression of Chicano identity and pride.

> In the Chicano world hand-made tattoos are not considered amateur work; in many instances, they are called art. Chicanos have continued to [tattoo] without the use of technology. This may be due to the high cost of professional tattoos or it could be Chicanos prefer *los dubijos de mano* [the hand-made drawings].
>
> Today's society views tattooing somewhat as a disfiguration of the body. But it should be understood, that our modern, yet conservative society still has not completely accepted the human body for its beauty—and will hardly accept any alteration. However, some Chicanos continue tattooing themselves for whatever reasons—to express sentiment and devotion, to make the body more sexually attractive, or to conform to a peer group. Tattooing continues to be a form of expression, a personal art; and as in literature, there is a Chicano literature; in politics, a Chicano politics; and in tattooing there exists the Chicano tattoo

My fieldwork on tattooing practices among Chicanos confirms Orozco's claims.[1] Tattooing in the *barrio* is a complex phenomenon that is affected by social, economic, and political factors. The impulse to obtain a tattoo may be religious, as expressed in Christian symbols ranging from a small, simple cross, to the Virgin of Guadalupe covering the full back. Or the statement may be social or political and utilize the emblems of "La Aguila" (the United Farmworker eagle) or slogans such as "*Chicanos Unidos*" (Chicanos United), or gang designs, small crosses, initials, and other esoteric marks. Although statistics are unavailable, field observations suggest that Christian designs are most numerous.

The earliest notice of Christian tattooing on record is that by Procupius of Gaza in A.D. 496 (in Durkheim 1915:264–265). The devotional impulse expressed in Christian tattoos among Chicanos echoes the tradition of Coptic and Abyssinian Christians living in villages surrounding Jerusalem and in upper Egypt (Carswell 1958; Meinardus 1970). The tattoo beliefs and practices of Copts and Abyssinians themselves date back more than a thousand years.

Among ancient as well as present day Copts and Abyssinians Christian imagery includes images of Christ, the Crucifixion, the Resurrection, and a small cross (placed on the wrist or hand between the thumb and index finger). (All of these designs are also found among Chicanos in urban barrios of Texas, New Mexico, Arizona and California.) It is likely, as historian John Carswell (1958) maintains, that the "cross was incised on converts from the earliest stages of Christianity, and that the Crusaders adopted the practice and showed with pride, crosses tattooed a little above their wrists." Yet, it is clear that this tradition of tattooing was never adopted by the mainstream of the Western

church. In fact, the dearth of literature on the subject of early Christian tattooing suggests that the Church adhered to the commandment in Leviticus 19:28, "You shall not make any cuttings in your flesh on account of the dead, or tattoo any marks upon you" (Hertz 1969:503). This statement rejects tattooing on the grounds that it is, as Maimonides (1962:65b,81a) says, "idolatrous."

In the *barrio*, tattoos of Christian images may not have exclusively religious meanings. The "Pachuco" gangs of the 1940s and 1950s used a small cross (on the hand between the thumb and index finger) to identify members and to reinforce group solidarity. For outsiders, particularly Anglo-Americans, the "Pachuco cross" symbolized crime and violence. In the 1950s, several articles in the *New York Times* identified "Mexican American hoodlums" by their tattoos (8/23/54; 8/24/54; 8/29/54; 8/31/54). But not all Chicanos with simple cross tattoos were Pachucos. Historian Ricardo Romo recounts the following:

> Kids in the barrio in San Antonio where I grew up drew crosses on their hands with ball-point pens. I did, and my parents scolded me, "You don't want tattoos. They're bad. Look at your uncle. He regrets his tattoos" (pc:6 July 1983).

According to Romo, kids made the tattoos on their hands to emulate the *vato loco* ("crazy street dude"). Tattooing was an "initiation ritual" among some peer groups, a way of permanently asserting allegiance to the *barrio*. Moreover,

> in a personal way a tattoo was symbolic of manhood. Most Chicanos first think about tattoos around the age of 13 or 14, and then again at 17 or 18. At both times, there is considerable peer pressure if you don't get tattoos; tattoos are a test of loyalty (pc:6 July 1983).

Romo says that present-day "Pachucos" carry on the tradition of the "street dudes, who might or might not belong to a gang, but usually have tattoos" (pc:6 July 1983). Lawrence Honrada, a native of East Los Angeles, says that for his friends, the simple cross was more than just a gang tattoo (Fig. 1). "It was something you did with your brothers. It expressed a very deep feeling" (pc:10 November 1982). However, fourteen years after getting his hand tattooed, Honrada's perceptions changed. During a six-year incarceration in the New Mexico State Penitentiary, he realized that "private tattoos are better than public ones. They are not so easily misunderstood" (pc:24 January 1986). Honrada intends to have the tattoos on his

1. *Lawrence Honrada's hand, Santa Fe, 1983. Photograph by Alan Govenar.*

hands removed, although he is still proud of his other tattoos, most of which were done by fellow prisoners.

Tattooing in prison is done in secrecy, usually during the day hidden away from the guards, while other inmates are playing sports, cards or other recreational activities. According to Honrada, "If the guards catch you, they take away the machine and ink. And if the tattoo gets sore or infected, you might be punished for defiling state property." Nonetheless, he maintains that the tattooing process in prison is more sophisticated technologically than that found "on the streets."

In the *barrio*, most amateur tattoos are hand-picked with sewing needles, but in prison, electric machines are used. "In the joint, some guys make electrically-powered rotary machines with a cassette tape recorder motor which is connected to a guitar string which vibrates up and down in the tube of a Bic pen" (pc:Honrada 10 November 1983). Using this technique, prison tattooers are able to achieve finer lines and more detailed shading and modeling than someone using a sewing

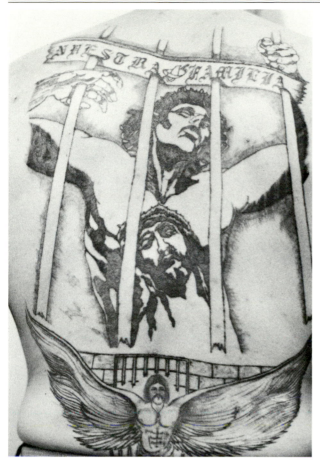

2. *Lawrence Honrada's back, Santa Fe, 1982.*
Photograph by Alan Govenar.

needle. However, prison tattoos, like amateur street tattoos, are monochromatic, made with black ink.

Honrada's prison tattoos iclude both Christian and secular themes. His largest tattoo, by fellow inmate Cole Douglas, features a dramatic scene that covers his back. It is bordered on the top by the inscription, *Nuestra Familia* (''Our Family'') and on the bottom by an angel with flowing wings supporting the foundation of a prison cell (Fig. 2). The central part of the tattoo is a man behind bars, shown from the waist up; the prison bars are piercing his hands, and Christ's head is in agony on his chest. For Honrada, this tattoo is a way of identifying with the suffering of Christ: ''In prison, I could understand better what Christ must have gone through as victim and prisoner. The tattoo represented the quest for freedom that everyone in the joint must feel—Nuestra Familia'' (pc:25 January 1983). On his stomach Honrada has another Christian image: a cross embellished with black roses. This tattoo covers a scar from a stab wound he acquired in prison. About his tattoo,

Honrada says, ''Again, my belief held up. I lived.'' Honrada acknowledges the importance of his Christian tattoos, and he believes the tattoos had a therapeutic value in his life: ''Without them, I could never have gotten out of the joint psychologically'' (pc:25 January 1983).

On each side of the cross with roses, Honrada is tattooed with secular images: finely detailed lowrider automobiles. He picked these designs because they signified his life on the streets. On his arms, Honrada has other secular tattoos, including the *Lowrider* magazine trademark, a mustached *vato* wearing sunglasses and a low-brimmed hat. Folklorist William Gradante, who studied the Lowrider subculture, reports that few owners of lowriders have tattoos. They do buy automobiles and accessories which, to some extent, display tattoolike imagery.

> The artwork on a lowrider car is created for an audience consisting of spectators at a lowrider car show or ''happening,'' and motorists and pedestrians who encounter the lowrider as he cruises. Lowriders are aware that they are a highly visible element of the Mexican-American society as a whole. The window etchings and full-color murals on the automobiles, as well as the commercially produced lowrider t-shirts worn by school children and club members alike, reflect the community that spawned lowriders (Gradante 1982:32).

Window etchings and automobile murals illustrate a wide variety of themes.

> A common design featured a Mexican girl with *Mi Vida* [''My Life,'' or more broadly, ''My Reason for Living''] inscribed on a banner, often with the name of the lowrider's girlfriend, wife or daughter. Another depicted a Mexican *charra* [''cowgirl''] wearing a wide sombrero. A portrait of the Virgin of Guadalupe decorated one car. Other etchings included a solitary lowrider in front of his ride, a pair of lowriders greeting each other with the Chicano handshake beneath a banner that proclaimed *Chicanos Unidos* [''Chicanos United''], and a portrait of *La Indita* [a Mexican Indian maiden]. (Gradante 1982:32).

Motifs found in automobile window etchings and murals, and tattoos such as the Virgen de Guadalupe (Figs. 3,4,5,6), the Mexican *charra* (Fig. 7), and political slogans, also appear in wall murals. Since the early 1970s, Chicano mural projects have received support from private foundations and governmental agencies. In Los Angeles, the Chicano mural movement brought together a diverse group of individuals—the self-taught artist, the sign painter, the house painter, the mass pro-

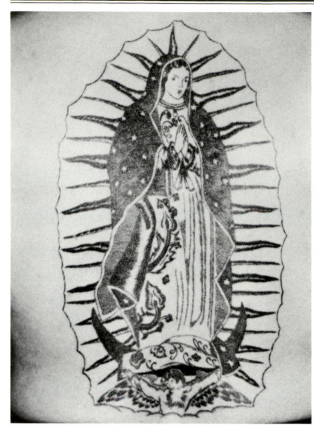

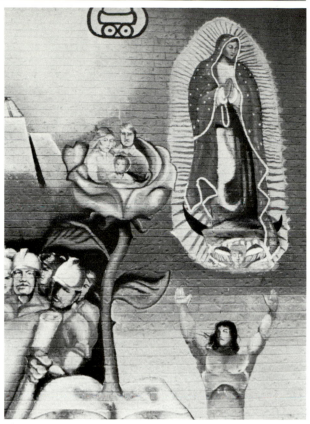

3. *Virgen de Guadalupe tattoo, New Mexico State Penitentiary, 1985. Photograph by Alan Govenar.*

4. *Virgen de Guadalupe mural, San Antonio, 1981. Photograph by Alan Govenar.*

duction painter from billboard companies, the college art student, and the graffiti artist:

> Some of these people were from Los Angeles or other urban areas of the Southwest or Mexico and had previously been affected by Posada, Rivera, Orozco, Michelangelo, Leonardo da Vinci, and urban education. Others were farm workers or immigrants from the *ranchitos* and other rural areas within different regions of the United States and Mexico. The artists possessed different levels of schooling. Nonetheless, those who converged in Los Angeles at this time had some things in common: They resided within a complex metropolitan area; they saw the mural as positive affirmation of their Mexican heritage; they had been affected by one another; and they shared a minority status.
>
> The artist's relationship to his community and the community's role in society would determine the objective. The decorative, educational, catechetical, and social protest murals demonstrated institutionalized social control. The murals were painted to merely cover a wall; for ornamentation; to teach onlookers about various historical, legendary or other types of themes about their or other peoples; to convert; or to create an awareness about social ills or political protests (Gonzales 1982:155).

Tattooing may involve many of the same decorative, educational, religious, and protest themes found in murals, but the context in which tattoos are mde is significantly different. Tattooing among Chicanos, especially those associated with the prison or gang experience, tends to oppose institutionalized social control and conventional community values. The emphasis in such tattooing is upon interpersonal relations and closely knit small groups which often meet in secrecy. Hand-picked tattoos may be negotiated for small sums of cash, for cigarettes in prison, or in some instances, for services, such as exchange tattoos. Lawrence Honrada says, "That's how you learn to tattoo. Someone works on you and you work on them, although once you become a master like Cole Douglas, who did my back, then you can charge a better price" (pc:Honrada 10 November 1982).

Hand-picked tattoos usually signify a lower socioeconomic status than machine-made tattoos. Anglo-American tattooer Jimmy Farmer (who has a shop near the Alamo in San Antonio) says that many of his Chicano clients get their hand-picked tattoos covered with larger machine-made tattoos: "They can't afford professional [machine-made]

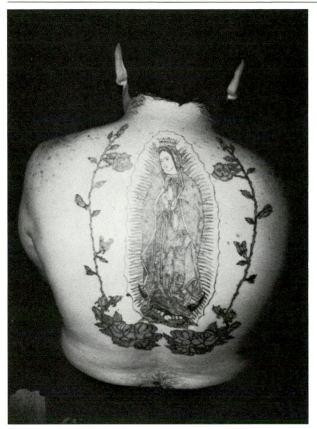

5. *Virgen de Guadalupe tattoo by Gilbert Coriz, Santa Fe, 1985. Photograph by Alan Govenar.*

6. *Virgen de Guadalupe mural, East Los Angeles, 1983. Photograph by Alan Govenar.*

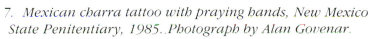

7. *Mexican charra tattoo with praying hands, New Mexico State Penitentiary, 1985. Photograph by Alan Govenar.*

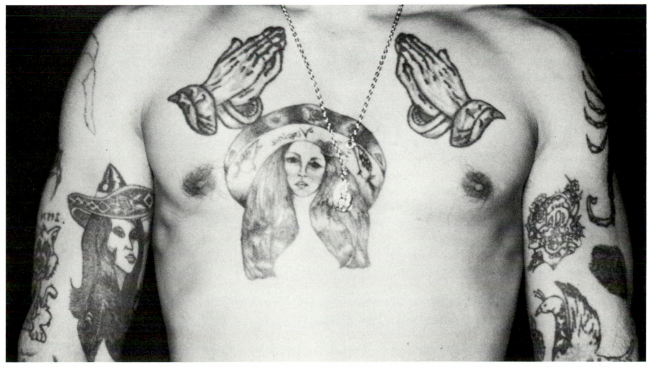

8. *666,* Mark of the Beast *mural, East Los Angeles, 1983. Photograph by Alan Govenar.*

tattoos until they get older, more established with money. Then they can come in and afford to pay the fifty or so dollars it might cost" (pc:Farmer 11 June 1980). Farmer says that these clients usually come to this shop with other men, although in some instances they come with girlfriends, wives, or children:

> A big part of my business comes from enlisted men, the ones stationed at Fort Sam Houston or at Lackland Air Force Base. Sometimes, the Chicanos get initials or gang marks covered with patriotic designs, such as flags, eagles, and military insignia. Other men want religious designs, maybe a cross with roses or Virgen de Guadalupe (pc:11 April 1981).

Among upwardly mobile Chicanos, tattooing is considered "lower class," and, as mentioned earlier, is discouraged in the home, at school, and in church (pc:Romo 10 July 1983). The gangs may react against this pressure in interesting ways. For example, there is a mural in East Los Angeles that depicts a hand with the tattoo "666" (Fig. 8). Next to the hand, is the inscription, "The Mark of the Beast," in both English and Spanish. Over the years since its creation, this mural has been defaced many times with gang graffiti, while the Virgen de Guadalupe mural around the corner has never been touched. A Chicano parking lot attendant who works near the "666" mural explains that "some murals have been accepted by the community, while others have not (pc:Luis Flores 11 November 1982). In this fashion, rather than identifying with the "Mark of the Beast" mural, the gangs expressed their disapproval of it.

Freddy Negrete, a tattoo artist in East Angeles during the 1970s, says that he got gang tattoos on his hands as a teenager, but in his twenties his attitude changed. Like Lawrence Honrada, Negrete rejected his "crude" hand tattoos as part of his "juvenile delinquent" past. His other tattoos are finely executed with an electric machine, and consequently are more highly valued. Negrete began tattooing as a teenager, using India ink and sewing needles or stick-pins to puncture the skin. In the early 1970s, he learned about prison-vintage electric rotary machines and in 1975, graduated to the conventional professional tattoo machine with

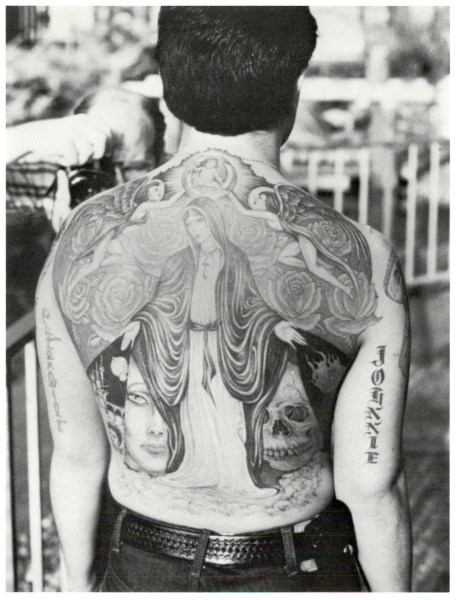

9. East L.A. Madonna, Sacramento, 1980. Tattoo by Freddy Negrete. Photograph by Alan Govenar.

a single-needle setup (pc:Negrete 10 January 1980). At that time, professional tattoo artists were using three, five or seven needles clusters to produce bold outlines, heavy shading and flat blocks of color. With a single needle, Negrete was able to achieve the finer lines and more delicate shading typical of hand or prison-machine work. In some respects, Chicano tattooing parallels the technique used by Chicano muralists in their wall paintings: both the tattoo artists and muralists work from fine line sketches and proceed from black outlines to shading and color.

In the late 1970s, Negrete became well known for his ''photo-realistic'' tattoos and had a steady clientele in the East Los Angeles shop he operated with Jack Rudy (see Rubin, ''Renaissance''). Many of his customers were Chicanos who brought in photographs of their wives, mothers, children or deceased relatives and friends to be copied on their bodies. Pivotal to the rapid growth of Negrete's and Rudy's acclaim was the support of San Francisco tattoo artist Ed Hardy. Hardy had by then achieved international prominence and was interested in supporting younger tattoo artists who showed originality and skill. In 1980, Negrete was voted ''Tattoo Artist of the Year'' at a tattoo convention in Sacramento (Fig. 9). In 1981, Negrete stopped tattooing in order to

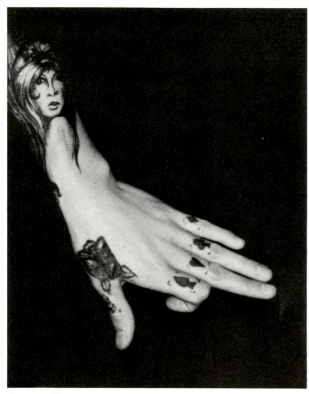

10. *Full Hand with Bent Finger, New Mexico State Penitentiary, 1985. Photograph by Alan Govenar.*

11. *Woman in the Panther's Mouth, New Mexico State Penitentiary, 1985. Photograph by Alan Govenar.*

12. *Handcuffs on the neck, New Mexico State Penitentiary, 1985. Photograph by Alan Govenar.*

13. *Weight room, New Mexico State Penitentiary, 1985. Photograph by Alan Govenar.*

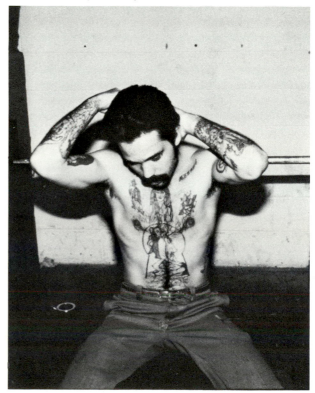

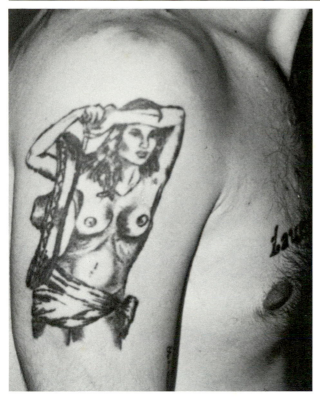

14. *Muscle woman, New Mexico State Penitentiary, 1985. Photograph by Alan Govenar.*

Notes

1. This paper was based on interviews and particpant observation in the following cities: Austin (1974–1975; 1980–1983), San Antonio (1979–1981), Dallas (1980–1983), Santa Fe and Albuquerque (1982–1986), Los Angeles (1980–1983). I am grateful to Ed Hardy who introduced me to Chicano tattooing and to the work of Jack Rudy and Freddy Negrete. My research was supported in part by grants from the National Endowment for the Arts and the New Mexico Arts Division.

devote more time to his family and his church. Although this transition initially surprised his partner, Rudy acknowledges that Negrete was "making a good living as a tattoo artist. He could afford to stop and put his energy into the Catholic church, which had become more important since his marriage" (pc:Rudy 13 November 1982). Negrete still "respects tattooing," although he has a strong negative reaction to some tattoos: "Anyone who tattoos their face with tears [to show how many years they've spent in the joint] or with gang marks on their hands, is branding themselves for life. They are cutting themselves off" (pc:15 March 1981).

Facial and hand tattoos which feature prison or gang imagery are clearly anti-social (Fig. 10). At present, however, there is insufficient data to assess the relative frequency of these tattoos when compared with others in the Chicano community. In sum, it does appear that the practice of tattooing is fairly common. Chicano tattoos can express Christian devotion, affirmative political commitment, and community solidarity, but can also signify deviance in imagery which emphasizes sexuality, violence and individualistic values (Figs. 11–14).

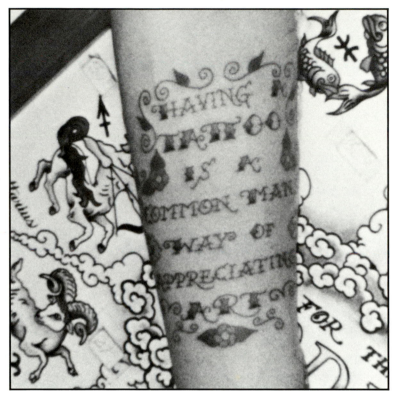

1. "Having a tattoo is a common man's way of appreciating art." Photograph courtesy of Rick Walters.

Drill and Frill: Client Choice, Client Typologies, and Interactional Control in Commercial Tattooing Settings[1]

Clinton R. Sanders

Introduction

Despite its popularity as a form of body decoration in a variety of social groups, contemporary Western tattooing has been virtually ignored in the social science literature (see Govenar 1977; Becker and Clark 1979; and Sanders 1983, 1984 for exceptions). Most of the serious material on tattooing comes from anthropologists who have studied body decoration among tribal groups (e.g., Polhemus 1978:149–173; Brain 1979:48–67; Van Stone and Lucier 1974; Handy and Handy 1924; Hambly 1925) or from psychologically-oriented analysts who regarded the tattoo as symptomatic of psychopathology (e.g., Pollak and McKenna 1945; Yamamoto, Seeman, and Lester 1963; Ferguson-Rayport, Griffith, and Straus 1955; Goldstein 1979a; Grumet 1983).

While the tattooing phenomenon encompasses a wide variety of sociological issues (e.g., tattooist careers, social diffusion and redefinition of tattooing, the impact of tattoo/stigmata on everyday interaction), the following discussion will focus on key features of the limited, face-to-face interaction that occurs when a client chooses and receives a permanent body marking from a tattooist.[2] Following a brief discussion of the sources of interactional conflict within the tattoo setting, two aspects of tattooee decision-making that are centrally related to his orientation toward the tattoo-product will be presented—choice of a design and body location. The focus of the discussion will then turn to the tattooist's interaction with and resultant definition of the client. The tattoo recipient's design and body placement decisions and his compliance with normative expectations—especially those related to appropriate receiving demeanor—are key indicators that the tattooist employs to typologize clients. This presentation, therefore, will conclude with an analysis of the characteristics that tattooists use to differentiate between "good" and "bad" clients.

Conflict and Interactional Control in the Tattoo Setting

The major participants in the tattoo experience define the tattoo setting in radically different ways. As a consequence, this commercial situation, in which there is interaction between the service provider (tattooist) and the client, is potentially conflictual (cf., Emerson 1970; Schroder 1973:183–262; Sanders 1984). For example, conflict may revolve around such issues as whether the participants define tattooing as a business or an artistic activity, whether the client is treated as an object or an autonomous person, and the implications of the tattooist's intimate physical contact with the client/stranger. Of central importance is the fact that the tattooing situation is routine for the tattooist while it is usually novel and unfamiliar to the client. In order to avoid problematic "performance incapacity" (Emerson 1970) on the part of the recipient, the tattooist defines the setting and organizes his interaction with the client so as to present a clear indication of expected recipient behavior, thereby limiting the chances of conflict (Fig. 2). Diplomas, expertly rendered de-

2. Exterior, with typical tattoo-shop graphics. Bert Grimm's Tattoo Studio, "The Pike," Long Beach, California. The style and ambience of Grimm's studio, and its location in what was formerly an "amusement zone," resembles that of the shop described in this chapter. Photographed by Richard Todd, courtesy of Col. William Todd.

sign sheets ("flash"), technical objects (e.g., autoclaves, racks of shiny tattoo machies), signs that overtly present shop regulations ("No tattooing of drunks," "You must be 18 to get a tattoo") are examples of ways in which the tattooist structures the setting in order to indicate his expertise and the serious nature of the activity. This physical display of professionalism reinforces the tattooist's right to "manage the tattooing event" (Govenar 1977:43).

The tattooist's ability to guide the interaction with the client is further supported by his overt display of technical skill and knowledge. Unhesitating responses to client questions, routine ease in handling and adjusting the tattooing equipment, and matter-of-fact, almost ritualized, activities surrounding the preparation of the body area to be tattooed attest to the tattooist's skill and his consequent right to control the interaction. This overt display of expertise is especially important when dealing with novice clients. As one artist stated:

When someone comes in to get their first tattoo they are usually pretty nervous and don't know what to expect. What I do is go through this ritual. I take my time adjusting the machines and I prepare the pigments and stuff like that. I'm getting ready to tattoo them but I'm also showing them how professional I am. They're just sitting there but I know they are watching. I don't need to go through all of that with people who have a lot of work because I know they trust me. I just do it with new people. (Interview, Winter 1983).

Other participants in the setting—fellow tattooists, regular hangers-on, and so forth—help to support the tattooist's definition of the situation. These regulars act as members of the tattooist's "team" (see Goffman 1959). By engaging in casual conversations about arcane features of the tattooing subculture, technical issues, and other matters unfamiliar to the client, team members aid in creating the "front" the tattooist needs in order to exercise interactional control.

Without this concerted display of expertise,

3. Interior, showing mounted sheets of "flash" from which prospective clients select designs. Bert Grimm's Tattoo Studio, Long Beach, California. Photographed by Richard Todd, courtesy of Col. William Todd.

the tattooist would have difficulty managing some of the necessary features of the tattoo process. In most settings in the everyday world, extensive physical contact, the willful infliction of pain, and the exposure of intimate body parts are severe violations of norms regulating interaction among strangers. Tattooing would be highly conflictual if the client did not view the tattooist as skilled, knowledgeable, in control and, as a consequence, permit himself to be treated (to some degree) as a technical *object*.

Complete depersonalization of the client could increase the potential for conflict and threaten the tattooist's interactional control. Therefore, the tattooist must employ certain "expressive skills" (Govenar 1977:48–50) that indicate to the client that he is being dealt with as a person. The skilled tattooist uses humor, expressions of concern, personal questions, and reassurance in order to put the client at ease. Through the use of these interpersonal skills, the tattooist affirms the client's individuality and further decreases the likelihood that conflict will occur during the course of the tattoo interaction.

The tattoo process is far more lengthy than most uninitiated clients expect. In addition, the technical work necessary before a tattoo can be applied (e.g., assembling the tattoo machine, adjusting its speed and stroke, sorting through files of plastic stencils of the standard designs, and preparing and arranging pigments) requires a significant expenditure of time. Consequently, it is common for a potential recipient to wait quite a while before being tattooed. Waiting for long periods or being told to "Come back tomorrow when we open" may precipitate conflict with clients who are single-minded and focused on undergoing what they anticipate to be a painful experience. On their part, commercial tattooists commonly define the rather languid pace of the process as a mark of professionalism and artistry. As they see it, only tattooists who are "only into it for the money" or who are technically unskilled rush the process. The following comes from field notes recorded at the end of a busy work day:

> Bob comes into the back room complaining about the people who are still waiting to get work done. "Man, if some tattoo artist said it was too late for him to work on me I wouldn't complain. These assholes come in here and expect it to be

like S____ E____'s (a popular commercial studio in an adjacent state). If this was his shop he would have just put some half-assed shit on them and taken their money. All of these people would have been out of here by now but they would have had lousy tattoos."

The slowness of the process and the resultant waiting time are dealt with in various ways. Most shops have waiting areas where clients can read well-worn biker magazines or the latest issue of *People*. Others have amusement arcades with electronic games, pinball machines, or pool tables to distract clients from the passage of time. Another way of dealing with this occupational problem is to work only by appointment. The commercially-oriented tattooists observed in this study saw this solution as pretentious as well as causing "no-show" problems and discouraging prospective walk-in clients.[3]

The Client's Motivation and Choice of Design

In the commercial shop where most of my data were collected, clients generally chose tattoo designs from the numerous sheets of "flash" covering the available wall space (Fig. 3). While the proprietor prided himself on having the largest selection of designs in the New England area (more than 2000), only a small percentage (approximately 10%) were regularly selected by clients. One consequence of this pattern was the boredom experienced by many tattooists after routinely applying the same designs day after day. Additionally, it was difficult for them to see themselves as skilled artists in the face of the repetitive quality of their work. Their conversations emphasized the fact that they were predominantly involved in a "business" activity in which "the customer is always right" and in which technical skill is valued over creative artistry. In other words, the tattooists saw themselves as being involved in an activity oriented to consumer needs rather than to their own needs as creators of fine art (cf., Browne 1972; Kando 1975:40–49; Hirschman and Wallendorf 1982).

Given the wide variety of people now receiving tattoos, explanations that focus on simplistic motivations such as rebellion against convention or psychosexual pathology are largely inadequate. People choose to be tattooed and choose particular designs for a wide variety of reasons. In general, however, recipient motivations may be divided into five relatively discrete categories.

1. SYMBOLIZATION OF AN INTERPERSONAL RELATIONSHIP. One of the most common responses clients have to the question, "How did you go about deciding on this particular tattoo?" is to refer to an associate with whom they have a close emotional relationship. Some choose a specific tattoo because it is like one worn by a close friend or a member of their family. Others choose a design that incorporates the name of their boy/girlfriend or spouse.[4] Traditional tattoos like "Mom" or "Mother" surrounded by hearts, flowers, ribbons, and other romantic symbols continue to be popular. Tattoos associated with self-identity—especially the recipient's own name or nickname—are also routinely requested (see Anonymous 1982).

2. PARTICIPATION IN A GROUP. Group membership often determines design choice. For example, military personnel pick tattoos that indicate their service connection, motorcycle gang members choose club insignia,[5] members of sports teams request designs that relate to their particular sport or the team name,[6] and participants in religious groups may choose esoteric or obvious religious symbols. This group-identity function is traditional in tattooing and represents the recipient's indelible commitment to the group and the social experience and identity it provides.

3. REPRESENTATION OF KEY INTERESTS AND ACTIVITIES. Clients frequently choose designs that represent important personal involvements, hobbies, or occupations. For example, in the course of one day's fieldwork, I recorded a rabbit breeder receiving a rabbit tattoo, and an eye surrounded by a flaming circle inscribed on the upper arm of an optician.

4. SELF-IDENTITY. An attempt to represent pictorially aspects of personal identity also motivates the choice of design. Many people choose their birth sign as a first tattoo since it can be small, inexpensive, and personally meaningful. One client chose an eye design because his weak eyesight was an important element in his self-concept. Some designs are seen as having a kind of magical/protective significance.

Two guys in their twenties come in and look at the flash. After looking for a while one guy comes over to me and asks if we have any bees. I tell him to look through the book because I have seen some bees in there. "Why do you want a bee? I don't think I've ever seen anyone come in here for one." "I'm allergic to bees. If I get stung by one again I'm going to die. So I thought I'd come in and have a big mean-looking bee put on. I want one that has this long stinger and these long teeth and is coming in to land. With that, any bee would think twice about messing with me." (Field notes, Spring 1980; cf. Hardy 1983).

5. DECORATIVE/AESTHETIC STATEMENT. Designs are selected on the basis of aesthetic appeal and the belief that the tattoo will be decorative. The most common responses clients make to questions about why a particular design was chosen are that they "liked the colors" or "thought it was pretty." One tattooist acknowledged the aesthetic evaluations of the working-class "taste culture" (Gans 1974) from which most of his clientele was drawn when he observed (Figs. 1,4):

> Tattooing is really the most intimate art form. You carry it on your body. The people who come in here are really mostly just "working bumpkins." They just want to have some art they can understand. This stuff in museums is bullshit. Nobody ever really sees it. It doesn't get to "the people" like tattoo art. (Field interview, Summer 1980)

In addition to altering the client's definition of his body by inscribing a primary design, many tattooists also do some cosmetic tattooing (e.g., covering birthmarks, hiding scars, filling in unpigmented areas; see Tucker 1976:30; Paine 1979:43) and cover up unprofessional or flawed body markings. While requests for cosmetic tattooing were rarely recorded (the work was considered "not creative"), cover-ups accounted for approximately thirty percent of the work done. In general, the size and color of cover-ups are determined by the original work (they must be larger and darker). This sort of work is considered to be interesting and valuable. Covering an old tattoo usually requires creativity and technical skill, and it is rewarded by customer satisfaction.[7]

The Client's Choice of Body Location

Many factors are involved in the client's choice of location for a tattoo. For men, the arm is by far the most popular choice. In his study of 2,000 Royal Navy patients in a dermatological clinic, Scutt found that, of the 923 (46.2%) tattooed, 98 percent carried their tattoos on their arms (Scutt and Gotch 1974:96). The next most common location was the chest, with 15 percent having tattoos on this area. Women, on the other hand, tend to choose more private tattoo locations. Most commonly, women are tattooed on the breast, shoulder, or hip (see Webb 1979:41). Apart from convention, it may be that men and women choose different locations based upon their perceptions of the function of tattoo. Women tend to regard their tattoos (which are often small and delicate) as aesthetic body decorations intended for personal pleasure or for the enjoyment of those with whom the woman is most intimate. Prevailing attitudes toward tattoo may influence the placement of women's designs; privacy assures that one will not be defined as deviant by strangers or casual associates. This perception is well illustrated by an exchange with a young woman who had a large rose-and-snake design on her upper arm.

> S: How did you decide on that design?
> Interviewee: I wanted something really different, and I'd never seen a tattoo like this on a woman before. I really like it, but sometimes I look at it and wish I didn't have it.
> S: That's interesting. When do you wish you didn't have it?
> I: When I'm getting real dressed up in a sleeveless dress and I want to look. . .uh, prissy and feminine. People look at a tattoo and think you're real bad . . . a loose person. But I'm not. (Field notes, Fall 1981)

For men, who generally choose larger designs and have them located in more visible body areas, tattoos publically assert masculinity, proof of a relationship, or personal identification.

Tattooists also have a vested interest in the body location chosen by the client. Because the tattoo process requires grasping and stretching the skin, working on the recipient's arms or legs presents fewest problems. Most tattooists charge more (usually 25%) when the client requests that the tattoo be applied to an area other than an extremity.[8]

Pain plays a part in the location choice for a tattoo. Tattooists routinely inform clients that boney areas are particularly sensitive to pain as are certain other body parts.

Male tattooists consistently express distaste for jobs that require them to have contact with a male client's genitals.

> Bob is doing a cartoon bird on the inside of a young man's leg. He is doing the coloring as I enter, and I notice he is not being very careful and is not very concerned with keeping the pigment and blood from staining the client's underwear. After being bandaged and ritually given hygiene instructions, the kid pays $45 and leaves. When he is gone, Bob heatedly states, "I hate to do shit like that!" I assume he is referring to the lame design the kid chose but I ask what he means. "All the time I was doing it I had to hold onto the guy's cock. It really creeps me out. The next time I have to do that I'm going to charge $100 minimum. I don't care what design they choose." (Field notes, Fall 1980)[9].

Intimate tattooing of female clients, predicta-

4. View of inside doorway: "Thank you, art lovers." Bert Grimm's Tattoo Studio, Long Beach, California. Photographed by Richard Todd, courtesy of Col. William Todd.

bly, does not generate this type of distaste. In point of fact, the male tattooists consistently maintain they are not sexually excited by the exposure of or contact with intimate parts of female clients' bodies. Tattooists observed working on or near women's private areas routinely maintained a serious facial expression and did not engage in the usual joking interaction. Like some gynecologists (see Emerson 1970), they commonly adopt a rigid, businesslike demeanor so as to avoid the potentially conflictual sexual situations that could result from intimate physical contact. On their part, women clients commonly also exercise some care when planning for and receiving tattoos on their breasts, buttocks, hips, thighs, or other private locations. They usually are accompanied by a female friend and wear leotards or bathing suits under their clothes. Curtains may be used to conceal the process from the casual observer (cf. Becker and Clark 1979:14–15).

Appropriate Receiving Demeanor

Although the tattooing process is not especially painful, pain is a major concern of most first-time clients. "Does it hurt?" was, by far, the most common question asked during field conversations with waiting clients. How painful the tattooing process is depends on the location of the tattoo, the skill of the tattooist, the quality of the equipment (especially the condition of the needles), and the pain threshold of the client. Because of the consistent concern about pain expressed by recipients, most tattooists have a standard response to make light of, or deflect, the client's fear. One tattooist, when asked "Does it hurt?" usually replied, "No, I don't feel a thing." Govenar (1977:49) reports that tattooist Stoney St. Clair often answered the pain question with the humorous response, "Did you ever jerk off with a handful of barbed wire?" If not employing a humorous response, tattooists usually attempt to relax the client by offering a straightforward description.

It's not too bad. Sort of a stinging or burning feeling. You kind of get used to it. The outline will hurt a little more than the coloring I'll do later. I'll stop for a while if it gets too uncomfortable. (Field notes, Summer, 1981; see also Morse 1977: 70; St. Clair and Govenar 1981:112,117,119)

*5. View of working area, showing tattooists'
"stations" with "flash," photographs, and shop
rules behind partition. Bert Grimm's Tattoo Studio, Long Beach, California. Photographed by
Richard Todd, courtesy of Col. William Todd.*

Interestingly, most tattooists maintain that women seem less bothered by the pain than men. The following interaction is between the proprietor of a shop and a visiting tattooist:

> Visitor: The worst part of getting a tattoo is waiting. [Clients] get real nervous. I had this chick come in yesterday to get a rose put on her breast, and she didn't move at all. She did look kinda pale.
>
> Tattooist: Yeah, women, are usually better than guys. I see these big tough guys come in here, and you start working on them, and you have to stop before they pass out. It's not the pain; it's the idea of the thing. It's like getting a needle; it's all in the mind. (Field notes, Summer 1981)

Other tattooists account for the differences in the responses of men and women to the pain by saying that childbearing makes women more accustomed to pain, that women are more used to having their bodies altered and worked on, or that women who get tattooed have thought more about and are more committed to the process than are men (Tucker 1976:31).

The receiving demeanor expected and enforced by tattooists is that of motionlessness and silence. The client must maintain the posture determined by the tattooist to prevent the work from being distorted or spoiled by unexpected movement. Because the client's stillness is closely correlated with the quality of the finished product, tattooists typically discourage the recipient from smoking, talking, or watching the tattoo process. The "best" clients are quiet, relaxed, cooperative and commonly stare into the middle-distance during the process. "Troublesome" clients, on the other hand, jerk away, attempt to engage the tattooist in conversation, or try to observe the work.

A persistent myth among the general public is that many of the people who receive tattoos do so because they are drunk and pressured into it by similarly intoxicated associates. Actually, most tattooists are extremely careful to avoid working on people who are obviously under the influence of alcohol (or other depressants). Drunken clients tend to generate conflict in the shop, and tattooists are aware that tattooing someone who is not able to enter into the procedure in full command of his

judgment and faculties has the potential for causing trouble in a business that continues to labor under the reputation of being, at best, only marginally respectable. Most shops have a prominently located sign explicitly stating the cardinal rules of the establishment—"Pay in cash. No tattooing of drunks or minors" (Fig. 5). While most intoxicated clients use alcohol as an analgesic in anticipation of a painful process rather than as a deinhibiting motivator, they are roundly disliked by tattooists and often the object of humorous disdain.

The artists get into talking about how hard it is to work on drunks.

> *Mitch:* These fuckers come in here drunk, and they're no good at all. You can't get them to stay still. They just keep on falling over.
> *Bob:* When I was working down in Georgia, this guy came in real drunk and wanted a pattern put on. I got him shaved and put the stencil on and the guy got up. looked at it in the mirror, paid his forty bucks, and left. (Laughter.)
> *Mitch:* The other day I was working on this guy, and he was drinking soda. But he was getting loaded—he had booze in the can. Finally he started to fall off the stool, and his brother had to come over, and we leaned him against the wall. His brother was real pissed. Apologized all over the place. (Field notes, Summer 1981)

In addition to the possible legal and interpersonal conflicts associated with intoxicated clients, tattooists frown on drunkenness because it interferes with the client's demeanor. The drunken recipient is unable to remain still and follow the tattooist's instructions.

Tattooists' Typifications of Clients

General discussions of service work (e.g., Mennerick 1974; Spiggle and Sanders 1983) and social scientific analyses of specific service delivery interactions (e.g., Sudnow 1965; Browne 1976; Roebuck and Frese 1976; Faulkner 1983) clearly demonstrate two key features of commercial settings in which there is direct contact between buyer and seller and the product is intangible and relatively nonstandardized. Service workers, from tattoo artists to psychiatrists, are intensely interested in controlling the service interaction. Further, they tend to typologize their clients in order to predict interactional problems and to devise effective strategies to cope with conflict.

In general, the typologies employed by service deliverers are based on five definitional dimensions.

1. Facilitation of work. Does the client assist or hinder the service worker in his activities?

2. Control. Does the client allow the service worker to exercise maximum control over service delivery, or does he attempt to wrest control from the service provider?

3. Gain. Does the client allow the worker to profit, or does the interaction require extensive expenditures of time and effort while providing little payoff?

4. Danger. Does the client pose a physical and/or psychological threat to the service worker?

5. Moral acceptability. Is the client morally acceptable, or does he violate the service worker's values and normative expectations (Mennerick 1974:400–406)?

Although all these dimensions apply to the tattoo setting, customers usually are defined simply as either "good" or "bad." The comparative simplicity of the tattooist's typology is due to three important characteristics of the service and the interactional setting in which tattoos are applied. First, commercial tattooing, while requiring at least minimum technical skill and experience, is not particularly complex relative to other service activities (e.g., that of airline ticket agents or plastic surgeons). Second, even with the recent diffusion of tattooing into an increasingly wide spectrum of economic groups and subcultures, the clientele encountered in most commercial studios is relatively homogenous. Third, the tattoo service is provided in a setting over which the service deliverer exercises significant control (Fig. 6). The tattooist works in his familiar "home territory" with clients who are commonly inexperienced, unknowledgeable, fearful, and interactionally tentative (see Mennerick 1974:407–411 for a general discussion of factors affecting typological complexity).

Factors that are both behavioral and physiological affect the tattoo clients' *facilitation of the work* and their consequent categorization as "good" or "bad." Certain characteristics of the organic "canvas" the client presents to the tattooist aid or impede the tattoo process. "Good" clients have finely textured, clear, light skin ("like fine vellum paper"). Dark, coarse skin presents artistic and technical problems.

> Clear, white, unwrinkled and unblemished skin is the best. That's one reason I like to work on women. The worst kind of skin is on those guys who have laboring jobs or who are out in the sun all the time. The sun breaks down the elasticity of the skin. That's why when you see sailors or

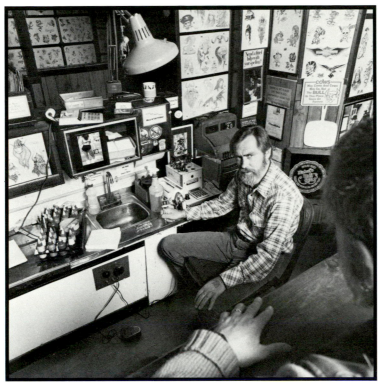

6. Rick Walters with tattooing equipment. Bert Grimm's Tattoo Studio, Long Beach, California. Photographed by Richard Todd, courtesy of Col. William Todd.

old cowboys they have loose, wrinkled skin that just seems to hang there. You see a lot of that in shops around seaports. Some guys come into the shop, and you can't really tattoo them. You just mark up their skin. (Field interview, Fall 1982)

Clients who bleed profusely, whose skin swells in reaction to the needle, who have a low pain threshold, or who faint during the process also tend to be negatively defined by tattooists.

As discussed above, the client's choice of body location may either aid or impede the tattooist's activities. Problematic clients choose body sites that present special technical problems or which necessitate troublesome contact with intimate parts of the body. "Good" tattooees, in contrast, receive work on conventional locations with minimal technical problems and are easily manipulated by the tattooist (Fig. 7).

Whether or not the client adheres to the appropriate receiving demeanor described earlier also determines how he is defined. Tattooees who are overly talkative, struggle to observe the tattoo application process, or move about in response to pain impede the service delivery and are negatively evaluated.

A young man who brought in a stag's head insignia from a rifle manufacturer is getting the piece put on the left side of his back at the shoulder. I know from previous conversations that back work is somewhat more painful—reportedly because it is a boney area and the recipient is unable to watch the process—but this guy is making quite a show of the pain. As he continues to squirm about and complain [the tattooist] gets increasingly annoyed. [The tattooist] takes a deep breath and gives instruction. "Just let the pain pass through you—think of it that way. When you tense up you just make it worse. Feel the pain when you breathe in, and let it out of you when you breathe out." A bit later the guy complains that it is taking a long time. With considerable show of exasperation, [the tattooist] responds, "You would have been out of here a long time ago if we didn't have to keep dancing around like this." (Field notes, Summer 1984)

Following the application and bandaging of the tattoo, the recipient is instructed on how to care for the new acquisition during the healing process. Commonly, the client receives a set of written instructions (often printed on the back of the tattooist's business card) in addition to verbal advice on hygiene. There is some variation in aftercare instructions. The extent of the client's ad-

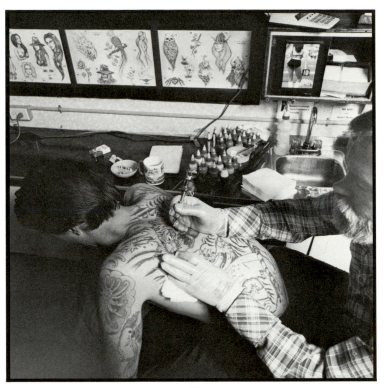

7. *Rick Walters working on back tattoo. Bert Grimm's Tattoo Studio, Long Beach, California. Photographed by Richard Todd, courtesy of Col. William Todd.*

herence to the instructions has significant impact on the quality of the final product. Recipients who disregard or are careless about hygiene are routinely defined as problematic by tattooists. Tattoos that become infected or heal improperly tend to lose color or have spotty outlines. Consequently, the ''bad'' client who fails to follow aftercare instructions impedes the tattooist's work in various ways. Most legal and medical concerns focus on fears of infection or the communication of diseases due to improper or inadequate sterilization procedures (see Goldstein 1979b). But even scrupulous hygenic precautions on the part of the tattooist do not guarantee infection-free tattoos without the full cooperation of the client. Further, clients who are dissatisfied with the quality of their tattoo—even when they are at fault—may not return for additional work or recommend the studio to associates. Because satisfied clients become repeat customers and the major source of new business, most tattooists will recolor or reline a piece that is flawed due to improper healing; this service is typically provided free of charge.

''Good'' tattoo customers are thoughtful and knowledgeable about design and location. They have a general sense of what they want, but at the same time, they are amenable to the tattooist's suggestions, display respect for his expertise, and relinquish a certain amount of artistic *control*. Here, for example, is one artist's description of a good client:

> If someone comes in and they have thought about [what tattoo they want] and they have some artistic ideas and class, then I take care in working on them. A chick came in to get a tattoo yesterday. She was really serious about it. She brought in all of these books, and we spent over an hour deciding on the design and where it should go. She was really artistic herself. She finally decided on a stylized Indian bird design on the side of her breast. That kind of person is really satisfying for me. It gives me a lot more freedom. (Field interview, Spring 1982)

Negatively defined tattooees, on the other hand, are pushy and critical. They thwart the tattooist's attempts to maintain control over the service interaction and attack his self-defined expertise. Here, for example, is a description of the overly critical and controlling client offered by a tattooist who prides himself on his formal artistic training:

You have these morons who have absolutely no idea of what is artistic . . . to have them sitting there telling you how things ought to be done. Nothing galls me more than to be putting a piece on and have them look at it and say, "That's enough shading." I've done years in art school. If it shouldn't really be that way, I wouldn't have been doing it that way. One kid came in last weekend and wanted a Tasmanian devil. It was on a t-shirt, and when you reduced it, it didn't look right. So I added some shading to give it this three-dimensional look. There's nothing like having a seventeen-year-old kid standing there and saying, "Well, should this really be there?" Of course it should be there, fool! (Interview, Spring 1984)

While most commercial tattooists have some degree of artistic self-definition, all readily acknowledge that their primary goal is profit. Consequently, tattooees are evaluated on the basis of the potential economic *gain* versus the amount of time and energy they require. Recipients who shop for a tattoo on the basis of price ("What can I get for $25?") are typically seen as "bad" clients. They are defined as ignorant and lacking in the commitment that characterizes a valued customer.

> It's amazing to me! Some guy will blow $200 on coke and sit around the kitchen table and snort it up in 45 minutes. Then he comes in here, and you tell him that the tattoo he wants—a tattoo he is going to wear for the rest of his life—costs $200. He says, "That's too much, what can I get for $100?" It's just stupid! (Field interview, Summer 1984)

The tattooist's interest in artistry and control is often in conflict with his profit orientation. As described above, clients who display artistic sensibilities and negotiate a custom design with the tattooist are usually defined positively. However, this is not always the case. A variety of factors—for example, the tattooist's mood, the personal attractiveness of the client, or the number of people waiting for work—affect the tattooist's estimation of the "uncertain" client. What follows is a description of an interaction with a recipient whose uncertainty interferes with the tattooist's interest in maximizing gain while limiting time and energy expended:

> The shop is unusually busy for a weekday afternoon. A husky biker type has been waiting for some custom work. He has a large skeleton with a gun on his left bicep and wants Fred to do some work around the existing piece. "I don't care what you do. Just make it look good. You know, maybe a cemetery or something like that." Fred grimaces as he takes out his pen and begins to

> draw tombstones on the guy's arm. He works slowly—drawing, making a face, spraying the arm with green soap and rubbing off the sketch, trying again. Finally, he puts down the pen and says, "Why don't you just look around at the flash and see if there is something you want. We're busy here, and I can't take the time with this shit. If you want a tattoo, I'll do it, but you come in here and don't know what you want and expect me to do it all for you. You don't want a piece, you just want to get tattooed." (Field notes, Winter 1981)

There is a certain amount of danger associated with all businesses that operate on a cash basis. Tattooists, who commonly work at night, frequently have sizable quantities of cash on hand, and tend to encounter a rather rough clientele, are well aware of the risks. Thus, they typologize clients with regard to their apparent *dangerousness*. Like police officers (Wilson 1970), prostitutes (Hirschi 1962), cab drivers (Henslin 1968), and other service workers who routinely find themselves in high-risk situations, tattooists are wary of clients who make furtive movements, ask unusual questions, or exhibit forms of behavior that are out of the ordinary.

In recent years, tattooists have become aware of the health risks inherent in coming into contact with blood. There is a very real possibility of contracting hepatitis, herpes, AIDS, or other diseases (cf. Becker, et al. 1961:317–318). Most will refuse to work in customers with rashes or obvious skin lesions. Some tattooists take the sensible precaution of wearing surgical gloves while working on clients.[10]

Finally, tattooists typologize recipients on the basis of *moral acceptability*. Objectionable personal hygiene, choice of hostile or abusive symbols, and requests for tattoo placement on genital areas or highly visible and stigmatizing body sites result in negative evaluations of the morals, lifestyles, or attitudes of certain clients. It is common for tattooists to refuse to service those individuals who appear to violate overtly what they perceive to be standards of good taste and propriety.

Given the close physical contact involved in the delivery of the tattoo service, it is understandable that cleanliness is one of the most common characteristics tattooists mention when asked about the differences between good and bad clients. One of the more misanthropic interviewees put it this way:

> On the negative side of tattooing, you have the scum element of the public; the ones that don't think it is necessary to bathe or change their

clothes or whatever after work before coming to the tattoo shop. They think dirt is fine. There's the asshole biker types who thrive on dirt and want to talk about their motorcycle life constantly while you are tattooing them. These are the ones I dislike the most because I could care less about their motorcycles or their biker lifestyle. But when you work with the public, you have to expect a certain percentage of geeks, filthy people, and scum in general because a large percentage of tattooing is done on this type of person. (Interview, Summer 1984)

As discussed in a preceding section, choice of design and body location reveal much about the client's interests, values, and attitudes. Ordinarily, most reputable tattooists frown on and will refuse to work on the face or hands. The desire to make such a public display of the tattoo/stigmata is seen as aggressively deviant. Requests for tattoos on "public skin" are also denied because facial or hand tattoos could have a negative impact on the tattooist's reputation and business and aggravate the public's antipathy toward tattooing, tattoo workers, and tattoo art.

> This guy came in and wanted me to tattoo something on his forehead. I refused to do that. Large designs on people's faces . . . I don't think the world is ready to accept that yet . . . unless you are a Maori chief. The society doesn't accept it, and I don't want my name associated with something like that. Tattooing should not be flaunted in the face of the public. If someone wants "fuck you" written across his forehead, I don't want it known that I was the one that did it. I wouldn't do it because I think it is a stupid thing to do. You have to draw the line somewhere. (Field interview, Winter 1983)

The tattooist sees the design a client requests as an indicator of his taste and, by extension, his acceptability. Most commercial tattooists do not feel that their economic circumstances permit them to refuse to apply joking, cartoonish designs or name/vow tattoos that continue to be popular in street tattooing. Yet, they will often attempt to redirect the interests of those people whose hearts are set on getting Yosemite Sam making an obscene gesture or the Pink Panther smoking a joint or the name of their current girl/boyfriend permanently affixed to their bodies. Those clients who insist on images of this kind are usually objects of ridicule. Conversely, recipients who request extreme right-wing symbols (e.g., swastikas) or overtly antisocial phrases (e.g., "fuck niggers") are deemed unacceptable and are denied service. Like the tattooist's reluctance to mark public skin, refusals of this kind are also based on a desire to avoid negative public reaction.

> A young chick came in the other day and had "born to be wild" put on her wrist. She's going to have a hell of a time getting a job when they see that. (Are there any tattoos you won't do?) I don't refuse to do many things. I try to talk people out of some of the things they want. I don't do political stuff—swastikas and things like that. I don't want people thinking this is a place for a bunch of Nazis. (Field interview, Fall 1982)

Conclusion

Three considerations have been used here to evaluate the commercial tattoo setting: sources of interactional conflict, elements of client choice, and the customer typology tattooists employ to differentiate among recipients. Conflict is an ever-present possibility in the commercial tattoo studio. Clients are typically unfamiliar with the service delivery setting, unknowledgeable about the normative constraints to which they are expected to conform, and fearful of the pain of the tattoo process. Within this context of general uncertainty, tattooees make choices of design and location based on interpersonal, aesthetic, and socially symbolic criteria which they have often only vaguely examined and defined.

Concerned with minimizing conflict while maximizing economic and interpersonal rewards, the tattooist has a clear interest in understanding the client and channeling his intentions and behavior. The tattooist's understanding of and consequent interaction with the client is facilitated by the use of a basic typological system that allows the differentiation between good and bad recipients. Customers are categorized on the basis of whether they can be expected to facilitate the tattooist's work, cede appropriate control, provide sufficient gain for the time and energy expended, present little danger, and demonstrate an acceptable level of taste and morality.

The tattoo client also has a vested interest in fostering a positive and conflict-free relationship with the tattooist. Within the immediate tattoo setting, the recipient's experience will be more intrinsically rewarding and less anxiety-producing if he attends to the cues by which the service provider communicates the normative expectations constraining the interaction. In turn, the quality of the tattooee's relationship with the tattooist affects the quality of the service rendered. This connection between positive personal interaction and the care exercised in applying a tattoo is a theme that arose frequently in my conversations with tattoo-

ists. As one artist/interviewee observed:

> I can assess people when they come in the door.
> I know what it is going to take to please that per-
> son and who not to waste the effort on. I don't
> mean [I will] not do a good job on someone—
> cheat them. It's always going to be done properly
> in here, and they are going to get what they see
> on the flash. But the people I do the creative
> work on . . . they're my friends, you know. . . .
> There's a difference between doing it and putting
> your heart into it. (Interview, Summer 1984)

Notes

1. Valuable assistance with the form and conceptualization of this discussion was provided by Derral Cheatwood, Robert Faulkner, Edward Kealy, Steve Markson, Eleanor Lyon, Arnold Rubin, and Susan Spiggle.

2. This paper is based on data collected during approximately four years of participant observation in several tattoo studios in the Northeast. While I have observed interactions and conducted field interviews in twelve establishments, the majority of the field data presented here derives from my experiences in one shop located in a major New England urban area. Additional data were drawn from thirteen semistructured interviews conducted with tattooists.

3. Those shops in which commercial values are dominant—especially those that cater primarily to military personnel—deal with the time problem by speeding up the process. Some shops employ an assembly-line mode of organization. The least experienced employee applies the design using a plastic stencil and fine carbon powder, the senior tattooist does the most exacting work of outlining the design with black pigment, after which, the client is passed on to assistants who shade and color the design. While this procedure was generally denigrated by the tattooists I interviewed, it was, at the same time, seen as a reasonable approach for high-volume shops located near military bases.

4. At times this relational tattooing may become rather extreme. One midwestern tattooist I interviewed recounted the following story:

> I have this chick that comes in every once in a while—a black chick. Her boyfriend is some hot soul musician who has a couple of hits on the soul charts. Everytime she comes in she gets the same thing. She gets his name put on her thigh. I don't know, she's a real nice looking chick but she has G____ T____ about fifteen times on her thigh. I try to get her to let me put a heart or a butterfly or something on but she just wants the name. Last time she was in she got something different. She got "property of" put before the name. (Field interview, Fall 1981)

Because relationships are often subject to change, most tattooists get a significant number of clients who request that names of past intimates be covered up with new designs or who simply want the name/tattoo blacked out.

5. Since the clientele of the studios I observed was often drawn from biker groups, Harley-Davidson insignia were by far the most common designs requested.

6. One young man requested a frog because this was the name of the Little League team he coached.

7. See Ferguson-Rayport et al. 1955, Edgerton and Dingman 1963, and Scutt and Gotch 1974 for other discussions of the functions, meaning, and motives surrounding tattoo design.

8. Facial tattooing is a controversial practice; many tattooists refuse to do it beyond some minor cosmetic work, because of the "bad name" that the stigmatizing marks could bring to the profession. The following was printed on the bottom of the registration form for the 1982 convention held by the National Tattoo Club of the World:

> This convention is for Tattoo Artists and Fans [sic] who care about the Tattoo Profession. Anyone breaking the following rules will be asked to leave with no refunds. Facial tattoos other than cosmetic (eyebrows, lines, etc.) not permitted. Piercing of the private parts of the anatomy not permitted to be shown at any time. Any facial piercing with bones, chains, etc. must be removed during entire convention.

9. Some psychoanalysts would interpret this kind of distaste as relating to the tattooist's latent homosexual fears. In the 1934 volume of *Psychoanalytic Quarterly*, Susanna Haigh presents the conventional sexual interpretation of tattooing:

> The symbolism of the act of tattooing is pointed out as observing the needle as the penis introducing the tattooing fluid into a cavity. The tattooist is the more or less sadistic aggressor; the person tattooed, the passive recipient . . . As might be expected the tattoo is used often as an unconscious representation of a penis both by men and women . . . [There is an] anal element in the tattoo. There is surely a definite relationship between the impulse of the child to smear itself with feces and that of the adult to have himself smeared with indelible paint (quoted in Morse 1977:122).

10. Dermatologist Gary Brauner emphasized the potential health hazards associated with the tattooist's contact with clients in a lecture delivered at the 1984 convention of the National Tattoo Association in Philadelphia. He strongly advised the audience to wear surgical gloves while tattooing.

The Tattoo Renaissance
Arnold Rubin

Since about 1960, the nature and practice of tattoo in the United States has been changing so dramatically that the term "renaissance" is justified.[1] These changes have influenced the evolution of the medium in other parts of the world, and their wider ramifications encompass a fascinating spectrum of issues and ideas. This essay seeks to articulate a systematic conceptual and chronological framework for considering these phenomena.

There have been a number of popular, impressionistic, and journalistic attempts at writing a history of Europe and American tattoo since the introduction of electrical instruments in the last decade of the nineteenth century. None of these succeeded in adequately documenting this early modern period, nor has there been an adequate examination of the subsequent degeneration of European and Euro-American tattoo into an increasingly conventionalized and schematized folk or popular art. This idiom, here designated as the "International Folk Style," is still overwhelmingly predominant.[2] It represents the essentially proletarian rootstock from which the "Tattoo Renaissance" emerged and by which it is regularly renewed.

International Folk Style

Tucker (1981:44) has observed that the International Folk Style "is characterized by agglomerate designs, often executed by many different tattooists on a single client, which results in a 'collection' of conflicting styles, sizes and images," with little attention to their relationship to the forms of the body (Figs. 1,2). The following artistic and contextual parameters characterize this style of tattoo in the United States.

Practice

Comparatively small, standardized, stock designs are transferred by means of reusable acetate stencils. Price is determined by the complexity of the design, its size and location. Arms and legs are the most popular and inexpensive sites; bodywork usually costs extra. Most artists refuse to tattoo hands or faces to avoid attracting undesirable attention to the medium or themselves. Emphasis is placed on rapid, consistent execution. The customer makes a selection from drawings ("flash") displayed on the walls of the shop. Custom designs and large-scale work based on a unified concept are rare. A heavy black outline usually determines the design, which is followed by black shading, then touches of color from a palette limited, in most cases, to red, green, blue, brown, and yellow.[3] A significant proportion of professional practice is dedicated to repair, camouflage, or unification of previous work (Hardy 1983a). Until recently, sanitation practices were minimal.

Structure

The industry was organized as an informal guild, sharing a considerable body of technical and trade secrets. These included how to mix colors, the construction and maintenance of machines,

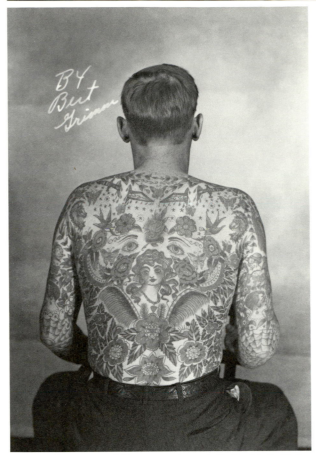

1. Back tattoo ("International Folk Style") by Bert Grimm, 1930's–1940's. Photograph by Bert Grimm, courtesy Bob Shaw.

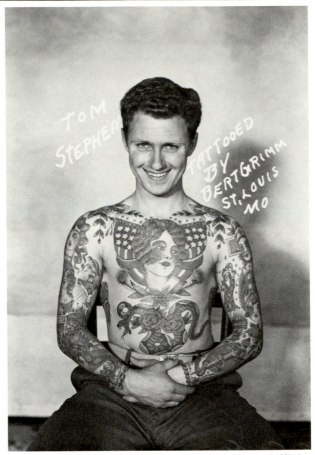

2. Chest tattoo ("International Folk Style") by Bert Grimm, 1940's. Photograph by Bert Grimm, courtesy Bob Shaw.

and sources for designs, pigments, equipment, and supplies. This information circulated among trusted friends through an underground communication network (Morse 1977:22; Hardy 1982a). At the center of this network was a small nucleus of committed, highly independent, often peripatetic entrepreneurs who were accustomed to responding quickly to legal and social sanctions and changing economic conditions. Situations that impacted on the economy of the industry were the expansion or contraction of military installations and major industries, and changes in transportation patterns (Fried and Fried 1978:166–168). Artists were distributed fairly evenly throughout the United States, although there were concentrations in the entertainment zones of large urban centers (with a collateral involvement with traveling fairs and circuses).[4] Publicity was avoided because it usually generated a repressive reacton.

Practitioners usually came from blue-collar backgrounds and had little or no formal training in art. They were primarily attracted to the field by the lifestyle: independence, a regular and substantial income, and comparatively easy work. Serious recruits usually entered the field through a loose system of apprenticeship (Morse 1977: 7,16,82; Webb 1979:17–18). Many responded to "teach-yourself" advertisements in the popular press but attainment of professional status by this route was rare because of the importance of hands-on experience: "Learning to tattoo from a book is just about as successfully accomplished as learning to swim from an instruction manual in your living room" (Phil Sparrow quoted in Morse 1977:14; Hardy 1982c).

Patronage

Clients were predominantly male, relatively young, artistically uninformed or conservative, and typically blue-collar. Their first exposure to the medium was usually a nonprofessional homemade tattoo associated with military, marginal, or institutionalized (primarily prison) subcultures.

Avant-Garde

Since 1960, the nature and setting of work being done in a small but influential sector of the field have changed drastically. These changes have been the result of dramatic shifts in the social, economic, and cultural environment in which tattoo is practiced and reflect a contrast to the practice, structure, and patronage of International Folk Style tattoo.

Practice

Significant numbers of unique, large-scale, unified, custom designs, derived from a host of nontraditional sources, are being produced and, in some cases, even copyrighted (Teresi 1981). Japanese design triggered the first wave of this expansion and it continues to inspire experimentation and elaboration. Advanced artists lately have begun to explore a variety of "tribal" styles as well as imagery from popular and mass media (especially science fiction) and other sources.[5] While some advanced artists still offer "flash," a portfolio of previous work is even more common. The palette has been dramatically expanded, with innovations in technique emphasizing unorthodox use of color, inflected outlines, and highly detailed, delicate, fineline work. Placement of the work on the body receives careful attention. Outstanding artists usually charge by the hour—now $75 and up—rather than by the piece, although consultation is usually *gratis*. Sanitation is scrupulous, including sterilization of instruments.

Structure

Centralized suppliers of equipment and materials with extensive, well-produced mail-order catalogues have supplanted marginal, small-scale suppliers. John Lemes' *The Complete Handbook of Tattooing Techniques for the Artist* (1980) was an attempt to broadcast the trade secrets of tattoo. Associations publish illustrated newsletters and hold annual conventions, which together serve as clearinghouses for information and ideas.[6] While professional-level tattoo skills and knowledge must still be obtained through apprenticeship, many recruits now have university or art school backgrounds, including advanced degrees (Fried and Fried 1978:168; Webb 1979:31). Many of this new generation of artists appear to be drawn to the field less by economic factors than by the intrinsic appeal of the medium; they frequently refer to it as "magic" (Tucker 1981:47; Hardy 1983b). These artists also express impatience with what they see as the limitations, distortions, and irrelevance of conventional elitist modes of art production, although many also work extensively in media other than tattoo (Tucker 1981:43–44,46–47; Webb 1979:103). True apprenticeship, in the sense of creative collaboration between senior and junior artists, has emerged in some cases.

A few artists enjoy the economic security that comes from an international reputation and are able to work only on projects that give them the greatest artistic freedom (Morse 1977:5). Advanced artists are concentrated in the western United States, but New York City is a satellite with its own artistic identity. Recently, some West Coast artists have been invited to work on the East Coast, in England, and Europe by tattooists seeking to experience the design and technical innovations they have pioneered.[7]

Patronage

As would be expected, given the nature of the medium—i.e., the requirement of an unmediated transaction between artist and client—independent entrepreneurship continues. This pattern appears to be accompanied, however, by increased stability, professionalism, and the use of media for self-promotion (Hardy 1982a). Artists are regularly approached for large-scale projects by persons with few or no previous tattoos and who return for additional work (Crawford 1974). Major demographic shifts have brought in a greater number of females and generally older, better educated, more affluent, and more artistically sophisticated clients.[8]

The Emergence of the Avant-Garde

The foregoing contrasts the essentially conservative "mainstream" with more innovative "renaissance" tattooing. Avant-garde tattooing has, however, also changed the mainstream in significant ways: sterilization of equipment is now practically ubiquitous; access to information, equipment, and supplies is easier; the traditional and conventional repertoire of designs has been expanded to include Japanese, fineline, and "tribal" styles; and the client-pool has been diversified.[9]

One way of comprehending the changes that have taken place in tattoo since 1960 is to trace the careers and assess the contributions of a small number of key artists, viewed against the social,

economic, and political panorama of the times. The stage for these developments may have been set, paradoxically, by the prohibition or rigorous restriction of tattoo which occurred in many areas of the United States during the 1950s. In 1952, tattoo was outlawed in Norfolk, Virginia, which, by virtue of its concentration of military and merchant marine activity, had functioned as a primary center. Shortly thereafter, Detroit, Little Rock, New York City, and the entire state of Massachusetts followed suit. Illinois raised the age limit for tattoo from eighteen to twenty-one in 1963. In 1970, Florida prohibited tattooing except under medical supervision.[10]

The 1950s saw a major influx of tattooists to metropolitan areas in northern and southern California as well as to Hawaii and the Pacific Northwest (Govenar 1981:xxiv). This shift was probably a response to the population expansion and prosperity brought on by military and defense/industrial growth along the West Coast during and after World War II and the Korean War. The relaxed social conventions associated with the "California lifestyle" provided a congenial environment for tattoo, as did the rising tide of popular interest in Oceanic and Asian—particularly Japanese—culture. Tattoos from this period were, however, of the International Folk Style.

Two seminal figures working the 1950s and 1960s may be said to have reoriented, or even reinvented, the medium and to have launched what is here called the Tattoo Renaissance. Phil Sparrow (Samuel M. Steward) was wholly original in his approach to the performance of his art as well as in his relationships with his clients. Sailor Jerry (Norman Keith) Collins of Honolulu revolutionized the medium in terms of the nature and character of the designs and the use of color. He also helped to professionalize the image of tattoo by advocating sterile procedures and improved hygiene. He expanded his clientele by using the mails and through international travel (Hardy 1982a).

The importance of these two artists is evident from the biographies of two men who have been at the center of the evolution of the medium during the past fifteen years: Cliff Raven and Ed Hardy.

Cliff Raven

Cliff Raven may be said to embody in his own life and art the westward trend of advanced tattoo in the United States.[11] Raven was born in 1932 in East Chicago, Indiana. At age fifteen, drawing upon information culled from an encyclopedia description of tattoo, he used sewing needles and India ink to tattoo a winged wheel on his arm "because that's what a tattoo ought to look like." He received the B.A. in Fine Arts from Indiana University in 1957, following a two and a half year hiatus (1953–1955) in his education spent "living the Bohemian life" in New York City and Milwaukee. (During that period Raven recalls declining to enter a tattoo shop with a friend because he, Raven, "wanted nothing to do with such trashy stuff.") Following his graduation, Raven returned to Chicago and worked in a commercial art studio for four years, freelancing thereafter until he became a full-time tattooist.

In Chicago, Raven met Phil Sparrow (Morse 1977:14,44,50). He was impressed with the uniqueness of Sparrow's shop and in July of 1958 obtained a Sparrow tattoo—a butterfly—on his upper arm. Raven received additional tattoos from Sparrow over the next few years along with some casual instruction in the medium. In return, he passed out Sparrow's business cards to sailors from the Great Lakes Naval Training Staton as they got off the train in downtown Chicago. During this time, Raven began to assemble his own tattooing kit with supplies obtained from Sparrow and Milt Zeis, then a supplier in the Chicago area. Zeis recommended Raven as a tattoo artist to the owners of an amusement arcade/tattoo studio in Rantoul, Illinois, near Chanute Air Force Base. Raven worked there on weekends for about a year until 1963, when Illinois changed the age limit for tattoo from eighteen to twenty-one. This seemed to signal the end of any viable tattoo business, so all but one of the many shops along South State Street in Chicago closed. Sparrow invited Raven to join him in a new venture in Milwaukee, Wisconsin, also a popular liberty town. Together they ran the Milwaukee shop on weekends for two years. Their nearest tattoo neighbor was Amund Dietzel, who was one of Sparrow's teachers (Steward 1981:80; Morse 1977:50).

Eventually the hotel in which the Milwaukee shop was located was torn down. Sparrow was then inclined to move to Paris, but realized the difficulties involved in establishing a tattoo studio there. For this reason, in 1965 he decided to go instead to Oakland, California. Following Sparrow's departure, Raven felt ethically free to reopen in Chicago and established the Old Town Tattoo Salon at 1953 North Larrabee. Old Town Tattoo was an on-demand or "buzzer" operation, with Raven willing to undertake traditional or innovative tattoos—"anything the client asked for." His only competition was the last remaining South

State Street shop, then being run by Tatts Thomas (Zeis 1968:8–9; Aurre 1983:14; Morse 1977:6). Thomas soon left to work with Amund Dietzel in Milwaukee, and the artist who replaced him died after one year, leaving Raven with the only tattoo shop in Chicago.

In 1965, Milwaukee banned tattoo. Dietzel retired and Thomas (with Greg May) established a new shop in Kenosha, Wisconsin, which lasted until tattoo was outlawed there in 1969. When, in 1966–1967, urban renewal claimed his building in Chicago, Raven moved to larger quarters at 900 West Belmont, first calling his new establishment Cliff Raven Tattooing and later, The Chicago Tattooing Company. He was by then tattooing full-time. Tatts Thomas frequently visited Raven on his days off from the Kenosha shop "like many old-timers, determined to be helpful." The hippie movement was at its peak, and the Chicago Convention of the Democratic Party was about to take place. Raven characterizes this period of transition in his own life, in the field of tattoo, and in the social and cultural life of the United States as "the end of an era." From Kenosha, May and Thomas had moved to Racine, Wisconsin, but a ban on tattoo was promulgated while they were preparing to open their shop. May then moved to Lake Geneva, Wisconsin, a popular summer resort. Thomas, tired of commuting and seriously ill, went to work at the Chicago Tattooing Company with Raven. He died shortly thereafter, just before his 69th birthday.[12] Dietzel died, in his 80s, a few years later.

At the Chicago Tattooing Company, Raven was addressing the entire spectrum of work of which he was aware, from traditional to custom. Although claiming no special talent or ability, he feels that his work at the time was redeemed by reasonable drawing skills, a concern with hygiene, and the light touch that Phil Sparrow had taught him. He aspired to master the style developed by August Coleman as interpreted by Huck Spaulding and Paul Rogers: clear lines, regular, modulated shading, and consistent, even applications of color.[13] The bulk of the demand at the Chicago Tattooing Company was for standard 'flash' designs executed for "ordinary people—Mexican factory workers, Polish gas-station attendants, 99.9% male." Bored and frustrated by the repetitious work, Raven was ready for "the new order" as embodied in the work of Sailor Jerry Collins.

During visits to Milwaukee, Raven had seen Deitzel's photographs of Collins' work and was impressed with their lush, brightly colored, over-lapping compositions. The fresh Oriental feel of the designs contrasted sharply with the standardized execution and separation of motifs typical of traditional American tattoo. Raven sees these works as the precursors of the Tattoo Renaissance. Although Phil Sparrow had introduced him to Japanese tattoo (in the form of poor quality black-and-white illustrations in old books), Raven had felt no particular affinity for what he saw. Collins' work, on the other hand, struck him as attractive, surprising, even disorienting, and Raven decided to visit him to find out more about it.[14]

Also around 1967, Raven saw a small dragon —colorful, with fine lines and delicate shading— that had been tattooed by Zeke Owens in Seattle (Morse 1977:27). Owens, Raven learned, had worked in Guam with Johnny Walker and subsequently in Honolulu near Collins; Walker, in turn, later moved to Honolulu and actually worked with Collins. Raven came to regard Walker as the "quintessential machine man," aware of the primary importance of a properly tuned instrument for producing a high-quality tattoo. He believes Walker imparted this mechanical skill to Collins at the same time that Collins was absorbing Oriental design concepts through correspondence and as an arrangement to trade supplies in exchange for designs with Kazuo Oguri, an outstanding Japanese tattooist. Owens had been tattooing in Honolulu during the time this convergence was taking place, and Raven believes his work was also influenced.

Through photographs Raven also developed an interest in the work of Don Nolan, who was then working with Bert Grimm in Long Beach, California.[15] Nolan had previously worked with his step-brother, Tom Yeomans ("Hong Kong Tommy"), then employed in another Pike studio. At that time, Raven considered Nolan to be the superior designer, Yeomans the more skilled technician. They sometimes collaborated on Japanese-style tattoos, which represented an important procedural innovation.

By 1969 the West Coast—from San Diego to Los Angeles, San Francisco, Portland and Seattle, and including Honolulu—had become the nucleus of the tattoo renaissance. This revolution drew upon designs originated, for the most part, by Kazuo Oguri in Japan and transmitted into the underground network by Sailor Jerry Collins. Raven was still based in Chicago, but his ties to the Midwest were beginning to loosen; he was making long (two weeks to two months) and frequent working trips to New York City. Compared to Chicago, New York offered a larger number of clients who

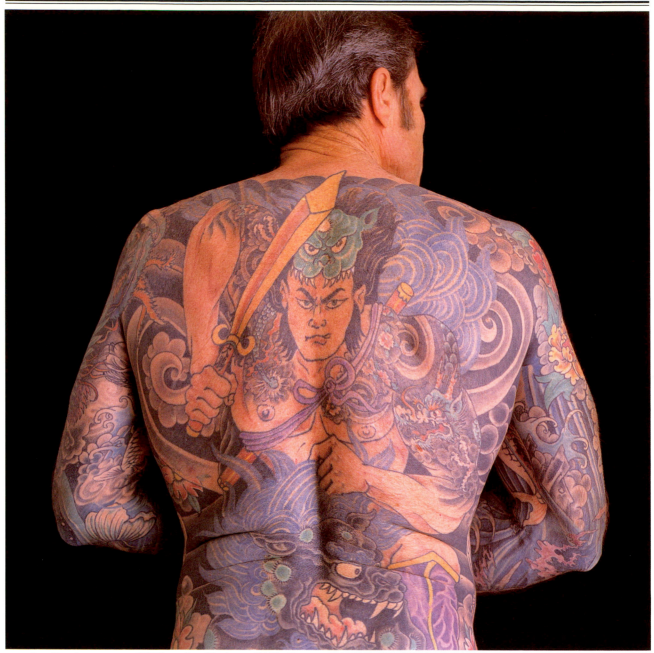

3. *Back tattoo ("Warrior") by Cliff Raven, 1976–77. Photograph by Richard Todd, 1986.*

were more artistically and technically demanding. Although Raven's design repertoire was shifting toward the new, reinterpreted Japanese style, he was aware of his limitations in executing the dragons, flowers, and other motifs involved.

In 1969 Raven made a tattoo tour of Vancouver, Seattle, Portland, Tacoma, and San Francisco. In 1970 he traveled to Honolulu and Southern California. His objective was to experience firsthand work he had only seen in photographs or heard about and to meet the artists responsible: Zeke Owens, Don Nolan, Hong Kong Tommy, Lyle

Tuttle, and especially Sailor Jerry Collins. At Lyle Tuttle's shop in San Francisco (the tattoo center of the San Francisco hippie movement), Raven met Davy Jones, who was exploring the large-scale black, geometric tattoo style of Samoa, an initiative later identified with Tuttle.[16] In Honolulu, Raven spent several days with Sailor Jerry Collins; Collins suggested that he seek out a promising young tattooist, then working for Doc Webb in San Diego, named Ed Hardy. Raven did so, and they met in early 1970 for what he remembers as a very intense exchange of tattoo experiences,

ideas, and information. Between 1968 and 1970, Raven had attempted some custom full-back compositions, but did not feel technically adequate; thereafter, he refered prospects for large-scale Japanese-style back-work to Hardy.

In 1975 Raven produced a set of commercial flash—a compendium of traditional, Japanese, late hippie, and black designs—which made a substantial contribution to his reputation in the field. In 1976 in Houston, he was named ''Tattoo Artist of the Year'' by the first world convention of the North American Tattoo Club. That same year, he decided to leave Chicago. He first considered establishing himself in New York, but the harsh climate and unappealing social and professional circumstances he would face—tattoo was still illegal—turned him toward the West Coast. While not his first choice, and with some misgivings about smog and the ''Hollywood'' lifestyle, Raven decided that Los Angeles offered the clearest opportunities for the venture he had in mind. When, in early 1977, Lyle Tuttle decided to give up his Southern California branch shop at 8418 Sunset Boulevard, Raven bought the lease. (In 1978 Don Nolan started work on Raven's own back tattoo.)

As the Sunset Strip shop became well established, Raven increasingly left the work there to associated artists and (in 1979) shifted his own appointments to a private studio at 1611 North Cherokee in Hollywood. In 1980 he opened ''Raven's Tattoo Works'' at 451 9th Street, in San Francisco, in what he thought would be a more congenial personal and professional environment. Commuting proved exhausting, however, and the arrangement was terminated when the lease was lost in December of 1982. In January 1984, Raven opened a studio in 29 Palms, California, oriented toward more traditional work, and in January 1985, he closed his Cherokee studio. During August 1985 he began to divide his time between 29 Palms and the Sunset Strip studio but, early in 1986, he sold the Sunset Strip studio to Robert Benedetti, a long-time associate. He spent the summer of 1986 tattooing in Chicago, escaping the heat of 29 Palms, which he now considers ''home.'' In 29 Palms, he tattoos entirely by appointment and pursues other art-related activities in a ''cabin'' which has no distinguishing marks which would identify it as a tattoo studio.

During his first few years in Southern California, Raven produced a considerable volume of large-scale, freehand, Japanese-style custom work, including his first mature full-back compositions (Figs. 3,4,5). He achieved his objective of reaching a sophisticated clientele and expanding his na-

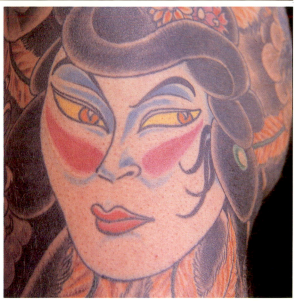

4. *Torso tattoo (Female mask) by Cliff Raven, 1979–80. Photograph by Richard Todd, 1986.*

5. *Back tattoo (Dragon) by Cliff Raven, 1978. Photograph by Francoise Fried, 1979.*

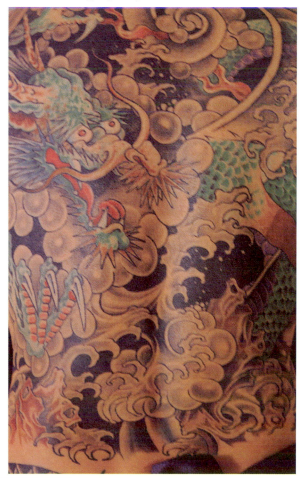

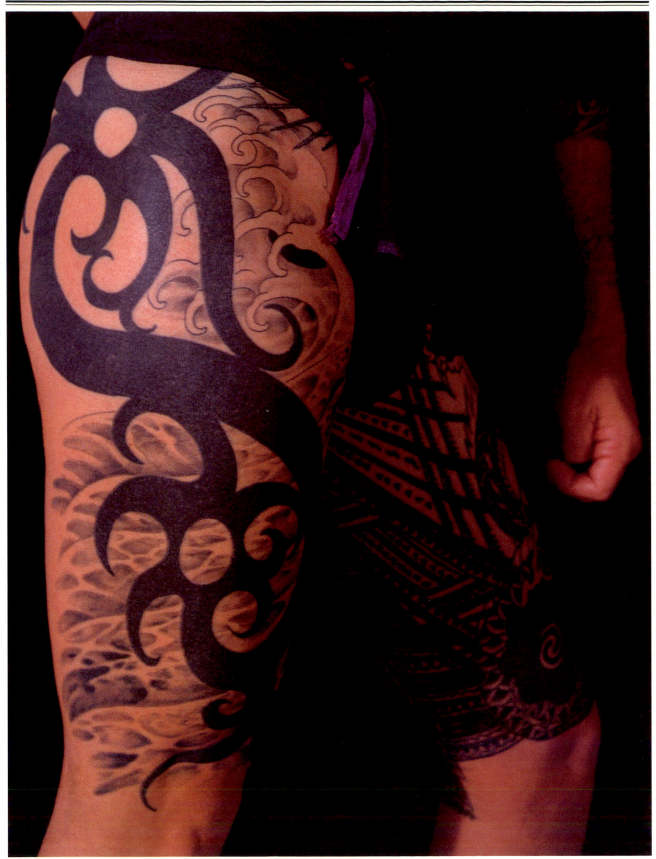

6. *Thigh tattoo (Indonesian design) by Cliff Raven, 1981–82. Photograph by Frances Farrell, 1985.*

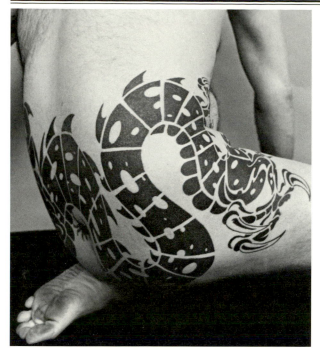

7. *Buttocks tattoo (Dragon, blackwork) by Cliff Raven, 1983–84. Photograph by Mark I. Chester, 1986.*

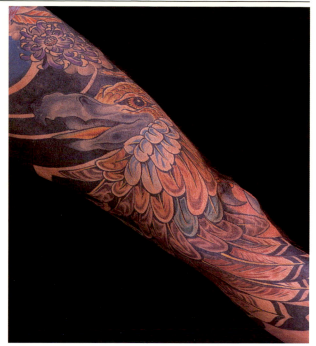

8. *Leg tattoo (Eagle) by Cliff Raven, 1982–83. Photograph by Richard Todd, 1986.*

tional and international reputation. This liberation from the constraints of repetitious, standardized designs gave him an opportunity to develop his style and technique and to consider new designs and imagery. In particular, he had long been interested in exploring monochromatic (i.e., black) "primitive" traditions and in developing a nonethnic black style (Figs. 6,7). During the mid- to late 1970s, the expanded palette that Sailor Jerry had bequeathed was dominating everyone's work. As he gained experience, however, Raven became disenchanted with strong color as a design element, in part because it increased the risk of an allergic reaction. Moreover, the more stable and subtle carbon- and iron oxide-based pigments, together with titanium dioxide for white, went into the skin more easily. Raven experimented with limiting his palette to these pigments but found the results drab and monotonous. During the mid-1980s, he is exploring two directions: monochromatic gray-and-black (including "pretechnological") designs and the full range of available colors, muted with iron oxide and other pigments (Figs. 8–10; Hardy 1982a:6; Raven 1982:10–11). In 1983 he began production of a second set of commercial flash. While these new designs include some completely new conceptions, emphasis is on reinterpreting old themes rendered in traditional style, requiring only an "average" level of skill.

Ed Hardy

If Raven represents the immigrant to California—the global center of the Tattoo Renaissance—Hardy may be said to embody its native essence.[17] He was born in 1945, and his childhood was spent in Corona del Mar, approximately twenty miles south of Long Beach. The first tattoos Hardy remembers (he was about ten years of age) were World War II Navy insignias on the father of a friend. They inspired him to draw designs with colored pencils on the skins of neighborhood children. Later in 1955–56, when he learned of the tattoo shops on the Pike in Long Beach, he began making regular visits there by bus. As he was considerably underage, most shop owners only allowed him to watch through the windows, but Bert Grimm invited him in, answered his questions, and let him do small chores. Hardy made sketches from Grimm's design sheets and developed his own versions of them. He ran a "make-believe" tattoo studio in a spare room of his house for approximately two years and wrote a history of the medium. Determined to become a professional tattooist, he acquired catalogues of equipment and supplies and planned for the future. He did some experimental tattoos by hand with sewing needles and ink, but recognized the need for professional equipment. Bert Grimm told him that he would take him on as an apprentice when he

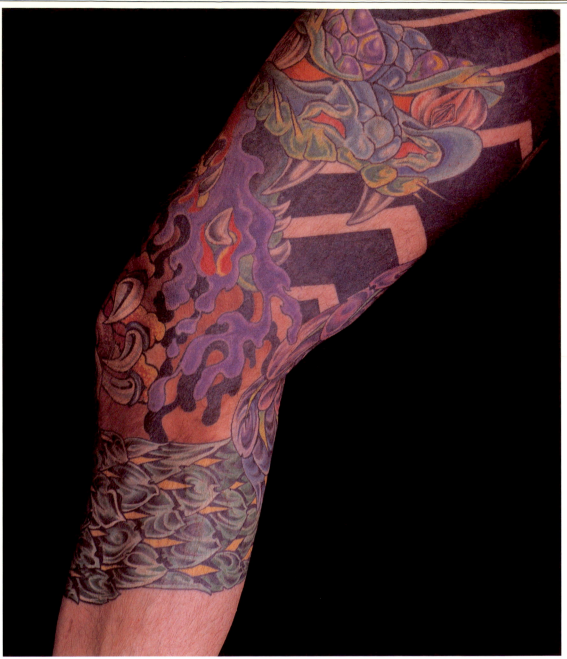

9. Leg tattoo (Serpent) by Cliff Raven, 1983–84. Photograph by Richard Todd, 1986.

turned fifteen, but in the interim, Hardy's interests shifted to airbrushing sweatshirts and detailing automobiles.

In high school, Hardy became oriented toward a serious art career. By the time he graduated, he was showing drawings, watercolors, and prints in galleries on La Cienega Boulevard in Los Angeles and participating in group exhibitions that were national in scope. He enrolled in the San Francisco Art Institute with the B.F.A. in printmaking as his objective. In the early 1960s, he became interested in Pop Art. His involvement with tattoo

was rekindled when, in 1966, he was asked to speak at the San Francisco Art Institute on tattoo as an American art form and its relationship to Pop Art. The talk was well received and, when his fellow students asked whether he had any tattoos, he decided it was time to get some. He first sought out Phil Sparrow's studio in Oakland, having heard of Sparrow through Milt Zeis' tattoo course, but found it closed that day. Instead, he got a rose on one arm from Ray Steiner in Frisco Bob's shop and the next night another tattoo on the other arm from Oakland Jake. The following day he visited

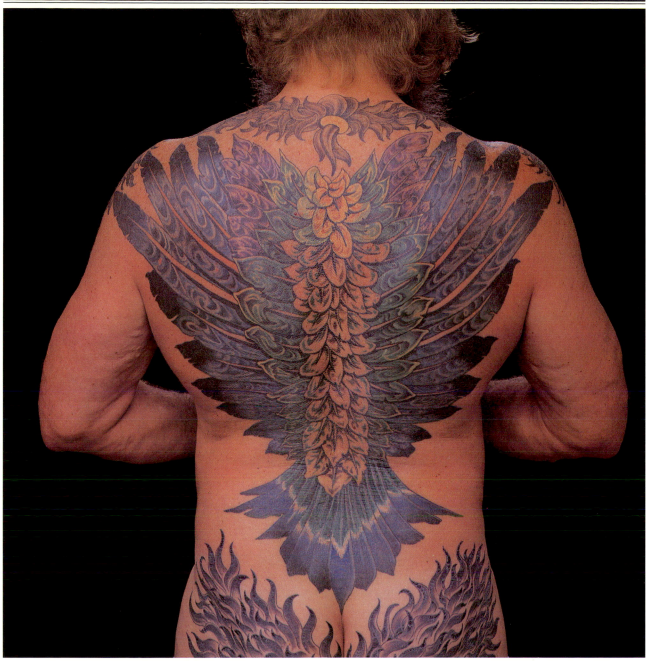

10. Back tattoo (Feather design) by Cliff Raven, 1987. Photograph by Richard Todd, 1987.

Sparrow's shop and was impressed with how much its decor differed from conventional tattoo shops: there was classical music, a dramatic red-and-black color scheme, and the design sheets were hung to look like "real" art. During the several hours Hardy spent with Sparrow, he had his first exposure to Japanese-style tattoo. Although Hardy had studied Japanese art at the Art Institute, and his mentor, Gordon Cook, was deeply influenced by Asian art and philosophy, he had never before seen Japanese tattoo.

After this first meeting, Hardy began to visit Sparrow regularly for tattoos and information. He recalls being fascinated by the possibilities of fusing the world of fine art with "the dark world of tattoo." Sparrow was an appropriate and effective mentor in this regard: he had been a member of Gertrude Stein's circle in Paris and had taught English literature at Loyola University in Chicago before abandoning the academic life to become a tattooist (Steward 1981:79; Morse 1977:50). Hardy decided to commit himself to tattoo as a career—in particular, to explore the creative possibilities of large-scale, Japanese-style work—and asked

Sparrow to instruct him. Sparrow declined, urging Hardy to pursue a conventional career in studio printmaking, exhibition, and teaching. Hardy, however, was determined to learn tattoo with or without Sparrow's help, and Sparrow ultimately relented in the face of such resolve. After learning the basics, Hardy's first tattoo—as is traditional—was on himself: a rose with his wife's portrait in the center of his left ankle. Shortly thereafter, he did a swallow for a friend, and he recalls his first unusual tattoo: a black coffee pot to cover an unwanted Marine design.

Hardy estimates that he did about fifty tattoos for friends at the Art Institute during the winter and spring of 1966–1967, but he supported himself by working for the Postal Service. Although he wished eventually to establish himself as a tattooist in the San Francisco area, he was unwilling to begin his career there, knowing that a novice's reputation and mistakes are difficult to outgrow and that it was important first to develop his own distinctive style.

Hardy considers Bert Grimm's in Long Beach to have been the most professional and technically advanced studio of the late 1960s, turning out high quality designs and a clean product; it was there that Hardy learned about sterile procedures. During visits to Grimm's shop in 1967 to obtain tattoos and stay in touch with "the scene," Hardy met Tom Yeomans, Grimm's premier artist. He was especially impressed with Yeoman's smooth, bright colors. He also recalls frequently hearing about artists doing unusual work, but rarely seeing any examples. Yeomans had a dragon outlined by Sailor Jerry Collins on his chest. He also had three photographs of Collins' earliest quasi-Japanese work that combined Oriental vigor and directness with American detail and vibrant color. Hardy realized that, in Collins, he had found his artistic mentor. On the basis of his encounter with Yeomans, Hardy wrote to Collins seeking to establish a relationship, but he received no reply. (He later learned that Collins and Yeomans had not parted on good terms.)

When he returned to San Francisco, Hardy's friends at the Art Institute suggested Vancouver, British Columbia as an ideal place to begin a career. After a reconnaissance in the summer of 1967, Hardy moved his family to Vancouver in April 1968 (following his graduation) and opened Dragon Tattoo on Carrall Street. The four traditional shops already in Vancouver presented no competition for the large-scale Japanese derived designs and extensive use of color in which Hardy intended to specialize. By the following summer,

Dragon Tattoo was succeeding, but Hardy was beginning to suspect that he had overestimated his ability to provide basic American-style tattoo, much less the innovative work which was his objective, while also running a studio. He began to make regular trips to Seattle to meet with Zeke Owens, about whom Phil Sparrow had told him. Owens, then twenty-eight years old, had been born in California. He had a Japanese stepfather and a long-standing interest in Japanese culture. He had worked for Bert Grimm (1963–1966) before Tom Yeomans and had also worked in Honolulu where he met Sailor Jerry. Owens' design-sheets were the best Hardy had seen, and Owens also had photographs of Sailor Jerry's recent work. Hardy begged Owens for a job, even offering to give him the Vancouver shop. In the end, Owens took him on and Hardy closed his Vancouver operation. Illness and insufficient income during the winter of 1968–1969 compelled Hardy to return to Southern California, however. He sought employment at Bert Grimm's and elsewhere on the Pike, but there were no openings. In January 1969, Tom Yeomans helped him get a job at Doc Webb's in San Diego, where he remained until January 1971, traveling regularly to Long Beach to learn and to get more tattoos (Hardy 1986; Morse 1977:82). During this time Hardy met Don Nolan, Yeomans' stepbrother and collaborator on large-scale custom body-work. Nolan, also working on the Pike, drew the designs, Yeomans developed the outlines, and Nolan put in the color. In January 1971, Hardy decided to open his own shop in San Diego, Ichiban Tattoos, at 963 Columbia Street, on the edge of Sailortown near the servicemen's YMCA. He attempted to persuade Zeke Owens to join him in this venture but was unsuccessful.

Hardy had again written Sailor Jerry Collins and this time succeeded in establishing what amounted to an apprenticeship by correspondence. Hardy visited Collins in Honolulu for one week in the fall in 1969 and again in the spring of 1972 when he spent a congenial month doing large-scale custom work in Collins' shop (Morse 1977:48,90; Hardy 1982a). Although Collins was doing a large volume of standard Navy tattoos, he realized that the future lay with custom work and that adequate photographic documentation was essential in reaching prospective clients. A San Diego physician who had received extensive body-work from Collins was serving as a conduit for photographs and news of Collins' projects for a nucleus of afficionados in San Diego and beyond —particularly in New York City, where a pool of prospects for large-scale, advanced designs was

emerging. Collins had long carried on a world-wide tattoo correspondence, and during the 1960s he regularly traded pigments for designs with a number of Japanese tattooists—notably Horiyoshi and Horisada of Tokyo and Horihide (Kazuo Oguri) of Gifu City (Hardy 1982a).

Hardy decided to open his own shop in Honolulu for custom work, in order to further explore the Japanese style; it would also be a stepping-stone for actual visits to Japan. He returned to San Diego to begin implementing this plan, but his first visit to New York—three weeks during the summer of 1972—intervened. There, for the first time, he encountered clients receptive to his most advanced concepts. He also met (and tattooed) Mike Malone, a professional photographer who was learning to tattoo and had helped organize the Museum of American Folk Art tattoo exhibition in New York in 1971. Malone had previously contacted Hardy regarding an article on tattoo he was working on for *Esquire*. In September 1972, when Hardy reluctantly returned to Ichiban Tattoos in San Diego and the predominantly military trade he had built up, Malone came along with him as a partner.

During December 1972, Kazuo Oguri intended to visit the United States, but only got as far as Hawaii, where he stayed three days. Hardy, Malone, and Malone's wife, Cathy, flew to Honolulu to meet him. Des Connoly, from Australia (one of Sailor Jerry's "pen pals") had also flown in for the occasion, and Oguri executed a number of souvenir tattoos by hand as well as some larger works by machine for the group. Oguri invited Hardy to work with him in Japan, and they agreed that he would come the following summer. Malone felt the need (as had Hardy in Vancouver) to polish his skills under the tutelage of a master so, in January 1973, he joined Zeke Owens in San Diego. Hardy continued with Ichiban Tattoos until May 1973, painting Japanese designs in preparation for his trip. He then closed and dismantled the shop to preclude the possibility of competition with Owens and Malone. Oguri visited friends on the United States mainland in June 1973, after which he and Hardy flew to Tokyo. During the summer and fall of 1973, Hardy did color and shading on Oguri's outlines, as well as a few complete (traditional Japanese) designs. Hardy had intended to remain in Japan indefinitely. However, in spite of Oguri's acceptance and support, culture shock and the necessity that he subordinate his artistic identity to Oguri's style caused Hardy to return to the United States in November of 1973.

Sailor Jerry had died shortly after Hardy's departure for Japan, and his widow offered to sell Hardy the Honolulu shop. Then unwilling to leave Japan, he declined the offer, whereupon Mike Malone bought the Collins shop and moved to Honolulu in July 1973. Following his return to the United States, Hardy decided it was finally time to establish himself in San Francisco. He took a job with Zeke Owens in San Diego from November 1973 until March 1974 in order to finance this undertaking, and then opened his Realistic Tattoo Studio at 2535 Van Ness in May of 1974. Hardy's plan was to fuse the Japanese model—a low-profile location where original, one-of-a-kind tattoos were executed by appointment—with the interpretive possibilities offered by an American clientele. In his own words, he was determined

> to involve the client to a greater degree in the decision of what would be tattooed, and how. To my knowledge, no one anywhere had taken it to that extreme. Admittedly, my personal bias was and is toward Asian imagery and philosophy; but part of the true assumption of those qualities manifested in the Eastern cultures is to pierce apparent form and subject and integrate the vaster rhythms "behind it all"—i.e., not be stuck on one style or promote an exclusive repertoire. To me this was a real gamble; there were no precedents to follow (pc:12 August 1984).

From spring of 1974 until January 1977, Hardy worked alone at Realistic and tattooed for one month of each year at Sailor Jerry's (now Mike Malone's) Honolulu shop. In 1975–1976 he completed his "squid" backpiece, which combined Japanese detailing with American scale and color and his "Bicentennial" backpiece, which was essentially an updated homage to American-style tattoo (Figs. 11,12,13; Morse 1977:30–31). In January 1977, Hardy and Malone took a booth at the Reno convention of the North American Tattoo Club. There they met Jack Rudy and Charlie Cartwright, who were then developing (at Good Time Charlie's Tattooland on Whittier Boulevard in East Los Angeles) a fineline, monochromatic style and distinctive imagery derived from the Chicano/Latin prison/gang tradition (see Govenar). Rudy and Cartwright had at that time been working in East L.A. for approximately one year. Hardy and Malone judged Good Time Charlie's to be the first new approach to the medium since the introduction of Japanese designs; by the time of the Reno convention "everyone" was doing Japanese-style work.

In Reno, Hardy also encountered Bob Roberts, then working for Cliff Raven, but eager to leave Los Angeles. (Hardy had tattooed Roberts'

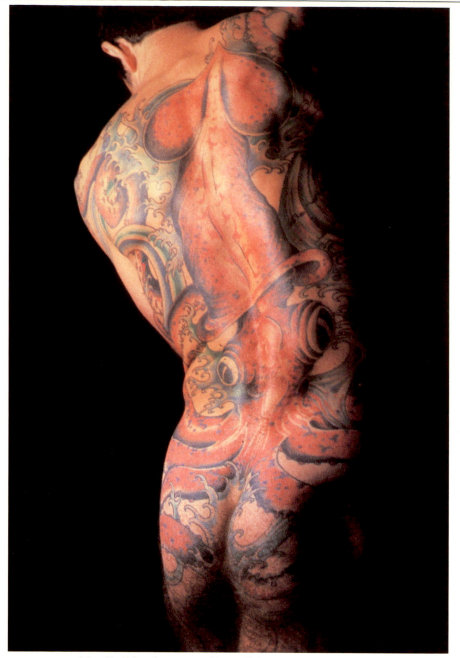

11. Full-body tattoo (Squid) by Ed Hardy, 1975.
Photograph by Francoise Fried, 1979.

chest in the fall of 1976.) Impressed by his style and technique—then also predominantly oriented toward Latin/fineline—Hardy invited Roberts to join him at Realistic; Roberts did so in January 1977. They decided to open a satellite shop in a Latin neighborhood of San Francisco to expand the appeal of Realistic which had previously depended on Hardy's reputation for advanced Japanese-style work. In the fall of 1977, Hardy leased a large space in the Mission District for this purpose, calling the new shop Tattoo City. Tattoo City was staffed by Roberts, Jamie Summers (who, with her husband Bob Rasmussen, had been a student at the Art Institute and was one of Hardy's links to the "straight" art world of San Francisco), and Chuck Eldridge, a longtime tattoo enthusiast. Tattoo City lasted until June 1978, when the building burned down, after which Roberts and Summers joined Hardy at Realistic.

The years 1976–1977 were pivotal in the evolution of Hardy's tattoo design consciousness. In 1976, after seeing the work of Masami Teraoka, he

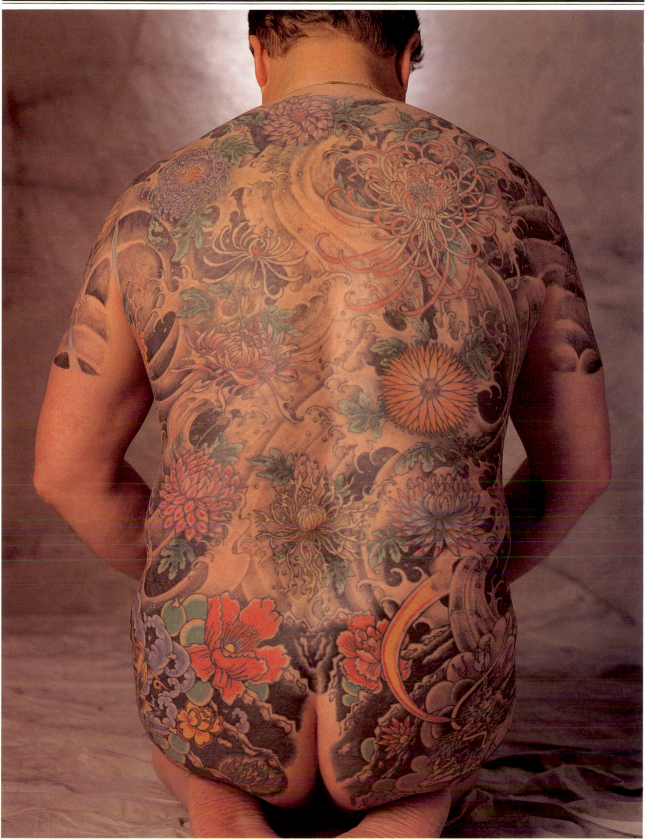

*12. Back tattoo (Japanese flower and water designs)
by Ed Hardy, 1978. Photograph by Richard Todd, 1987.*

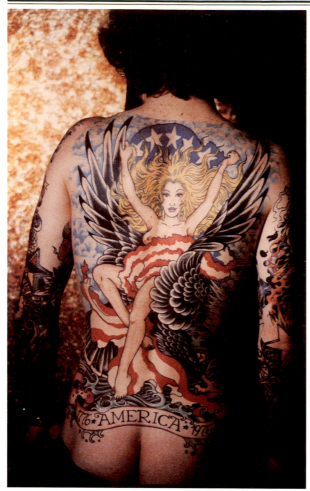

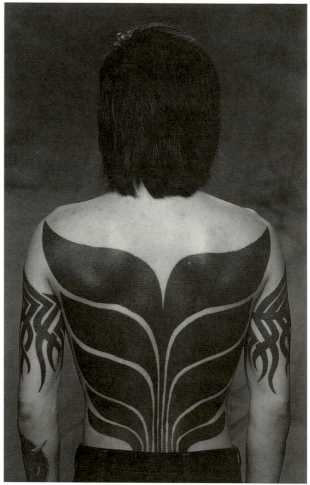

13. *"Bicentennial Backpiece" tattoo by Ed Hardy, 1976. Photograph by Jan Stussy, 1979.*

14. *Shoulder tattoo (Watery skull, blackwork) by Ed Hardy, 1979. Photograph by Richard Todd, 1986.*

15. *Back and arm tattoos (Micronesian, Indonesian designs) by Ed Hardy, right arm, 1978; left arm, 1987; back piece (based on Central Carolines [Micronesia] designs), 1982–83. Photograph by Richard Todd, 1987.*

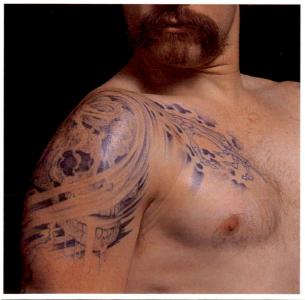

realized the potential for expanding and updating the imagery and techniques of *ukiyo-e*, the foundation of traditional Japanese tattoo (Link 1979). As a result of his contact with Roberts and Rudy, he also expanded into Latin/fineline, returning to the discipline of his previous involvement with monochromatic drawing and printmaking (Fig. 14). Finally, in 1978, Hardy came under the influence of Leo Zulueta's passion for Indonesian design and undertook his first major all-black "tribal" work (Fig. 15).

Shortly after the opening of Tattoo City, Cartwright left tattooing and Good Time Charlie's for religious reasons. Late in 1977, with the objective of sustaining—and participating in—the style that the shop represented, Hardy bought Good Time Charlie's lease, and Rudy was joined by Fernando ("Freddy") Negrete, a highly accomplished Chi-

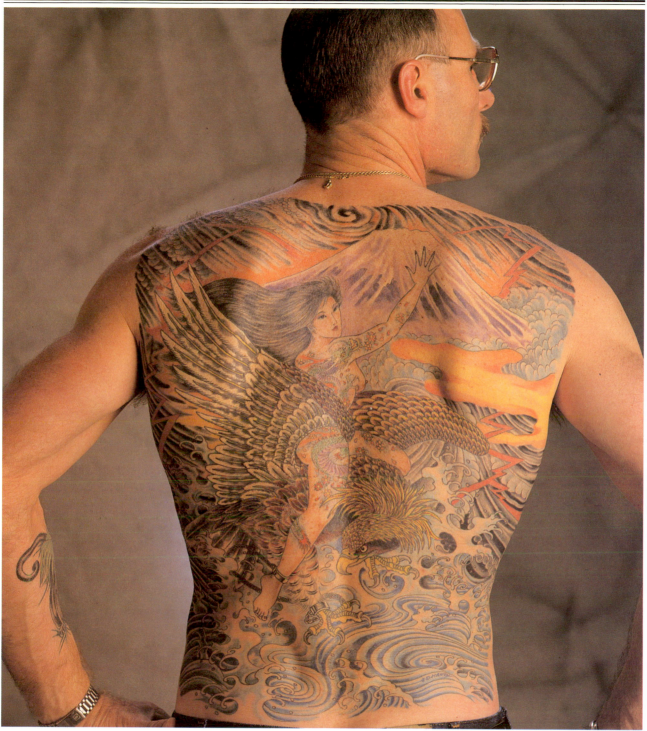

16. Back tattoo by Ed Hardy, 1985–6. Photograph by Richard Todd, 1987.

cano artist. However, their building was bought by another tattooist and Rudy and Negrete were evicted. In the spring of 1978, Hardy purchased and renovated a building at 6144 E. Whittier Boulevard, and Good Time Charlie's Tattooland repoened in its new locattion on 13 May 1978 (pc:Jack Rudy 1984). (Negrete won the "Outstand-

ing Tattooist" award at the Sacramento Convention of the North American Tattoo Club in 1980 but, within a year, also abandoned the field for religious reasons.)

In October 1979, Hardy took the first of a series of annual working trips to England. He spent four or five weeks as artist-in-residence at the

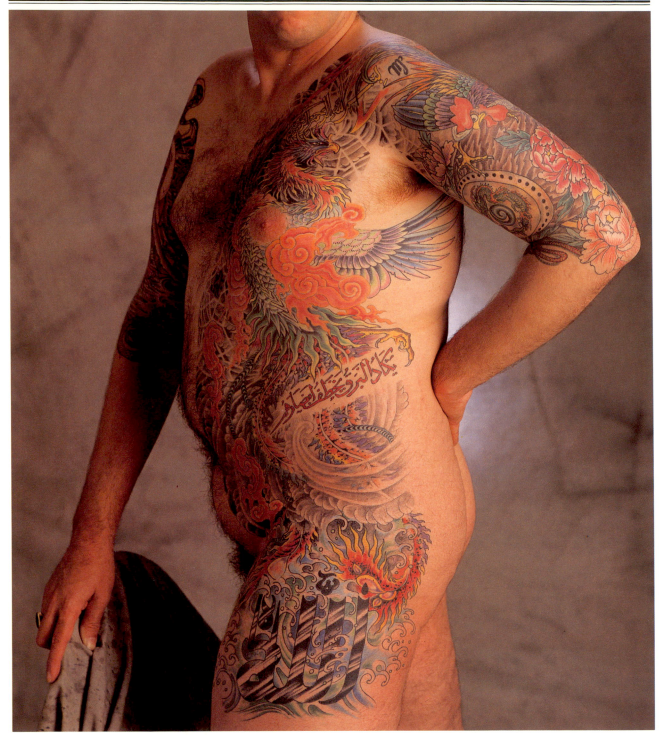

17. Torso tattoo by Ed Hardy, 1986. Photograph by Richard Todd, 1987.

studio of Ron Ackers in Portsmouth and carried out additional work in London at the studio of Dennis Cockell, who shared his enthusiasm for the cross-fertilization of Asian and Western imagery. During this trip Hardy met several other U.K. artists and initiated a professional dialogue which still continues.

Roberts left San Francisco for New York City late in 1979, and Summers established her own practice (based on strikingly original custom work) in San Francisco in 1980. Hardy was once again solo at Realistic, making periodic working trips to Hawaii and the East Coast. He took a sabbatical during January and February of 1982 to research

a book relating his work and ideas to the larger spectrum of tattoo history and culture. The book was put into abeyance, however, when, in March 1982, Ernie Carafa, a New Jersey tattooist and supplier, proposed that they collaborate on a convention oriented specifically toward the artistic potential of tattoo. Hardy, Carafa, and Ed Nolte (a San Francisco printer who had for several years been producing T-shirts with artwork by various tattooists) incorporated themselves as Triple-E Productions and staged Tattoo Expo on the Queen Mary in Long Beach early in November 1982. They used this occasion to launch another joint project, a lavishly illustrated journal called *Tattootime*, intended to "document the world of tattoo culture."

Tattoo Expo provided Hardy with a reason and opportunity finally to contact the distinguished Japanese tattoo artist Horiyoshi whom he had long admired. A delegation from Horiyoshi's studio attended the convention, and after a hiatus of ten years, Hardy returned to Japan for three weeks in October of 1983 to receive a tattoo from the master. He also executed a number of American-style tattoos for Japanese patrons, mostly "Rockabilly style for kids into the 50s scene." On his way back to San Francisco from Japan, he tattooed briefly in Guam and Palau in Micronesia. Late in 1984, Hardy turned over his Realistic location to Dan Thome, Greg Irons, and Bill Salmons, moving his own practice to a private studio apartment in downtown San Francisco in March 1985. Late in 1986, he shifted his base of operations to Honolulu, commuting to San Francisco for one week per month. He now works entirely by appointment and limits his production to Japanese-style work (Figs. 16,17).

Largely due to the inspiration of Horiyoshi, he aims to be less categorical, less exclusive in his enthusiasms, less oriented toward "a look" than toward substantive understanding of a system— to struggle, in effect, against his own instinctive eclecticism (Fig. 18). He seeks a personal idiom of expression, a compounded fusion of his experiences that will translate into an appropriate style and imagery for future clients.

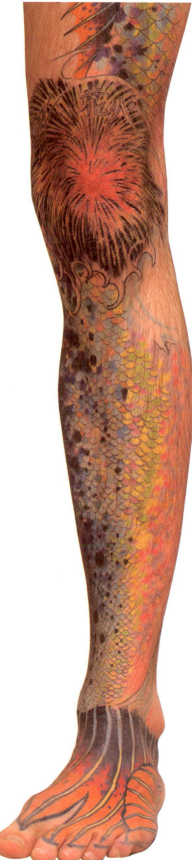

18. *Leg tattoo (Salmon) by Ed Hardy, 1987. Photograph by Richard Todd, 1987.*

The Tattoo Renaissance in Context

Viewed from the perspective of the biographies of Raven and Hardy, the foregoing narratives seem to support delineation of a succession of generations of advanced tattoo artists in the United States. In order to complete the picture, however, the contributions of several artists who have not figured in the discussion so far, or have done so only peripherally, must be assessed.[18] The first "Renaissance" generation comprises:

	Born	Began Tattooing
Lyle Tuttle	1931	1949
Cliff Raven	1932	1962
Don Nolan	1938	1955
Zeke Owens[19]	1940	1957
Spider Webb	1944	1958
Ed Hardy	1945	1966

The second "Renaissance" generation includes:[20]

Bob Roberts	1946	1973
Jamie Summers	1948	1977 (d. 1983)
Jack Rudy	1954	1975

Both Raven and Hardy credited Don Nolan with introducing them to the creative potential of Japanese tattooing, leading them ultimately to the initiatives pioneered by Sailor Jerry Collins. Nolan attributes his own awareness in this regard to Collins.[21] Born in 1938 in New London, Connecticut, Nolan was attracted to art at an early age but had no formal training. He and his stepbrother, Tom Yeomans, learned tattooing by practicing on each other, using equipment obtained from old-timers working in the region. They opened a shop in 1955 in New London, which lasted until an accident in 1960 incapacitated Nolan for two years. Nolan and Yeomans next worked in a "syndicate shop" on State Street in Chicago (next to Tatts Thomas) until 1963, when the age limit for tattoo was raised from eighteen to twenty-one. They then worked for about a year in Anchorage, Alaska, moving on to Honolulu in 1964. Nolan worked for Lou Norman for a few years, Yeomans more briefly for Sailor Jerry Collins, subsequently shifting to Bert Grimm's studio in Long Beach. Nolan followed Yeomans to the Pike, first working for Fred Thornton, then joining his stepbrother at Grimm's. In 1967–1968, Nolan established his own shop in Eugene, Oregon; after a few years, however, he moved to Bremerton, Washington, where he painted, sculpted, and tattooed by ap-

19. *Arm tattoo (Punk design) by Bob Roberts, 1983. Photograph by Bob Roberts, 1983.*

pointment. In 1981, he bought a sailboat and moved to the Caribbean, tattooing ("American/Japanese, some traditional") at Dave Yurkew's studio in Minneapolis (and elsewhere) every few months for a few weeks—"12 hours a day, seven days a week"—in order to support his painting. He prefers painting to tattooing, but "it's harder to make a living at it." During 1986, Nolan shifted his activities, full-time to Santa Fe, New Mexico.

In many ways, Lyle Tuttle falls outside this network of, by now familiar, people and places. As the right person (mischievous, iconoclastic), in the right place (San Francisco), at the right time (the hippie period of the 1960s), he made his contribution less in the realm of imagery or technique than as a celebrity; he lent an earthy, proletarian focus and contour to a new, liberated conception of the body as expressed in Asian/Pacific religion and philosophy. He also contributed a certain complementary raciness and spice to '60s counterculture, which otherwise expressed itself primarily in musical terms—i.e., folk and rock-and-roll (Govenar 1981:xxiv; Morse 1977:56–57; Fried and Fried 1978:168). Tuttle's subsequent activities as founder of the Tattoo Art Museum and Hall of Fame in San Francisco and publisher of the *Tattoo Historian* have been more substantive, primarily concerned with preserving and documenting the historical and ethnographical records and

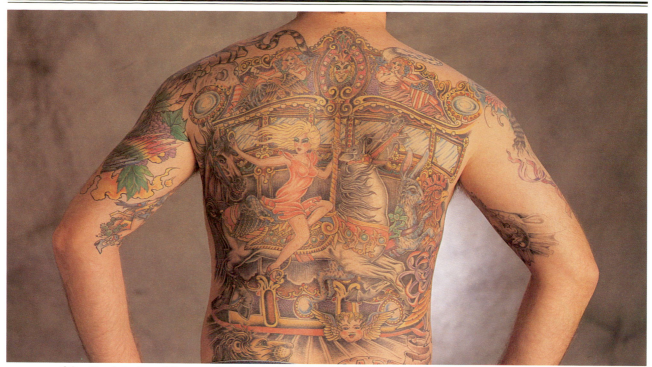

20. *Back tattoo (Carousel) by Bob Roberts, 1986. Photograph by Richard Todd, 1987.*

material culture of the medium (Hillinger 1983).

Spider Webb (Joseph Patrick O'Sullivan) worked for many years in Mount Vernon, just outside New York City. He has published two major books in the field (1976, 1979) and challenged New York City's prohibition of tattoo by tattooing at the entrance of the Museum of Modern Art. Like Tuttle, he has used tattoo to attain celebrity —or notoriety—but in a highly cerebral, self-consciously decadent, distinctively tough and hard-edged New York manner (Morse 1977:46–47; Webb 1977). This contrasts with the "softness" of the California style and is central to the emergence of what can be called a New York school of advanced tattoo.[22] The idiom involved is expressed in the work of Ruth Marten and reflected in certain aspects of the work of two California transplants, Bob Roberts and Jamie Summers.

Roberts was born in Hollywood in 1946.[23] Through high school, he divided his time between music (he played saxophone in rock groups) and art, in the form of surrealistic oil painting. At about the time of his graduation, his ideas about "good" art underwent a drastic change, and he became interested in tattoo imagery. He found his way to the Long Beach Pike and was initiated into the field by Bob Shaw and "Colonel" William Todd, who had by then taken over Bert Grimm's studio. Roberts worked at Bert Grimm's for three years

(until 1976), simultaneously pursuing his music. He tattooed at Cliff Raven's Sunset Strip studio between June and December of 1976 and then moved to Ed Hardy's in San Francisco in January 1977. After Tattoo City burned, he worked at Realistic until late 1979, when, stranded in New York after a band tour fell apart, he and Hardy parted company. Roberts had by then already been considering going off on his own but was unable to find a congenial location not overcrowded with tattooists: "San Francisco didn't feel right, and nothing was happening in L.A." New York seemed to offer a large, if underground, market with no serious competition, so he opened Spotlight Tattoo in a loft-studio at 285 3rd Avenue in Greenwich Village. Compared to patrons in northern and southern California, he characterized his New York clients as more decisive, more spontaneous, and prouder of their tattoos, with a definite preference for strong and colorful designs rather than West Coast Latin/fineline.

Roberts tattooed in New York until October 1982 when personal and real estate problems prompted him to leave. For six months he tattooed "on the road" in Europe—Copenhagen, Amsterdam, Dusseldorf, Ostend, and elsewhere. After deciding to reestablish Spotlight Tattoo in Los Angeles, he searched for six months before finding the location at 5855 Melrose where he

21. *Chest tattoo (Punk design) by Leo Zulueta, Los Angeles, 1985. Photograph by Leo Zulueta, 1985.*

opened his studio on 12 April 1983. In June 1983, he was joined by Leo Zulueta, who specializes in black ''tribal'' work, currently much in vogue among punks. Roberts feels he made the right decision in returning to Los Angeles. He describes his current clientele as ''mostly Hollywood types— punks and musicians'' (Figs. 19,20).[24] While estimating that 75% of his current tattoo work is music-oriented, he himself no longer plays professionally. Leo Zulueta has since moved on. Following an extended period of tattooing in Europe, he worked at Mike Malone's studio in Honolulu, and is now tattooing in Garden Grove, California (Figs. 21,22).

Sociological and Psychological Considerations

A consistent feature of discussions of early modern tattoo is the listing of tattooed politicians, aristocrats, tycoons, and other members of the social and political elite.[25] Entertainers—particularly rock musicians—have dominated comparable lists for the Tattoo Renaissance. Members of these elite

22. *Arm tattoo (Indonesian/Punk design) by Leo Zulueta, Amsterdam, 1985. Photograph by Leo Zulueta, 1985.*

sectors of the population—each in its own time—identify (and are identified) with the original patrons of tattoo: primitives, sailors, outlaws, and members of other marginal/deviant subcultures. In a polemical essay entitled "Ornament and Crime" (1908), the Austrian modernist architect Adolf Loos dealt explicitly with these conventional associations:

> The Papuan tattoos his skin, his boat, his rudder, his oars; in short, everything he can get his hands on. He is no criminal. The modern man who tattoos himself is a criminal or a degenerate. There are prisons in which eighty per cent of the prisoners are tattooed. Tattooed men who are not behind bars are either latent criminals or degenerate aristocrats. If someone who is tattooed dies in freedom, then he does so a few years before he would have committed murder (Munz and Kunstler 1966:226).

The proclamation issued by Governor Jerry Brown of California on 12 November 1982 to welcome Tattoo Expo to California takes another perspective:

> In decadent phases, the tattoo became associated with the criminal—literally the outlaw—and the power of the tattoo became intertwined with the power of those who chose to live beyond the norms of society.
>
> Today, the realm of the outlaw has been redefined: the wild places which excite the most profound thinkers are conceptual (*Tattootime* 1983:64).

These upper and lower strata of society—aristocrats, rock musicians, primitives, and criminals—come together in asserting their nonconformity to conventional middle-class attitudes and values. In this sense, they function as exemplars, however, since one intriguing characteristic of the Tattoo Renaissance has been the expansion of its clientele into the middle class. This expansion may be read as a dissemination of unconventional, individualistic values, and also as a reflection of better education, enhanced economic security, and openness to a wider ranger of experiences (including other cultures and subcultures through travel, music, dance, literature, food, dress, adornment, etc.).

At another level, however, Cliff Raven insists that the process of opening the texture of American society during the past twenty years was not one of "benign relaxation." Rather, he asserts, social conventions were torn out as each sector and subculture asserted its claims to full participation in the social, economic, political, and artistic life of the country—from hippies to punks, from Black to Women's to Gay Liberationists. The Tattoo Renaissance, then, is another reflection of the end of the idea of America as a melting pot. The insecurities and anxieties previously felt only by marginal populations began to encroach upon the middle class in the form of inescapable interest-group identities (based on, for example, race, religion, national origin, residence, age, or economic, legal, or medical status). Tattoo is one way of reassuring, or reinforcing, the ego under pressure. It provides an expanded, alternative, volitional identity: one *can* come to terms with the psychic constraints of the slot(s) one occupies in society. One *can* escape to a simpler time and more straightforward values by putting on the marks of a Maori chief, a North African courtesan, a pirate, an Indonesian headhunter, a Japanese samurai, an outlaw motorcyclist, a Scythian warrior, a Buddhist monk, or a twenty-first century time-traveler. Such options, however, depend upon the wide range of historical, ethnographical, and societal data that the "information explosion" has made available. They also draw upon the vivacity and stimulation of exotic cultures as well as the forbidden aspects of subcultural ("street") life, in this way paralleling the vicarious experiences of many *fin de siècle* European and Euro-American artists and writers.[26] Finally, and perhaps paradoxically, in a world of qualified commitments and maximized options, of transitory fads and institutionalized obsolescence, the fundamental appeal of "renaissance" tattoos seems to be precisely in their irreversibility, inalienability, and the unavoidable face-to-face encounter between artist and client.

However, Raven insists that in the last analysis a tattoo is only a tattoo—pigment embedded in the skin—and that, essentially, a tattoo embodies its own imperative. His central premise is that, even in alienated, late twentieth-century postindustrial society, the act of putting on a tattoo, as such, does not make a statement about the system; nor does it constitute a revolutionary act.[27] As in all cultures, such meanings and implications depend on the body of attitudes, motivations, and intentions that are brought to the transaction and depend on the nature, size, and placement of the design—whether ostentatious or hidden, decorative or challenging. Raven asserts that tattoo is no more monolithic than music or painting and, in the last analysis, the statement is the client's. He sees himself essentially as a technician and advisor, "a craftsman who is trying to be an artist" (Morse 1977:44), working in a relaxed atmosphere, dealing with interesting people, having a good

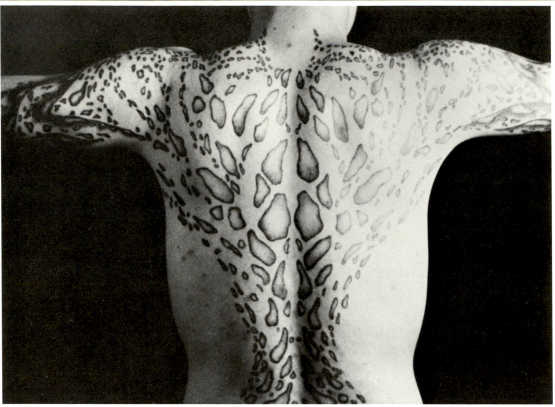

23. Back tattoo (Leopard frog spots) by Jamie Summers, 1979. Photograph by Jan Stussy, 1979.

time, doing art, and making a living. Raven further believes that the discipline of serious tattoo is so demanding, both technically and psychically, as to preclude significant involvement in other media; in other words, it is impossible to be a serious artist who occasionally tattoos. The work and professional postures of Ruth Marten and Jamie Summers also focus on the key issues of how tattoo differs from other media and whether tattoo is just another medium for the artist.[28]

Jamie Summers

Jamie Summers was born in Salinas, California in 1948. While an M.F.A. student at the San Francisco Art Institute, she decided to reject what she felt were the petty and trivial aspects of an artist's life—playing gallery politics, producing irrelevant commodities, installing insignificant shows. Instead, she aspired to integrate her art and her life at the highest level and, concluding that the domain of ritual would probably be most productive in this regard, began a cross-cultural investigation of rituals. She first became interested in tattoo after hearing Ed Hardy's talk on tattoo at the Art Institute; she subsequently traveled to San

Diego and was tattooed by him. She and Hardy became friends following his return to San Francisco in 1976. Summers initially declined Hardy's offer to take her on as an apprentice but reconsidered following Mike Malone's encouragement. She went into Tattoo City with Bob Roberts, who introduced her to the equipment and taught her technique. Although she worked well with the predominantly Chicano clientele, she found the street-shop environment unsatisfactory and increasingly offensive to her sensibilities. She felt that her coworkers viewed tattooing as trivial—"just a job, or a joke"—but realized that the client would wear the results for life; her coworkers, for their part, "thought she took the work too seriously." When Tattoo City burned, she and Roberts shifted to Realistic with Hardy.

At Realistic, initially, Summers adopted a deferential attitude toward those who knew more about the medium than she. Gradually, however, she began to question aspects of Hardy's practice, which led to clashes; she felt that her preference for pastel colors, unconventional techniques, and nonviolent imagery were perceived as an affront to the tattoo community, although they were not intended as such.

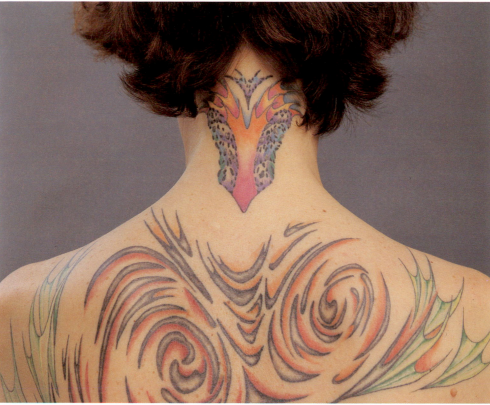

*24. Back and neck tattoo by Jamie Summers,
1980. Photograph by Jamie Summers, 1980.*

By 1980 Summers felt stifled and realized that she could no longer remain at Realistic. With neither money nor prospects, nor even a clear idea of what she wanted to do, she established her own studio in San Francisco.[29] Through extensive readings and consultations with psychologist and psychic Helen Palmer of Berkeley, she received reinforcement in her determination to pursue her own line of development, with emphasis on removing her ego from the transaction and generating uniquely appropriate imagery for each client. Although based in San Francisco, she began to spend increasing amounts of time in New York City, both tattooing and creating art installations. By the time of my interview with her, she considered herself a permanent transplant to New York, although she still advised graduate students at the San Francisco Art Institute during periodic visits to the city.

Summers had come to identify "the development of intuition," expressed essentially in shamanistic terms, as a unifying thread in all her art.[30] She acknowledged the problems of reconciling the beliefs, practices, and values of ancient cultures with conditions of life in the modern, urbanized, industrialized world, but was dedicated to helping others (and herself) achieve fulfillment through development of their psychic potential. Tattoo was "just another medium" for accomplishing this objective. Through extensive consultations with clients, often over an extended period of time, design decisions emerged from interior sources, rather than from the artist's ego or through the process of intellectualization (Figs. 23,24,25). (Most of her clients—museum people, artists, musicians, psychics, astrologers—came to her predisposed toward such a process.) The illegality of her medium did not pose a problem since highly placed people supported her. She did not, however, work only for the wealthy, but required only an "exchange of energy" in some form: "everything has a cost. If a client couldn't come up with the money—or something—his/her attention was not on the work."

Ed Hardy continued to be an important factor in Summers' perception of tattoo, insofar as she had come to reject everything she felt he stood for—particularly, what she regarded as the projection of the artist's ego on another person's body. Although she acknowledged that he was turning out the best available Japanese, traditional American, and other designs, she felt that he had

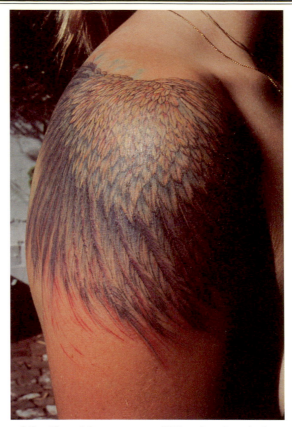

25. Shoulder tattoo (Wingfeathers) by Jamie Summers, 1981. Photograph by Jamie Summers, 1981.

never developed his own style. She felt that his mastery of technique and tendency toward intellectualization had produced only highly accomplished surface decoration, rather than the revelation of interior states, which had come to be her sole objective. While acknowledging that her position would appear elitist to traditional tattooists, she was less and less disposed to try to explain herself to them.

As is evident from his involvement with Tattoo Expo, *Tattootime*, and a 1985 exhibition in Rome, Hardy has a deep sense of responsibility toward the field—expanding options, raising standards, improving the image—and maintains an extensive network of contacts among practitioners at all levels.[31] While he shares Summers' ambivalence toward certain aspects of the "roots" of tattoo—specifically, her repudiation of its "roughneck, silly aspects"—he feels a deep sense of respect for Jerry Collins, Paul Rogers, Bert Grimm, and others who "upheld the craft with honor, even if what they had produced wasn't great art." Hardy is anxious about the hazards of the spiritual or therapeutic aspects of tattoo, the special rela-

tionship which often emerges between the artist and client that goes beyond drawing skill and technical mastery. As is also evident in Cliff Raven's position, the key questions to Hardy are how tattoo differs from other media and whether it is possible to accept its uniqueness while reconciling it with serious work in other media. For his part, Hardy had deep reservations about what he regards as Summers' aloof elitism and esoteric intellectualism ("the tattooist as priest or guru"). He considers that recognition of and respect for connections between his work and tattoo traditions of other times and places is a responsible way of reducing the role of his own ego in the transaction and the risks of reinventing the medium for each new project.

Summers' untimely death (2 July 1983) terminated this fascinating debate, but the issues involved will almost certainly continue to affect the evolution of the medium into the twenty-first century.

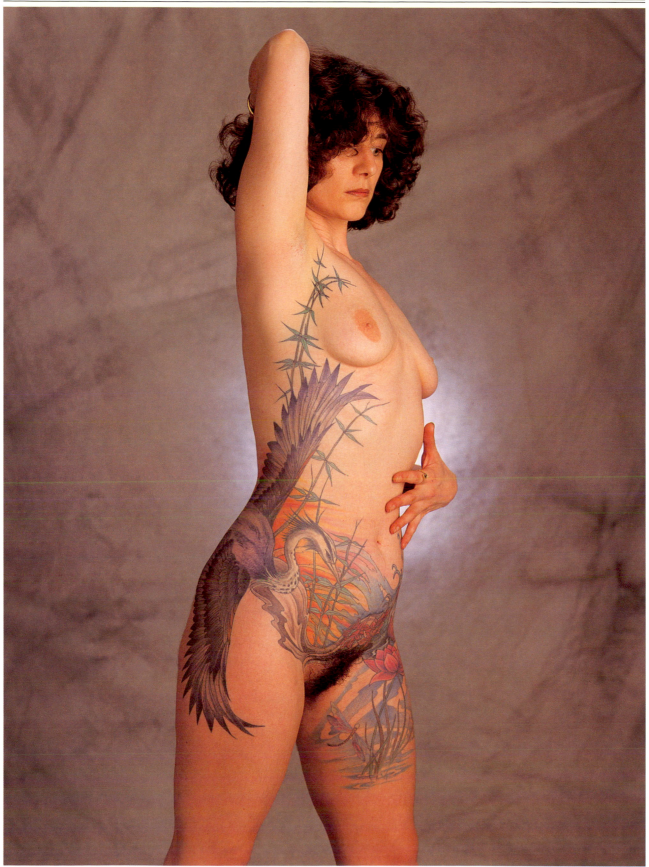

26. *Torso tattoo (Crane) by Vyvyan Lazonga, 1984. Photograph by Richard Todd, 1987.*

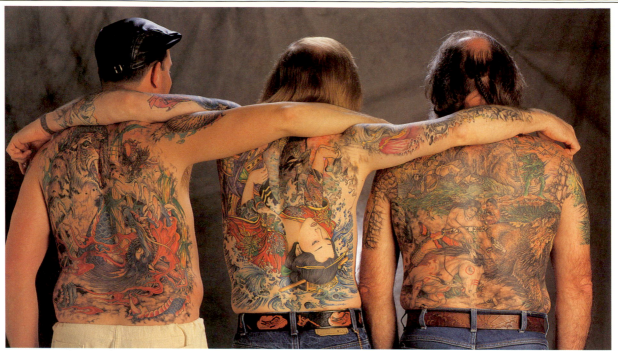

27. *Three back tattoos by Kari Barba, 1986–7. Photograph by Richard Todd, 1987.*

Epilogue

The diversity and vitality of contemporary tattoo and its lively exploration of the relationship between art, culture, history, psychology, and sociology are evident from the foregoing. The Tattoo Renaissance has moved the medium and its practitioners into a trenchant engagement with a wide spectrum of issues and ideas, including its position among the "fine" arts and rights to freedom of expression.[32] In the last analysis, Cliff Raven's admonition that tattoo is not monolithic should probably be expanded; given the nature of the medium and the conditions of its creation, tattoo has never been, nor is it ever likely to be, monolithic (Figs. 26,27). For those who are involved in these explorations, this diversity and vitality are summed up in the assertion by Mike Bakaty that tattoo is "the only form of human expression we have left that has magic to it. Everything else is academic" (Tucker 1981:47).

Notes

1. This essay is based upon a wide-ranging involvement of approximately eight years. It depends heavily, however, on *ad hoc* interviews with many of the artists whose work is chronicled. Responsibility for the form in which their testimony is rendered, as well as the interpretations thereof, are my own. Citations in the text are intended to reinforce or corroborate specific points in the narrative or analysis, or to identify key illustrations. I owe thanks to Frances Farrell and Cecelia Klein for the favor of close, critical readings of an earlier version and to the Academic Senate, UCLA, for continuing support of my research. Regarding use of the term "renaissance" in conjunction with contemporary tattoo, see Anon. 1970; Hill 1970; Webb 1979:42,173; Scutt and Gotch 1974:57.

2. For the United States, see Sanders, Govenar 1981, Parry 1971:44–57, Webb 1976; 1979:22–31, Davis 1971, Fried, Fried and Fried 1978:158–169; for England, Scutt and Gotch 1974, Burchett and Leighton 1958, Ebensten 1953; for France, Bruno 1970, Caruchet 1976, and Dube 1980 (francophone Canada). Comparable documentation exists for Germany and Scandinavia.

3. In its most advanced manifestation, this technique is called "Coleman Style" after August Coleman of Norfolk, Virginia, who died in 1973 at 89 years of age (Morse 1977:16,64; Hardy 1982a:26; 1982b:39–40; Fried and Fried 1978:167).

4. Regarding the linkage between carnivals/circuses and tattoo, see Morse 1977:6,20,64,112; St. Clair and Govenar 1981; Webb 1979:17; Hardy 1982b; and various articles in *Tattoo Historian*, published by the Tattoo Art Museum, San Francisco.

5. Regarding a late-nineteenth/early-twentieth century episode of Japanese influence on European and American tattoo, see Fried and Fried 1978:166; Parry 1971:27,99–102, 104,136; Scutt and Gotch 1974:48,53.

6. Morse 1977:15,42–43; Hardy 1982c. Govenar (1981:xxvi, xxxii n. 38) provides a summary of tattoo conventions held in the United States, beginning with the one organized by Dave Yurkew of the North American Tattoo Club in Houston in 1976. Other organizations (in the United States, Europe, and the Southwestern Pacific) have held conventions subsequently, including the annual meetings of the National Tattoo Association, affiliated with National Tattoo Supply of Long Island, New York, and publisher of *National Newsletter*. Ed Hardy's *Tattootime* was launched at the Tattoo Expo which he organized on the Queen Mary in Long Beach, California, in November 1982. Lyle Tuttle's Tattoo Art Museum in San Francisco, publisher of *Tattoo Historian*, is a spectacularly rich repository of tattoo-related materials from all times and places, but emphasizing twentieth-century "International Folk Style" collections from Europe and America. Other periodicals in the field include *Tattoo News* (New York), *Tattoo Life* (Winchester, Va.), and recent compendia by *Easy Rider* and *Biker Lifestyle*. Other suppliers of tattoo equipment and supplies include Spaulding and Rogers of Voorheesville, New York, and Guideline, Ltd. of Tom's River, New Jersey.

7. See, e.g., "L.A. East" studio in Laconia, New Hampshire (Anon. 1984a). One of Ed Hardy's recent business cards carries the caption "Tattoo Ambassador" and features a world map linking England, San Francisco, Micronesia, and Japan. Bob Roberts worked for an extended period in Europe and England during 1982. Since 1979 Jack Rudy has regularly taken in-residence positions in studios in the mid-western and northeastern United States, and Jamie Summers maintained studios in San Francisco and New York for several years. Leo Zulueta spent most of 1985 tattooing in Holland and elsewhere in Europe.

8. Regarding demographic shifts in clients, see Friedman 1982; Nadler 1983; Tucker 1976,1981:43; Crawford 1974; Webb 1979;49–56,97–98. Regarding the importance of homosexual clients for the artistic evolution of the medium, see Steward 1981:81–82,85,89–90.

9. As used here, "Japanese" tattoo refers to designs derived from Japanese mythology and decorative art expressed primarily in the idiom of *ukiyo-e* woodblock prints (see McCallum). Such designs are for the most part based closely on versions of these motifs developed specifically for late-nineteenth/early-twentieth century Japanese tattoo. "Fineline" refers to representational tattoos (or lettering) executed entirely in black with an instrument operating with one rather than the more usual three (or more) needles. Shading is developed through linework, producing an effect resembling prints made by drypoint. The style originated among the Mexican-derived populations of the southwestern United States, especially in conjunction with gang activity (see Govenar). Much of the tattoo in this style was done clandestinely in prison, hence colloquially called "joint-work" or "joint-style." Typical designs include gang names or logos, religious motifs, pinups, flowers, skulls, snakes, and other references to violence or the Chicano lifestyle. "Tribal" tattooing refers to interpretations of the bold, black, abstract designs predominantly associated with certain Polynesian, Indonesian, and Southeast Asian traditions.

10. See Webb 1979:59 and Govenar 1981:xxvi,xxxiii. According to Goldstein (1979:913–915), tattoo is also illegal in Hampton, Newport News, Portsmouth, and Virginia Beach, Virginia; Albuquerque, New Mexico; and the states of Connecticut, Kansas, Oklahoma, South Carolina, and Vermont. It is my impression that enforcement tends to be sporadic and desultory in most cases; "bootleg" (i.e., clandestine) professional tattooing certainly goes on in New York City, and probably elsewhere, along with the usual complement of work by amateurs.

11. Information included in this section derives, for the most part, from interviews conducted on 2 and 16 December 1982 in Los Angeles, and subsequently. As indicated in note 1, citations refer to information that corroborates or reinforces Raven's own narrative.

12. Thomas' death followed a "sentimental journey" to visit Sailor Jerry Collins in Honolulu. Collins, while a trainee at Chicago's Great Lakes Naval Training Center, had been befriended (and instructed in tattoo) by Thomas, and they remained in contact subsequently through correspondence (Morse 1977:106; Letter from Collins to Thomas postmarked 9 July 1946; Archives, Tattoo Art Museum, San Francisco).

13. Regarding Coleman, see note 3; Spaulding and Rogers, see note 6 above; also Morse 1977:64; Hardy 1982b.

14. Raven was also impressed by a 1960s newsletter article by Collins advocating sterile procedures and began to autoclave his equipment. Collins had convinced everybody in this regard, but told Raven during his visit that his own equipment was merely window dressing, "just for show, when the Health Department comes around." Collins professed to believe that the (ineffective) dry-heat (glass-bead) dental sterilizer that he actually used for his instruments was sufficient and that, in the last analysis, the quality of his work would be compromised by changing his setup for each customer.

15. Bert Grimm, an outstanding figure in the field, had moved in the early 1950's from St. Louis to "The Pike" in Long Beach, a recreational zone situated near major naval and merchant marine installations (Aurre 1983:31–32; Morse 1977:7; Makosfke 1985). See illustrations to Sanders.

16. See Anon. 1970; Hill 1970; Morse 1977:70; Hardy 1982b:8; Webb 1979:96; Govenar 1981:xxiii–xxiv. The question of whether Janis Joplin was tattooed by Tuttle or by Pat Martynuik is still debated. Tuttle's shop was, in any case, instrumental in the introduction and dissemination of the new design vocabulary associated with the hippie/anti-Vietnam War/drug-oriented counterculture composite: peace signs, musical logos, underground comics, astrological signs, distinctive lettering and other graphics, marijuana leaves, Zig Zag Man, etc.

17. Most of the information in this section derives from a telephone interview on 13 December 1982, and subsequent conversations. As with the preceding section, sources cited provide corroboration or reinforcement. In the interest of continuity and in support of the arguments developed here, some redundancy (as regards Raven's narrative) will be evident in references to key events and personalities. Also see Morse 1977:28.

18. Bert Grim (b. 1901; d. 1985), Sailor Jerry Collins (b. 1911; d. 1973), and Phil Sparrow (b. 1909; began tattooing 1952) have been portrayed, in effect, as forerunners.

19. Dates for Zeke Owens were obtained by telephone from Louie Lombi of Mt. Vernon, New York, on 23 August 1984.

20. Among the large number of tattooists who have passed through Cliff Raven's Chicago and Los Angeles studios, Robert Benedetti, Dennis Dwyer, and Kevin Brady are especially promising. Greg Irons (1947–1984) was considered an outstanding talent; see Irons 1985; also *Tattootime* 3(1):96 for his obituary.

21. I obtained biographical information on Nolan in a telephone interview with him (in Minneapolis) on 12 August 1982, largely at the initiative of Cliff Raven. Raven felt (after reading an earlier version of this paper) that Nolan "got lost," although (judging from examples he had seen of Nolan's recent work) "alive and well, breaking new ground technically and artistically." This omission serves to highlight what emerges as continuing problems of access to established and promising artists and their key works despite the more open texture and higher profile of the medium that currently prevail.

22. See Webb 1979 for examples of his own work and a discussion of the legal issues. The name of Tom de Vita is also frequently mentioned as influential in the evolution of the New York school, but I have not seen enough of his work to gain an impression (see e.g., *Tattootime* 1982:8). Marcia Tucker, Director of New York's New Museum, is important as an interpreter of the interface between tattoo and the Fine Arts—so far, a distinctively New York pursuit. Her close relationship with Jamie Summers culminated in Summers' 1983 New Museum exhibition (see Tucker 1981, Gumpert 1983).

23. Biographical information on Roberts was obtained in an interview in Los Angeles on 26 July 1984; also Gehman 1983. See Hardy (above) regarding "Tattoo City."

24. Roberts 1985; Gehman 1983. The punks seem to be generating the next wave of advanced tattoo in terms of technique (blackwork, with heavy lines), imagery (musical, violent), and placement (emphasizing maximum visibility, including hands and face; Webb 1979:182; Salewicz 1982; L. Hardy 1985; Zulueta 1985).

25. See Govenar 1981:xvi–xvii; Parry 1971:50,91,97–98,102; Burchett and Leighton 1958; Goldstein 1979:855–856; Scutt and Gotch 1974:165–170; Gehman 1983; Anon. 1984a:64; Govenar 1981:xxiv; Steur 1982; Gonzales 1981:130; Taylor 1980; Abcarian 1984; Mann 1979; Levine 1980. Norman Goldstein's forthcoming book, *Micropigmentation*, will include an extensive list of tattooed celebrities; see also "L'Asino e la Zebra" (note 31 below).

26. E.g., Toulouse-Lautrec, Modigliani, Baudelaire, Hemmingway.

27. Except perhaps in places where tattoo is illegal; see note 10.

28. Tucker (1981:44) quotes Mike Bakaty, a New York sculptor who also tattoos: "Being a tattoo artist is different from being a good tattooist." Marten is a painter, illustrator, tattooist, and conceptual/performance artist, mostly known through a few works published or discussed in Tucker 1976:33, 1981:44–45. Information and ideas about Summers presented in the following section are based on a telephone interview conducted on 27 December 1982, supplemented by Gumpert 1983, Friedman 1982:94, and Teresi 1981.

29. According to Gumpert (1983 n. 14), Summers spent a year in a rural area near Santa Rosa, not mentioned in my interview with her.

30. In 1983 Summers founded the Center for Investigative Studies of Intuition as a focus for these concerns.

31. Hardy coordinated "L'Asino e la Zebra [The Donkey and the Zebra]: origini e tendenze del tatuaggio contemporaneo," Rome, Mercati Traianei, 11 aprile–5 maggio 1985; the catalogue (De Luca Editore) contains a number of essays on different aspects of the medium. Numerous illustrations of ethnographical, archaeological, and more recent works are included, many in color, including a number of previously unpublished works by Jamie Summers.

32. Legalized persecution of tattooing continues; e.g., in Upper Chichester Township, New Jersey (*Philadelphia Enquirer*, 2 October 1979, Section 3, p. 1) and Camden County, Georgia (*Times and Democrat*, Orangeburg, South Carolina, 22 July 1984, p. 10a).

AFRICA

Ancient Egypt

Bakir, Abd el-Mohsen
 1952 *Slavery in Pharaonic Egypt*. Cairo.

Bianchi, Robert S.
 1982 "Egyptian Mummies—Myth and Reality." *Archaeology* 35:18–25.
 1983 No. 25. In *Neferut net Kemit*. Robert S. Bianchi, James F. Romano, and Richard A. Fazzini (eds.). Brooklyn.
 1985 "Tätowierung." *Lexikon der Aegyptologie* 6:146. W. Helck and E. Otto (eds.). Wiesbaden.

Bierbrier, Morris
 1982 *The Tomb-Builders of the Pharaohs*. London.

Bruno, C.
 1974 *Tatoues, Qui etes-vous . . . ?* Paris.

Bruyere, B.
 1939 *Rapport sur les fouilles de Deir el-Médineh (1934–1935) III: Le village, les décharges publiques, la station de repos du col de la Vallée des Rois*. Cairo.

Caminos, R. A.
 1954 *Late Egyptian Miscellanies*. London.

Carswell, J.
 1958 *Coptic Tattoo Designs*. 2nd ed. Beirut.

Castel, G.
 1985 "Gebel Zeit: Paraonische Bergwerke an den Ufren des Rotes Meeres." *Antike Welt* 16:15–28. G. Castel, J.-F. Gout, G. Soukassian, P. Levi, and D. Leyval.

Daumas, F.
 1977 "Hathor." *Lexikon der Aegyptologie II*. W. Helck and E. Otto (eds.) Wiesbaden.

Derchain, Ph.
 1982 "Appendix K." In *Excavations in the Animal Necropolis at North Saqqara*. G. T. Martin (ed.). London.

Desroches-Noblecourt, C.
 1953 " 'Concubines du mort' et meres de famille au Moyen Empire." *Bulletin de l'Institute Français d'Archéologie Orientale du Caire*. 53:7–47.

Dolger, F. J.
 1929 "Die Kreuz-Tätowierung im christlichen Altertum." *Antike und Christentum* 1:202–211.

Doll, S. K.
 1982 In *Egypt's Golden Age: The Art of Living in the New Kingdom 1558–1085 B.C.* Boston.

Easton-Krauss, M.
 1976 *Aegyptische Kunst aus dem Brooklyn Museum*. No. 47. J. S. Karig and K.-Th. Zauzich (eds.). Berlin.

Erman, A.
 1928 *Wörterbuch der Aegyptischen Sprache* II:171–172. A. Erman and H. Grapow (eds.). Berlin.

Faulkner, R. O.
 1936 "The Bremner-Rhind Papyrus-I." *The Journal of Egyptian Archaeology* 22:122.

Firth, C. M.
 1927 *The Archaeological Survey of Nubia. Report for 1910–1911*. Cairo.

Foster, J. L.
 1974 *Love Songs of the New Kingdom*. New York.

Hayes, W. C.
 1937 *Glazed Tiles from a Palace of Rameses II at Kantir*. New York.

Hornblower, G. D.
 1929 "Predynastic Figures of Women and their Successors." *The Journal of Egyptian Archaeology* 15:28.

Husson, C.
 1977 *L'offrande du miroir dans les temples égyptiens de l'époque gréco-romaine*. Lyon.

Kantor, H. J.
 1974 "Aegypten." In *Frühe Stufen der Kunst*. M. J. Mellink and J. Filip (eds.). Berlin.

Keimer, L.
 1943 "Un Bès tatoué?" *Annales du Service des Antiquites de l'Egypte* 42:159–161,508.
 1948 *Remarques sur le tatouage dans l'Egypte ancienne*. Cairo.

Krutchen, J.-M.
 1981 *Le Décret d'Horemheb*. Brussels.

Le Corsu, F.
1978 "Cléopâtra-Isis." *Bulletin de la Société Francaise d'Égyptologie* 82:24–25.

Meeks, D.
1979 *Anne Lexicographique* III:136.

Meinardus, O. F. A.
1970 *Egypt: Life and Faith.* Cairo.

Mey. P.
1980 "Installations rupestres du Moyen et du Nouvel Empire au Gebel Zeit (près de Räs Dib) sur la Mer Rouge." *Mitteilungen des Deutschen Archeologischen Instituts, Abteilung Kairo* 36:299–318.

Milward, A. J.
1982 In *Egypt's Golden Age: The Art of Living in the New Kingdom 1558–1085 B.C.* Boston.

Müller, H. W.
1975 "Eine viertausend Jahre alte Nilpferdfigur aus aegyptischer Fayence." *Pantheon* 33:287–292.

O'Connor, D.
1978 "Nubia before the New Kingdom." In S. Hochfield and E. Riefstahl (eds.). *Africa in Antiquity: The Arts of Ancient Nubia and The Sudan I.* Brooklyn.

Omlin, J. A.
1973 *Der Papyrus 55001 und seine satirisch-erotischen Zeichnungen und Inschriften.* Turin.

Osten, H. H. van der
1927 *Explorations in Hittite Asia Minor.* Chicago.

Posener-Krieger, P.
1984 "Les travaux de l'Institut Français d'Archéologie Orientale en 1983–1984." *Bulletin de l'Institut Français d'Archéologie Orientale du Caire* 84:349–350.

Romano, James F.
1980 "The Origins of the Bes-Image." *Bulletin of the Egyptological Seminar of New York* 2:39–56.
1982 *Egypt's Golden Age: The Art of Living in the New Kingdom 1558–1085 B.C.* Boston.

Sauneron, S.
1960 *The Priests of Ancient Egypt.* A. Morrisett (trans.). New York.

Schneider, Hans D.
1977 *Shabtis* I. Leiden.

Schuster, C.
1948 "Modern Parallels for Ancient Egyptian Tattooing." *Sudan Notes and Records* 29:71–77.

Seguenny, E.
1984 "Quelques elements de la religion populaire du Soudan ancien." *Meroitica* 7.

Sourouzian, H.
1981 "Une tête de la reine Touy à Gourna." *Mitteilungen des Deutsches Archeologischen Instituts, Abteilung Kairo* 37:445–455.

St. John, B.
1853 *Village Life in Egypt I.* Boston.

Thévoz, Michel
1984 *The Illusion of Reality: The Painted Body.* Geneva.

Tondriau, J.
1950a "Tatouage, lierre et syncrétisme." *Aegyptus* 30:57–66.
1950b "La Dynastie Ptolémaique et la religion Dionysiaque." *Chronique d'Égypte* 50:294–295.

Ucko, P. J.
1968 *Anthropomorphic Figurines of Predynastic Egypt and Neolithic Crete with Comparative Material from the Prehistoric Near East and Mainland Greece.* London.

Vandier D'Abbadie, J.
1938 "Une fresque civile de Deir el Médineh." *Revue d'Egyptologie* 3:27–35.
1959 *Catalogue des ostraca figurés de Deir el Médineh.* Cairo.

Vila, A.
1967 *Aksha II: Le cimetiere meroitique d'Aksha.* Paris.

Wenig, Steffen
1978 *Africa in Antiquity: The Arts of Ancient Nubia and The Sudan.* Brooklyn.

Winlock. H. E.
1947 *The Rise and Fall of the Middle Kingdom at Thebes.* New York.

Yoyotte, J.
1958 "Le dénommé Mousou." *Bulletin de l'Institut Français d'Archéologie Orientale* 57:81–89.

Zimmerman, K.
1980 "Tätowierte Thrakerinnen auf griechischen Vasenbildern." *Jahrbuch des Deutsches Archäologishen Instituts* 95:163–196.

Southeast Nuba

BBC-TV
1982 *Southeast Nuba.* Documentary film. London.

Faris, James
1969a "Sibling Terminology and Cross-Sex Behavior: Data from the Southeastern Nuba Mountains." *American Anthropologist* 71(3):482–488.
1969b "Some Cultural Considerations of Duolineal Descent Organization." *Ethnology* 8(3):243–254.
1972a *Nuba Personal Art.* London.
1972b "Southeastern Nuba Age Organization." In *Essays in Sudan Ethnography Presented to Sir Edward Evans-Pritchard.* Ian Cunnison and Wendy James (eds.). London.
1978 "The Productive Basis of Aesthetic Traditions: Some African Examples." In *Art and Society.* Michael Greenhalgh and J. Megaw (eds.). London.
1980 "Polluted Vision." *Sudanow* 5(5):38.
1983a Review, *Is There a Text in This Class? The Authority of Interpretive Communities*, by Stanley Fish. *Language in Society* 12(2):252–255.
1983b "From Form to Content in the Structural Study of Aesthetic Systems." In *Structure and Cognition in Art.* Dorothy Washburn (ed.). Cambridge.
1987 *Southeast Nuba Social Relations.* Aachen.
1988 "Southeast Nuba: A Biographical Statement." In *Anthropological Filmmaking.* Jack Rollwagen (ed.) London.

Foucault, Michel
1972 *The Archaeology of Knowledge.* London.

Hirst, Paul and Penny Woolley
1979 *On Law and Ideology.* Atlantic Highlands.

Iten, Oswald
1977 "Bilder und Zarrbilder der Nuba." *Tages Anzeiger Magazin* 50(17):6–12.

Riefenstahl, Leni
1976 *The People of Kau.* New York.

Tabwa

Anonymous
n.d. Handwritten, unpaginated notebook without title, probably by a catechist or seminarian at Mpala (perhaps Stefano Kaoze). MS 803/121 in a file with documents collected but not written by Joseph Weghsteen, White Fathers' Central Archives, Rome.

Biebuyck, Daniel
 1973 *Lega Culture.* Berkeley: University of California Press.

Burt, Eugene
 1982 ''Eroticism in Baluyia Body Arts.'' *African Arts* 15(1): 68–69,88.

Campbell, Dugald
 1914 ''A Few Notes on Butwa, An African Secret Society.'' *Man* 14(38):76–81.

Clifford, James
 1986 ''On Ethnographic Allegory.'' In *Writing Culture: The Poetics and Politics of Ethnography.* J. Clifford and G. Marcus (eds.). Berkeley: University of California Press.

Colle, Pierre
 1912 ''Le Butwa (société secète nègre).'' *Revue Congolaise* 3:195–199.
 1913 *Les Baluba.* 2 vols. Brussels: Albert Dewit.

Crawford, Dan
 1924 *Back to the Long Grass.* London: Hodder and Stoughton.

Davis-Roberts, C.
 Forthcoming ''Magic and the Missed Reality.''

Debeerst, Gustave
 1984 ''Essai de grammaire tabwa.'' *Zeitschrift für Afrika und Ocean. Sprachen* I–II.

Derricourt, Robin
 1980 ''People of the Lakes: Archaeological Studies in Northern Zambia.'' *Zambian Papers* 13. Lusaka: Institute for African Studies.

Faik-Nzuji, Madiya
 1983 ''Représentation idéologique de la 'Parole Forte.' '' In *Melanges de Cultures et de Linguistique africaines.* M. Faik-Nzuji and E. Sulzman (eds.). Berlin: Dietrich Reimer.

Ferber, N.
 1934 ''Rapport de route, *secret*: Les 'Butwa.' '' 2 November. MS in the Archives of the Sous-Région du Tanganyika, Kalemie.

Guillemé, Mathurin
 1887 Letter to Mgr. Morel from Kibanga, August. MS C.19.438, White Fathers' General Archives, Rome.
 1897 ''Autour du Tanganika.'' *Bulletin des Missionaires d'Afrique (Péres Blancs)* 122,528–529; 123,555–557; 124,161–166; 125,198–201.

Heusch, Luc
 1972 *Le roi ivre ou l'origine de l'Etat.* Paris: Gallimard. Translated by Roy Willis as *The Drunken King, or, The Origin of the State* (1982). Bloomington: Indiana University Press.

IAAPB (Institute Apostolique Africain des Pères Blancs)
 1892 *Près du Tanganika.* Anvers: Imp. H. Majoor.

Jacques, Victor and Emile Storms
 1886 *Notes sur l'ethnographie de la partie orientale de l'Afrique Equatoriale.* Brussels: F. Hayez for the Academie Royale de Belgique.

Kazadi Ntole
 1980 ''Scarification et langage dans la culture des Bahemba.'' Unpublished conference paper.

Laude, Jean
 1973 *African Art of the Dogon.* New York: Viking Press.

Neyt, Francois
 1986 ''Tabwa Sculpture and the Great Traditions of East-Central Africa.'' In *The Rising of a New Moon: A Century of Tabwa Art.* A. Roberts and E. Maurer (eds.). Ann Arbor: University of Michigan Museum of Art.

OED (Oxford English Dictionary)
 1982 *The Compact Edition of the Oxford English Dictionary.* New York: Oxford University Press.

Reefe, Thomas
 1977 ''Lukasa: A Luba Memory Device.'' *African Arts* 10(4): 49–50,88.
 1981 *The Rainbow and the Kings: A History of the Luba Empire to c. 1891.* Berkeley: University of California Press.

Roberts, Allen
 1980 ''Heroic Beasts, Beastly Heroes: Principles of Cosmology and Chiefship among the Lakeside Tabwa of Zaire.'' Unpublished PhD dissertation, Department of Anthropology, University of Chicago.
 1981 ''Passage Stellified: Speculation upon Archaeoastronomy in Southeastern Zaire.'' *Archaeoastronomy* 4:27–37.
 1983 '' 'Fishers of Men': Religion and Political Economy Among Colonized Tabwa.'' *Africa* 54(2):49–70.
 1986a ''Social and Historical Contexts of Tabwa Art.'' In *The Rising of a New Moon: A Century of Tabwa Art.* A. Roberts and E. Maurer (eds.). Ann Arbor: University of Michigan Museum of Art.
 1986b ''Duality in Tabwa Art.'' *African Arts*, 19(4):26–35, 86–87.
 1986c ''A Survey of Tabwa Body Arts.'' *Arts d'Afrique Noire*, 59, 15–29.
 1987 '' 'Prendre au serieux le merveilleux': Reflections on the *Mythes et Rites Bantous* series of Luc de Heusch.'' L'Homme, forthcoming.
 Forthcoming ''History, Ethnicity and Change in the 'Christian Kingdom' of Southeastern Zaire.'' In *The Creation of Tribalism in South and Central Africa.* L. Vail (ed.). London: James Curry.

Roberts, Allen and Evan Maurer (ed.)
 1986 *The Rising of a New Moon: A Century of Tabwa Art.* Ann Arbor: University of Michigan Museum of Art.

Roelens, Victor
 1938 *Instructions aux Missionaires Pères Blancs du Haut-Congo.* Baudouinville (now Kirungu, Zaire): Vicariat Apostolique du Haut-Congo.

Storms, Emile
 1883 ''Voyage à Oudjidji.'' MS in the Fonds-Storms (B2.F3), Royal Museum for Central Africa, Tervuren.

Theuws, Theodore
 1968 ''Le Styx ambigu.'' *Bulletin du Centre d'Etudes des Problèmes sociaux indigènes* 81,5–33.

Thompson, Robert
 1983 *Flash of the Spirit.* New York: Random House.

Thomson, Joseph
 1881/1968 *To the Central African Lakes and Back.* 2 vols. London: Frank Cass.

Turner, Victor
 1969 *The Ritual Process.* Chicago: Aldine.
 1970 *The Forest of Symbols.* Ithaca: Cornell University Press.
 1985 *On the Edge of the Bush: Anthropology as Experience.* Edited posthumously by Edith Turner. Tucson: University of Arizona Press.

Tytgat, L.
 1918 ''Sectes secrètes et coutumes: le chisimba.'' Annex to ''Rapport Mod. B, 2e trimestre,'' from Mpweto, 29 June. MS in the Archives of the Sous-Région du Tanganika, Kalemie.

Van Acker, August
 1907 ''Dictionnaire kitabwa-français, français-kitabwa.'' *Annales du Musée Royal du Congo Belge.* Series V, Ethnographie-Linguistique.

Bibliography

Van Avermaet, Edouard and Benoit Mbuya
1954 "Dictionnaire kiluba-français." *Annales du Musée Royal de l'Afrique Centrale.* Serie VII, Linguistique.

Vansina, Jan
1984 *Art History in Africa.* New York: Longman.

White Fathers
1954 *The White Fathers' Bemba-English Dictionary.* London: Longmans, Green.

Zahan, Dominique
1975 "Colors and Body Painting in Black Africa: The Problem of the 'Half-Man.'" *Diogenes* 90,100–119.

Ga'anda

Aitchison, P. J., M. G. Bawden, D. M. Carroll, P. E. Glover, K. Klinkenberg, P. N. de Leeuw, and P. Tuley
1972 *Land Resourcs of North East Nigeria.* Vol. 1, The Environment. Land Resource Study No. 9, Foreign and Commonwealth Office, Overseas Development Administration. Surrey, England.

Berns, M. C.
1986 "Art and History in the Lower Gongola Valley, Northeastern Nigeria." Ph.D. dissertation, University of California, Los Angeles.

Bohannan, P.
1956 "Beauty and Scarification Amongst the Tiv." *Man*, September, 56(129):117–121.

Boyle, C. V.
[1913] "Lala District: historical and anthropological notes," NAK (National Archive, Kaduna) J–18, Adamawa Provincial Archives.
1915 "The Lala People and their Customs." *Journal of the African Society*, October, 15(57):54–69.
1916a "The Ordeal of Manhood." *Journal of the African Society*, April, 15(59):244–255.
1916b "The Marking of Girls at Ga'anda." *Journal of the African Society*, July 15(60):361–366.

Chappel, T. J. H.
1977 *Decorated Gourds in North-Eastern Nigeria.* London.

Hammandikko, M.
1980 "History of Ga'anda/Tarihin Ga'anda." Edited and translated by M. Berns. *Occasional Paper No. 21*, African Studies Center, University of California, Los Angeles.

Kirk-Greene, A. H. M.
1969 [1958] *Adamawa Past and Present. An historical approach to the development of a Northern Cameroons Province.* Oxford.

Meek, C. K.
1931 *Tribal Studies in Northern Nigeria.* 2 vols. London.

Newman, R. Ma
1971 "A Case Grammar of Ga'anda." Ph.D. dissertation, University of California, Los Angeles.

Nissen, M.
1968 *An African Church is Born: The Story of the Adamawa and Central Sardauna Provinces in Nigeria.* Denmark.

Rubin, A. et al
Forthcoming *Sculpture of the Benue River Valley.* Museum of Cultural History Monograph Series, Los Angeles.

Yoruba

Abraham, R. C.
1958 *Dictionary of Modern Yoruba.* London.

Adepegba, C.
1976 "A Survey of Nigerian Body Markings and their Relationship to Other Nigerian Arts." Unpublished Ph.D. dissertation, Indiana University.

Ajayi, J. F. A. and R. Smith
1964 *Yoruba Warfare in the 19th Century.* Cambridge.

Anonymous
1937 *A Dictionary of the Yoruba Language.* Oxford.

Babalola, S. A.
1966 *The Content and Form of Yoruba Ijala.* London.

Burton, R.
1863 *Abeokuta and the Cameroon Mountains.* 2 vols. London.

Caldwell, J. C. and P. Caldwell
1977 "The Role of Marital Sexual Abstinence in Determining Fertility: a Study of the Yoruba in Nigeria." *Population Studies* 31(2):193–217.

d'Avezec, M.
1845 *Notice Sur Le Pays Et Le Peuple Des Yebous.* Memoire de la Societe Ethnologique, 2 (part 1). Paris.

Drewal, H. J.
1977 *Traditional Art of the Nigerian People.* Washington.
1980 *African Artistry.* Atlanta.
1987 "Ifa Divination Art: Design and Myth." *Africana Journal*, 14(2&3) [special issue on art].
Forthcoming "Art or Accident: The Relationship of Ogun and Iron to Yoruba Body Artists and their Art." In S. Barnes (ed.). volume on the Yoruba deity Ogun.

Drewal, H. J. and M. T. Drewal
1983 *Gelede: Art and Female Power among the Yoruba.* Bloomington, Indiana.

Drewal, M. T.
1977 "Projections from the Top in Yoruba Art." *African Arts* 11(1):43–49,91–92.

Drewal, M. T. and H. J. Drewal
1978 "More Powerful than Each Other: An Egbado Classification of Egungun." *African Arts* 11(3):28–39,98,99.
1987 "Composing Time and Space in Yoruba Art." *Word and Image*, 3(3):225–251.

Faleti, A.
1977 "Yoruba Facial Marks." *Gangan* 7:22–27.

Johnson, S.
1969 [1921] *The History of the Yorubas.* Ibadan

Lloyd, P. C.
1974 *Power and Independence.* London.

MacFie, J. W. W.
1913 "A Yoruba Tattooer." *Man* 13:121–122.

Merlo, C.
1975 "Statuettes of the Abiku Cult." *African Arts* 8(4):30–35,84.

Morakinyo, O. and A. Akiwowo
1981 "The Yoruba Ontology of Personality and Motivation: A Multidisciplinary Approach." *Journal of Social and Biological Structures* 4;19–38.

Prince, R.
1960 "Curse, Invocation and Mental Health among the Yoruba." *Canadian Psychiatric Association Journal* 5:65–79.

Smith, R.
1969 *Kingdoms of the Yoruba.* London.

Tereau and V. Huttel
1949–1950 "Monographie du Hollidge." *Etudes Dahomeennes* 2:59–72 and 3:10–37.

Thompson, R. F.
1973 "Yoruba Artistic Criticism." In *The Traditional Artist in African Societies*. W. L. d'Azevedo (ed.). Bloomington, Indiana.

Warren, D. M., A. D. Buckley, and J. A. Ayandokun
1973 *Yoruba Medicines*. Legon.

Baule

Holas, Bohumil
1949 "Notes sur le vêtement et la parure baoulé." *IFAN Bulletin* 9, no. 3–4:438–57.

Labouret, H.
1914 "Notes contributives à l'étude du peuple baoulé." *Revue des Études ethonologiques et sociologiques*, no. 3–4:187–94, no. 5–6:83–91.

Nebout, A.
1900 "Note sure le Baoulé." *A Travers le Monde*, 2e semestre 1900:393–96, 401–04, 409–12; ler semestre 1901: 17–20, 35–36.

Vogel, Susan
1973 "People of wood; Baule Figure Sculpture." *Art Journal*, 33:23–26.
1977 *Baule Art as the Expression of a World View*. Ph.D. dissertation. New York University.
1980 *Beauty in the Eyes of the Baule: Aesthetics and Cultural Values*. Working papers in the Traditional Arts. Philadelphia.

ASIA

Japan

Aoki Kazuo (ed.).
1982 *Kojiki. Nihon Shisō Taikei*, vol. 1. Tokyo.

Aston, W. G.
1972 *Nihongi: Chronicles of Japan from the Earliest Times to A.D. 697*. Tokyo.

Befu, Harumi
1965 "Yayoi Culture." *Studies in Japanese Culture* 1:1–49. Ann Arbor.

Bleed, Peter
1972 "Yayoi Cultures of Japan: An Interpretive Survey." *Arctic Anthropology* 9(2):1–23.

Buck, Pearl S. (trans.)
1933 *All Men Are Brothers*. New York.

Edwards, Walter
1983 "Event and Process in the Founding of Japan: the Horserider Theory in Archaeological Perspective." *Journal of Japanese Studies* 9(2):265–295.

Egami Namio
1973 *The Beginnings of Japanese Art*. New York and Tokyo.

Elisseeff, Vadime
1973 *Archaeologia Mundi: Japan*. Geneva, Paris, Munich.

Esaka Teruya
1967 *Dogū*. Tokyo.

Goodrich, L. Carrington (ed.).
1951 *Japan in the Chinese Dynastic Histories: Later Han through Ming Dynasties*. South Pasadena.

Gunji Masakatsu and Fukuda Kazuhiko (eds.).
1977 *Genshoku Ukiyo-e Shisei Hanga*. Tokyo.

Hamada, Kengi (trans.)
1964 Saikaku Ihara, *The Life of an Amorous Man*. Rutland, Vermont, and Tokyo.

Hibbet, Howard (trans.)
1970 Junichirō Tanizaki, *Seven Japanese Tales*.

Hillier, Jack
1957 *Hokusai: Paintings, Drawings, and Woodcuts*. London.
1980 *The Art of Hokusai in Book Illustration*. Berkeley and Los Angeles.

Iizawa Tadasu and Fukusi Katsunari (eds.).
1973 *Genshoku Nihon Shisei Taikan*. Tokyo.

Irwin, Richard G.
1953 *The Evolution of a Chinese Novel: Shui-hu-chuan*. Cambridge.

Japan Tattoo Institute (ed.).
1983 *Nihon Shisei Geijutsu: Horiyoshi*. (English title: *Japan's Tattoo Arts, Horiyoshi's World*.) Tokyo.

Kaplan, David E. and Alex Dubro
1986 *Yakuza: The Explosive Account of Japan's Criminal Underworld*. Reading, Mass.

Keene, Donald
1976 *World Within Walls: Japanese Literature of the Pre-Modern Era, 1600–1867*. New York.
1984 *Dawn to the West: Japanese Literature of the Modern Era*. New York.

Keyes, Roger S. and Keiko Mizushima
1973 *The Theatrical World of Osaka Prints*. Philadelphia.

Keyes, Roger S. and George Kuwayama
1980 *The Bizarre Imagery of Yoshitoshi*. Los Angeles.

Kidder, J. Edward
1964 *Early Japanese Art: The Great Tombs and Treasures*. London.
1965 *The Birth of Japanese Art*. London.
1966 *Japan Before Buddhism*. New York.
1968 *Prehistoric Japanese Arts: Jomon Pottery*. Tokyo.

Kiley, Cornelius J.
1973 "State and Dynasty in Archaic Yamato." *Journal of Asian Studies* 33(1):25–49.

Kobayashi Chū
1975 *Kaburagi Kiyokata. Nihon no Meiga* vol. 7. Tokyo.

Ledyard, Gari
1975 "Galloping Along with the Horseriders: Looking for the Founders of Japan." *Journal of Japanese Studies* 1(2):217–254.

Miki Fumio
1974 *Haniwa. Arts of Japan*, vol. 8. New York and Tokyo.

Obora Kazuo
1962 *Nantō Irezumi Ko*. Tokyo.

Pearson, Richard J.
1986 *Windows on the Japanese Past: Studies in Archaeology and Prehistory*. Ann Arbor

Philippi, Donald L.
1969 *Kojiki*. Tokyo.

Riccar Art Museum
1979 *Exhibition of Suikoden by Kuniyoshi*. Tokyo.

Richie, Donald and Ian Buruma
1980 *The Japanese Tattoo*. New York and Tokyo.

Robinson, B. W.
1961 *Kuniyoshi*. London.
1982 *Kuniyoshi: The Warrior Prints*. Ithaca, New York.

Sakamoto Tarō (ed.).
1967 *Nihon Shoki. Nihon Koten Bungaku Taikei*, vols. 67–68. Tokyo.

Sekai Daihyakka Jiten
 1981 "Irezumi." 2:466–468. Tokyo.

Stern, Harold P.
 1969 *Masterprints of Japan: Ukiyo-e Hanga*. New York.

Takayama Jun
 1969 *Jōmonjin no Irezumi: Kodai Shuzoku o Saguru*. Tokyo.

Thayer, John E.
 1983 "Tattoos." *Kodansha Encyclopedia of Japan*. 7:350–351. Tokyo.

Van Gulik, W. R.
 1982 *Irezumi: The Pattern of Dermatography in Japan*. Leiden.

Watanabe Makoto
 1984 *Zoho Jōmon-jidai Shokubutsushoku*. Tokyo.

Yamada Hideo
 1979 *Nihon Shoki*. Tokyo.

Yamao Yukihisa
 1972 *Gishi Wajinden*. Tokyo.

Newar

Bernier, Ronald M.
 1970 *The Temples of Nepal (An Introductory Survey)*. Kathmandu.

Teilhet-Fisk, Jehanne
 1978 "The Tradition of the Nava Durga in Bhaktapur, Nepal." *Kalish: A Journal of Himalayan States* (Winter).

Gujarat

Bohannan, Paul
 1956 "Beauty and Scarification amongst the Tiv." *Man* Sept:117–121 (no. 129).

Bosch, Frederick D. K.
 1960 *The Golden Germ: An Introduction to Indian Symbolism*. s'Gravenhage.

Devmurari, Parshuram
 1979 The Folk Literature of the Cattle Breeders of Panchal Hills and its Relation with their Folk Culture. Unpublished Ph.D. dissertation. Department of Folklore, Saurastra University, Rajkot.

Durrans, Brian
 1982 "Vasna: Village life in Gujarat." Brian Durrans & Robert Knox (eds.). *India: Past into Present*. London.

Elson, Vickie C.
 1979 *Dowries from Kutch: A Women's Folk Art Tradition in India*. Los Angeles.

Faris, James C.
 1972 *Nuba Personal Art*. Toronto.

Fischer, Eberhard & Haku Shah
 1970 *Rural Craftsmen and Their Work: Equipment and Techniques in the Mer Village of Ratadi in Saurastra, India*. National Institute of Design, Ahmedabad.
 1973 "Tatauieren in Kutch." *Ethnologische Zeitschrift Zurich* II:105–129.

Gupte, B. A.
 1902 "Note on Female Tattoo Designs in India." *The Indian Antiquary: A Journal of Oriental Research . . .* (Bombay) 36 (July):293–298.

Jacobson, Doranne
 1971 "Women and Jewelry in Rural India." Giri Raj Gupta (ed.). *Family and Social Change in Modern India* (Main Currents in Indian Sociology—II). Durham.

Joshi, Om Prakash
 1976 "Tattooing and Tattooers: A Socio-cultural Analysis." *Bulletin*, International Committee on Urgent Anthropological and Ethnological Research. Vienna.

Koppar, D. H.
 1971 *Tribal Art of Dangs*. Department of Museums, Baroda.

Lal, R. B.
 1979 *Sons of the Aravallis: The Garasias*. Tribal Research and Training Institute, Gujarat Vidyapith, Ahmedabad.

Mathur, K. S.
 1963 *Socio-Economic Survey of Primitive Tribes in Madhya Pradesh*. National Council of Applied Economic Research, New Delhi.

Morab, S. G.
 1977 *The Kellekyatha, Nomadic Folk Artists of Northern Mysore*. Anthropologial Survey of India, Calcutta.
 1982 "Values and world view of the nomadic Killekyatha." Misra and K. C. Malhotra (eds.). In *Nomads in India: Proceedings of the National Seminar*. Anthropological Survey of India, Calcutta.

Parmar, Shyam
 1981 *Folklore of Madhya Pradesh*. Folklore of India Series. National Book Trust, New Delhi (1972).

Pearson, M. N.
 1976 *Merchants and Rulers in Gujarat*. Berkeley.

Rubin, Arnold
 1985 "Tattoo in India." *The Tattoo Historian*, No. 7.

Ruhela, Saitya Pal
 1968 *The Gaduliya Lohars of Rajasthan: A Study in the Sociology of Nomadism*. New Delhi.

Shah, P. G.
 1967 *Vimukta Jatis: Denotified Communities in Western India*. Gujarat Research Society, Bombay.

Srinivas, M. N.
 1956 "A Note on Sanskritization and Westernization." *Far Eastern Quarterly* 15(4); reprinted, Thirtieth Anniversary Commemorative Series, *Far Eastern Quarterly/Journal of Asian Studies, 1941–1971*, Vol. 3 (South and Southeast Asia).

Staal, J. F.
 1963 "Sanskrit and Sanskritization." *Journal of Asian Studies*, 22(3); reprinted, Thirtieth Commemorative Series, *Far Eastern Quarterly/Journal of Asian Studies, 1941–1971*, Vol. 3 (South and Southeast Asia).

Trivedi, Harshad R.
 1952 "The Mers of Saurastra: A Study of their Tattoo Marks." *Journal of the Maharaja Sayaji Rao University of Baroda* 1(2):121–132.

Tuttle, Lyle
 1985 "Magic Wand." *The Tattoo Historian*, No. 7:24–26.

OCEANIA

Hawai'i

Arago, Jacques
 1823 *Narrative of a Voyage Round the World*. London.
 1840 *Souvenirs d'un avengle, voyage autour du monde*. 2 vols. Paris.

Arning, Eduard
 1931 *Ethnographische Notizen aus Hawaii, 1883–86*. Hamburg Museum für Völkerkunde Mitt. Vol. 16. (Translated by Muller-Ali in Bishop Museum.)

Beaglehole, J. C. (ed.).
1967 *The Journals of Captain James Cook on His Voyages of Discovery, The Voyage of the Resolution and Discovery 1776–1780.* Cambridge, Published for the Hakluyt Society.

Bennett, F. D.
1840 *Narrative of a Whaling Voyage Round the Globe, 1833–1836.* 2 vols. London.

Choris, Louis
1822 *Voyage Pittoresque Autour du Monde.* Paris.

Cook, James and James King
1784 *A Voyage to the Pacific Ocean . . . 1776–1780.* London.

Dixon, George A.
1789 *A Voyage Round the World . . . 1785, 1786, 1787 and 1788.* London.

Ellis, William
1783 *An Authentic Narrative of a Voyage performed by Capt. Cook and Capt. Clerke.* London.

Ellis, Rev. William
1827 *Narrative of a Tour Through Hawaii.* London.

Emory, Kenneth P.
1946 "Hawaiian Tattooing." *Bishop Museum Occasional Papers* 18(17). Honolulu.

Fornander, Abraham
1918–1919 *Fornander Collection of Hawaiian Antiquities and Folk-lore.* Bishop Museum Memoirs. Vol. 5.

Green, Roger
1979 "Early Lapita Art from Polynesia and Island Melanesia: Continuities in Ceramic, Barkcloth, and Tattoo Decoration." In *Exploring the Visual Art of Oceania.* Sidney M. Mead. (ed.). Honolulu.

Kaeppler, Adrienne
1975 *The Fabrics of Hawaii (Barkcloth).* Leigh-on-Sea: F. Lewis Publishers.
1980 *Pahu and Pūniu: An Exhibition of Hawaiian Drums.* Honolulu.
1982 "Genealogy and Disrespect: A Study of Symbolism in Hawaiian Images." *RES* 3:82–107.
1985 "Hawaiian Art and Society: Traditions and Transformations." In *Transformations of Polynesian Culture.* Antony Hooper and Judith Huntsman (eds.). Auckland.
In preparation *Hula Pahu and Haʻa: The Movements of Dance and Ritual.* To be published by Bishop Museum Press.

Kamakau, S. M.
1964 *Ka Poʻe Kahiko: The People of Old.* Honolulu: Bishop Museum Special Publication 51.

Kotzebue, Otto von
1821 *A Voyage of Discovery into the South Sea and Beering's Straits.* 3 vols. London.
1830 *A New Voyage Round the World, in the Years, 1823, 24, 25, and 26.* 2 vols. London.

Krämer, Augustin
1906 *Hawaii, Ostmikronesien, und Samoa.* Stuttgart.

Mader, Huapala
n.d. *Notes in Bishop Museum Library.*

Mathison, G. F.
1825 *Narrative of a Visit to Brazil, Chile and Peru and the Sandwich Islands.* London.

McLaughlin, John
1973 Hawaiian Tattoo Motifs. Manuscript in Bishop Museum Library.

Paris, J. D.
1926 *Fragments of Real Missionary Life.* Honolulu.

Pickering, Charles
1848 *The Races of Man.* The United States Exploring Expedition, Vol. 9. Philadelphia.

Portlock, Nathaniel
1789 *A Voyage Round the World . . . 1785–1788.* London.

Roth, H. Ling
1900 "Artificial Skin Marking in the Sandwich Islands." *Archiv für Ethnog* 13:198–201.

Stokes, John
n.d. *Notes and manuscripts in the Bishop Museum Library.*

Tyerman, Daniel and George Bennet
1831 *Journal of Voyages and Travels . . . 1821–1829.* London.

Maori

Allingham, E. G.
1924 *A Romance of the Rostrum.* London.

Bellwood, Peter
1978 *Man's Conquest of the Pacific: The Prehistory of Southeast Asia and Oceania.* Auckland.

Best, Elsdon
1974 *The Maori As He Was.* Wellington.

Buck, Sir Peter (Te Rangi Hiroa)
1950 *The Coming of the Maori.* 2nd ed. Wellington.

Cowan, James
1910 *The Maoris of New Zealand.* Christchurch.
1921 "Maori Tattooing Survivals." *Journal of the Polynesian Society* 30:241–245.
1930 *The Maori Yesterday and To-day.* Wellington.

Firth, Raymond
1929 *Primitive Economics of the New Zealand Maori.* London.

Green, Roger C.
1979 "Early Lapita Art from Polynesia and Island Melanesia: Continuities in Ceramic, Barkcloth, and Tattoo Decorations." In Sidney M. Mead (ed.) *Exploring the Visual Art of Oceania.* Honolulu.

Hawkesworth, John
1773 *An Account of the Voyages Undertaken . . . for Making Discoveries in the Southern Hemisphere.* London.

Jackson, Michael
1972 "Aspects of Symbolism and Composition in Maori Art." *Bijdragen tot de Taal-, Land- en Volkenkunde* 128:33–80.

King, Michael
1972 *Moko: Maori Tattooing in the 20th Century.* Wellington.

Luomala, Katherine
1949 *Maui-of-a-Thousand-Tricks: His Oceanic and European Biographers.* Bernice P. Bishop Museum Bulletin 198. Honolulu.

McEwen, J. M.
1966 "Maori Art." In A. H. McLintock (ed.). *An Encyclopaedia of New Zealand.* Vol. 2. Wellington.

Metge, Joan
1976 *The Maoris of New Zealand: Rautahi.* 2nd ed. London.

Robley, Major-General
1896 Moko; or Maori Tattooing. London.

Robley, H. G.
n.d. *Moko, or Maori Tattooing: Sketches by H. G. Robley.* (Scrapbook in Fuller Collection, Library, Bernice P. Bishop Museum, Honolulu.)

Salmond, Anne
 1976 *Hui: a Study of Maori Ceremonial Gatherings.* 2nd ed. Wellington.

Simmons, Dave
 1983 "Moko." In Sidney M. Mead and Bernie Kernot (eds.). *Art and Artists of Oceania.* Palmerston North.

Skinner, H. D.
 1974 "Culture Areas in New Zealand." In *Comparatively Speaking: Studies in Pacific Material Culture 1921–1972.* Dunedin.

Trotter, Michael and Beverley McCulloch
 1971 *Prehistoric Rock Art of New Zealand.* Wellington.

White, John
 1889 *The Ancient History of the Maori, his Mythology and Traditions.* Vols. 1, 2 (English versions). Wellington and London.

Williams, Herbert W.
 1971 *A Dictionary of the Maori Language.* 7th ed. Wellington.

NATIVE AMERICA

Navtive Alaska

Anderson, H. Dewey and Walter Crosby Eells
 1935 *Alaska Natives.* Stanford.

Beechey, Frederick W.
 1831 *Narrative of a Voyage to the Pacific and Beering's Strait.* 2 vols. London.

Birket-Smith, Kaj
 1959 *The Eskimos.* London.

Boas, Franz
 1901 "The Eskimo of Baffin Land and Hudson Bay." *American Museum of Natural History Bulletin,* 15.
 1964 *The Central Eskimo.* Lincoln, Nebraska.

Chance, Norman A.
 1966 *The Eskimo of North Alaska.* New York.

Choris, Ludovik
 1822 *Voyage Pittoresque Autour du Monde.* Paris

Collier, John Jr.
 1973 *Alaskan Eskimo Education: A Film Analysis of Cultural Confrontation in the Schools.* New York.

Cook, James and James King
 1784 *A Voyage to the Pacific Ocean, Undertaken, by Command of His Majesty, for Making Discoveries in the Northern Hemisphere.* 4 vols. Atlas. London.

Fitzhugh, William W. and Susan A. Kaplan
 1982 *Inua: Spirit World of The Bering Sea Eskimo.* Washington, D.C.

Hoffman, Walter James
 1897 *The Graphic Art of the Eskimos.* Washington, D.C.

Jacobi, A.
 1937 "Carl Heinrich Mercks Ethnographische Beobachtungen über die Völker des Beringsmeers 1789–91." *Baessler-Archiv* 20, Pt. 3–4.

Jenness, Diamond
 1962 "Eskimo Administration: I. Alaska." *Arctic Institute of North America Technical Paper,* 10.

Jochelson, Waldemar
 1925 *Archaeological Investigations in the Aleutian Islands.* Washington, D.C.

Kotzebue, Otto von
 1821 *A Voyage of Discovery into the South Sea and Beering's Straits . . . in the Years 1815–1818.* 3 vols. London.

Langsdorff, G. H. von
 1817 *Voyages and Travels in Various Parts of the World, during the Years 1803, 1804, 1805, 1806, and 1807.* Carlisle.

Lantis, Margaret
 1946 "The Social Culture of the Nunivak Eskimo." *Transactions of the American Philosophical Society,* 35, Pt. 3.
 1966 *Alaskan Eskimo Ceremonialism.* Seattle.

Larsen, Helge and Froelich Rainey
 1948 "Ipiutak and the Arctic Whale Hunting Culture." *Anthropological Papers of the American Museum of Natural History,* 42.

Lisiansky, Urey
 1814 *A Voyage Round the World in the Years 1803, 1804, 1805, and 1806.* London.

Murdoch, John
 1892 "Ethnological Results of the Point Barrow Expedition." *Bureau of American Ethnology Report,* 9.

Nelson, Edward William
 1899 "The Eskimo About Bering Strait." *Bureau of American Ethnology Report,* 18, Pt. 1.

Oswalt, Wendell H.
 1967 *Alaskan Eskimos.* San Francisco.

Petitot, E.
 1876 *Vocabularie Francais-Esquimau.* Paris.

Ray, Dorothy Jean
 1977 *Eskimo Art: Tradition and Innovation in North Alaska.* Seattle.
 1981 *Aleut and Eskimo Art: Tradition and Innovation in South Alaska.* Seattle

Sarytschew, Gawrila
 1806 *Account of a Voyage of Discovery to the North-East of Siberia, the Frozen Ocean and the North-East Sea.* London.

Sauer, Martin
 1802 *An Account of a Geographical and Astronomical Expedition to the Northern Parts of Russia . . . in the Years 1785 etc. to 1794.* London.

Spencer, Robert F.
 1959 "The North Alaskan Eskimo." *Bureau of American Ethnology Bulletin,* 171.

Stefansson, Vilhjalmur
 1914 "The Stefansson-Anderson Arctic Expedition of the American Museum: Preliminary Ethnological Report." *Anthropological Papers of the American Museum of Natural History,* 14, Pt. 1.

Stockton, Charles H.
 1890 "The Arctic Cruise of the U.S.S. Thetis in the Summer and Autumn of 1889." *The National Geographic Magazine,* 2.

Thalbitzer, William
 1912 "Ethnological Collections from East Greenland." *Meddelelser om Grönland,* 39.

VanStone, James W. and Charles V. Lucier
 1974 "An Early Archaeological Example of Tattooing from Northwestern Alaska." *Fieldiana,* 66(1).

Tlingit

Bettelheim, Bruno
1954 *Symbolic Wounds*. New York.

Boas, Franz
1916 "Tsimshian Mythology." *31st Annual Report of the Bureau of American Ethnology*.

Brown, Judith
1963 "A Cross-Cultural Study of Female Initiation Rites." *American Anthropologist* 65:837–853.

Chardin, J.
1950 *Notas preliminares sobre la dispersion continental de un adorno de labio en los pueblos aborigenes, el bezote labret, o tembeta*. Ovalle, Chile.

Codere, Helen
1950 *Fighting with Property: A Study of Kwakiutl Potlatching and Warfare, 1792–1930*. New York.

Colette, J.
1933 "Le labret en Afrique et en Amerique." *Bulletin de la Société des Americanistes de Belgique* 13:5–61.

Dall, William
1882 "Masks, Labrets, and Certain Aboriginal Customs." *3rd Annual Report of the Bureau of American Ethnology*:67–203.

Douglas, Mary
1966 *Purity and Danger*. London.
1970 *Natural Symbols*. New York.

Duff, Wilson
1981 "The World is as Sharp as a Knife: Meaning in Northern Northwest Coast Art." In *The World is as Sharp as a Knife: An Anthology in Honor of Wilson Duff*. Donald N. Abbot (ed.). Victoria, BC.

Emmons, George
n.d. Collection notes, Department of Anthropology, American Museum of Natural History. New York.

Fisher, Seymour and Sidney Cleveland
1958 *Body Image and Personality*. Princeton.

Freud, Sigmund
1950 *Totem and Taboo*. London.

Geertz, Clifford
1983 "Art as a Cultural System." In *Local Knowledge: Further Essays in Interpretive Anthropology*. New York.

Gennep, Arnold van
1960 *The Rites of Passage*. Chicago. Translation of *Les Rites du Passage* (1909).

Goldman, Irving
1975 *The Mouth of Heaven*. New York.

Gunther, Erna
1966 *Art in the Life of the Northwest Coast Indian*. Portland.
1972 *Indian Life on the Northwest Coast of North America as Seen by the Early Explorers and Fur Traders during the Last Decades of the Eighteenth Century*. Chicago.

Jonaitis, Aldona
1986 *Art of the Northern Tlingit*. Seattle.

Keddie, Grant R.
1981 "The Use and Distribution of Labrets on the North Pacific Rim." *Syesis* 14:59–80.

Krause, Aurel
1956 *The Tlingit Indians*. Seattle. Translation of *Die Tlinkit-Indianer* (1885).

Labouret, Henri
1952 "A Propos des labrets en verre de quelques populations Voltaïques." *Bulletin, Institut Français d'Afrique Noire* 14:1385–1401.

Laguna, Frederica de
1972 *Under Mount St. Elias: The History and Culture of the Yakutat Tlingit*. Smithsonian Contributions to Anthropology, Vol. 7.

Lebeuf, Jean-Paul
1953 "Labrets et greniers des Fali." *Bulletin, Institut Française d'Afrique Noire* 15:1321–1328.

Lévi-Strauss, Claude
1969 *The Elementary Structures of Kinship*. Boston. Translation of *Les Structures élémentaires de la parente* (1949), Paris.
1982 *The Way of the Masks*. Seattle. Translation of *La voie des masques* (1979), Paris.

McClellen, Catherine
1954 "The Interrelations of Social Structure with Northern Tlingit Ceremonialism." *Southwestern Journal of Anthropology* 10:75–96.

McLaren, Carol
1978 "Moment of Death: Gift of Life. A Reinterpretation of the Northwest Coast Image 'Hawk.'" *Anthropologica* 20:65–90.

Mauss, Marcel
1967 *The Gift*. New York. Translation of *Essai sur le don* (1925).
1979 "Body Techniques." In *Sociology and Psychology: Essays*. London and Boston and Henley. Translation of "Techniques du corps" (1936).

Myerhoff, Barbara
1982 "Rites of Passage: Process and Paradox." Victor Turner (ed.). *Celebration: Studies in Festivity and Ritual*. Washington, D.C.

Oberg, Kalervo
1973 *The Social Economy of the Tlingit Indians*. Seattle.

Olson, Ronald
1967 "Social Structure and Social Life of the Tlingit in Alaska." *Anthropological Records of the University of California* 26.

Polhemus, Ted
1978 "Introduction." In *The Body Reader*. New York.

Postal, Susan
1978 "Body Image and Identity." In *The Body Reader*. T Polhemus (ed.). New York. First published 1965.

Reid, Susan
1979 "The Kwakiutl Man-Eater." *Anthropologica* 21:247–276.
1981 "Four Kwakiutl Themes on Isolation." Donald N. Abbot (ed.). *The World is as Sharp as a Knife: An Anthology in Honor of Wilson Duff*. Victoria, B.C.

Rosman, Abraham and Paula Rubel
1971 *Feasting with Mine Enemy: Rank and Exchange among Northwest Coast Societies*. New York.

Seeger, Anthony
1975 "The Meaning of Body Ornaments: A Suya Example," *Ethnology* 14(3):211–224.

Shotridge, Louis
1929 "The Bridge of Tongass." *Museum Journal* 19:131–156.

Swanton, John
 1908 ''Social Condition, Beliefs, and Linguistic Relationship of the Tlingit Indians.'' *26th Annual Report of the Bureau of American Ethnology*:391–512.
 1909 ''Tlingit Myths and Texts.'' *Bureau of American Ethnology Bulletin 39.*

Turner, Victor
 1967 *The Forest of Symbols*, Ithaca.

Walens, Stanley
 1981 *Feasting with Cannibals: An Essay on Kwakiutl Cosmology*. Princeton.

Widerspach-Thor, Martine de
 1981 ''The Equation of Copper.'' Donald N. Abbott (ed.). *The World is as Sharp as a Knife: An Anthology in Honor of Wilson Duff*. Victoria, BC.

Young, Frank
 1965 *Initiation Ceremonies: A Cross-Cultural Study of Status Dramatization*. New York.

CONTEMPORARY EURO-AMERICA

Chicano

Carswell, John
 1958 *Coptic Tattoo Designs*. Beirut.

Durkheim, Emile
 1965 *The Elementary Forms of Religious Life*. Joseph Swain (trans.). New York. First published 1915.

Govenar, Alan B.
 1977 ''The Acquisition of Tattooing Competence.'' *Folklore Annual* 7/8:43–53.
 1981 ''Culture in Transition: The Recent Growth of Tattooing in American Culture.'' *Anthropos* 76:216–219.
 1982 ''The Changing Image of Tattooing in American Culture.'' *Journal of American Culture* 5(2):30–37.
 1983 ''Christian Tattoos.'' *Tattootime* 2(1):4–11.
 1985 ''Tattooing in Texas.'' Francis Abernethy, editor. *Folk Art in Texas*. Dallas.

Hertz, J. H. (ed.).
 1969 *The Pentateuch and Haftorahs*. London.

Hyamson, Moses (ed.).
 1962 *Mishneh Torah*. Jerusalem.

Gonzalez, Alicia
 1982 ''Murals: Fine, Popular or Folk Art?'' *Atzlan* 13(1,2):155,157.

Gradante, William
 1982 ''Low and Slow, Mean and Clean.'' *Natural History* April:32.

Maimonides
 1962 *Mishneh Torah*. Moses Hyamson (ed.). Jerusalem.

Meinardus, Otto
 1970 *Christian Egypt, Faith and Life*. Cairo.

Orozco, Sylvia
 1980 ''Chicanos and Tattoos.'' *Arriba* Aug:9.

St. Clair, Leonard L. and Alan B. Govenar
 1982 *Stoney Knows How: Life as a Tattoo Artist*. Lexington.

Commercial Tattoo

Anonymous
 1982 ''The Name Game.'' *Tattootime* 1(1):50–54.

Becker, H., B. Geer, E. Hughes, and A. Strauss
 1961 *Boys in White*. Chicago.

Becker, N. and R. E. Clark
 1979 ''Born to Raise Hell: An Ethnography of Tattoo Parlors.'' Paper presented at the meetings of Southwestern Sociological Association, Fort Worth, Texas.

Brain, R.
 1979 *The Decorated Body*. New York.

Browne, J.
 1976 ''The Used Car Game.'' In *The Research Experience*. M. P Golden (ed.). Itasca, Illinois.

Browne, R.
 1972 ''Popular Culture: Notes Toward A Definition.'' In *Side-Saddle On the Golden Calf*. G. Lewis (ed.). Pacific Palisades, California.

Edgerton, R. and H. Dingman
 1963 ''Tattooing and Identity.'' *International Journal of Social Psychiatry* 9:143–153.

Emerson, J.
 1970 ''Behavior in Private Places: Sustaining Definitions of Reality in a Gynecological Examination.'' In *Patterns of Communicative Behavior* (Recent Sociology, No. 2). H. Dreitzel (ed.). New York.

Faulkner, R.
 1983 *Music on Demand*. New Brunswick, New Jersey.

Ferguson-Rayport, S., R. Griffith, and E. Straus
 1955 ''The Psychiatric Significance of Tattoos.'' *Psychiatry Quarterly* 29:112–131.

Gans, H.
 1974 *Popular Culture and High Culture*. New York.

Goffman, E.
 1959 *The Presentation of Self in Everyday Life*. Garden City, New York.

Goldstein, N.
 1979a ''Psychological Implications of Tattoos.'' *Journal of Dermatologic Surgery and Oncology* 5:883–888.
 1979b ''Complications From Tattoos.'' *Journal of Dermatologic Surgery and Oncology* 5:869–878.

Govenar, A.
 1977 ''The Acquisition of Tattooing Competence: An Introduction.'' *Folklore Annual of the University Folklore Association* 7&8:43–53.

Grumet, G.
 1983 ''Psychodynamic Implications of Tattoos.'' *American Journal of Orthopsychiatry* 53:482–492.

Hambly, W.
 1925 *The History of Tattooing and Its Significance*. London.

Handy, E. and W. Handy
 1924 *Samoan House Building, Cooking and Tattooing*. Honolulu, Hawaii.

Hardy, E.
 1983 ''Tattoo Magic.'' *Tattootime* 2(1):40–51.

Henslin, J.
 1968 ''Trust and the Cab Driver.'' M. Truzzi (ed.). *Sociology and Everyday Life*. Englewood Cliffs, New Jersey.

Hirschi, T.
 1962 ''The Professional Prostitute.'' *Berkeley Journal of Sociology* 7:37–48.

Hirschman, E. and M. Wallendorf
 1982 ''Characteristics of the Cultural Continuum: Implications for Retailing.'' *Journal of Retailing* 58:5–21.

Kando, T.
 1975 *Leisure and Popular Culture in Transition*. St. Louis.

Lemes, A.
1979 *Tattoo: Trade Secrets* 1(3). Mimeographed manuscript.

Mennerick, L.
1974 "Client Typologies: A Method of Coping with Conflict in the Service Worker-Client Relationship." *Sociology of Work and Occupations* 1:396–418.

Morse, A.
1977 *The Tattooists.* San Francisco.

Paine, J.
1979 "Skin Deep: A Brief History of Tattooing." *Mankind*, May:18–19,40–43.

Polhemus, T. (ed.).
1978 *The Body Reader: Social Aspects of the Human Body.* New York.

Pollak, O. and E. McKenna
1945 "Tattooed Psychotic Patients." *American Journal of Psychiatry* 101:673–674.

Roebuck, J. and W. Frese
1976 "The After-Hours Club: An Illegal Social Organization and Its Client System." *Urban Life* 5:131–164.

St. Clair, L. and A. Govenar
1981 *Stoney Knows How: Life As A Tattoo Artist.* Lexington, Kentucky.

Sanders, C.
1983 "Physical Graffitti: Perspectives on Tattooee Motives and the Interactional Consequences of Tattoos." Paper presented at the XIth International Congress of Anthropological and Ethnological Sciences, Vancouver.
1984 "Tattoo Consumption: Risk and Regret in the Purchase of a Socially Marginal Service." *Advances in Consumer Research*, Vol. XII. E. Hirschman and M. Holbrook (eds.). New York.

Schroder, D.
1973 "Engagement in the Mirror: Hairdressers and Their Work." Ph.D. dissertation, Northwestern University.

Scutt, R. and C. Gotch
1974 *Art, Sex and Symbol.* New York.

Spiggle, S. and C. Sanders
1983 "The Construction of Consumer Typologies: Scientific and Ethnomethods." T. Kinnear (ed.). *Advances in Consumer Research*, Vol. XI. Provo, Utah.

Sudnow, D.
1965 "Normal Crimes." *Social Problems* 12:255–275.

Tucker, M.
1976 "Pssst! Wanna See My Tattoo" *Ms.* April:29–33.

Van Stone, J. and C. Lucier
1974 "An Early Archeological Example of Tattooing from Northwestern Alaska." *Fieldiana Anthropology* 66(1):1–9.

Webb, S.
1979 *Pushing Ink: The Fine Art of Tattooing.* New York.

Wilson, J.
1970 *Varieties of Police Behavior.* New York.

Yamamoto, J., W. Seeman, and B. Lester
1963 "The Tattooed Man." *Journal of Nervous and Mental Disease* 136:365–367.

Tattoo Renaissance

Abcarian, Robin
1984 "Tattoos: putting designs on a lifetime." *Daily News* (Los Angeles), "L.A. Life," 7 July, pp. 4–5.

Anon.
1970 "Tattoo Renaissance." *Time* 96(25):58.
1984a "L.A. East Tattooing." *Tattoo* 1(1):30–33.
1984b "Cliff Raven Studios." *Tattoo* 1(1):64–67.

Aurre, Judy
1983 "Meet Bert Grimm." *Tattoo Historian* 2(March):12 ff.

Brereton, Leo
1982 "Tattooed in Borneo." *Tattootime* 1(1):12–17.

Bruno, C.
1970 *Tatoues, Qui Etes-Vous . . . ?.* Paris.

Burchett, George and Peter Leighton
1958 *Memoirs of a Tattooist.* London.

Caruchet, William
1976 *Tatouages et tatoues.* Poitiers/Liguge.

Crawford, Lynda
1974 "The Tattoo of Life." *Soho Weekly News* July 18.

Davis, Douglas
1971 "Pins and Needles." *Newsweek* (December 13):113.

Dube, Philippe
1980 *Tattoo-tatoue.* Montreal.

Ebensten, Hans
1953 *Pierced Hearts and True Love.* London.

Fellowes, C. H.
1971 *The Tattoo Book.* Princeton.

Fried, Fred and Mary Fried
1978 *America's Forgotten Folk Arts.* New York.

Friedman, Nancy
1982 "Tattooed Ladies." *Playgirl* vol. no. (February):48–50,68,90–95.

Gehman, Pleasant
1983 "Rock's Tattooist." *L.A. Weekly*, Aug. 26–Sept. 1:6.

Goldstein, Norman
1979 "Laws and Regulations Relating to Tattoos." *Journal of Dermatologic Surgery and Oncology* 5(11):913–915.

Gonzales, Lawrence
1981 "Deep in with David Carradine." *Playboy* 28(2):124 ff.

Govenar, Alan B.
1981 "Introduction." Leonard St. Clair and Alan Govenar, *Stoney Knows How: Life as a Tattoo Artist.* Lexington.

Gumpert, Lynn
1983 *Jamie Summers: Metamorphic Rite.* The New Museum of Contemporary Art, New York.

Hardy, Ed
1982a "The Upsetter." *Tattootime* 1(1):26–31.
1982b "Interview: Paul Rogers." *Tattootime* 1(1):37–45.
1982c "The Mark of the Professional." *Tattootime* 1(1):46–49.
1982d "Lets Face It: Tattoo Visibility." *Tattootime* 1(1):33–36.
1983a "Inventive Cover Work." *Tattootime* 2(1):12–17.
1983b "Tattoo Magic." *Tattootime* 2(1):40–51.
1986 "George L. 'Doc' Webb: A Reminiscence," National Tattoo Assn. *Newsletter* (October:2–5,9).

Hardy, Lal
1985 "Punks." *Tattootime* 3(1):77–82.

Hill, Amie
1970 "Tattoo Renaissance." *Rolling Stone* (67):38–39.

Hillinger, Charles
 1983 ''Tattoo Artist Leaves Mark in Museum.'' *Los Angeles Times* (Part I) 23 May:23.

Irons, Greg
 1985 ''Sailors Grave and the Great Wave.'' *Tattootime* 3(7):40–47.

Lemes, Andrew John
 1980 *The Complete Handbook of Tattooing Techniques for the Artist*. Hollywood.

Levine, Paul G.
 1980 ''Rock Stars Film It Their Way.'' *Los Angeles Times* (Calendar) Jan. 13:6–7.

Link, Howard A.
 1979 *Masami Teraoka*. Whitney Museum, New York.

Makofske, Flo
 1985 ''Bert Grimm: Feb. 8, 1900–June 15, 1985.'' *National Tattoo Assn. Newsletter* (July-August):16–17.

Mann, Roderick
 1979 ''Waiting for Dracula's Call.'' *Los Angeles Times* (Part IV) Feb. 20:10.

Morse, Albert
 1977 *The Tattooists*. San Francisco.

Munz, Ludwig and Gustav Kunstler
 1966 *Adolf Loos: Pioneer of Modern Architecture*. London.

Nadler, Susan
 1983 ''Why More Women Are Being Tattooed.'' *Glamour* 81(5):196–198.

Parry, Albert
 1971 *Tattoo: Secrets of a Strange Art*. New York (1933).

Raven, Cliff
 1982 ''Thoughts on Pre-Technological Tattooing.'' *Tattootime* 1(1):10–11.

Roberts, Bob
 1985 ''Tattoos and Music.'' *Tattootime* 3(1):83–88.

Salewicz, Chris
 1982 ''Scratching the Skin, Scarring the Soul.'' *Time Out* No.637 (Nov. 5–11), London, p. 13.

Scutt, R. W. B. and Christopher Gotch
 1974 *Art, Sex and Symbol: The Mystery of Tattooing*. South Brunswick.

St. Clair, Leonard L. & Alan B. Govenar
 1981 *Stoney Knows How: Life as a Tattoo Artist*. Lexington.

Steur, Patricia
 1982 *Rock Star Tattoo Encyclopedia*. Antwerp.

Steward, Samuel M. (Phil Sparrow)
 1981 *Chapters from an Autobiography*. San Francisco.

Taylor, Richard
 1980 ''Fascinating Stories Behind . . . Tattoos of the Stars.'' *National Enquirer* 55(19):38.

Teresi, Dick
 1981 ''Psychic Tattoos.'' *Omni* (9):134.

Tucker, Marcia
 1976 ''Psst! Wanna See My Tattoo. . . .'' *Ms.* vol. 4 no. 10 (April):29–33.
 1981 ''Tattoo: the State of the Art.'' *Artforum* 19(9):42–47.

Tuttle, Lyle
 1970 *Tattoo 70*. San Francisco.

Walman, Diane
 1971 ''Tattoo.'' *The Art of Personal Adornment*. Museum of Contemporary Crafts, New York.

Webb, Spider
 1976 *Heavily Tattooed Men and Women*. New York.
 1977 *X*. New York.
 1979 *Pushing Ink: The Fine Art of Tattooing*. New York.

Zeis, Milton H.
 1968 [1951] *Tattooing the World Over*. Rockford.

Zulueta, Leo
 1985 ''Punk Rock Tattooing.'' *Tattootime* 3(7):89–95.

Author Profiles

Marla C. Berns

Received her Ph.D. from the University of California, Los Angeles, in art history. After three years of field research in northeastern Nigeria she is currently the Director of the Goldstein Gallery, University of Minnesota. Berns, with Barbara Rubin Hudson, authored *The Essential Gourd: Art and History in Northeastern Nigeria* and guest curated the associated traveling exhibition for the Museum of Cultural History.

Robert Steven Bianchi

Received his Ph.D. from New York University's Institute of Fine Arts in 1976, was a Fulbright-Hayes scholar at the Aegyptisches Museum in West Berlin in 1977, and has been associated with The Brooklyn Museum since 1976.

Paul Bohannan

Professor emeritus of Anthropology at the University of Southern California. He has taught at Oxford University, Princeton and Northwestern. An anthropologist, he did field work among the Tiv of the Benue Valley in Nigeria from 1949 to 1953, and has written several books and over thirty articles on that people.

Henry John Drewal

Presently Professor of Art History of the Art Department at Cleveland State University, he was an Andrew W. Mellon Fellow at The Metropolitan Museum of Art from 1985 to 1987. He has done more than five years of fieldwork in Africa and Brazil since 1970 and has published numerous books, catalogs, and articles on various aspects of African art and aesthetics.

James C. Faris

Professor of Anthropology at the University of Connecticut, he received his Ph.D. in 1966 from Cambridge University, and has previously taught at McGill University and the University of Khartoum. He has published on Newfoundland fishing communities, the Nuba Mountain region of Sudan, and Navajo religion, as well as contemporary theory, art and political criticism, and cultural knowledges in general.

Peter Gathercole

Fellow (and until recently Dean) of Darwin College, Cambridge. Previously Curator of the Museum of Archaeology and Anthropology at the University. Has also taught at Otago and Oxford Universities. Specializes in Polynesian ethnohistory and the history of archaeology.

Alan Govenar

Received a Ph.D. in Arts and Humanities from the University of Texas. Currently he is Director of Documentary Arts, Inc. in Dallas and is producing films and photographs on regional cultures in the Southwest, as well as a syndicated radio series "Traditional Music in Texas." His new book *Meeting the Blues* will be published in Fall, 1988.

Joy L. Gritton

Ph.D. candidate in art history at the University of California, Los Angeles, majoring in Native American Art. Her Master's thesis at the University of New Mexico (1984) dealt with the iconography/iconology of 19th century Inuit carved wooden masks from Angmagssalik, East Greenland. For her dissertation, she is currently studying the Institute of American Indian Arts in Santa Fe, New Mexico.

Aldona Jonaitis

An art historian who has written extensively on the art of the Northwest Coast Indians. She is currently on the faculty of the State University of New York at Stony Brook, and is a Research Associate in the Department of Anthropology at the American Museum of Natural History.

Adrienne L. Kaeppler

Curator of Oceanic Ethnology and Chairman of the Department of Anthropology at the Smithsonian Institution. Her Ph.D. is from the University of Hawai'i (1967) and she was an anthropologist on the staff of the Bishop Museum, Honolulu, from 1967–1980. Her field research on social and cultural anthropology has been primarily in Tonga and Hawai'i, and she has carried out extensive museum research on Polynesian material culture and the collections from the voyages of Captain Cook.

Donald F. McCallum

Teaches the history of Japanese Art and Archaeology at UCLA. Although concerned with all periods of Japanese Art, from Jōmon to modern times, he concentrates most of his research on Buddhist sculpture.

Allen F. Roberts

Received his Ph.D. in 1980 from the University of Chicago. He teaches anthropology at Albion College and conducts research at the Center for Afroamerican and African Studies of the University of Michigan, Ann Arbor. He has been engaged in African Studies for more than twenty years, having lived for about nine years in Zaire, Chad, Benin, Mali, Gabon and Burkina Faso. His principal fieldwork has been among the Tabwa of southeastern Zaire (1973–7). With his wife, art historian Mary Kujawski, Roberts is currently working to establish an African National Museums Program to assist in research and educational programs with counterpart staff in African museums.

Arnold Rubin

The late Dr. Arnold Rubin was an Associate Professor of Art History in the Department of Art, Design and Art History, University of California, Los Angeles, specializing in the arts of sub-Saharan Africa. In addition to the work reported in this volume, his field-research included studies of the sculpture of the Benue River Valley, Northeastern Nigeria; artistic evidence for the African historical and cultural presence in India; and unconventional art in southern California, especially the Pasadena Tournament of Roses. At the time of his death he was curating an exhibition of Benue Valley sculpture for the Museum of Cultural History, UCLA, scheduled for 1990.

Clinton R. Sanders

Associate Professor of Sociology at the Greater Hartford Campus of the University of Connecticut. His major areas of professional interest are popular culture, social deviance and qualitative research methods. Professor Sanders is currently involved in the investigation of social interaction between animals and humans.

Jehanne Teilhet-Fisk

Associate Professor and art historian at the University of California, San Diego, in La Jolla, California. Publications and research focused now on gender issues and acculturated arts in Oceania.

Susan Vogel

Executive Director of The Center for African Art, New York, she received her PhD from the Institute of Fine Arts, New York University (1977). She has travelled widely in Africa and conducted field research among the Baule of the Ivory Coast from 1968 to the present. She was responsible for the African section of the Rockefeller Wing at the Metropolitan Museum, and curator of the collection from its inception until 1985. Before that she was curator of the same collection at the Museum of Primitive Art.

Credits

Editing: *Irina Averkieff*
Coordination: *Paulette Parker*
Design & Publication Coordination: *Robert Woolard*
Typesetting: *Freedmen's Organization*
Printing: *Alan Lithograph*